Expressionist Film — New Perspectives

Studies in German Literature, Linguistics, and Culture

Edited by James Hardin
(*South Carolina*)

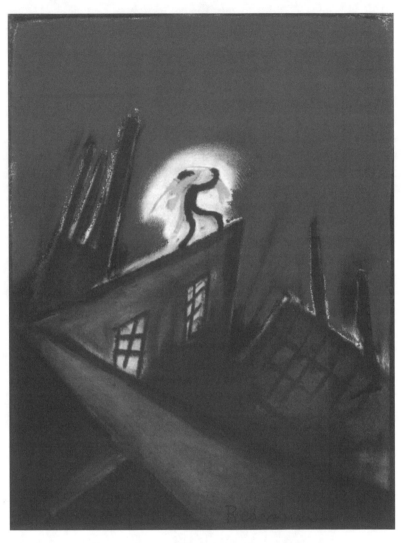

Walter Reimann, "Cesare abducts Jane."
Sketch for the set design of Robert Wiene's
The Cabinet of Dr. Caligari (1920).

Expressionist Film

NEW PERSPECTIVES

Edited by
Dietrich Scheunemann

CAMDEN HOUSE

Copyright © 2003 Dietrich Scheunemann

First published 2003
by Camden House

Camden House is an imprint of Boydell & Brewer Inc.
668 Mt. Hope Avenue, Rochester, NY 14620 USA
and of Boydell & Brewer Limited
PO Box 9, Woodbridge, Suffolk IP12 3DF, UK

ISBN: 1–57113–068–3

Library of Congress Cataloging-in-Publication Data

Expressionist film — New perspectives / edited by Dietrich Scheunemann.
 p. cm. — (Studies in German literature, linguistics, and culture)
"The present volume is the first outcome of a joint research project
carried out by the Centre for European Film Studies at the University
of Edinburgh, the Institute for Film Studies at the University of Mainz,
and the German Film Museum in Frankfurt am Main." —Pref.
Filmography: p.
Includes bibliographical references and index.
ISBN 1-57113-068-3 (hardcover: alk. paper)
 1. Motion pictures — Germany — History. 2. Expressionism.
I. Scheunemann, Dietrich. II. Series: Studies in German literature,
linguistics, and culture (Unnumbered).

PN1993.5.G3N49 2003
791.43'0943--dc21

 2003000502

A catalogue record for this title is available from the British Library.

This publication is printed on acid-free paper.
Printed in the United States of America.

Contents

IV. The Street, the Vaudeville, and the Power of the Camera

V. Avant-Garde Film

Preface

FOR HALF A CENTURY, two books have shaped the understanding of the cinema of the Weimar Republic, Siegfried Kracauer's *From Caligari to Hitler* and Lotte Eisner's *The Haunted Screen*. While Kracauer aimed at a socio-psychological reading of the films with a view to disclosing dispositions in the psyche of the German people that would explain the surrender of broad sections of the population to fascism, Lotte Eisner focused on aesthetic aspects pursuing in particular the development of expressionist features in films of the 1920s. Both works, complementing each other in their approaches and results, have acted as guides for film historians ever since they appeared in 1947 and 1952, respectively, and it is to their credit that the films of this period have remained so alive in the cultural memory.

However, fifty years on there is a growing awareness that the two books, although still recognized as the authoritative sources on its subject, do not tell the whole story of Weimar cinema, that important aspects, trends and films which do not easily fit into the lines of inquiry are neglected and that in particular in the case of Kracauer's book the highly problematic historiographic approach has led to interpretations and classifications of individual films and the whole cinema period which require a more solidly based reassessment. In addition, materials relating to the production of films have come to light which call interpretations in both books into question. The discovery of the script of *Caligari* for instance has rendered Kracauer's analysis of this film dubious in several respects. Since the interpretation of *The Cabinet of Dr. Caligari* forms one of the pillars of his overall argument about Weimar cinema, the framework of his whole book, the perspective in which he contextualized the cinematic developments of Weimar, has lost its power of persuasion.

Kracauer's book is still one of the great documents of its time, one of the seminal attempts by German writers in exile to find an explanation for the course of German history toward the seizure of power by Hitler. The screen of Weimar thus became the ground on which to explain the German catastrophe. Noble as the aim of this undertaking was, the terrain of its execution as well as the historiographic armature employed undermined the validity of its outcome. The German cinema experienced

one of its most creative and progressive periods in the years of Weimar. It absorbed trends in French, Scandinavian, Russian and American cinema and inspired in turn film cultures worldwide. Placing the achievements of this cinema in the context of the German people's disposition to Nazism begs a number of questions which Kracauer does not answer. In addition, the construction of a uniform and linear narrative of the political, social and cinematic history of Weimar combined with the simplistic assumption that films act in a rather uncomplicated way as mirrors of the mentality of a nation neglected divergences between political and cultural developments and forced interpretations on films that — in some distance from the events — appear simply untenable. By identifying the schoolboys in Josef von Sternberg's *The Blue Angel* as "born Hitler youth," or Dr. Caligari, the offspring of a Hoffmannesque tale, as a "premonition of Hitler," the book gives away the credibility which it gained on the grounds of its intention. What made Weimar cinema one of the legendary film cultures of its time, as Paul Rotha and Peter Gay confirm, and what enabled it to become the source of so "many valuable attributes to the cinema of the world," remains unexplained and unexplored in Kracauer's investigation. Instead, the "master narrative" takes its predetermined course: against all evidence the decline of the political history in the last years of Weimar had to be mirrored by a decline of the cinema culture.

The present volume is designed to pave the way to a historiography of Weimar cinema that places greater emphasis on the complexities of historical and cultural developments and encourages the investigation of nonsynchronous developments and the variety of trends that form the history of the cinema of this period. It will thus focus on discontinuities, inconsistencies, and the multiplicity of contexts which have given shape to the film culture of Weimar rather than trying to construct one coherent, linear story of all spheres of public life. Most important, it will attempt to sketch out the multiplicity and variety of film styles that emerged during this "Golden Age" of German cinema.

It is to the credit of Lotte Eisner that the artistic side of Weimar cinema has received the illumination it deserves. Eisner's love affair with expressionism has provided us with enthusiastic and perceptive descriptions of expressionist features in the films of this period. Her critical writings have added a dimension to film historiography lacking in Kracauer's and other critics' accounts of the first decades of cinema history: the contribution that other art forms such as painting, theater, and literature made to the formation of the new medium film. Understandable as it is that not only avant-garde filmmakers of the time, but

also critics and film historians have devoted much energy to the quest for the unique, genuine properties of film and thus to its demarcation from other art forms and media rather than an investigation of its links with them, it is precisely the awareness of these, the awareness of interchanges and interrelations of film with other arts and the impetus which it received from them in the process of its formation for which Eisner opened our eyes.

However, while Kracauer's "realist" understanding of film as a mirror of the mentality of a nation mislead him in his assessment in particular of the meaning and significance of "non-realist" devices and approaches to film form, Lotte Eisner's predilection for expressionist art tends to eclipse other stylistic developments in the cinema of Weimar. Neither the adoption of the highly successful French serial films in the work of Joe May and Fritz Lang in the early years of Weimar, nor the emergence of a specific German version of cinematic continuity style in the years of the political stabilization of the Republic, nor the formation of a montage style of Eisensteinian format in the last years of Weimar caught her attention. With the focus firmly on expressionist features, the book promoted a view of the cinema of Weimar which is as unison in its terms as Kracauer's historical construction: expressionist film became widely synonymous with Weimar cinema.

In two articles from 1958 and 1978 Lotte Eisner herself expressed regrets about this obvious misunderstanding of the intentions of her book and tried to redress the impression it had given. The present volume takes up this thread. Grateful to Lotte Eisner for both the establishing of a perspective in film history which evaluates the achievements of the new medium not primarily in terms of its uniqueness, but in the context of its interrelations and fruitful exchanges with other arts, and also for her attempt to correct an all too one-dimensional understanding of the cinema of Weimar solely in terms of expressionist film, the present volume attempts to map out an alternative landscape for the cinema of this period. The volume will focus on the early years of Weimar. In this context its task is twofold: to reassess what makes those films which in the view of all critics are unquestionably expressionistic the representatives of this avant-garde art style in film history, and at the same time to identify other styles and trends in the most notable other films of this period, including the historical spectacles by Ernst Lubitsch and the murder-mystery serials by Fritz Lang, F. W. Murnau's and E. A. Dupont's varied contributions to the art of cinematography, and the emergence of another avant-garde film style related to the Dadaist art movement rather

than to expressionism in the films by Walther Ruttmann, Viking Egge-ling, and Hans Richter.

The present volume is the first outcome of a joint research project carried out by the Centre for European Film Studies at the University of Edinburgh, the Institute for Film Studies at the University of Mainz and the German Film Museum in Frankfurt am Main. The project is designed to undertake a comprehensive reassessment of the cinema of Weimar from its beginnings to 1933. This volume focuses on the cinema of the Weimar Republic in its first years. While the two introductory essays open up more general perspectives on alternative notions of the domi-nant film styles and the main motifs in the cinema of this period, the main body of the following contributions concentrates on individual outstanding films.

The project partners will continue with their research. A second book focusing on developments from 1924 to 1933 and including arti-cles on Joe May and Fritz Lang, G. W. Pabst and Bertolt Brecht, Béla Balázs and Phil Jutzi, Robert Siodmak, Leontine Sagan, and Max Ophüls is currently in preparation. The research partners wish to record their gratitude for the support which they received from the British Council, the British Academy and the DAAD for carrying out this project. The publisher's patience in waiting for the revised picture of the cinema of Weimar to emerge is also gratefully acknowledged as is the tireless assis-tance of Dr. Mehrnoosh Sobhani in the preparation of this volume.

Edinburgh
September 2002
D. S.

Illustrations and Credits

ALL ILLUSTRATIONS IN THIS volume are courtesy of Deutsches Filmmuseum and Deutsches Institut für Filmkunde, Frankfurt am Main.

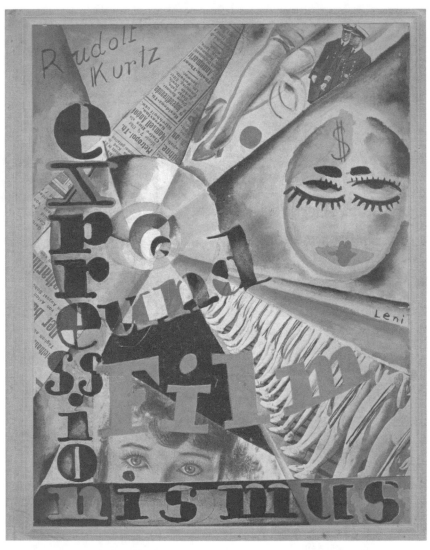

Cover of the first book publication on expressionist film,
Rudolf Kurtz's *Expressionismus und Film* (1926).
Cover design by Paul Leni.

I. Expressionist Film — Weimar Cinema

Activating the Differences: Expressionist Film and Early Weimar Cinema

Dietrich Scheunemann

I.

IN HIS ARTICLE ON "Expressionism and Film" Werner Sudendorf laments over the "great confusion" that has befallen "the definition of expressionist cinema."[1] Touching briefly on Rudolf Kurtz's pioneering study on *Expressionismus und Film* (Expressionism and Film, 1926) and the more recent article by Leonardo Quaresima on "Expressionismus als Filmgattung" (Expressionism as a Film Genre, 1992), both of which have in Sudendorf's view contributed to the "great confusion," he bestows most of the blame on Lotte Eisner's book *The Haunted Screen*. "The confusion referred to," Sudendorf writes,

> was probably initiated by the subtitle of Lotte H. Eisner's history of cinema, *The Haunted Screen: Expressionism in the German Cinema and the Influence of Max Reinhardt*, which first appeared in French in 1952. Suddenly, all the classic German films made during the Weimar Republic were termed "expressionist."[2]

And worse was yet to come. From the late 1960s onward several book publications extended the "expressionist" label beyond the period of Weimar to *films noir* and contemporary films as long as these showed some eccentricity in their set designs and used "lighting and camera techniques which distort perspectives."[3] Sudendorf has good reason to criticize the arbitrariness of such attribution of the expressionist label, isolating it from the historical and artistic context of its formation and from its initial function and thus rendering it "devoid of any real meaning."

Sudendorf shares this concern with Barry Salt who had voiced his unease about the extended use of the expressionist label in a spirited article from 1979 in which he maintained that

> Expressionism is well on the way to having so many vague meanings
> attached to it that it could become meaningless, and also useless as an
> analytic tool, as has happened with "realism."[4]

Trying to "salvage the concept of Expressionism" as a distinct style of
artistic production in various other arts as well as in film, Salt felt the
need to confine the number of films which could lay claim to the title of
expressionist cinema to six films made between 1919 and 1924. These
include *Das Cabinet des Dr. Caligari* (The Cabinet of Dr. Caligari,
1920), *Genuine* (1920), *Von morgens bis mitternachts* (From Morn to
Midnight, 1920), *Torgus* (1921), *Raskolnikov* (1923) and *Das Wachsfi-
gurenkabinett* (Waxworks 1924). Being indebted to expressionist paint-
ing and drama and showing corresponding traits in most of their features
were the criteria for this selection.

In a similar move Sudendorf confined his investigation on works
produced in the early years of Weimar. Placing the films in the context
of the expressionist art movement as well as the context of the "unsettled
and uncertain" social and political situation of the postwar years became
his particular concern. It is obviously this double vision that led Suden-
dorf to retain a wider selection of films characterized as expressionist.
This, however, is rather surprising since Sudendorf repeatedly emphasizes
Lotte Eisner's "tireless efforts to clarify the misunderstanding" which her
book had caused.[5] Of course, this misunderstanding was not in the first
place caused by the subtitle of Eisner's book, as Sudendorf suggests, but
by Eisner's overenthusiastic attribution of the expressionist label to films
of different genre and style throughout the Weimar period. While Su-
dendorf responded decisively to the latter, he remained unconcerned
about the former. He confined the expressionist period in cinema to the
early years of Weimar, but within this realm he continued to assemble
the old acquaintances under the expressionist label notwithstanding their
significant generic and stylistic divergences. So we find *Dr. Mabuse der
Spieler* (Dr. Mabuse the Gambler, 1922) and *Nosferatu* (1922) easily
grouped together with *The Cabinet of Dr. Caligari* and *From Morn to
Midnight*. In the case of *Mabuse* it is an expressionist trace in the sets, in
the case of *Nosferatu* the rendering of nature into a "cipher for threat,"
which provide the link to the great, recognized manifestations of expres-
sionist film, *Dr. Caligari* and *From Morn to Midnight*.[6]

In his most recent book on *Weimar Cinema and After*, Thomas El-
saesser refers to the same confusion as highlighted by Sudendorf, but
suggests a different response to it. Starting from a similar observation, i.e.
that "the German cinema of the Weimar Republic is often, but wrongly
identified with Expressionism,"[7] and obviously sharing the concern about

the demise in the meaning of the term "expressionist film," Elsaesser attempts to infuse new significance and a new operative value into it. He confronts "expressionist film" to "Weimar cinema," associating both terms with the two great prospects of the German cinema of the 1920s, Eisner's *The Haunted Screen* and Kracauer's *From Caligari to Hitler*. Elsaesser emphasizes that both terms "cannot simply be 'deconstructed,' nor can the labels lay claim to any obvious historical truth."[8] On the other hand, allowing them to become such general descriptions "as to be virtually meaningless" does also not offer itself as an enlightened option.[9] For Elsaesser the two terms associated with the books of Eisner and Kracauer signify "two kinds of imaginary constructs" about the German cinema of the 1920s. "Dialogically positioned," they draw up two divergent imaginaries, one emphasizing the production of art, the other searching for reflections of an assumed disposition of the "German soul" in the period under investigation.[10] Elsaesser is not especially interested in the doubtful nature of the assumptions being made by Kracauer in this context or in Eisner's overboarding enthusiasm for expressionist features in the films discussed. For him the value of the two labels, "and by extension, the two books," lies in the fact that they have created an imaginary fabric that "holds the individual films in place and lends a semblance of consistency" to the cinema of the period. The imaginaries created, Elsaesser maintains, "now belong to the films and are part of their identity for cinema history."[11]

The present volume pursues — with the help of Thomas Elsaesser — a different strategy. Eisner was brave enough to risk undermining the great reputation, which her book had gained, in two subsequent articles published in 1958 and 1979 where she radically restricted the radius of expressionist cinema to only a few films and only the first few years of the Weimar Republic. Furthermore, in her books on Fritz Lang and Murnau from 1976 and 1979 respectively, she questions a number of the stylistic attributions that she had initially made. Having become aware of the distortions which the apprentice sorcerer's broom had created in the minds and hearts of film enthusiasts about the radiation of expressionist film in Weimar, Eisner tried to confine the broom's activities without losing the basic, valuable insight of her book, i.e. that German cinema of this period is indeed to a significant degree art cinema guided by artistic styles and generic choices. Eisner's attempts to redress the balance of her book is no doubt a result of the close contact and cooperation which she maintained with directors like Fritz Lang, the communication which she afforded with people from all walks of film production in Weimar and her great familiarity with contemporary documents and echoes. Neither

in the exchange of letters or conversations with Lang, nor in documents relating to the lighting or camera techniques in Murnau's films, does the expressionist label play any significant role. It is not accidental, therefore, that Eisner reduced, six years after the publication of *The Haunted Screen,* the number of genuinely expressionist films to no more than three: *Dr. Caligari, From Morn to Midnight,* and "in particular the last episode" of *Waxworks.*[12] And it is not accidental either that we now read about Lang's "documentary instinct" and his "narrative exuberance" in Eisner's book on the director alongside the expressionist influences identified in her earlier account.[13] In the book on Murnau the term expressionism does not feature at all as a descriptive of any film or any stylistic device of the director's. One of the leading questions of this account is whether Murnau can be considered "a realist" — the option of referring to him as an expressionist no longer poses itself.[14] Nevertheless, the imaginary constructs which Elsaesser discusses, have not ceased to infuse current accounts of 1920s German film. No doubt, the imaginaries have become part of the films and their reception. However, half a century after their construction as memoranda in exile it seems that it is time to honor Eisner's attempts at redressing the emphasis of the story of expressionist cinema as told in 1952 and to start rewriting the historical imaginaries once created. Fulfilling this legacy of Eisner's will imply the paradoxical move to depart from her book in significant ways.

The most important respect in which the present volume leaves the paths laid out for the discussion of expressionist film in Eisner's book concerns the concept of a period style. The expectation that a particular period has one dominant style that affects more or less, although in different ways, all art and literature production of this period is a rather unfortunate convention of the historiography of art and literature of the past century. Eisner is aware of the fact that her focus on the development of a particular style of the period is part and parcel of her "training as an art historian."[15] No doubt, it is this training that has enabled her to provide a nuanced account of Weimar cinema in stylistic terms thus filling an important gap which Kracauer's sociological study had left behind. However, the same focus has obviously tempted Eisner to impose a single dominant style on the whole of the film production of Weimar, to the detriment of other styles that have emerged and to the detriment of a differentiating analysis of individual features of filmmaking in this period. We thus find the work of directors who have little or no connection at all to the expressionist art movement, who show none of its characteristic features and who, in some cases, have explicitly chosen alternative stylistic orientations, presented within the framework of a

display of the art of expressionist film. The concept of a period style, still alive also in Sudendorf's and Elsaesser's responses to the "great confusion" over the term expressionist film, provides the theoretical underpinning to Eisner's enthusiasm for expressionist art.

At the beginning of the twenty-first century, however, we have more than one good reason to bid farewell to this concept. Arnold Hauser has questioned its validity from the point of view of the social production of art, drawing attention to the simultaneity of different styles in any given period: "There is no unified style of a period dominating a whole epoch," he writes, "since there are as many styles at anytime as there are productive social groups."[16] Jost Hermand has shown how the blossoming of the concept of "Epochenstil" in aesthetic theories since the beginning of the twentieth century quickly turned into forceful exercises of homogenizing anything and everything within a given time frame, rendering the terms in which styles and periods are described empty and void.[17] Most importantly, however, it seems that at a time when, for good reasons, the confidence in the "grand narratives" of history shows serious signs of decline and their credibility is widely and irrevocably shattered, it would be highly inappropriate to cling to constructs of allegedly coherent frameworks for a great mass of films of different stylistic and generic origin. What is called for as an alternative approach, is the attempt to disentangle such idealist and ideological constructs. Instead of trying to place the whole of a period under one stylistic register, it would seem timely and sensible to adapt some of the strategies as suggested by Jean-François Lyotard in his deliberations on the breakup of grand narratives, i.e. to "activate the differences" and thus "save the honor of the name,"[18] and to shift the focus from all-embracing metanarratives to the multiplicity of "little narratives," not least because it is the little narratives that may prove to be "the quintessential forms of imaginative invention"[19] and, as I hope, of imaginative intervention as well.

To disentangle the expressionist style of filmmaking and the period of Weimar in which it emerged, will require two simultaneous operations. Firstly, it will be necessary to establish with greater clarity the contribution which the expressionist movement has made to the formation of the art of film in early Weimar cinema. Such a reassessment will have to start with a re-evaluation of the epitome of expressionist film, *The Cabinet of Dr. Caligari*. The fact that after half a century the script of *Dr. Caligari* has been discovered and has been made available is an important factor in this context. It enables us to clarify that contrary to Eisner's and other critics' assumption the language of the script does not show any traces of expressionist influence. Nor does the central motif of

the film. Just as the paramount motif of other films produced since 1913 such as *Der Student von Prag* (The Student of Prague, 1913), *Der Golem* (The Golem, 1915) or *Waxworks*, it is indebted to the revival of gothic themes of the Romantic movement in the artistic vicinity of Prague. "There is no inherent expressionist content in the original scenario," David Robinson rightly argues.[20] Neither the language of the script, nor the motifs of the story, show any expressionist properties. It is "from the decorative element," as Kurtz clarified in his book from 1926, that "the expressionist form invaded the film."[21] The consequences which this "invasion" had on other elements of the film, and the function which the expressionist design of the film's décor fulfilled for the presentation of its gothic-Romantic story are the paramount questions which a reassessment will have to answer. These basic questions pose themselves differently in the case of *From Morn to Midnight*. Here we have a genuine expressionist *Stationenstück* with the characteristic motifs and structure of expressionist playwriting heightened in their effects by abstract sets and expressionist acting. Contrary to mythical rumors, camerawork and lighting do not play any significant role in either of these films. Their achievement lies somewhere else. A comment of René Clair's from 1922 provides perhaps the most enlightening insight in this respect, illuminating at the same time the significance which *The Cabinet of Dr. Caligari* had for the development of cinema internationally. "And then came *The Cabinet of Dr. Caligari*," he wrote, and "overthrew the realist dogma" of filmmaking which had been considered as final and conclusive before.[22] Paradoxically, it may well be that this liberating achievement of *Dr. Caligari* is at the same time one of the reasons why so many critics are inclined to call "expressionist" so many different things that do not meet "realist" expectations.

Secondly, however, and this may well prove to be the more difficult and challenging part of any revision of what has been considered as expressionist cinema in the past, there is the need to develop a set of alternative descriptors for the stylistic features of those films which have been placed within the framework of expressionist film although their paramount artistic and generic orientation is of different origin. The development of such alternative ways of describing and understanding the majority of the films of the early years of Weimar can of course not start from Eisner's study, neither can it take any encouragement from Kracauer's book. The categories of "historical pageants," "tyrant films," "instinct films" and "street films," which Kracauer introduced, all place their emphasis on the content of the film's narrative, not on stylistic devices. In addition, Kracauer approached all the films he discussed with

a basic "realist" understanding of film form which allowed for wide-ranging allegorical readings of the films, often neglecting the contribution which style and generic conventions make to the film's meaning. The analysis of style is usually subsumed to the analysis of content, supporting its results rather than questioning them. It is thus not fortuitous that Kracauer failed to recognize the historic achievement which *The Cabinet of Dr. Caligari* or Walther Ruttmann's montage film *Berlin. Die Sinfonie der Großstadt* (Berlin. The Symphony of a Great City, 1927) had for the development of film styles within the cinema of Weimar, but also on an international scale. For trying to activate the differences between expressionist and other stylistic and generic orientations in the early years of Weimar, the outstanding directors of these years, Ernst Lubitsch, Fritz Lang and F. W. Murnau, provide more reliable and more helpful guidance. None of them accepted the label of expressionism, which Eisner retrospectively tried to project onto their work for the sake of constructing a coherent framework for the discussion of Weimar cinema. The directors suggest instead, in interviews and through their work, a differentiated approach to the quest of expressionist film.

II.

In an interview with the Berlin correspondent of the *Moving Picture World* from September 1920, Ernst Lubitsch was asked whether he considered making an expressionist film in the near future. Lubitsch did not show great enthusiasm for the idea. "It would be nonsense if directors would suddenly start making only expressionist films," he replied.[23] Although not ruling out the possibility right away he indicated that he would prefer a different kind of stylization, one which he had already explored in *Die Puppe* (The Doll, 1919). In this film Lubitsch had introduced a lighthearted, ironic play with illusions, appearing himself as a puppeteer who sets up his toy shop that unexpectedly turns into the setting of the play. As Barry Salt has pointed out, this kind of undermining the built-in illusionism of the medium does not show "any connection with the visual forms of expressionist art."[24] It prepares, however, for other playful approaches appearing in subsequent films by Lubitsch. The "slight touch of exaggeration," which Béla Balázs observes in his early comedies,[25] and the disrespectful smile with which Lubitsch reduces world political events to emanations of private erotic desires in his historical costume films, are further variations of the slight displacement of the actions which Lubitsch made a characteristic of his film style. It is this subtle undermining of the seriousness of his *sujets* and the medium itself which has added the proverbial "touch" to his films and made watching

them such an entertaining experience. Apart from this, Lubitsch relied, as Hans Wollenberg has observed, on ingredients which today one would associate with the dominant features of the "classical Hollywood style" of filmmaking: "a logical story, carried by psychologically motivated characters, . . . superb acting and grand décor."[26]

None of these can in any way be related to characteristics of the expressionist movement. Not the well-built "logical" story, but "Stationentechnik," the progression in stages with a contempt for the conventional logic of causality, was the principle of plot design in expressionist plays. Psychological motivation was the arch enemy in this context. Not "superb," but exaggerated acting became the hallmark of expressionist performances. And instead of grand decorations, we find hand-painted sets in expressionist theater as well as in films. While it is easy to see that the "classical" features of filmmaking emerging in Lubitsch's films paved the way for him to move to the studios of Hollywood, neither the well-built story, the creation of star personalities and the grand décor of his productions, nor his lighthearted play with the *sujets* and the illusionism of his medium were in any way related to expressionist trends in contemporary art, literature or theater. Yet, a remark which Lubitsch made to Rudolf Kurtz indicating that he intended to direct his comedy *Die Bergkatze* (The Mountain Cat, 1921) in a manner "far from everyday life" as a "grotesque" parody of militaristic habits on the Balkans was enough to secure him a place among the directors identified as using "expressionist elements" in their films.[27] From Rudolf Kurtz's book *Expressionism and Film* from 1926 to Ulrich Gregor's survey of "Film in Berlin" from 1982,[28] Lubitsch was able to retain this position — with no justification at all.

Although developing different film styles and working in different genres, the two other great directors of early Weimar cinema, Fritz Lang and F. W. Murnau, did not show any greater enthusiasm for the expressionist art movement. From Eisner we know that Lang "has always vigorously declared that he was not an expressionist" and that he has always "rejected such an arbitrary label."[29] Not expressionism, but American and French adventure and detective serials and Joe May's attempts to surpass both of them in exoticism and suspense in his monumental serial projects had provided the schooling for Lang. His own early work is "serial cinema," "Feuillade cinema," as Frieda Grafe rightly points out.[30] In contrast to Lubitsch it is not the psychologically well-built plot and not the single, self-enclosed work that characterize Lang's early films, but instead a bewildering abundance of exotic and sensational adventure hurled upon one another in rapid succession. Not surprisingly, the plots of his films have their "improbabilities" and "impossibilities," as Kurt Pinthus

observed.[31] However, the constant change of scenery and action, the abundance of different locale, disguises and trapdoors renders any incoherence unnoticed. The character of the serial is inscribed in these films not only through the "technique of the penny dreadful, keeping the spectators in suspense, waiting for the next installment," as a reviewer of the first part of *Die Spinnen* (The Spiders, 1919) noted,[32] but more importantly through a plot structure that makes the rapidly progressing *Kolportage* of unexpected action its moving principle. The "disjointed narrative," so often observed in Lang's films, does not at all result from a calculated "subversion of the dominant forms of bourgeois cinema," as Ann Kaplan assumes,[33] but from the particular strategies of what Vicki Callahan has recently called the "aesthetic of uncertainty," an aesthetic that foregrounds an abundance of unexpected action and the spectacular display of adventure rather than providing a coherent and motivated story line.[34]

The Spiders, the first extant serial of Lang's, exploits these features to the full. It has consequently not been associated with expressionism by any critic, rather with the traces of William S. Hart and Pearl White, the *films aux épisodes* of Feuillade and the books of one of Lang's favorite "serial authors," Karl May. It is different, however, with *Dr. Mabuse the Gambler,* the film that established Lang's reputation as a director. *Dr. Mabuse* is a serial, too. In its confrontation of an almost auratic criminal, a man of many disguises and magic powers, with a rather helpless, ever so unsuccessful detective the film reproduces quite blatantly the immensely attractive constellation of the main protagonists of the *Fantomas* serial. Yet, the design of some of the sets and the direct reference to expressionism in a conversation between Count Told and Dr. Mabuse have encouraged wide-ranging speculations about Lang's indebtedness to the expressionist art movement. Lotte Eisner is cautious enough to point out that "it is possible that more expressionism has been read into the film than was intended" and that "the only genuine expressionist feature is the restaurant with its flame walls, where Wenck and his friend have dinner," while other interior decorations rather recall "the ornamental stylization of the Viennese or Munich workshops" or Art Deco style.[35] Unfortunately, such circumspect approach does not extend to her interpretation of the conversation between Count Told and Dr. Mabuse. Here Eisner overlooks the critical function which this conversation has in the context of the film.

"What is your attitude toward expressionism, Doctor?," asks Count Told, a rich, distinctly decadent aristocrat who likes to surround himself with modern paintings and sculptures. Dr. Mabuse responds: "Expres-

sionism is just a game. . . . But why ever not? — Everything is just a game today — !" an answer which encourages Count Told to suggest that "since everything is a game, Doctor, I hope you will not take it amiss if we now go over to playing poker. . . ." Lang could hardly have inserted his critical attitude toward expressionism more pronouncedly in his film than through this conversation. Expressionism is identified as an integral part of the pandemonium of the period, as part of the "frantic excesses" of the time, on a par with gambling, spiritistic séances and other forms of addiction. Contemporary critics were quick to grasp the meaning of the conversation about expressionism and the expressionist features in some of the pictures and tapestry in the film.

> This film is a document of our time, an excellent portrait of high society with its gambling passion and dancing madness, its hysteria and decadence, its expressionism and occultism,

wrote the correspondent of *Die Welt am Montag*.[36] And in an excellent review in the *B.Z. am Mittag,* which also highlights the importance of the episodic nature of the film, its reliance on "rhythm and speed" rather than on a well-built plot, the reporter gives a highly perceptive account of the film's main intention of conveying "a picture of the time" and of the place which the reference to expressionism holds in it:

> Not one important symptom of the post-war years is missing. Stock exchange maneuvers, occultist charlatanism, prostitution and over-eating, smuggling, hypnosis and counterfeiting, expressionism, violence and murder! There is no purpose, no logic in this demonic behavior of a dehumanized mankind — everything is a game.[37]

It is only in later comments, unfortunately encouraged by the writings of Lotte Eisner, that Lang's critical reference to expressionism in *Dr. Mabuse* is turned from an integral part of the portrayal of a restless, confused, and frantic epoch into a confirmation of a stylistic influence on the director. Once Lotte Eisner had identified — if not expressionist features, then an expressionistic "mood" of the film and some expressionist "lighting effects" — the label was extended by other critics to the discovery of "expressionistic gestures," "expressionistic flavors," even to the "realist expressionism" of Fritz Lang.[38] Lotte Eisner objected to the contradiction in terms in the latter phrasing. Yet, this did not prevent further contributions to an expressionist reading of selected aspects of the film. Even Sudendorf, although drawing attention to Eisner's efforts to confine the damage of the "misunderstanding" of her book, did not hesitate to exceed Eisner in his own assessment of the director maintain-

ing that "Lang adopted all the elements of Expressionism he could use in the visualization of his ideas."[39] And according to David Cook's *History of Narrative Film* the whole of *Dr. Mabuse the Gambler* offers "an expressionistic treatment of a Caligariesque master criminal,"[40] a statement which tries to squeeze into a single "expressionist" frame the gothic-Romantic "Doppelgänger" Caligari and the media expert Mabuse, a descendent of Fantomas for whom the surrealists developed a great fascination.

As opposed to Eisner and Cook, John Barlow has noticed the critical element in the conservation between Count Told and Dr. Mabuse. At the same time, his book promotes an extended use of the expressionist label in the most uninhibited manner. Caught in the dilemma of his awareness of Lang's critique of expressionism within the film and his own book's demands of including Lang among the outstanding expressionist directors, he arrives at a surprising, but intriguing conclusion. Since the film participates in expressionism, he argues, the critique of the expressionist art movement voiced in the conversation between Count Told and Dr. Mabuse implies a critique of the filmic medium itself.[41] There is indeed a scene in the second part of *Dr. Mabuse* which displays a self-reflective element. In the disguise of the hypnotist Sander Weltmann, Dr. Mabuse creates, by means of cinematographic projection, the suggestion of a caravan entering the stage of a music-hall. Not unexpectedly, neither the caravan arriving on the stage nor the process of projection bear any resemblance at all with any expressionistic design. Not the assumed participation of *Dr. Mabuse* in expressionism, but the film's display of the audience's susceptibility to the sensational experience of hypnosis creates the self-reflective moment of this scene. The craving for sensation turns the audience, including the unsuccessful State Attorney von Wenck, into compliant victims of Dr. Mabuse's magical tricks. It is the same craving that determines Countess Told to watch the Russian Lady in the gambling room, and the same that drives Dr. Mabuse to manipulate the stock market and his gambling partners, to hypnotize his audience and to gain spiritual and physical power over Countess Told. "There is no such thing as love," he lets the Countess know, "there is only desire . . . and the will to gain power." Cinematic projection is indeed displayed as one of the means to exercise such power. This tells something about Fritz Lang's attitude toward cinema, it contributes nothing, however, to support the view of an intentional or unintentional adaptation of expressionist elements in his film.

In an interview published in *Film Kurier* from 11 September 1922, F. W. Murnau declared himself strongly in favor of two genres of con-

temporary cinema, the "wholly fantastic film and the quiet *Kammer-spielfilm.*"[42] With *Nosferatu* (Nosferatu, 1922), the first treatment of the Dracula motif in film, and *Der Letzte Mann* (The Last Laugh, 1924), the peak of the series of *Kammerspielfilms* in the early 1920s, Murnau has himself excelled in both these genres. Because of the uncanny nature of its main protagonist, *Nosferatu* has often been compared with *The Cabinet of Dr. Caligari*. However, the uncanny and its various embodiments in the form of doubles, vampires and artificial creatures are not in itself motifs of the expressionist movement. As Andrew Webber, and also Judith Mayne in her study of *Nosferatu,* have pointed out, these are *Leitmotifs* of the Romantic period.[43] Their revival in German films from *The Student of Prague* (1913) and *The Golem* (1915) to *Der Januskopf* (1920) and *Nosferatu* (1922), but also in American productions from Edison's early *Frankenstein* (1910) to several versions of *Dr. Jekyll and Mr. Hyde* (1911 and 1920) and *Dracula* (1927 and 1931) cannot be explained by any reference to expressionism, nor by speculations about the psychic disposition of the German people in the postwar period. If one follows contemporary testimonies, the main reasons for giving new blood to the uncanny creatures of Romantic heritage are to be found in the challenge and the nature of the filmic medium itself.

As Paul Wegener explained in a talk from 1916, the *sujet* of *The Student of Prague,* the first major German contribution to world cinema, had been chosen with a view to achieving effects in film which are based on the specific technology of the medium and cannot be obtained through other artistic means. "The genuine author of film," Wegener maintained, "has to be the camera."[44] Only through refined use of the camera, he implied, can film become an equal to other art forms. Wegener thus carries a rather traditional aesthetic axiom, i.e. the founding of art forms on their genuine, distinct and noninterchangeable means of artistic expression, into the discussion of the latest muse that had emerged. And he draws conclusions from this which are clear cut and entail far-reaching effects. "The technology of film," he points out, does not only provide the essential legitimation for the new medium's status as an art form, but the technology must also determine "the selection of the content."[45] And Wegener left his audience in no doubt about the content he had in mind. He underlines the possibilities which the photographic technique offered for the presentation of "E. T. A. Hoffmann's fantasies of the double and mirror images."[46] In *The Student of Prague* and the first version of *The Golem,* the two films which mark the beginning of serious German cinema, this program was put into practice. So, it was in the years between 1913 and 1915, ahead of any expressionist

influence on German cinema, and hardly encouraged by any longing for tyrants, but rather in the wake of exploring the artistic possibilities of the new technology of film, that Romantic fantasies and legends became the source material of German film productions.

In terms of cinema's historiography this observation is remarkable enough. It does not only suggest a shift in the periodization of German film history, but it also offers a variant in the description of the general progress which cinema made in its first decades. Following in the foot-steps of Tom Gunning and David Bordwell, critics tend to understand the history of cinema in its first decades as a move from the "cinema of attractions" to the narrative models and strategies of the "continuity style" of classical Hollywood cinema. German contributions from *The Student of Prague* and *The Golem* to *The Cabinet of Dr. Caligari, Nosferatu* and *Metropolis* provide a different prospect. The attraction which cinema held in its first decade, the attraction of "making images seen," of the "visibility" of "real living moving scenes,"[47] was replaced by "the other." Cinema discovers, as a preview to *Nosferatu* highlights, the "tremendous attraction" which the presentation of the invisible, the uncanny and eerie holds for the audience.[48] And cinema discovers the suitability and great potential of its technological armature for the display of uncanny experiences. It is the cinema as a "kingdom of shadows" as described by Maxim Gorki, or the realm of incorporeal and yet so clearly discernible specters as described by Robert Wiene, that caught the imagination of film directors as well as audiences.[49]

However, the ways in which the directors realized this trend and the styles and techniques which they developed for the display of the un-canny, the ghostly, the "unreality" of their *sujets* differed considerably. While Wegener used sophisticated camera techniques, mirror effects and trick photography to achieve the eerie atmosphere of *The Student of Prague,* Wiene employed the expressionist design of the décor in *The Cabinet of Dr. Caligari* for the same end, and Murnau shooting *Nosfera-tu* largely on location turned to nature and its nuanced photographic capture as Eisner has described with great intensity:

> Murnau, however, making *Nosferatu* with a minimum of resources, saw all that nature had to offer in the way of fine images. He films the frag-ile form of a white cloud scudding over the dunes, while the wind from the Baltic plays among the scarce blades of grass. His camera lingers over a filigree of branches standing out against a spring sky at twilight. He makes us feel the freshness of a meadow in which horses gallop around with marvelous lightness.

> Nature participates in the action: sensitive editing makes the bounding waves foretell the approach of the vampire, the imminence of the doom about to overtake the town. Over all the landscapes — dark hills, thick forests, skies of jagged storm-clouds — there hovers what Balázs calls the great shadow of the supernatural.[50]

It is not surprising that in the light of these observations emphasizing the role of nature in the film and the subtle photography and editing Lotte Eisner was rather reluctant to situate *Nosferatu* in the context of the expressionist art movement. Instead, she explicitly distances Murnau from "directors such as Lang and Lubitsch" who had been "turned away from reality" by "expressionist precepts."[51] Significantly, in her book on Murnau which includes the original script of *Nosferatu*, the term "expressionism" hardly appears throughout the book. Yet, one exclamatory remark about the "most expressive expression as called for by the expressionists,"[52] which Eisner made in referring to the procession of the pallbearers through the narrow streets of Lübeck, was sufficient to encourage critics to refer to Murnau as allegedly the "greatest of the expressionist directors" and to *Nosferatu* as "the high point of Murnau's expressionist period."[53]

Although noticing that the "outdoor, naturalistic photography" calls the attribution of the expressionist label into question, and conceding that "Murnau himself was not much of an expressionist,"[54] John Barlow holds on to the idea that "it is impossible to think of *Nosferatu* without taking into account the expressionistic milieu of its origin and the expressionistic spirit of its conception."[55] The milieu of the film's origin, however, was not the expressionist art movement, but the rediscovery and reactivation of Romantic fantasies and gothic nightmares in the medium of film which had started with *The Student of Prague* in 1913. In 1920, Murnau had already contributed a version of the Dr. Jekyll and Mr. Hyde story to this development, and with *Nosferatu* he now took it to a level that proved inspiring for generations of filmmakers to come. Concerning the spirit and style of the film's conception, however, they may well be described as an attempt to free the gothic-Romantic themes from their embrace by expressionist art design and promote a mode of their revival that is based on the creative development of subtle nuances in naturalist photography.

Such a characterization includes even those instances in which Murnau clearly transcended the normal pattern of evoking uncanny effects through the presentation of the supernatural in realist surroundings. In the thirty-sixth and thirty-seventh scene of the film he first in-

troduced a stop-motion technique to mark the transition of the coach into the demonic world of Count Orlok's estate, and immediately following he inserted "white" images of the forest to characterize the eerie otherness of the land of the undead. Barlow criticizes the first maintaining that "the experiment does not work," but he is enthusiastic about the insertion of negative film calling it "one of the most striking images of film expressionism."[56] I prefer to see both experiments in the context of Murnau's exploration of photographic and editorial innovations. The images created, the jerky image of the coach as well as the "white forest," as Murnau called the negative image in his script,[57] do not show any reduction of form, any distortion of perspective, any substantial abstraction from the objects shown, as one would expect from an expressionist design. Instead, they mark a significant turning point in the story by creating, through the abrupt, unexpected change of the photographic style, a shock effect that will last and impinge on the reception of the action that unfolds in Count Orlok's castle. The photographic and editorial experiments in *Nosferatu* are thus the overture to the exploration of innovative effects of the cinematographic apparatus which Murnau further developed with the "unchaining of the camera" in *The Last Laugh*.

In an article written after the completion of *Nosferatu* and before work started on *The Last Laugh,* Murnau gave a lucid description of the spirit and direction of these explorations. It is in this article that he conceives of the "freely moving recording apparatus" that can be directed to any point in space "at any time during the shooting in any speed."[58] And he clearly notes the artistic goal which he hopes to achieve with the unchained, freely moving camera. Calling for such an instrument, he writes,

> does not imply the creation of a new technically complicated apparatus, in artistic terms it means rather the opposite, i.e. the regaining of a simplicity and finality of the technical process, which is artistic in itself because it creates wholly neutralized material susceptible to any forming process.[59]

Fred Gehler and Ullrich Kasten have rightly called the article "a manifesto of the mobile camera."[60] However, the artistic aims proclaimed in this manifesto are not the expressionist cry, distorted perspectives or the reductions and abstractions of images, but "simplicity," "finality" and the creation of "wholly neutralized material." Not unexpectedly, Murnau uses aesthetic categories detrimental to any programmatical manifestation of expressionism. The realization of the proclaimed concept in *The Last Laugh,* imaginatively supported by the cameraman Karl Freund, has made this film one of the outstanding documents of early Weimar cin-

ema, encouraging Willy Haas to ring in "a new epoch in the history of cinematography."[61] Haas was aware that the story of the old porter loosing his uniform and with it his social status bore all the hallmarks of a naturalist conception. But he also observed very perceptively that "through the movement of the recording apparatus" Murnau succeeds in rendering the naturalist surface "immaterial."[62] Neither Haas nor other contemporary critics such as Rudolf Kurtz or Béla Balázs have associated *The Last Laugh* in any way with expressionism in "spirit" or in style. Like the critic of the *Film-Kurier* who in 1922 had introduced Murnau to his readers as a rising star among the directors of contemporary cinema they praised the virtuosity, intensity and the painterly nuances of the pictures he created. And for Paul Rotha, who celebrated the "plastic fluidity" of *The Last Laugh,* the eminent importance of the film lay in the fact that, as he put it, it "laid down the elementary principles of filmic continuity,"[63] a characteristic that places *The Last Laugh* within the notion of "classical cinema."

The shift which the publication of *The Haunted Screen* caused in the discussion of early Weimar cinema becomes clearly discernible in the case of this film. Also the particular structure of argument, which Eisner employs throughout her book in all those cases where the integration of films under the umbrella of expressionist cinema causes obvious difficulties, is particularly transparent in this case. Eisner does not avoid addressing these difficulties. So she points out in a comment on *Scherben,* the first in the series of *Kammerspielfilme* which achieved its climactic manifestation in *The Last Laugh,* that the whole genre represents "the psychological film *par excellence.*"[64] And in a comment which Eisner adds to this statement in the German version of her book she highlights that the expressionists "again and again" condemned "psychology" and any "individual, petit-bourgeois tragedy."[65] Nothing else but individual tragedies of *Kleinbürger* are however presented in the story of the keeper of the railroad crossing in *Scherben* who becomes a murderer as well as in the story of the degraded porter in *The Last Laugh.* Referring to Lupu Pick, the chief promoter of the *Kammerspielfilm* genre who had drafted the first treatment of *The Last Laugh,* Eisner points out that Pick "deliberately went counter to all expressionist principles."[66] Pick's own characterization of another film as "a naturalist slap in the face of expressionist snobs" certainly supports this assessment and highlights at the same time the stylistic origin of the genre.[67] No doubt, the story of *The Last Laugh* was not conceived as a manifestation of expressionist sentiments or techniques. And Eisner underlines this in her introductory remarks: "*The Last Laugh* goes against expressionist precepts," she writes.[68]

LOTTE H. EISNER

l'Écran Démoniaque

INFLUENCE DE MAX REINHARDT
ET DE L'EXPRESSIONNISME

COLLECTION
ENCYCLOPÉDIE DU CINEMA
DIRIGÉE PAR
ANDRÉ FRAIGNEAU

ÉDITIONS ANDRÉ BONNE, 15, RUE LAS CASES, PARIS

Title page of the original French edition of Lotte Eisner's
The Haunted Screen (1952).

But then the tide turns and we read of "remnants" of an expression-ist doctrine, of "expressionist techniques" used in the dream sequence, eventually of the "oblique body-attitude" of the old porter leaning against a wall in despair which Eisner likens to the oblique lines in the decorations of *Dr. Caligari*.[69] The vagueness of some of these observations, the pure formality of others and the rather forceful interpretation of the porter's "oblique body-attitude" hardly add plausibility to the change of direction in the argument. Critics following Eisner in her footsteps — and this is as characteristic as the structure of the argument

in her book — discovered even more expressionist precepts in the film. "Although not as expressionistic as it is sometimes reputed to be," writes Barlow, keeping the source of the alleged reputation from the reader, *The Last Laugh* "owes more to expressionism than Lotte Eisner seems willing to concede."[70] Even such a general artistic principle as the use of contrasts now serves as evidence for the alleged expressionist style of the film.

Wegener's *Golem* film of 1920 provides a similar case in question. Again, the literary source, the novel *Der Golem* (1915) by Gustav Meyrink, has no relationship whatsoever with the expressionist literary movement, neither in style nor in theme. The novel is part of the neo-Romantic revival of the prewar years telling the age-old legend of Rabbi Löw's attempt to avert the expulsion of the Jews from the Prague Ghetto. What distinguishes this adaptation of the legend from the two earlier versions which Wegener had made in 1915 and 1917, is in particular the meticulous planning and execution of the film's architecture. In an article which investigates the importance of architectural design for the development of German cinema in the 1920s, Helmut Weihsmann pursues various influences on Poelzig's design of the houses, the tower and the fountain in the ghetto and the interiors of Rabbi Löw's house and alchemist workshop. Weihsmann reminds his readers that Wegener had "always rejected the assumption that his *Golem* could be considered an expressionist film, let alone one that were prophetic in political terms."[71] For Weihsmann the film is, like its predecessors from 1915 and 1917, "predominantly a romantic horror tale," and he supports this also by referring to Kurtz's assessment of the architectural design as having "everything of a gothic dream."[72] Gothic arches are indeed the basic form of all the architectural elements.

Eisner offers a slightly different account. Although starting from the same observation concerning the attitude which Wegener had adopted in the question of the stylistic qualification of his film, she finds that the sets may encourage a description in expressionist terms:

> Paul Wegener always denied having had the intention of making an expressionist film with his *Golem*. But this has not stopped people from calling it expressionist, doubtless because of the much-discussed settings by Poelzig.[73]

Again, Eisner does not rush to conclusions. She emphasizes that the "original gothic forms are still somehow latent in these houses" and that the sets "owe very little to abstraction." Yet, the angular, oblique outlines in the buildings' structure and "expressionistic shock lighting ef-

fects" to be found from time to time suffice to allocate *The Golem: How He Came into the World,* at least partially, a place within the ranks of expressionist film.[74]

For Seth Wolitz this was not enough. In an article written as part of the reassessment of the "Expressionist Heritage" in the early 1980s, the period of an expansionist trend in the writings about expressionist films, Wolitz undertook to correct "Eisner's reticence to dub Wegener's *Golem* an expressionist film" and to secure a firm and unreserved place for it "within the expressionist wave of films."[75] The aspects called upon to support the claim include the observation that the old legend had been infused with "expressionist angst, isolation and desperation" and that the film presents a "world of cosmic catastrophe so dear to the expressionists."[76] In formal respect Wolitz sees "the same techniques of distortion" and "anti-naturalist sets and acting" at work as displayed in *Caligari* and *Nosferatu.*[77] While the thematic aspects listed are certainly all too general to offer substantial support to the claim pursued, the stylistic observations do not only ignore the substantial difference in the "techniques of distortion" and the settings of *Caligari* and *Nosferatu,* but also fail to take account of the particular properties of the architectural design of the "Golem Schtetl" as opposed to the expressionist sets of *Caligari* and the uncanny, but naturalist surroundings of *Nosferatu.*

As Claudia Dillmann rightly points out, "variations of gothic arches" are the principle method of creating the ghetto.[78] The contours of the houses do not violate the conventions of the central perspective as they do in *Caligari.* Yet, as Heinrich de Fries informs in an article written and published during the shooting of the film in 1920, Poelzig had demanded that the exterior buildings should take on an active role and appear to be communicating with each other. For that reason they lean toward each other. Poelzig had used the word "mauscheln" to describe the impression of the activity aimed at.[79] The stylistic device is not at all of expressionist origin. It translates rather faithfully into the set design what the narrator in Meyrink's novel tells us about the mysterious activities of the buildings in the old city of Prague, about their silent bustle and their animated communication with each other. A film critic of the *New York Times* spoke very perceptively of the "eloquence" of the settings.[80] And the anthropomorphic design of the exteriors has its complement in the biomorphic execution of the interiors. As Dillmann points out, the spiral staircase in the alchemist's workshop takes the form of a human ear, the wall of the ghetto follows the curved line of a woman's back, floral ornaments characterize the world of the court. These are certainly forms of "anti-naturalist" stylization; but their origin is the art

of *art nouveau* rather than the pictures of Kirchner, Kandinsky, Klee and Feininger. Paul Westheim, an art and architecture critic writing in the *Kunstblatt* of 1920, has consequently stressed the "stark contrasts" between the "eloquent" architecture of *The Golem* and the "flat," abstract decorations of expressionist films.[81]

Activating the differences should of course not tempt the writer and reader to overlook what such films as *Dr. Caligari, Nosferatu* and *The Golem* produced within the span of two years, may have in common. If a participation and contribution to the expressionist movement can be established only for one of these films, what else is it that makes them an expression of at least a facet of their time, or a document giving an indication of contemporary developments in the cinema of the early years of Weimar? Again, it is a contemporary critic, one of the leading theorists of the period, who with a great sensitivity for the aesthetic challenges of the new medium of film in his time makes an important point in this context. In his book *Der sichtbare Mensch oder Die Kultur des Films* (The Visible Man or The Culture of Film) from 1924 Béla Balázs wrote:

> The point is this that the stylization of nature — whether in impressionist or expressionist manner — is the condition for a film to become a work of art. For in film . . . "nature" is never a neutral reality. It is always milieu and background of a scene whose mood it has to carry, underline and accompany.
>
> Just as painting becomes an art by not photographically reproducing nature, so the filmmaker has the paradoxical task to paint atmospheric pictures with the photographic apparatus. And he achieves this through the particular selection of motifs, the framing and artistic lighting effects and through setting up a stylized nature in the studio.[82]

To consider film not as an industry providing entertainment, but as an artistic activity extending the ensemble of existing art forms is the starting point of Balázs' theoretical considerations. "The art of film," he says in his introductory remarks, requests "representation, place and voice" in the imaginative academy of the arts.[83] He thus formulates on the level of aesthetic theory what the directors of *Caligari, Nosferatu* and *The Golem* share in their practice of filmmaking: a clear orientation toward film as an art form. By laying emphasis on stylization as opposed to the mimetic, photographic principle of imitation as the basic condition for film to achieve the status of art, Balázs ensures that film does not join the other arts with an outdated aesthetic concept in its baggage, but participates instead in the formation of modern, constructive concepts of art production.

Balázs is thus much more in tune with the general orientation of contemporary art movements than Kracauer for whom the photographic technique of film production justifies a return to nineteenth-century realist aesthetics. And he is much more in tune with the work of Robert Wiene, F. W. Murnau and Paul Wegener than Eisner, when he emphasizes that *stylization* as a condition for film to participate in artistic creation took on different forms and involved different elements of film. Differentiating as between the expressionist set design of *Dr. Caligari* with its distorted perspectives, the nuanced naturalist photography of *Nosferatu* further developed in the inventive use of the "mobile camera" in *The Last Laugh,* and the "eloquent" biomorphic symbolism of the architecture in *The Golem* which takes up typical forms of stylization of the *art nouveau* movement, seems little more than a further elaboration of Balázs' theory, an elaboration, however, that avoids the temptation of all too forcefully constructing a single stylistic paradigm for the films of the period, while still underlining their joint artistic aspiration.

III.

The variety of generic and stylistic orientation in early Weimar cinema is by no means exhausted with these preliminary references. Rudolf Kurtz deserves credit for drawing attention, in a separate chapter of his book from 1926, to another important branch of filmmaking in these years. As opposed to expressionist film this development which Kurtz presents under the title of "absolute film" emerged simultaneously in France and Germany. The painters Walther Ruttmann, Viking Eggeling and Hans Richter were the most important contributors to the "absolute film" in Germany, Man Ray, Fernand Léger, and Marcel Duchamp in France. The first public showing of any of their works was the première of Walther Ruttmann's *Lichtspiel Opus 1* in the *Marmorhaus* in Berlin on 24 April, 1921. At the same place *The Cabinet of Dr. Caligari* had come out fourteen months earlier. Several of the artists contributing to the "absolute film" were closely related to the Dadaist art and anti-art movement. Richter's first film, *Film ist Rhythmus* (Film is Rhythm, later retitled as *Rhythmus 21*, 1921), was first shown together with Man Ray's *Retour à la Raison* (Back to Reason, 1923) at the last great Dada event in Paris, the *Soirée du Cœur à Barbe*. It may therefore not be inappropriate to describe these films as the last flowers of the Dadaist movement. Even in the case of Léger's *Le Ballet Mécanique* Richter insisted that in spite of Léger's cubist affiliations as a painter, "his *Ballet Mécanique* is 100% Dada."[84] However, in an article from 1952, Richter himself preferred to

speak of "avant-garde films,"[85] a term that more accurately reflects the fact that artistic concerns from several of the avant-garde movements of the 1910s and early 1920s contributed to the formation of this filmic development.

The exploration of the material properties of film is the particular domain of the abstract filmic experiments of the painters. Emphasizing the flatness of the screen and exposing the conditions of spatial illusionism characterizes several of their films. To add the dimension of time to the static medium of painting, to equip pictures with the dynamism of motion organized in line with musical structures was another important focus. It is the time of the filmic "symphonies," initially executed in animated fashion with abstract geometrical shapes as their basic objects, but increasingly using photographic reproductions of everyday objects as "raw material" of their compositions. Cubist, futurist and Dadaist concerns thus fed into these experiments. And just as the photomontage of the Berlin Dadaists was not an accidental invention falling from heaven, but a consequential step in the development of avant-gardist painting, so filmic montage became a focus of the avant-garde films. With René Clair's *Entr' Acte* (Between the Acts, 1924), to which Francis Picabia had written the scenario and Eric Satie the musical score, and Walther Ruttmann's *Berlin. Die Sinfonie der Großstadt* (Berlin. The Symphony of a Great City, 1927) for which Edmund Meisel had composed the score, two avant-garde films emerged in the coming years that made the discovery of the effects of montage in filmic composition their core activity. Together with Sergei Eisenstein's *Bronenosets Potemkin* (Battleship Potemkin, 1925) *Entr' Acte* and *Berlin. The Symphony of a Great City* represent the most radical experiments in filmic montage in the mid-1920s. A new culture of filmmaking, shifting the focus of production from the theatrical *mise en scène* and the artistic design of sets and architecture toward the technical process and the possibilities of montage thus emerged in various European national cinemas. While the discovery of the aesthetic effects of this technique propelled the Russian film to the zenith of its international reputation, the most important German contribution to it was Ruttmann's *Berlin*.

Entr' Acte was shown together with Richter's *Film is Rhythm*, Eggeling's *Diagonal Sinfonie* (Diagonal Symphony, 1923), Ruttmann's *Opus 2, 3* and *4* (1922–25) and Léger's *Images Mobiles* (the title under which *The Ballet Mécanique* was presented) at the famous matinee "Der absolute Film" of the *Novembergruppe* in Berlin in May 1925.[86] As Walter Schobert has pointed out, this matinee had important repercussions on the development of the German avant-garde film of the 1920s insofar as

it "opened Ruttmann's and Richter's eyes to the fact that one could make abstract, non-narrative films not only with animated images but also with real photography,"[87] with snippets of documentary footage. Eisenstein's *Battleship Potemkin* had its Berlin première with a musical score by Edmund Meisel on 26 April 1926. Bertolt Brecht seeing the film wrote an enthusiastic poem, while Walter Benjamin, in a response to a review in *Die literarische Welt,* highlighted what he saw as the epoch-making significance of Eisenstein's work. That it grounds its political effects on the technical means which the latest "revolution" in the arts had provided, made *Potemkin* in Benjamin's view "a great film, a rare achievement" and a contribution to the "vital, fundamental advances" in contemporary art.[88] *Berlin. The Symphony of a Great City* had its première to great acclaim in the *Tauentzienpalast* in Berlin on 23 September, 1927. The formal brilliance which it reached in the exploration of montage effects and the fresh, uninhibited integration of a great diversity of material made *Berlin* an encouraging model for the city symphonies which Dziga Vertov (*The Man with a Movie Camera,* 1928) and Jean Vigo (*A Propos De Nice,* 1929–30) composed in the following years. No other than the Russian director Vsevolod Pudovkin praised the "precise montage rhythm" which Ruttmann had achieved in *Berlin.*[89]

It is not at all surprising that neither Eisner nor Kracauer were able to recognize the importance of the development of the avant-garde film and the significance of Ruttmann's *Berlin* for the cinema of Weimar and beyond. Eisner's search for expressionist features as well as Kracauer's preference for realist-illusionist photography have obviously not heightened the writers' sensitivity toward both the abstract films as well as the montage experiments emerging from them. So all we find in Eisner's book *The Haunted Screen* on these matters are the puzzling statement that "apart from the abstract film the German silent cinema never had a proper avant-garde such as that found in France," accompanied later by a critique of the undesirable effects which Ruttmann's *Berlin* had in Eisner's view on other films, i.e. encouraging them to experiment with a seemingly "unpleasant" mixing of "documentary passages with melodrama."[90] Kracauer's comment on Ruttmann shows an even greater lack of understanding of the film's historical role and its technical advances. Pursuing his basic proposition that the films of the period reflect the collective mentality of a people, Kracauer presents the technique of "rhythmic montage" as "symptomatic of a withdrawal from basic decisions into ambiguous neutrality" and the film as a whole as a "product of the paralysis" of the German people.[91] This is not only a far-fetched interpretation begging the question of any supporting evidence, but also

FROM CALIGARI TO HITLER

A PSYCHOLOGICAL HISTORY

OF THE GERMAN FILM

By SIEGFRIED KRACAUER

PRINCETON UNIVERSITY PRESS · 1947

Title page of the original American edition of Kracauer's
From Caligari to Hitler (1947).

one that overlooks the actual achievements of *Berlin*. Through exploring
the technique of montage by using documentary footage the film has
given the German avant-garde film of the 1920s a new direction. At the
same time it has made available a new and particularly suitable means of
filmic composition to those filmmakers who aspired to a determined
political impact of their work in the later years of Weimar. The particular
value of the new technique for such films derives from its genuine func-
tion which Ernst Bloch has described as the "dismantling" of the con-
texts of conventional surfaces and the improvised "combination of

variable constructions" out of the rubble gained.[92] Kracauer's expectation that montage should instead "uncover" significant contexts of contemporary social and political life, and his disappointment about the fact that *Berlin* did not fulfill this expectation, show the considerable misunderstanding of the new technique on his part and more generally his difficulties in finding an access to what he called "the vogue of cross-section, or 'montage,' films."[93]

Richter had all the advantages of a participant in these developments when he wrote his article on "The Avant-Garde Film," published only a few years after Kracauer's book and in the same year, 1952, in which Eisner's *Haunted Screen* appeared. In this article Richter did not only give an account of the formation of the "absolute film" in the early 1920s and the subsequent shifts and changes of its parameters, but also of its pivotal role in paving the way for a number of montage films in the late 1920s, including such remarkable productions as *Menschen am Sonntag* (People on Sunday, 1929) by Robert Siodmak, Billy Wilder and Fred Zinnemann, and *Kuhle Wampe* (1932) by Slatan Dudov and Bertolt Brecht. Although Richter felt ostensibly uneasy about the determined political agenda of *Kuhle Wampe*, he was able to see what the film had achieved in formal respect:

> The film was a masterpiece in the interrelation established between the composition and the cutting of the images and between the content and the rhythm of the dialogues.[94]

In *Kuhle Wampe* the technique of montage unfolded its full "productive force" (Bloch). The multiplicity of montage effects employed, and the functional precision of their use, made the film an outstanding example of the culture of political films in the last years of Weimar.[95] However, as Richter points out, *Kuhle Wampe* marked at the same time "the end of avant-garde film before the seizure of power by Hitler."[96]

Eisner has made the point that "film has come to expressionism only late."[97] Indeed, the expressionist writers Kasimir Edschmid, René Schickele, and Iwan Goll already pronounced the death of the expressionist movement when *The Cabinet of Dr. Caligari* announced its arrival in cinema. Four years later, in 1924, Paul Leni made *Waxworks*, which Eisner called "the swan song of expressionist films."[98] The swan song already consisted of a combination of different styles — quite in line with the cover of Kurtz's book on *Expressionism and Film* which Leni designed.[99] We have to familiarize ourselves with the idea that expressionism was a short-lived episode lasting just four years, an episode, however, accompanied by a number of other orientations in filmmaking. It was an

episode of immense importance, because it achieved overnight what neither the "Autorenfilm" nor the "film d'art" movement had achieved before in years of varied endeavors: to establish film as an art form which deserves all the attention of the culturally open-minded middle classes. For the future of European cinema this was of vital importance. It helped to provide the material basis for cinema as a cultural institution — through artistic innovation. However, other generic and stylistic orientations did not only benefit from this development, but clearly made their own contribution to it in a number of different ways: by adding stylistic touches to genre conventions that had been passed on; by transforming generic patterns to fit the demands of a "picture of the time"; by turning the technical apparati of film production into versatile artistic instruments; and by exploring, in correspondence with avant-garde painters, the material conditions of filmmaking, which, not surprisingly, led to the discovery of montage as a genuine device of filmic composition, "deeply grounded," as Eisenstein put it, in the characteristics of film material.[100]

Just as there was a lively interaction between German, French, and Scandinavian film productions, there was also an interchange between the characteristic developments within early Weimar cinema. The observation of such interchanges, however, does not justify, but contradicts the construction of a single dominant period style or an ensemble of genres that all somehow rhyme on the paralysis of the German people. The interrelations within the Weimar cinema do include outright opposition such as that between expressionist film and the naturalist *Kammerspielfilms*. It was not by chance that the latter remained as much an episode of Weimar cinema as the former, disappearing from the landscape of film forms together with the form it had opposed. What the last grand manifestation of *Kammerspielfilms, The Last Laugh,* passed on to film productions of the later Weimar years as well as the studios of Hollywood, was neither its generic nor its fundamentally naturalist stylistic orientation, but a vastly extended and refined mode of handling the camera and lighting. Next to the exploration of the vast possibilities which the technical apparatuses of film production offered, it was above all the experiments of the avant-garde filmmakers leading to the discovery of montage as a genuine filmic technique which exercised a longer lasting impact on the direction and stylistic innovation of Weimar cinema and beyond. In his article on "The Complex Seer: Brecht and the Film," Martin Walsh has drawn attention to the "crucial significance" which Brecht's work had for keeping alive concepts of an anti-illusionist montage style of filmmaking through the "Dark Ages" from the 1930s to the late 1950s.[101] Walsh relies on Brecht's critical writings. He has obviously

not seen *Kuhle Wampe*. No other film, however, supports his line of thought equally strongly. In the varied montage constructions of *Kuhle Wampe* the cinema of Weimar reaches its other pole, a conception of film designed to inflict political enlightenment instead of purging horror and fear. It is in the work of the new "European cinematic avant-garde" of the 1960s, in the context of the Nouvelle Vague and the New German Cinema, that this conception experienced its reformulation and renewed vitality.

Notes

[1] Werner Sudendorf, "Expressionism and Film: the Testament of Dr Caligari," in *Expressionism Reassessed,* ed. Shulamith Behr, David Fanning and Douglas Jarman (Manchester: Manchester UP, 1993), 91.

[2] Ibid.

[3] Ibid., 92. Sudendorf refers in particular to John Barlow, *German Expressionist Film* (Boston: Twayne, 1982); Francis Courtade, *Cinéma expressioniste* (Paris: Beyrier, 1984); and Mario Verdone, *Carl Mayer e l'Expressionismo* (Rome, 1969).

[4] Barry Salt, "From Caligari to who?" *Sight and Sound,* vol. 48 (1979): 119.

[5] W. Sudendorf, "Expressionism and Film," 91.

[6] Ibid., 94–96.

[7] Thomas Elsaesser, *Weimar Cinema and After. Germany's Historical Imaginary* (London, New York: Routledge, 2000), 3.

[8] Ibid., 24.

[9] Ibid., 27.

[10] Ibid., 34.

[11] Ibid., 24.

[12] Lotte H. Eisner, "Stile und Gattungen des Films," in *Das Fischer Lexikon. Film. Rundfunk. Fernsehen,* ed. Lotte H. Eisner and Heinz Friedrich (Frankfurt am Main: Fischer, 1958), 264.

[13] Lotte H. Eisner, *Fritz Lang* (New York: Oxford UP, 1977), 38f.

[14] Lotte H. Eisner, *Murnau. Der Klassiker des deutschen Films* (Hannover: Friedrich Verlag, 1967), 222f.

[15] L. H. Eisner, *Fritz Lang,* 8.

[16] Arnold Hauser, *Sozialgeschichte der Kunst und Literatur* (Munich: C. H. Beck, 1953), vol. I, 463 (trans. D. S.).

[17] Cf. Jost Hermand, "Das Epochale als neuer Sammelbegriff," in Hermand, *Synthetisches Interpretieren. Zur Methodik der Literaturwissenschaft* (Munich: Nymphenburger Verlagsbuchhandlung, 1968), 187–217.

[18] Jean-François Lyotard, "Answering the Question: What is Postmodernism?" in Lyotard, *The Postmodern Condition* (Manchester: Manchester UP, 1984), 82.

[19] Cf. J.-F. Lyotard, *The Postmodern Condition*, in particular 37f. and 60f.

[20] David Robinson, *Das Cabinet des Dr. Caligari* (London: British Film Institute, 1997), 39.

[21] Rudolf Kurtz, *Expressionismus und Film* (Berlin: Verlag der Lichtbildbühne, 1926), 122 (trans. D. S.).

[22] René Clair, *Kino. Vom Stummfilm zum Tonfilm* (Zurich: Diogenes, 1995), 29 (trans. D. S.).

[23] Ernst Lubitsch, "Ernst Lubitsch über Film, Filmkunst und sich. Ein Interview." *Film-Kurier* (1 September 1920).

[24] B. Salt, "From Caligari to who?" 121.

[25] Béla Balázs, "Die Selbstironie des Films," in Balázs, *Schriften zum Film,* vol. 1, ed. Helmut H. Diederichs (Munich: Hanser, 1982), 211.

[26] Hans H. Wollenberg, "Ernst Lubitsch." *Penguin Film Reviews,* no. 7 (1948), 64.

[27] R. Kurtz, *Expressionismus und Film,* 82.

[28] Ulrich Gregor, "Film in Berlin," in *Berlin 1910–1933,* ed. Eberhard Roters et al. (New York: Rizzoli, 1982), 177.

[29] Cf. Lotte H. Eisner, "Der Einfluß des expressionistischen Stils auf die Ausstattung der deutschen Filme der zwanziger Jahre," in *Paris — Berlin: 1900–1933* (Munich: Prestel, 1979), 270; and Eisner, *Fritz Lang,* 52.

[30] Frieda Grafe, "Für Fritz Lang. Einen Platz, kein Denkmal," in Grafe et al., *Fritz Lang* (Munich: Hanser, 1987), 7.

[31] Kurt Pinthus, "The World of Dr. Mabuse," in *Fritz Lang. His Life and Work. Photographs and Documents,* ed. Rolf Aurich, Wolfgang Jacobsen and Cornelius Schnauber (Berlin: Filmmuseum Berlin, 2001), 74–80.

[32] Cf. L. H. Eisner, *Fritz Lang,* 33.

[33] E. Ann Kaplan, "Fritz Lang and German Expressionism: A Reading of *Dr. Mabuse, der Spieler,*" in *Passion and Rebellion: The Expressionist Heritage,* ed. Stephen Eric Bronner and Douglas Kellner, 398–401.

[34] Vicki Callahan, "Detailing the Impossible." *Sight and Sound,* vol. 9, no. 4 (1999), 28f.

[35] L. H. Eisner, *Fritz Lang,* 61f.

[36] Cf. L. H. Eisner, *Fritz Lang,* 57.

[37] Ibid., 58.

[38] See for instance Barlow, *German Expressionist Film,* 115; also Eisner, "Der Einfluß des expressionistischen Stils," 270.

[39] W. Sudendorf, "Expressionism and Film," 96.

[40] David Cook, *A History of Narrative Film* (New York: Norton, 1981).

[41] Cf. J. Barlow, *German Expressionist Film,* 118.

[42] Cf. L. H. Eisner, *Murnau,* 232.

[43] Cf. Andrew Webber, *The Doppelgänger. Double Visions in German Literature* (Oxford: Clarendon Press, 1996), 350; and Judith Mayne, "Dracula in the Twilight:

Murnau's *Nosferatu,*" in *German Film and Literature: Adaptations and Transformations,* ed. Eric Rentschler (New York, London: Methuen, 1986), 26.

[44] Paul Wegener, "Neue Kinoziele," in *Kein Tag ohne Kino. Schriftsteller über den Stummfilm,* ed. Fritz Grüttinger (Frankfurt am Main: Deutsches Filmmuseum, 1984), 348 (trans. D. S.).

[45] Ibid.

[46] Ibid., 347f.

[47] Cf. Tom Gunning, "The Cinema of Attractions: Early Film, Its Spectators and the Avant-Garde," in *Early Cinema. Space, Frame, Narrative,* ed. Thomas Elsaesser (London: British Film Institute, 1990), 56; also the poster for an exhibition of the Lumières' "Cinematograph," in C. W. Ceram, *Eine Archäologie des Kinos* (Reinbek: Rowohlt, 1965), 182.

[48] "Der Gruselfilm." *Der Film* (16 October 1921): 54.

[49] Cf. Maxim Gorki, "The Lumière Cinematograph" (extracts), in *The Film Factory. Russian and Soviet Cinema in Documents 1896–1030,* ed. Richard Taylor (London, Routledge, 1994), 25–31; Robert Wiene, "Expressionismus im Film," in *Das Cabinet des Dr. Caligari: Drehbuch von Carl Mayer und Hans Janowitz zu Robert Wienes Film von 1919/20,* ed. Helga Belach and Hans-Michael Bock (Munich: edition text + kritik, 1995), 151f.

[50] Lotte H. Eisner, *The Haunted Screen. Expressionism in the German Cinema and the Influence of Max Reinhardt* (Berkeley: U of California P, 1973), 99.

[51] Ibid.

[52] This is a literal translation of the German text in Lotte H. Eisner, *Die dämonische Leinwand* (Frankfurt am Main: Fischer, 1980), 100; in the English version of the book the passage reads: "Never again was so perfect an Expressionism to be attained." L. H. Eisner, *The Haunted Screen,* 102.

[53] Cf. Janet Bergstrom in her portrayal of Murnau in *The Oxford History of World Cinema,* ed. Geoffrey Nowell-Smith (Oxford: Oxford UP, 1996), 146; and David Cook, *A History of Narrative Film,* 120.

[54] J. Barlow, *German Expressionist Film,* 84 and 91.

[55] Ibid., 84f.

[56] Ibid., 86.

[57] Murnau added in handwriting to the scenario: "frantic run of the coach through white forest." Cf. Eisner, *Murnau,* 444 (trans. D. S.).

[58] Friedrich Wilhelm Murnau, ". . . der frei im Raum sich bewegende Aufnahmeapparat." *Die Filmwoche,* no. 1 (1924); repr. in extracts in Fred Gehler and Ullrich Kasten, *Friedrich Wilhelm Murnau* (Berlin: Henschel, 1990), 141 (trans. D. S.).

[59] Ibid.

[60] F. Gehler and U. Kasten, *Friedrich Wilhelm Murnau,* 77 (trans. D. S.).

[61] Willy Haas, "Der Tag der großen Premiere. *Der Letzte Mann* im Ufa-Palast am Zoo." *Film-Kurier* (24 December 1924).

[62] Ibid.

[63] Paul Rotha, *The Film Till Now* (London: Jonathan Cape, 1930), 259.

[64] L. H. Eisner, *The Haunted Screen*, 179.

[65] L. H. Eisner, *Die dämonische Leinwand*, 182.

[66] L. H. Eisner, *The Haunted Screen*, 179.

[67] Ibid.

[68] Ibid., 207.

[69] Cf. L. H. Eisner, *The Haunted Screen*, 209 and 218.

[70] J. Barlow, *German Expressionist Film*, 146.

[71] Helmut Weihsmann, "Baukunst und Filmarchitektur im Umfeld der filmischen Moderne," in *Die Perfektionierung des Scheins. Das Kino der Weimarer Republik im Kontext der Künste*, ed. Harro Segeberg (Munich: Wilhelm Fink Verlag, 2000), 193 (trans. D. S.).

[72] Ibid.

[73] L. H. Eisner, *The Haunted Screen*, 56–58.

[74] Ibid., 58f.

[75] Seth L. Wolitz, "*The Golem* (1920): An Expressionist Treatment," in *Passion and Rebellion: The Expressionist Heritage*, ed. Stephen Eric Bronner and Douglas Kellner (South Hadley, Mass.: J. F. Bergin, 1983), 393.

[76] Ibid., 386.

[77] Ibid., 393.

[78] Claudia Dillmann, "Die Wirkung der Architektur ist eine magische. Hans Poelzig und der Film," in *Hans Poelzig. Bauten für den Film*. Exhibition catalogue (Kinematograph 12) (Frankfurt am Main: Deutsches Filmmuseum, 1997), 29.

[79] Ibid., 33.

[80] Ibid., 57.

[81] Paul Westheim, "Eine Filmstadt von Poelzig." *Das Kunstblatt*, no. 11 (1920): 325; repr. in extracts in *Hätte ich das Kino! Die Schriftsteller und der Stummfilm*, ed. Ludwig Greve et al. (Stuttgart: Klett, 1976), 120f.

[82] Béla Balázs, *Der sichtbare Mensch oder Die Kultur des Films* (Vienna, Leipzig: Deutsch-Österreichischer Verlag, 1924), 97f.

[83] Ibid., 9.

[84] Cf. Willy Verkauf, ed., *Dada. Monographie einer Bewegung* (Teufen: Niggli, 1957), 68.

[85] Hans Richter, "Der avantgardistische Film in Deutschland," in *Cinéast. Sonderheft Deutsche Filmtage Göttingen 1953*, 13–23.

[86] See the facsimile of the program on page 243 of this volume.

[87] Walter Schobert, *The German Avant-Garde Film of the 1920s* (Munich: Goethe-Institute, 1989), 14.

[88] Walter Benjamin, "Reply to Oscar A. H. Schmitz," in Benjamin, *Selected Writings*, vol. 2 (Cambridge, MA: Harvard UP, 1999), 16f.

[89] Cf. W. Schobert, *The German Avant-Garde Film of the 1920s*, 84.

[90] L. H. Eisner, *The Haunted Screen*, 19 and 330.

[91] Siegfried Kracauer, *From Caligari to Hitler. A Psychological History of the German Film* (Princeton, NJ: Princeton UP, 1974), 187.

[92] Cf. Ernst Bloch, *Erbschaft dieser Zeit* (Frankfurt am Main: Suhrkamp, 1973), 214f (trans. D. S.).

[93] S. Kracauer, *From Caligari to Hitler,* 188.

[94] H. Richter, "Der avantgardistische Film in Deutschland," 22 (trans. D. S.).

[95] Cf. Dietrich Scheunemann, "Montage in Theatre and Film. Observations on Eisenstein and Brecht." *Avant Garde,* vol. 5/6 (1991): 109–35.

[96] H. Richter, "Der avantgardistische Film in Deutschland," 22.

[97] L. H Eisner, "Der Einfluß des expressionistischen Stils," 266 (trans. D. S.).

[98] Ibid., 272.

[99] Cf. page xvi of this volume.

[100] Sergei Eisenstein, "The Montage of Film Attractions," in S. M. Eisenstein, *Selected Works,* vol. I, ed. Richard Taylor (London: British Film Institute, 1988), 40f.

[101] Martin Walsh, "The Complex Seer: Brecht and the Film," in Walsh, *The Brechtian Aspect of Radical Cinema* (London: British Film Institute, 1981), 5 and 20.

Weimar Cinema, Mobile Selves, and Anxious Males: Kracauer and Eisner Revisited

Thomas Elsaesser

Weimar Cinema — The Acceptable Side of the German *Zeitgeist?*

HISTORIANS OF WEIMAR culture have tended to consider the cinema as part of what makes Weimar "Weimar," but they have certainly been far from giving it the privileged status that either Kracauer or Eisner allow it, that of unlocking the Zeitgeist, the ever-elusive essence of an epoch. John Willett gives an apt summary in *The New Sobriety:*

> There are existing studies that deal with the culture of the Weimar Republic between 1918 and 1933 much more broadly. "When we think of Weimar," writes Peter Gay in the preface to his *Weimar Culture,* "we think of *The Threepenny Opera, The Cabinet of Dr. Caligari, The Magic Mountain,* the Bauhaus, Marlene Dietrich." More recently that other eminent historian Walter Lacqueur has defined its *Zeitgeist* in very similar terms as "the Bauhaus, *The Magic Mountain,* Professor Heidegger and *Dr. Caligari.*"[1]

The cinema as a colorful chronotope, providing an easily recognizable but also superficial time/space iconography, important mainly for its "atmospheric, essentially nostalgic relevance:"[2] such is the general view. It implies an idea of culture diametrically opposed to that of Kracauer, for whom the cinema was not an addition among the many forms of entertainment that flourished but its hidden center: a period thinks, represents, and interprets itself and its contradictions in all the products of its social life, but among the means of self-representation the cinema had for Kracauer an absolutely pre-eminent function. As T. W. Adorno put it, his way of considering the cinema as a cipher of social tendencies has long since become common property, so much that it is practically an unquestioned assumption underlying any serious reflection on the

medium in general.[3] And true enough, no serious history of the Weimar cinema has appeared since Kracauer's socio-psychological study of the "secret history involving the inner dispositions of the German people" which does not confirm Adorno's backhanded compliment about Kracauer's "unquestioned assumptions" of pertinent social tendencies reflected in the films.

Thus, ever since its publication, *From Caligari to Hitler* has been hailed as a breakthrough.[4] It seemed to make the analysis of movies relevant to sociology and politics, providing furthermore evidence for the widely held belief that the cinema had played a significant part in Josef Goebbels's propaganda machine during the Nazi years. In this sense, Kracauer merely added new cultural fieldwork to arguments also put forward by a number of similar works on the mass following of fascism written by German émigrés in the States, who had made the lower middle classes the subject of socio-psychological studies.[5] These studies, despite methodological differences, paid attention to the relationship between class and economic status on the one hand, and psychological makeup and personality structure on the other, asking how mass-psychological factors could have become as important as they did in the fascists' rise to power, breaking down the old class-based solidarity among urban populations, and making them fall for an ideology appealing to their resentments and aspirations, rather than their actual class position. What made middle class and petit-bourgeois families prone to Nazism, so the argument ran, were the hunger years of the First World War, followed by hyper-inflation and mass unemployment. It forced them to live in fear of the loss of social status, resenting anyone who was better off than themselves, while entertaining wildly utopian hopes of how to improve their lot:

> The behavior of broad middle class strata also seemed to be determined by overwhelming compulsions. In a study published in 1930 [*Die Angestellten*], I pointed out the pronounced white collar pretensions of the bulk of German employees, whose economic and social status in reality bordered on that of the working class or was even inferior to it. Although these lower middle class people could no longer hope for bourgeois security, they scorned all doctrines and ideals more in harmony with their plight, maintaining attitudes that had lost any basis in reality.[6]

Quoting his own late-Weimar study of the white collar class, Kracauer highlights the peculiar way in which class difference was both feared and disavowed among an upwardly ambitious as well as downwardly mobile population, many freshly urbanized since the Weimar Republic. In its

sophisticated analysis of the relation between rational behavior, uncon-
scious aggression and misrecognized self-interest, *Die Angestellten* is a
model of a new sociology of everyday life, pioneered by scholars like Paul
Lazarsfeld, Marie Jahoda and members of the Institute for Social Re-
search. Yet the intervening years and a vast literature on the origins and
causes of National Socialism have made it less urgent to read Kracauer's
"disclosures of the [German people's] dispositions through the medium
of the German screen" as a "help in the understanding of Hitler's ascent
and ascendancy," however timely it may have been in 1947.

Rather, Kracauer today might best be considered the historian of
something other than the German people's seduction by Nazism. Held
against the foil of *Die Angestellten* (1929), *From Caligari to Hitler* seems
to chronicle a particular socio-historical and sexual imaginary, charting
the dynamics of anxiety, repression and disavowal that might have
formed the psychic makeup of the German lower middle class in a period
of rapid social change. In an article of 1927, Kracauer offers a number
of reasons why this class and its dominant character type is representative
for the German people in the 1920s and why it is reasonable to assume
this to be the target audience of the films:

> Films are the mirror of the prevailing society. They are financed by cor-
> porations, which must pinpoint the tastes of the audience at all costs in
> order to make a profit. . . . A producer . . . will never allow himself to
> be driven to present material that in any way attacks the foundations of
> society, for to do so would destroy his own existence as a capitalist en-
> trepreneur. . . . In order to investigate today's society, one must listen
> to the confessions of the products of the film industries. They are all
> blabbing a rude secret, without really wanting to. In the endless se-
> quence of films, a limited number of typical themes recur again and
> again; they reveal how society wants to see itself. The quintessence of
> these film themes is at the same time the sum of the society's ideolo-
> gies, whose spell is broken by means of the interpretation of the
> themes.[7]

The passage suggests that Kracauer's own intellectual position before he
left Germany for the United States was more radical than the book which
was to make him famous there. He was a writer whose perspective on the
mass media was materialist and broadly Marxist, influencing Horkheimer
and Adorno's critique of the "Culture Industry" in their *Dialektik der
Aufklärung* (1947). Yet shorn of its economic analysis, Kracauer's thesis
in *From Caligari to Hitler* often reads like a tautological, self-fulfilling
conspiracy theory. That the reasons for this softening of critical focus
have to be sought in the United States' anticommunism after the Second

World War becomes clear from Kracauer's letters to his publisher and certain passages in the preface.[8]

Nonetheless, taking the Kracauer of *From Caligari to Hitler* together with the Kracauer of the journalism from the late 1920s, in particular the articles collected in *Das Ornament der Masse* (The Mass Ornament, 1963), and *Die Angestellten*, one discovers a surprisingly relevant entry-point to a wider issue, namely the importance of popular culture in the shaping of modernity under the conditions of industrial capitalism, increased leisure time and commodity production.

Middle Class Compulsions:
The *Angestelltenkultur*

The prototype of Kracauer's spectator in *From Caligari to Hitler,* his historical subject, is the petit-bourgeois employee, a sociological phenomenon in Germany only since the vast expansion of the bureaucratic apparatus following on unification in 1871, when Berlin became the capital of the Reich. This army of employees in the various new service industries was ideologically volatile and divided (drawn from the rural *Hinterland* of Berlin into the swelling metropolis), yet its appearance became politically important only after the (brief) economic recovery around the mid-1920s. Though its members did not possess a distinct class-consciousness of their own, their economic existence was such that they were thoroughly motivated by bourgeois ambitions while living in constant fear of being proletarianized.

In *Die Angestellten,* Kracauer described this new class, its work habits, public behavior, leisure pursuits, mating rituals and family structures. When published in 1930, it was not only a seminal work that anticipated many of the methods and findings of later studies from the 1940s and 1950s in the United States (those of David Riesman and C. Wright Mills, for instance). It also supplies the blueprint as well as the historical foil for Kracauer himself when he came to write *From Caligari to Hitler* in 1946/47. With his intellectual background in philosophy and sociology, Kracauer's early thinking about modernity and social life was indebted to Wilhelm Dilthey's *Lebensphilosophie,* to Max Weber and above all to Georg Simmel's phenomenological sociology. But he brought to this tradition a specificity of observation and a honing down of focus which paradoxically traces a much more dynamic historical perspective. Walter Benjamin recognized this well when, in a review of one of Kracauer's sociological texts, he describes the latter's method:

Not as an orthodox Marxist, and even less as a practical agitator does he penetrate dialectically into the conditions of the white collar workers. . . . However, his project leads him to the heart of the Marxist edifice precisely to the degree that the ideology of the white collar workers constitutes a unique superimposition of the memory-images and wish-fulfilling fantasies inherited from the bourgeoisie onto their existing economic reality, which is very close to that of the proletariat.[9]

Thanks to his investigative reporting on what one might call "objective false consciousness," Kracauer was able to reconstruct the life-world of a class which did not consider itself as one, the male and female office workers of Berlin in the late 1920s. What another famous socio-critical text, Ernst Bloch's *Erbschaft dieser Zeit* (Heritage of Our Times, 1935) a few years later attempted to do for an even broader segment of the national culture, namely to argue the coexistence and interpenetration of different layers of consciousness at a given historical moment, Kracauer undertook on behalf of the most symptomatic social group to have emerged as a direct consequence of postwar modernity, understood as the triumph of technical and administrative rationalization.[10] While Bloch's *Ungleichzeitigkeit* tried to account for the lack of appeal which left-wing political culture had had for the German working class in the 1920s, Kracauer diagnosed the mind-set of the urban employees, and discovered how complicit they were in being seduced by spectacle. However, given that one of the conditions for German industry to modernize itself was that it successfully revolutionized the social basis of its citizens, by turning them into modern consumers, it was inevitable, according to Kracauer, that industrialists like Alfred Hugenberg and politicians like Joseph Goebbels should enlist the help of the mass media in creating this new kind of culture.

Whereas Bloch concentrated on the *materialist* core contained in (Romantic and post-Romantic) popular and highbrow culture, in a bid to redeem so-called Romantic irrationalism, and make its energies productive for progressive social action, Kracauer focused on rootlessness, physical isolation, emotional insecurity and psychological stress as the material conditions which necessitated a new lifestyle: one increasingly dedicated to what one would now call consumption and conspicuous leisure, and which Kracauer was one of the first to recognize as a historically new phenomenon, giving it the name "the culture of distraction." No longer did this class which was not one, demand from art and entertainment that it represented them in idealized form, nor that it should show their lives as individually meaningful or heroically engaged in struggle, as was typical of a bourgeois form such as the novel, but simply

that it should be able to turn into play and make-believe what was facing them as the primary reality of urban life: depersonalization, violence, the drill and routine of the working day. If modern mass culture was a form of compensation, it was one where pleasure was derived from artifice and show, from the more or less imaginary but in any case brilliant imitation of life:

> Nothing is more typical of this life . . . than the manner in which it conceives of the higher things. They are not aimed at a content, but at glamour. . . . A typist given to ruminations expressed it as follows: "The girls here usually come from simple backgrounds and are attracted by the glamour." She then gave a curious explanation as to why they generally avoided serious discussions: "seriousness is merely a distraction from what is happening and stops one having fun." When a serious conversation is deemed to be a distraction, then the pursuit of distraction is indeed serious business.[11]

Paradigmatic spaces of this new serious business of popular culture were, of course, the movie theaters. But Kracauer also discusses the Berlin cafes and dance halls with their exotic décor, their sentimental yet also cynical reproduction of regional and national stereotypes. Above all, he highlights the role of popular music as the index of unfulfillable desires in an unredeemable life. What he finds is not Bloch's uneven development but an acceptance of the self as façade, and a preference for effects and illusionism over substance and realism:

> At the same time as the offices are being rationalized, the big cafes rationalize the pleasure of the office-workers' armies. . . . The ambiance is especially opulent at Haus Vaterland, which is the perfect prototype for the style also aimed at in movie palaces and the establishments frequented by the lower middle class. Its core is a kind of giant lobby, over whose carpets the guests of Hotel Adlon might stride without feeling humiliated. The lobby exaggerates the décor of the Neue Sachlichkeit, for only the latest fad is good enough for the masses. Nothing could reveal more strikingly the secret of the New Objectivity: behind the pseudo-severity of the lobby architecture there leers the spirit of Grinzing. Down the stairs and one is surrounded by the rankest sentimentality. A characteristic of the New Objectivity is to present a facade which hides nothing, which does not emerge from a depth but merely simulates one. . . . Haus Vaterland comprises the whole world. . . . Not the world as it is, but as it appears in popular songs. . . . The geography of such refuges for the homeless is born from the pop song, and even though as a rule the songs possess only vague local knowledge the panoramas are painted with painstaking care. . . . Floodlights and neon strips as used in the department store complete

the composition . . . with color effects which the sinking sun could not hope to rival. Lighting is such an integral part that one cannot but think these places have no existence during the day. Every evening they are created anew. Yet the true power of light is its presence. It estranges the flesh on the bodies, throws a costume over that which it transforms. The lights' secret powers give substance to glamour, and distraction becomes intoxication. But when the waiter eventually works the switch, the nine-to-five day stares back at you.[12]

Kracauer here describes a form of entertainment and a life style that has weathered the destruction of places like Haus Vaterland or the Residenz-kasino, the demise and rise from the ashes of the Adlon or the Potsdamer Platz because the condition that necessitated them and made them prof-itable have survived.[13] Glamour as a value enjoyed for its own sake, "der Similiglanz der gesellschaftlichen Scheinhöhen,"[14] and self-estrangement as a form of disguise or identity-costume allow the fantasy self to experi-ence itself as the true self: this split subjectivity under the sign of pleasur-able self-alienation is the social basis also for Kracauer's cinematic imaginary.

Male Hysteria and the Feminist Critique

If Kracauer based his analysis of the Weimar cinema's spectators on the sociological studies he conducted among the *Angestellten,* he may have taken the type of audience from around 1928 to 1930 and projected it backwards to the very beginning of the decade, for which there is in fact little evidence. The types of films Kracauer spotlights in *From Caligari to Hitler* as crucial in the formation of the tendencies he finds most symptomatic were made between 1919 and 1923 and may well have had a different target audience than the serious fun-seekers who only emerged as a critical mass during the brief stabilization period after 1926.

It could be argued, however, that Kracauer, although he generalized too readily from a certain class of historical spectator to the German people as a whole, he had got it right in one respect: that of gender. He had rightly recognized how many of the films from the early 1920s dealt with specifically *male* anxieties centered on vision, perception and fear of symbolic castration. Although such anxieties are not attributed specifi-cally to German males, since the same dispositions are said to be consti-tutive of the scopic regimes of all mainstream cinema,[15] the difference between Weimar film and Hollywood is that whereas in the latter, vo-yeurism is motivated by action, spectacle and a linear narrative drive, in

the German films by contrast, sight and seeing emerges as a troubled, uncanny, unstable relation of the characters to the powers of vision and filmic representation itself, often "feminizing" the men and representing the women as sexually ambivalent. This particular reading of male anxiety in Weimar cinema has in turn been challenged, for instance by Pat Mellencamp:

> *From Caligari to Hitler* consistently and repetitiously denies for over 270 pages a national, middle class oedipal/familial failure peculiar to Germany and its cinema, a failure which resulted in Hitler and The Second World War. Beneath its sociological pretense is a perverse discourse on sexuality (a staging of the repression thesis) which documents Foucault's thesis that from the mid-18th century on sexual discourse is "historically bourgeois . . . in its successive shifts and transpositions, it induces specific class effects." . . . Kracauer presents his thesis, his reading of German culture and politics through films as "reflections" of social problems due to their popular status. In this analysis, there was "something unaccountable in the domestic situation, not within the normal field of vision." Granted that his reading is abnormal, the argument places the blame on the domestic family, or historically patriarchy. What is not in psychoanalysis' field of vision as well as Kracauer's, except in absence or negative opposition, was female sexuality, the figure of woman, woman's sex. In one sense, Kracauer argues a massive failure of the family to properly inscribe males into the symbolic of paternal order. . . . Kracauer dramatises Foucault's thesis: he constantly speaks about sex while maintaining it is the secret through which every individual must pass in order to gain access to the proper construction of the social body. (Because this text speaks for itself, I feel little "compulsion" to analyze its position; clearly there are no secrets of reading involved, no concealed structures that must be brought to the surface. Neither amassed empirical facts nor his many thematic interpretations can conceal or contain the symptoms of male hysteria).[16]

Kracauer's historical and sociological analysis of the "German character" and the "national disposition" in terms of petit-bourgeois masochism would thus appear as a phallocentric version of politics and history, which, when deconstructed, speaks its truth not so much about Germany or fascism, but by necessity also about the obsessional, fetishistic nature of masculinity — even of Kracauer himself, and his unconscious attachment to the values of patriarchy. At the same time, the observation would not be specific to cinema, and therefore open up a wider social and historical framework. The idea that definitions of masculinity and male identity were in crisis during the Weimar years is itself, of course, a cultural-historical cliché. The father-son conflicts and their resolutions

in favor of the father, for instance, have long been recognized as part of the standard topoi of expressionist drama, to the extent of constituting in the minds of social and cultural historians the key to Weimar Culture's overall identity.[17] Possibly in the wake of Kracauer, but more likely independently from his work, Peter Gay more or less built the thesis of his influential book *Weimar Culture: The Insider as Outsider* around these father-son conflicts, frequently commented on at the time as typical of expressionist literature as a whole.[18]

"The rebellion that failed:" in such a configuration the oedipal or generational conflict does double duty as a metaphor for the class struggle. For what Kracauer also argued was that the depictions of Oedipal conflicts and their modes of narrative resolution in the films are so paranoid and perverse because they are a screen, a field of projection and a compensation for objectively insoluble political contradictions and immovable class barriers. Sexuality, always an overdetermined cultural code, becomes the site for the representation of highly ambiguous fears (ambiguous because libidinally charged) about any social existence outside the bourgeois order, outside the law, outside the hierarchical markers of identity and difference recognized by the middle class. This is not to say that the representation of sexual conflict or the many family tragedies in the Weimar cinema simply substitute themselves for the real tragedy of class conflict and economic ruin. Such a view would imply an almost trivial understanding of the Freudian notion of the unconscious, and a serious confusion of levels of reference, even in Kracauer. The bourgeois film of the Weimar period does indeed have a narrative structure whose symbolic code remains remarkably constant throughout the 1920s: it is Kracauer's achievement to have pointed this out. But it does not follow from this that the class conflicts of the period are structured in analogy to the stages of the Oedipal conflict. If the various revolutions on the Left failed in the years from 1917–1920, it was not because its militants were held back by castration anxiety! However, it is quite another matter if in the fictional and ideological discourses of the period, sexuality and the family become symbolic sites for the construction of political ideology.

Therefore, the second, and necessary corollary of the Weimar cinema's regimes of the look and of narration must be the question of gender. But if it is true that castration anxiety is that which is pointed to as the pivotal structure of the texts, and that the films of the Weimar cinema share with their severest critic, i.e. Kracauer, the same *male hysteria,* then it is clear that the differences between Weimar cinema and classical Hollywood narrative become less significant, compared to the

massive displacement and hysterical articulation of female sexuality that they are said to have in common. The question, then, becomes rather one of deciding how it is possible that certain films nonetheless allow the female spectator to appropriate them for the construction of *her* visual pleasure. This is the question which Patrice Petro's book on *Joyless Streets* wanted to answer, by adding a further turn of the screw.[19] Petro claims that the critics who drew attention to Kracauer's methodological blind spots were themselves guilty of a major blind spot. By conceiving the (implied ideal and empirical) spectator of Weimar films to have been male, paranoid and deeply troubled about his sexual identity, they overlook a number of salient historical points, already present in Kracauer (albeit negatively) and other media theorists of the time, notably Benjamin. According to Petro, there is both textual and extratextual evidence to suggest that the Weimar films were not only intended for women, but actually gave expression to specifically female needs and desires. Feminists have therefore seen in Kracauer's analyses the rather problematic attempt to come to terms with, and to control his own fascination with the cinema, by way of mass sociology and a theory of compensatory wish-fulfillment, projected mainly onto women.[20]

Yet what I take to be one of Kracauer's crucial points is that apart from the sociological significance of this form of spectatorship — the mechanisms of miscognition and disavowal affecting a whole class — Kracauer recognizes the pleasures of the cinema to be primarily the paradoxical pleasures of depersonalization, of nostalgia, trauma and loss: pleasures of the narcissistic self, and existing in their purest form in films whose narratives do not impose social parables on their material, such as those which preoccupy Kracauer in *From Caligari to Hitler*. In this perspective, the essay "The Little Shopgirls Go to the Movies," often cited as Kracauer's most serious early draft of a theoretically coherent analysis of the cinema's ideological function, clarifies his overall project only to the extent that he implicates himself in the cinema's *feminization* of culture, when he praises going to the movies as an experience of surface effects, complementing his (male) critique of the culture of distraction.[21]

The fetish of technology and the cult of the engineer in both mainstream Weimar cinema and by sections of the German avant-garde, above all by the Dadaists, could also be seen in a more directly gendered perspective, where *technique* functions almost as a defense against castration anxiety.[22] And the same could be said about narrative authority: in many Weimar films the origin and control of the act of narration is constantly foregrounded, and in a manner that has no equivalent in contemporary

silent cinema of other countries. The profusion of nested narratives, framed tales, flashbacks, en-abyme constructions and interlacing of narrative voices emerges as the index of the very difference that singled out German silent cinema as historically specific from its Hollywood counterpart.[23]

If the claim that this male imaginary is typically German would be stretching a point, it could nonetheless help to understand how an obsession with narrational or visual control represents another form of what Noël Burch has called the cinema's Edisonian imaginary, seeking to rearticulate the female within its own system of duplication, doubling, mirroring and transcription.[24] It once more suggests the notion of certain films as *bachelor machines* — meta-mechanical representations or simulations of life, which via the cinematic apparatus and its relation to both sexuality and (mechanical) reproduction function evidently as fetishes.[25]

German Gothic:
Autorenfilm and its Audiences

As other studies have shown,[26] the so-called *expressionist cinema* was a self-conscious attempt at wooing a bourgeois public, and meant to persuade the middle classes to accept the cinema as a legitimate art. In this, it repeated the earlier attempts at legitimation from 1913, the so-called *Autorenfilm*. At that time, several different formulas were tested, so to speak, from the Asta Nielsen films of Urban Gad, via the filmed novels and plays by Augustus Blom and Max Mack, to the fairy-tale, folk legend, or *gothic* films with Paul Wegener. With respect to the last group, one might cite a passage from Lotte Eisner: "It is reasonable," she writes, "to argue that the German [expressionist] cinema is a development of German Romanticism, and that modern technique [i.e. cinematography] merely lends a visible form to Romantic fancies."[27]

But Eisner's assertion, too, begs some questions: bearing in mind Kracauer's socio-psychological map, which identifies the most symptomatic films as reflecting the First World War and its aftermath at one end, and the cynical overconfidence of stabilization period at the other, why should it be Romantic motifs that returned with such force in an apparently quite inappropriate historical context? Secondly, can we assume that the "modern technique" did not affect the meaning of these Romantic themes, as the medium of the moving image appropriates them, possibly in the form of repetition, pastiche and ironic quotation?

In other words, if "Romantic fancies" were "made visible," could they nonetheless have been a response to political and economic pres-

sures which found in them at once their expression and an acceptably ambiguous resolution? The revival of the gothic novel in the nineteenth century, as indeed much else in the Romantic arsenal, was a Europe-wide phenomenon, usually attributed to a reaction against Enlightenment rationality. But it was also a more explicitly political response to the French Revolution (in Britain) and the Napoleonic Wars (in Germany). However, there is little question that the rapid industrialization following the Vienna Congress provoked another major site of dislocation, where the contrast between city and country was central and the relation to nature became profoundly refigured,[28] often with the result of making nature itself seem uncanny, haunting. Famous are the fantastic tales where the natural world is poised to avenge itself on those despoiling the earth in search of mineral wealth, or taking over rivers, lakes and waterfalls as sources of mechanical energy. Especially in Germany, figures such as Undine, Rumpelstilzkin, or the gingerbread house of Hansel and Gretel allude to this split, featuring characters hovering between earthbound space and encroaching civilization, on whom are projected fears and fascination of the protagonists. Their bad conscience treats all manner of natural habitats as picturesque sites or idyllic spaces, while at the same time, it makes dangerous monsters out of those that guard them. One thinks of the Giant Rübezahl (celebrated in one of Wegener's films, *Rübezahls Hochzeit,* 1916) haunting the woods and villages of the Erzgebirge, a mining region in Thuringia. Even the figures of Mime, Alberich and Etzel in Lang's *Die Nibelungen* (1924) have both a mysterious communion with nature *and* they pose a powerful threat to the more civilized protagonists.

Additionally, in mystery stories of the Romantic agony, what is often at stake are contested forms of political authority or social control, with the elements of horror or the supernatural both disguising the historical conditions of socio-economic struggles *and* foregrounding their destructive effects, by insistently imagining different, i.e. fantastic forms of agency and legitimacy. In the 1920s, contemporary relevance would translate itself into the violence and urgency of the irruptions, whose occurrence, however, is often set in another, more distant age. Surprisingly many films of the early Weimar thus take up these displacements of period and social structure. Medieval courts (*Der Golem, wie er in die Welt kam,* 1920), Renaissance principalities (*Die Pest in Florenz,* 1919; *Lucrezia Borgia,* 1922) or the struggles of the Reformation and counter-reformation provide the scenery for depicting class relations or giving vent to hostile feelings toward clergy and other father/authority figures.

In light of the delay in Germany's economic developments, it would be perfectly possible to find parallels between the 1820s to 1850s in Europe, and the Germany of the 1890s to the early 1920s. For while the unification of the German Reich under Bismarck in 1871 had finally done away with the small feudal courts and petty aristocratic principalities which had blocked Germany's industrial growth from a wholly rural patchwork of communities into a modern, bourgeois nation-state, Wilhelmine Germany remained nonetheless a predominantly agrarian society, its peasant morals and closed community values badly equipping it to make the transition to urban living, factory work and office employment without the strains showing in the body politic. The recurrence of Romantic and fantastic motifs might therefore be explained as a "working through" of this uneven development and the time lag that separated Germany from its European neighbors, especially Britain with its strong colonial and industrial base and France with its democratic institutions and centralized administration. The Bismarck revolution from above had left intact a powerful caste system, and a culture as well as an educational system deeply saturated with an elitist, feudal heritage. The survival of an Imperial Court and a bureaucratic-military administration, even after the defeat in 1918, along with the emergence of a heavily politicized working class, gave the struggle of the various sections of the bourgeoisie for power and hegemony quite distinctive features in Germany.

One of these distinct features in the cultural domain might actually be the reverse of what one traditionally associates with Romantic values: the gothic revival, generally read as politically conservative, reacting to modernity by nostalgically invoking a mythic golden age of stable hierarchies, can in this context be interpreted quite differently. Germany, it seems, periodically experiences a revival of Romantic art and fantastic literature after every "revolution that failed," notably those in 1798, 1848, 1918, 1968: this would make the prevalence of fantasy the reaction, usually of a cultural and/or geographic minority, to their exclusion from the sweep of historical events, and as such, the expression of a frustrated desire for change, rather than a resistance to change. A cyclical movement would unite Goethe's Faust/Prometheus figures, Georg Büchner's Danton and Woyzeck, E. T. A. Hoffmann's doubles and artist-magicians with the Golems and homunculi adapted for the cinema from the stories of the Prague School around Gustav Meyrink and Ernst Kubin, themselves the ancestors to the Aguirres and Fitzcarraldos of Werner Herzog, or Syberberg's Hitler, depicted as at once the puppet and puppeteer of German history. The prevalence of the Romantic and fantastic would hint at highly self-conscious moments of "national"

reflexivity and reinvention, and imply an ideologically more ambivalent politics of representation than either Eisner's notion of art historical influences or Kracauer's symptomatic tracking of the Weimar *Zeitgeist* across the films suggests.

If the German separate development into modernity is thus a salient constituent of the national culture inflected by Romantic themes, this does not answer the second question, which is why and how such motifs appear specifically in the cinema. Are there attributes of film technology that make it a particularly suitable vehicle for figurations of the fantastic — which is what the Eisner quotation seems to intimate? Or does the answer lie in the new public sphere that the cinema came to shape in cultural and social life during the Weimar period — which would in fact support Kracauer's case?

Paul Wegener and the Origins of the Fantastic Film

The key to both these questions may not be in the Weimar period, but in the situation of the German cinema prior to the outbreak of the First World War. Similar to developments in other European film industries, it was the year 1913 that became a turning point also for Germany. By then, film exhibition had stabilized around the full-length feature film, premiered in luxury cinemas, a necessary condition for Germany to emerge as a film producing nation rather than one that primarily consumed the films it imported or copied from France, the United States and Denmark.[29] Indigenous production not only increased, but also began to develop a number of genres that were to become typical. Outstanding among them were suspense dramas and detective films, some of them, such as *Die Landstrasse* (1913) by Paul Woringer,[30] *Die Faust des Gesetzes* (1913) by Heinrich Bolten-Baeckers[31] and *Der Mann im Keller* (1914) by Joe May[32] showing sophisticated narrational styles, such as Griffith-type parallel montage. Perhaps most strikingly, these genre films also featured doubles, dummies, mistaken identities and the "return of the repressed" — in other words, typical elements of the fantastic and the uncanny, though not in *Biedermeier* period costume or expressionists sets, but utilizing Berlin street locations and realistically furnished, contemporary interiors. With their car-chases and taxi-rides, railway pursuits and telephone calls, the films cast a fascinated eye on modern technology, on the mechanics of crime and detection, while the protagonists revel in disguise and transformation. The urban scenes are motivated by showing men from the underworld and women from the demimonde

mingling with respectable citizens, such as the Jekyll-and-Hyde judge in *Der Andere,* or organizing citywide advertising stunts in order to increase newspaper sales, as in *Wo ist Coletti,* both directed by Max Mack in 1913.

These genres and their stars have been eclipsed, perhaps unfairly, by the most commented-on aspect of 1913, namely, the emergence of the already mentioned *Autorenfilm.* Initiated under the impact of the French film d'art, the aim was to profit from the established reputation of published or performed authors, and to persuade the leading names of Berlin's theaters to lend glamour and cultural prestige to the screen. Popular but now forgotten middlebrow writers such as Paul Lindau and Heinrich Lautensack were signed on, but also Gerhart Hauptmann, Hugo von Hofmannsthal and Arthur Schnitzler. Many actors had been contractually forbidden to appear in films, but when Albert Bassermann agreed to star in *Der Andere* based on a Lindau play, others followed suit. Max Reinhardt, for instance, was financially enticed to direct two films, *Venezianische Nacht* (1914) and *Insel der Seligen* (1913), full of mythological and fairy-tale motifs, liberally borrowed from Shakespeare's comedies and German fin-de-siècle plays, while William Wauer, a writer close to Herwarth Walden's expressionist journal *Der Sturm,* directed a two-hour *Richard Wagner* (1913), a remarkable film on many counts, but certainly not for its expressionist influences.[33]

An especially militant advocate of the *Autorenfilm* was the cinema owner and novelist Hanns Heinz Ewers. Together with the Danish director Stellan Rye and the Berlin cameraman Guido Seeber, Ewers made *Der Student von Prag* (The Student of Prague, 1913), a film which stylistically had little in common with other *Autorenfilme,* but which otherwise is as rich a source for "Romantic fancies" as one could wish. The Danish connection in *The Student of Prague* is no accident, since the leading Danish company Nordisk was the prime force behind the German *Autorenfilm,* producing two of the genres' most costly ventures, *Atlantis* (1913), based on a novel of the same title by Hauptmann, and *Das fremde Mädchen* (1913), a *dream play* written for the screen by Hofmannsthal. Denmark also provided the German cinema with its first international film star, Asta Nielsen. From 1913 on she made all her films for German companies.[34] Thus in the same miracle year of 1913, and amidst detective films, comedies, melodramas and musician's biographies, the fantastic as a distinct filmic genre had its first masterpiece. *The Student of Prague's* outstanding creative personality, however, was neither the director nor the writer, but Paul Wegener, its leading man. A celebrated Max Reinhardt actor before he came to make films, Wege-

ner invented between 1913 and 1918 the genre of the fairy-tale film, acting in and codirecting after *The Student of Prague* what became the prototype of all monster/Frankenstein/creature features: *Der Golem* (The Golem, 1915), based on a Jewish legend and a story by Gustav Meyrink. There followed *Peter Schlemihl, Rübezahls Hochzeit, Der Rattenfänger von Hameln* (The Pied Piper of Hamelin, 1918) and several other films exploiting the rich vein of German Romantic legends and folk-myths. Wegener's pioneering role may not always have been appreciated, partly because his films contradict the thesis of the fantastic film as a postwar Weimar phenomenon, but also because he was compromised by his active role during the Nazi era, directing seven feature films and starring, as "State Actor," in several more.

Wegener's work in the 1910s, however, is crucial for the reasons already alluded to: the suitability of fantastic subjects for film technology, and the place of the cinema in the emergent public sphere of urban entertainment culture. Wegener, by his own testimony, was attracted to fantastic subjects because they allowed him to explore different cinematic techniques, such as trick photography, superimposition, special effects in the manner of Méliès' *féeries,* but with a stronger narrative motivation.[35] For this, he worked closely with one of the early German cinema's most creative cameramen, Guido Seeber, himself a still underrated pioneer whose many publications about the art of cinematography, special effects and lighting are a veritable treasure trove for understanding the German style of the 1920s. In 1919, for instance, Seeber published an essay entitled "Doppelgängerbilder im Film" in the trade journal *Die Kinotechnik,* in which, after detailed descriptions of how to overcome the difficulties of creating flawlessly illusionist doubles for the moving image as opposed to still photography, he concludes:

> The first large-scale application [of my device] in a feature film was demonstrated in *Der Student von Prag,* shot by me in 1913 with Paul Wegener in the lead and as his own double. The result caused a major sensation at the time. The illusion was so perfect that many experts simply would not believe me when I told them that I had exposed the relevant scenes twice in succession.[36]

Yet Seeber and Wegener's fairy-tale films also promoted the ingenious compromise which the *Autorenfilm* tried to strike between countering the immense hostility shown toward the cinema on the part of the intelligentsia and the educated middle class by reworking material with literary credentials.[37] At the same time, they reached the new urban masses

by providing sensationalist show values, such as the "special effects" described by Seeber.[38]

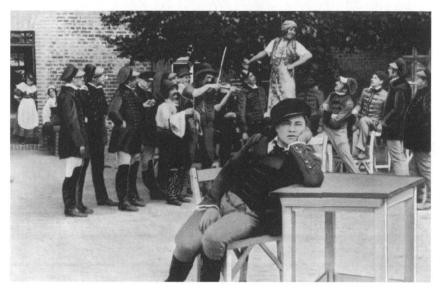

Paul Wegener in Stellan Rye's *The Student of Prague* (1913).

The question of how to account for the prevalence of the fantastic in the German cinema may therefore have a more prosaic answer than that given by either Eisner or Kracauer, who enlist it as proof of the Faustian motif of the two souls that inhabit one body, baring themselves on the screen. By imitating the Romantic *Kunstmärchen,* the fantastic films achieved a double aim: they militated for the cinema's respectability (which was at the core of the first *Kinodebatten*) by heavily borrowing from middlebrow Wilhelmine *Kultur* and children's literature, but they also mitigated the internationalist tendency of most films before 1914 from whatever country, by offering identifiable German (i.e. Romantic and *Biedermeier*) motifs. Up until then, filmmakers in most countries were either inspired by such popular entertainment forms as variety theater and music hall sketches, or they copied the successful film subjects of their foreign rivals and domestic competitors. Even the trick shot of Paul Wegener playing cards with himself in *The Student of Prague* has a French antecedent in a *Zigomar* film from 1907. It was with the rise of the French firm Pathé and the German *Autorenfilm* that adaptations of the national literature became an integral part of the notion of national cinema.

The Wegener tradition thus set a pattern which was to repeat itself throughout the 1920s: nostalgic and self-consciously national themes contrast sharply in the same films with a radically experimental and avant-garde outlook by which the filmmakers advanced the medium's technical possibilities and remained at the forefront of film innovation, such as lighting and camera technique. Trying to define a national cinema by blending a high-culture concept of national literature with a pseudo-folk culture as the popular, the Wegener tradition managed to take the wind out of the establishment's critical sails. It is the combination of both objectives in the fantastic film that made it such a mainstay of the German cinema for at least a decade (from 1913 until about 1923), suggesting that the celebrated expressionist film is the tail-end of this truce between highbrow culture and a lowbrow medium, rather than a new departure. As is well known, what breathed new life into the vogue was *Das Cabinet des Dr. Caligari* (The Cabinet of Dr. Caligari, 1920), mainly because of its extraordinary reception in France (and subsequently in the United States), which in turn made producers and directors self-consciously look for motifs the export market would recognize as German.[39] Both the character of Scapinelli in *The Student of Prague* and the mysterious doctor in *Dr. Caligari* are, however, traditional figures, referring back to the magicians, shadow-players (*montreurs d'ombres*) and magic lanternists with their phantasmagorias at fairgrounds and other popular entertainment shows all over Europe: their manipulation of illusionism might be seen as typical of the German cinema where they self-consciously elaborate parallels with the cinema itself, suggesting the increased (social) status of those who have control over the image as in the films from the early 1920s, such as *Das Wachsfigurenkabinett* (Waxworks, 1924), *Schatten* (Warning Shadows, 1923), *Tartüff* (Tartuffe, 1925). In this guise, the fantastic films often present Mephisto figures tempting young, petty-bourgeois Fausts — as in Murnau's *Faust* (1925), itself a vehicle for some hitherto unseen technical feats and special effects.[40]

Social Mobility[41]

Kracauer's sociological analyses of audiences highlighted a historical problem as to how to periodize audiences, as well as the theoretical one, how to define spectatorial identification. The historical question has to do with the social fantasies that would deem necessary in order to "bind" first a middle class audience, then the white collar employees, and finally, women as consumers to the institution cinema. The theoretical question points to a dynamics of "identification as miscognition" which Kracauer

took from Sigmund Freud, stressing projection, disavowal, castration anxiety and narcissism: concepts which Kracauer was one of the first to apply to cinematic spectatorship. That such forms of specular seduction and miscognition of self-interest (and class interest) might also be relevant to other sites of social interaction, including those of politics and the new public spheres of consumer culture makes his insight the more farsighted.

Identification as miscognition also opens up a new perspective on Kracauer's initial critical point about the lower middle class, of whom he claimed that, having lost their savings and their jobs, they were driven by fear and resentment, mainly regarding their social status and class identity. He found these fears reflected in the films, but he did not go far enough. For the feelings seem to undergo a double inversion: fear, first of all, disguises itself an ambition — that of social mobility and economic success — but by another inversion, it *returns* as fear, because the ambition is heavily punished. But in order to represent this double inversion, the whole complex undergoes a generic transformation: from being in reality a very modern, metropolitan anxiety of an upwardly mobile meritocratic-democratic society, social rise in the film is represented as a "feudal-gothic" motif, involving aristocrats and the bourgeoisie, rather than the lower middle class or white collar employees. Thirdly, even in this disguised form, it is curiously disavowed: the narrative may start with hinting at a problem of class or status, but then veers off in a quite different direction, possibly never to come back to the economic or class issue at all.

Thus, it would be inappropriate to look for a direct reflection of the consequences of inflation and pauperization in the films, or to extract from them a catalogue of motifs in which the markers of class, social status or economic prosperity are being depicted. Rather, one may have to track the motif of social rise/fear of social disgrace across symptomatic clusters — be they iconographic or narrative — in which class and social standing are at once articulated, disavowed and reconfigured. In other words: one would be looking for moments in the films where narration and genre do the ideological work on the story material (mostly a mix of literary, mythological and fairy-tale clichés) by way of foregrounding, repetition or excess. Although economic success and social mobility seems a matter of class and social status, the films often rework social mobility across other markers of difference, notably gender: the class issue of the protagonist resolves itself into finding, but then being rejected by the ideal woman. Once again, the anxious male emerges as the favored subject. His "negativity" at times creates paradoxical spaces for

problematic, but also productive redefinitions of femininity, in the many films which already Kracauer analyzed under the heading "the adolescent and the prostitute," but which on closer inspection give the women more room for agency than the derogatory term suggests.

That social mobility in many German films of the early 1920s should be treated not in an urban setting, but across the Romantic-fantastic and the gothic-supernatural, contrasts sharply to how other national cinemas, notably French and Hollywood films deal with the topic, where one is more likely to find it a fit subject for *comedy* or even farce.[42] In general terms, the potential of improving one's fortunes is a subject that appeals to a wide spectrum of audiences from working class to petty-bourgeois, from intellectuals to white-collar workers, and only excludes those who (at least in Germany) probably did not go to the cinema anyway: the rich and the super-rich. It is, of course, an ambition heavily couched in fantasy, but the fantasy normally stands in some relation to what forms and degrees of mobility are actually possible and feasible in a given society. As a hypothesis, I would argue that the more the "rags-to-riches" theme is treated in the comic mode, the more one can assume that the society in question encourages its members to strive after social mobility (which is certainly true of American society and its cinema). But in the European cinema, the motif comprises two elements which stand in a certain tension to each other, if not in an outright contradiction. On the one hand, being chosen by fate and chance for social success is itself a distorted version of a class struggle, in so far as a personal, individual solution is offered, while blocking off and suppressing the question of the whole class or group to which the individual belongs. Social rise is thus a version of the class struggle that denies the existence of this struggle.

In popular literature the theme emerges most consistently as a fairy-tale motif: a Cinderella story, or tales that involve an orphan and a Prince Charming. In this guise, it has a predominantly female protagonist or at least a clearly gendered narrational perspective. But in Charles Dickens's *Oliver Twist* (1838), for instance, one finds a slightly different configuration — that of melodrama. The orphan Oliver, forced to participate in a robbery, desperately wants to escape into a better world, but copes with his fear and anxiety by falling unconscious. As he wakes up, the setting has changed to an almost excessively cozy ambiance of middle class comforts, a world of wish-fulfilling fantasy, exuding security and parental care. Dickens' great skill is to have woven this moment of fantasy into what is essentially a realist novel, a transformation of Victorian stage melodrama into novelistic forms. The German cinema of the fantastic, on the other hand, with its generic and ideological proximity to

the (prewar) *Autorenfilm* was precisely not a realist or *classical* form, but a counter-cinema, therefore appealing to a self-selected public.

So what was this art cinema with its fairy-tale motifs trying to work out, with respect to the middle class audiences it aimed to impress? My argument would be that rather than reflecting the fear of proletarianization and compensating for it by fantasies of social rise, such films were about the disavowal of this fear: they taught their audience the thrills and virtues of self-repression itself, sometimes inaugurated by a very Dickensian swoon. Several Weimar cinema protagonists suffer such lapses of consciousness, under the conflicting pressure of anxiety and desire, moments which mark the intrusion of the fantastic and the uncanny into the narrative, as opposed to fairy-tale wish-fulfillment. The outstanding example would be F. W. Murnau's *Phantom* (1922, scripted by Thea von Harbou, after a novel by Gerhart Hauptmann). A poor clerk, his mind full of ambitious daydreams of a glorious future as a writer, is knocked unconscious by a white horse-and-carriage, as he crosses the street with an armful of books. A young lady, also in white, steps out of the carriage, bends over him to make sure he is unharmed, and then rides on. But for the young man, the incident sparks off a vision and a passion which pursues him all his life: it becomes the phantom of the title. Turned away by the young woman's parents, he becomes a criminal, even attempting a Raskolnikov-type murder of an old lady, only so as not to be once more refused as suitor. His social rise blocked by his love's aristocratic parents, he can — it seems — only be in free fall, as if there was no social structure to make him find his place in the order of things. The film ambiguously suggests that the woman he desires turns into the phantom haunting him, because of his failure not as a man, but as a social climber! Here, the class issue is avoided, by stylizing the loved woman into an unattainable ideal, yet at the same time, all the elements of class are present, but estranged and displaced across the Oliver Twist motif of the young man pressed into participating in an inner city robbery that ends in murder, depicted in scenes whose nightmarish quality are brutally set off against the *Biedermeier* serenity of the initial encounter and in stark contrast to the rural retreat that forms the frame to this narrative presented in flashback.

An inversely gendered perspective on the same desire for social climbing appears in *Das Mädchen aus der Ackerstrasse* (The Girl from Acker Street, 1920) where the generally realistic genre of the social melodrama supports the fantasy of a Cinderella-type wish for class advancement. Ella, the stepdaughter of a working class family is badly treated at home, exploited by her father, and humiliated by her mother.

She decides to leave home, but erring through the city streets, she breaks down and falls unconscious, before being rescued by a passerby who takes her home. Her unexpected savior turns out to be a well-to-do bachelor by the name of Dr. Albrecht, living alone in a large apartment. Delighted by the naïve charm and innocence of his find, he decides to keep her and spoil her with gifts. He covers the impropriety by declaring her to be his niece in front of his maid and butler. Two shadows loom over the newfound bliss: the fiancée of Dr. Albrecht, and the intrigues of the butler, who on learning who the parents of the young woman are, persuades them to blackmail their daughter's benefactor. Dr. Albrecht cannot make up his mind about leaving his fiancée, but allows himself to be caught in a compromising situation by her. He also fails in his attempts to stop Ella's greedy stepparents from reporting him to the police for seduction of a minor. In haste, he decides to pass Ella to an artist-friend of his, where she soon takes to the bohemian life, being courted and feted at their parties. In the meantime, to escape disgrace, Dr. Albrecht has shot himself, but Ella only hears about it by accident, when she passes by his house, sees the door open and the removal van outside. One of the workmen tells her that the owner has been dead for some weeks, and on hearing this, Ella falls unconscious. The film ends with her lifeless body prostrate in the empty salon.

Although the action takes place in contemporary Berlin settings, and starkly contrasts the slum conditions of the heroine's parental home with the leafy villas and large apartments of Dr. Albrecht's West End neighborhood, the film relies on a fairy-tale plot. The idea of the poor, mistreated stepdaughter discovered by a rich Prince Charming condenses a classic fairy-tale motif with the tragic action of melodrama, referring itself once more to nineteenth-century popular literature and twentieth-century romance fiction. The wish-fulfilling fantasy is, however, not worked into a happy ending, nor into a more cynical tale of a young gold digger, but retains a curiously resonant tragic ending, emphasized by the repetition of the image of the heroine falling unconscious — now no longer the prelude to waking up in a dreamlike other world.

The Student of Prague:
the Double as Disavowal

A film in which the issue of class and social rise is implicitly posited from the opening scene, only to be forgotten and covered by an apparently quite different concern is the 1913 *Student of Prague*. What in *Phantom* is the combination of falling unconscious, the white horse and the

woman in white, at the margins of which are criminality and violent death, was already present in *The Student of Prague* as a lady on horseback, whom Baldwin, the student of the title, rescues from the lake, after her horse has bolted. From there on, his goal is to possess this woman, which, as it turns out, necessitates eliminating the lady's cousin and fiancé. The film ends with the hero committing suicide. Here, the gothic elements act as the force of repression and disavowal, for on the narrational surface, the question of social rise is altogether a peripheral issue. The film is primarily about Baldwin selling his shadow to the mysterious Scapinelli, who in turn promises him riches and happiness. The social rise, to which Baldwin accedes with ease once he has the money, belongs altogether to the realm of magic and the fantastic, as if the dream of happiness had to be repressed so completely that only a fantastic guise could be made to represent it. The film borrows from the Faust legend as well as E. T. A. Hoffmann and E. A. Poe's short story *William Wilson* (1839): what is different is precisely the sociological emphasis which the uncanny allows the film to introduce while at the same time tabooing it.

Baldwin is visibly dismayed by the student scene, depicted in the background of the opening shot. With a dismissive gesture he sits down at a table apart from the others. He is broke, alarmed about his future, and in such a fit of depression that even his girlfriend cannot cheer him up. But instead of investigating the causes of what brought him to this state, the film blocks and breaks off the topic at this point, in order to introduce Scapinelli, the mysterious figure in hat and black overcoat. The visual composition with which it does so is significant: throughout this scene, Baldwin sits with his back to his girlfriend Lydushka, as she dances lasciviously on the tables behind, clearly intending to attract his eye. He looks straight into the camera, so that he is doubly separated from what goes on; spatially, and in terms of his field of vision. By contrast, the audience is made to identify with two distinct points of view: we participate as spectator-voyeurs in Lydushka's self-display (and are thus part of the student scene) but we also identify with Baldwin's refusal to participate; as spectators we are already split well before Baldwin's double appears. While a classical narrative might develop this plot in the direction of how to reconcile and mediate between these two levels, after having set up such a division or contradiction, *The Student of Prague* introduces such a mediator, in the shape of Scapinelli, who enters not from the direction of Baldwin's gaze, but sideways, from off-screen, and his black carriage completely blocks out the background of the young woman and fellow-students.[43] However, if Scapinelli provides the means whereby the contradiction is resolved, he does so in an excessive, mon-

strous, tabooed way: he enters the frame of the fiction in much the same way as Nosferatu's ghost ship eight years later enters the Baltic port to bring the plague in Murnau's film.

The narrational strategy of *The Student of Prague* is thus to allude to a problem of class and status, which the audience can identify as such, but only to interrupt its development, disguise its consequences and yet reinforce its importance on another level. The anachronistic figure of the *Biedermeier* student motivates the introduction of a magic and demonic chain of causality, with mystery figures and chance as the main form of agency. It thereby overwrites, through the mode of the uncanny, the desire for social rise *then*, but also the fear of social declassement and disgrace *now*. These contending forces of desire and fear engender a split in the protagonist, and so act as inhibitive agents rather than being the fairy-tale donors or helpers of a wish-fulfilling scenario. What is being repressed is the initial situation, in its social and historical dimension. The fact that it is repressed, rather than simply elided or passed over, characterizes the film as belonging to the genre of the fantastic, what one might call "the Double as disavowal."

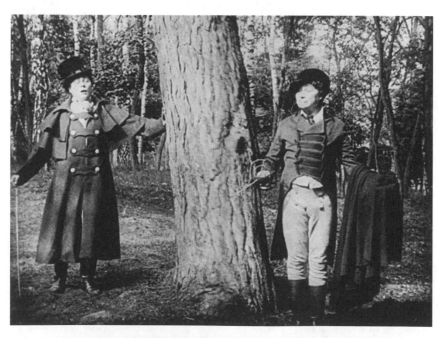

Paul Wegener and Lyda Salmonova in
Stellan Rye's *The Student of Prague* (1913).

For with *The Student of Prague* another figuration of the fantastic makes its appearance, that of the Double. If one looks to the literary antecedents, one finds that the motif is quite closely allied in German and English Romantic literature with a detection plot, whose solution, as in Poe's *William Wilson,* is the establishment of an identity between criminal and investigator, in other words, an explicitly Oedipal plot, which cannot but end in suicide or self-mutilation. In *The Student of Prague* this pure gothic storyline is complicated by all manner of other motifs — as indicated, mostly of a sociological nature — until it resurfaces at the end when Baldwin aims at his double appearing in the room, but firing the shot that actually kills himself. Between the hero and the external world, an alien power seems to interpose itself, and the films of the fantastic here operate quite a decisive break between cause and effect by letting a substitute motivation and a supernatural causality fill the gap: a process which the opening scene of *The Student of Prague* depicts literally in the figure of Scapinelli, who like Lydushka, the Gypsy with the Slav name, is a racially marked representation of the foreign other.

The repressed dimension of social or ethnic otherness returns to the hero in a horribly altered form, as the nightmare of the split self, as a crisis of identity and a compulsion toward self-destruction and death. In *The Student of Prague,* as in several other films, such as *Orlacs Hände* (*The Hands of Orlac,* 1924), the structure of disavowal is made visible across the shock which the uncanny return is capable of causing to the hero's body, be it because of what he *lacks* (his shadow in *The Student of Prague*) or of what there suddenly is *too much,* as is the case with the hands of the murderer in *The Hands of Orlac:* both times, the missing part or excessive supplement are the element of terror and total self-estrangement. In Hoffmann, Poe or Dostoevski's *The Double,* the uncanny moment results from trying to defend against a ubiquitous pressure and violence upon the self, but where the hero is able to do so only by turning this violence against the self. It is the structure of disavowal itself, more than what is being disavowed or what materializes in its stead, which produces the strongest effects of the fantastic.

The Sorcerer's Apprentice:
Reification and Alienated Labor

If one regards the films of the fantastic as ideological interventions in a number of social conflicts and crises of values, then these representations are not direct reflections of social structure. Their function in a society's ideological narratives only reveals itself at the more oblique points of

contact between subjectivity and social life. What in the fantastic becomes image and scene across the film's own generic codes of probability and verisimilitude is less by way of mimesis, but springs from embodied values and psychic energy, such as the moments of excess and extreme intensity in melodrama: that is to say, the fantastic manifests itself as fantastic not as reference, but *as discourse*.

One such valorization of excess, for instance, can be found in a figure of the fantastic whose function initially seems similar to that of the double: the sorcerer's apprentice. Enacting the dangerous spectacle of calling on magic forces, the sorcerer brings to life creatures whose power outstrip their creator and over whom he not only loses control, but who might actively turn against him. In the context of nineteenth-century literary forms, the motif has an eminently political character, especially where conservative and liberal writers ascribe this excess to conditions which are recognized as in need of change, but where the cure is suspected to be worse than the ills. The sorcerer's apprentice thus became a favorite metaphor of the radical turned conservative — a stance as topical for the German Romantics of the 1820s as for German expressionists disappointed with the socialist revolution of 1919. The sorcerer's apprentice thus becomes a figuration of hubris, but stripped of its tragic nobility. It even has a comic-didactic side, as in the fairy-tale of the three wishes, where the last wish is needed to undo the damage caused by the fulfillment of the others. What is remarkable is that the sorcerer's apprentice theme returns with a sort of spectacular vehemence in stories about the "first machine age," whether in *The Golem,* or in *Metropolis* (1927), in the somewhat earlier, very popular *Homunculus* serial of 1916, which was reissued in 1921,[44] or in the 1930s film versions of Mary Shelley's *Frankenstein.* The fact that it is a figure often connected with technologies of the body should not lead one to interpret it only as a conservative motif: in *The Golem,* for instance, it is associated with forces and values of a different kind, as Rabbi Löw creates the Golem in order to defend himself and his community against the arbitrary, financially as well as sexually predatory rule of an absolutist aristocracy. In this respect, it is also an antifeudal parable, typical for the bourgeoisie in its revolutionary militant phase. In this respect, the sorcerer's apprentice fairy-tale, when reworked in the cinema, is more than a reaction to industrialization: rather, it puts into play an imbalance of forces, of means and ends, which is being compensated in ways that themselves turn out to be excessive, irrepressible, destructive. As such, it is a an attempt to find a principle of equivalence or fair exchange (between effort and

result, means and ends), in circumstances where it is bound to be thwarted or fails.

However, looked at from a slightly different angle, the same motif can yield a more explicitly historical perspective. As I argued with respect to *The Student of Prague,* such an unequal exchange or "failed" symbolization — leaves its own traces in the text, in its stylizations, its sudden lapses, producing an uncanniness which attaches itself to idyllic worlds and the most benign relationships: in the midst of a lovers' tryst, Balduin's double appears as an unbidden helper. One way of recovering the historical dimension of uncanny motifs such as the double or the sorcerer's apprentice, therefore, is to relate them not to industrialization per se, but rather to the way its consequences are compensated: the drama is not the changed forces of production, such as the steam engine or the conveyor belt, but the changing *relations* of production, for instance, as they affect the artists and intellectuals, increasingly thrown upon the open market with their products, like any other small-holder. To some of Hoffmann's tales, notably *Der Sandmann* (1816–1817) or *Mademoiselle de Scudéry* (1819–1821), and to Balzac's *La Peau de chagrin* (The Wild Ass's Skin, 1831) or *Le Chef-d'oeuvre inconnu* (1832) one could apply what Marx as early as 1844 wrote about alienation and reification, namely that in the capitalist production process, his own labor confronts the worker as something alien, and his own person comes to seem to him uncanny. The 1840s were the period when artists began to lose their patrons, or rather, when literary and artistic production had to come to terms with the rising mass market of publishing and magazine illustration.

It is as if this process of alienated labor was being literalized in several of the fantastic films of the 1920s where the Double, the Faustian overreacher, or the creator half-possessed by his creature are the major motifs. Could it be that they reappear as a dominant configuration at precisely the point in history, when the conditions of production for artists and intellectuals undergo a further significant change, not least through the cinema, which by the early 1920s was very much perceived as a dangerously powerful rival to theater and serious fiction, giving rise to the second major *Kinodebatte.* The role of the writer as the representative of his time, as someone in whom the problems and dilemmas of the age find at first a personalized echo before finding their ideal (artistic) expression, dramatically declines. Another power, that of technological reproduction, the emergent mass media interposes itself, as both a lure and a threat. Its function is not reflection, but intervention: the film artist is once more divided, and in very typical form: he is a member of

the intellectual class, the bourgeoisie — often the *Bildungsbürgertum* — but his mode of production in the culture industry which is the cinema, puts him also at the forefront of technological experiment and innovation, and thus in a field of force quite different than that of the artist-writer.

The Paul Leni film *Waxworks*, in which a penniless writer hires himself out to the owner of a fairground waxworks show, vividly thematizes this pauperization of the writer. Not only is he haunted by patriarchal figures of grotesque or malevolent evil like Harun Al Rashid, Tsar Ivan the Terrible and Jack the Ripper, but he is woken from his nightmares by his pencil penetrating his chest like a knife. Here, social rise is doubly displaced: for a writer to be employed in a fairground is, of course, a step down rather than up, but since he ostensibly does it only to win the hand of the owner's daughter, the oedipal plot both disguises the social issue and — in the excess of the predatory father figures haunting the hero — it comically exaggerates the cover-up.

The Double as Sorcerer's Apprentice: *The Cabinet of Dr. Caligari*

Precisely because the uncanny functions as the very sign of disavowal, it can draw to it quite different societal motifs, including those of the ethnic Other, or the modern city and its own experiences of the uncanny, where the cinema plays a key function, not by familiarizing the Other, but by double-coding its unfamiliarity. The writer Hugo von Hofmannsthal, himself one of the protagonists around the *Autorenfilm*, noted in an essay on d'Annunzio how much the cinema offers the modern spectator his own double ("wir sehen uns doppelt"), arguing that this would herald an entirely new form of self-experience as self-estrangement. Similar comments can be found among other writers of European decadence and symbolism, such as Villiers de l'Isle-Adam in his *L'Eve future* (Eve of the Future Eden, 1886) and Guillaume Apollinaire in his short story *Un beau film* (Like a Film, 1907). Writers wondered if identity and self-possession might not in modern society be an effect of doubling, but in a mediated form, especially via looking, visual contact, and knowing oneself to be looked at, as in Charles Baudelaire's prose poem *Les Yeux des pauvres* (1864). While these writers concentrate on the mirroring of a cityscape that has become its own imitation and looking-glass maze, many of the stories told in the German films from the late 1910s and early 1920s are also set in the city, but center on doubles as split representations of the central character, often the conse-

quence of an unsuccessful challenge to authority, and implying a troubled narcissism.[45]

The subjects of the fantastic film might draw their special fascination from the self-displays of sight. In this respect, the theme of the double is also a motif more or less explicitly linked to the cultural transformations of identity and selfhood: where once an individual might have derived a sense of identity from his trade or profession, when work still connoted self-realization and not mere wage labor, the modern self negotiates identity across the monitoring of sight and appearances, the public spaces of seeing and being seen. In the original novel *Der Golem* (1915) by Gustav Meyrink, for instance, one encounters a demonic optician, who treats his patients for cataracts but in fact horribly blinds them, as if to punish them for their arrogant reliance on sight. An almost obsessive emphasis on eyes and sight recurs in many of the films from the years 1913–1923, in which the fantastic plays a role, as if the cinema were highlighting its function of promoting the reliance on sight by indexing across it a number of cultural changes in cognition, perception and bodily presence. In Dostoevsky's *The Double* (1846), the appearance of the *Doppelgänger* is the result of a problem of seeing and being seen, of the clerk trying to escape the all-seeing eyes of a malevolent bureaucracy, suggesting that the increasing impersonality of social life could only be grasped by translating it into a hideous dialectic of voyeurism and exhibitionism, across which the power-relations of the individual to the abstract forces of an administered world and the atavistic powers of the cultural "other" could be pictured in their properly excessive dimension.

One of the earliest films in which male anxiety, the evil power of the eye, the city and the ethnic other are the mutually implicated terms of an uncanny not coded as "gothic" is Ernst Lubitsch's 1918 melodrama *Die Augen der Mumie Ma* (The Eyes of the Mummy Ma). While the story at first seems a rather predictable concoction of oriental and colonial motifs, its way of resituating these motifs within the metropolis gives an indication of another logic, crucial to the fantastic, but here displaced across the signifiers of exoticism. The story concerns a famed Egyptologist, made curious and intrepid by rumors circulating about a mummy, whose eyes are said to move, staring at whoever dares to disturb its resting place. The Egyptologist discovers the hoax: the Bedouin guarding the tomb has been hiding a young woman inside the mask whom he keeps a prisoner in order to scare foreigners off the sacred sites of his sect. After overpowering the Bedouin, the Egyptologist rescues the young woman and takes her with him back to Berlin. The Bedouin has also been saved by German tourists who found him dying of thirst. He asks to be taken

to Germany as servant-slave, having vowed to avenge himself on his female companion. The Egyptologist has in the meantime passed the beautiful Ma, who performs as a belly dancer in a fashionable variety show, to a painter friend, who marries her. One day, the Bedouin discovers Ma's painted portrait in his master's salon, and overcome with rage, he repeatedly stabs the portrait with his dagger. He succeeds in discovering Ma's whereabouts, waits for the husband to leave, breaks into the house, where Ma, terrified by his sudden appearance, dies in his arms even before he has time to raise his dagger against her. Instead, grief-stricken, he turns it on himself, and the returning painter finds both of them, united in death.

What is most remarkable is the extent to which this rescue fantasy, with its echoes of *The Girl from Acker Street,* is thematized almost entirely across a series of power-relations defined by sight and eye. While initially it seems to be the seductive eye of the mummy embodied by the young Ma which cast the spell, it soon turns out that the truly fixating power of the gaze emanates from the Bedouin: not unlike similar stares in *Dr. Caligari* and *Dr. Mabuse,* it is his hypnotizing gaze from the box of the theater that makes Ma collapse unconscious on stage during one of her shows, and it is his gaze which pierces her like a dagger when she suddenly discovers him at the window of the painter's villa. His telepathic evil eye had earlier made her fall ill, just as it was finally his gaze, transferred to her, which at the start of the action, caused the initial visitors to the tomb to go insane with fright and perish in the desert. Thanks to the overdetermined orientalist motifs, the basic dynamics of the power-struggle are at once made metaphorically explicit and displaced. Emil Jannings, playing the Bedouin in blackface, attempts to control his surroundings through the gaze and via an intermediary, the young woman, who began as his medium and ends up his victim. Opposed to the Bedouin is the painter, who like the Egyptologist in the beginning, resists his gaze, and manages to appropriate Ma through his eye, i.e. the painting of her portrait, before the evil eye of the Bedouin regains possession, even if he then takes his own life. The constellation is remarkably similar to that of *Dr. Caligari:* Emil Jannings as the Bedouin plays the role of Werner Krauss, the doctor, and the young Ma/Lya de Putti occupies the position of *both* Conrad Veidt/Cesare *and* Lil Dagover/Jane. Shot in realistic décors and a recognizable cityscape, *The Eyes of the Mummy Ma* has opted for orientalism in place of expressionism as its visual discourse of the fantastic, with the mummy and the painted portrait standing in for the fairground and the box with the dummy, while the dagger in one, and the homicidal somnambulist in the

other film act as the desublimated extremes of what cannot be contained by the gaze and which the gaze is nonetheless called upon to represent: male castration anxiety and its fetish-disavowal, as one also finds it in *Waxworks, Die Strasse* (The Street, 1923) or *Von morgens bis mitternachts* (From Morn to Midnight, 1919), but also the figuration of the film-maker, master of the gaze via his various stand-ins: guardian of an exotic cult, painter, fairground showman, psychiatrist.

What in this group makes *Dr. Caligari* exceptional is the fact that it is such a veritable compendium of the motifs that define the German fantastic and constitute its uncanny moments. Beyond (blocked) class-mobility and (proscribed) social rise, *Dr. Caligari* indexes the figure of the double as part of the master-slave dialectic of the sorcerer's apprentice. But in the mystery with which it surrounds the different kinds of agency, authority and motivation among the characters, it is also the outstanding example of how "fantastic" representations in German films from the early 1920s seem to bear the imprint of pressures from external events, to which they refer only through the violence with which they disguise and disfigure them.

As with *The Student of Prague,* the initial situation of *Dr. Caligari* contains a social aspect involving class/status differences. We see Caligari, just arrived in town, deferentially asking for a permit to put up his tent show, only to be treated to insult and humiliation by the town clerk and his subordinates. The scene deftly conveys the psychologically fraught experience of feeling at once outraged and powerless in the face of an arrogant, petty bureaucracy: but while ordinary mortals can only murmur imprecations or vent their frustrations on others, Caligari is in a position to act on this impulse, taking revenge on the hated town clerk via his medium, Cesare, thus setting off the chain of events which makes up the narrative.

But, similarly to *The Student of Prague's* thwarted ambitions to status, in *Dr. Caligari* the causal nexus of a class society ruling by arbitrary decrees and thus itself provoking the violence it claims to contain thanks to the repressive apparatus, is in the film displaced. Instead, we find a commensurate omnipotence associated with Caligari's powers of hypnotism, which overcompensates for his social impotence, relating the story structurally to that of the sorcerer's apprentice. With Caligari's medium Cesare, as in the Golem, a force is set free which at least in part, escapes its creator's control. One is never quite sure whether the medium's nightly sorties are all planned and ordered by his master or take on a momentum of their own. But Cesare is also Caligari's double: the medium is the embodiment of his master's rebellious, antiauthoritarian

streak, itself standing in apparent contradiction to Caligari's own authoritarianism.

The force of this repression can also be located in the framing tale, which I shall discuss in the following chapter along with other nested narratives, to explain how Weimar films more generally manage to sustain hesitation and equivocation, appropriate to the fantastic, even when otherwise they do not belong to the genre. In the case of *Dr. Caligari* one might even say that what is striking about the décor is less that it has borrowed from the painterly techniques of expressionism, and rather, how in the expressionist style it has found an appropriately graphic metaphor for signaling its own sense of indeterminacy and multiplicity: it knows that it is telling a story that has many different angles.

Social Rise and Public Disgrace:
The Lost Shadow

Yet the double and sight belong together, according to Freud and Rank, by virtue of their relation to castration anxiety, so central in the dreams and wish fulfilling fantasies attaching to voyeurism and exhibitionism. Thematized as a fear of public disgrace, castration anxiety structures the field of seeing and being seen in a number of key films from the early part of the decade. Especially apt, because once more tied to social rise, is one of Paul Wegener' s films from 1921, *Der verlorene Schatten* (The Lost Shadow), a variation on the Schlemihl story already used in *The Student of Prague*. The protagonist, a poor musician, is teased, provoked and humiliated by a girl of superior social status until he listens to proposals of a demonic sorcerer of how to beguile the girl with a magic musical instrument and gain social reputation at the same time. Two motifs determine the story: on the one hand the shadow which the protagonist exchanges for the magic violin which beguiles everybody and thus becomes a symbol of a magic tool that has the power to bridge the gap between desire and achievement and also to abolish social difference. It thus fulfils the desire for omnipotence. On the other hand, there is the loss of the shadow which creates horror and contempt among fellow men and leads to total social ostracism. The dialectic of these motifs comes to the fore most clearly when the musician plays in front of invited guests, but is suddenly exposed by the sorcerer who snuffs out two candles which has the effect that violin and bow can be seen as shadows on the wall, while the musician's shadow, the confirmation of his existence, is missing. Full of despair he flees in shame. This scene shows a parallel to one in the beginning of the film in which, also in front of invited guests,

the musician produces nothing but discordant sounds on his instrument after watching the girl he loves courting with a different, socially elevated man. Jealousy and the feeling of inferiority put the instrument out of tune and render the musician susceptible to accepting the exchange proposed by the sorcerer. The dialectics of exchange becomes thus discernible. The musician gives his shadow in exchange for the violin. Items of unequal value are treated as equivalents. It is this which ultimately drives the protagonist to a state of crisis and continues to frustrate the fulfillment of his sexual as well as social desires.

In *The Lost Shadow* the social frustration linked to sexual frustration is projected on the figure of an artist. His struggle for social prestige is the film's main topic. The fact that the protagonist is an artist allows at the same time for a fantastic solution of the dilemma: the film takes a turn toward a happy ending in which the demonic sorcerer reveals himself as a good spirit and frees the poor musician from his pact. On the one hand, this represents a direct reversal of the plot comparable to *Dr. Caligari*. On the other hand we are dealing here with a kind of allegory of the *Autorenfilm*. Just as the violinist enacted by Paul Wegener strives for the favor of the nobility, so the film's director Wegener is concerned about the favor of the bourgeois audience and so similarly about social and cultural prestige. A striking analogy thus emerges between the plot of the film and the process of exchanges in the culture industry in general and cinema in particular. In its action the film exposes itself to a contradiction to which it owes its existence. The fact that this involves the eyes is an important element, because it shows that the abstraction of exchange values operates not only on products and goods, but may also be attached to sight, not least because decisive social values and relationships are mediated through the act of seeing.

Weimar Cinema's Artists As Cultural Demiurges

Earlier in the chapter, I put forward the suggestion that some of the anxieties that seem to cluster around the genre of the fantastic have to do with a sort of legitimation crisis affecting the status of the *artist* in relation to the cinema since the 1910s and continuing through the early Weimar period. Directors such as Wegener, Wiene, Lang and Leni, Murnau and Robison represent themselves through their protagonists as demiurges, the sorcerers that are afraid of the "sorcerers' apprentices," exercising control, losing control, are in fear of part-objects splitting off, being the ones who vampirize the culture, who seduce the public, half gloating half worried about the consequences. With this I was also im-

plying a level of self-reflexivity and textual allegorizing that may need a brief explanation and historicization.

One mountain to climb when looking afresh at Weimar cinema is the very heavy theorization the cinema received in the 1920s by German-speaking intellectuals. Georg Lukács, Béla Balázs, Siegfried Kracauer, Rudolf Arnheim, Hans Richter, Guido Bagier (to mention only the best-known names) published widely on the cinema, while Berlin film critics such as Hans Siemsen, Egon Fridell, Willy Haas, Alfred Kerr also theorized about the cinema as a new cultural phenomenon.[46] For institutional reasons of legitimation, German film historians have, in their perspectives on both Wilhelmine and Weimar cinema, focused on these authorities, and have tended to analyze the literary and intellectual response to the emergence of cinema.[47] Given such a bias, which translates itself into a preference in favor of the artistic film, the author's film, in short, would be part of a cinema that has already made its devil's pact with literary culture, or at any rate, with the bourgeois and intellectual establishment, first of the Wilhelmine Reich, then of the Weimar Republic.

For the fascination and horror with which subsequent generations would look at the "Germanness" of this cinema, seems something like a mirror effect produced by a strategic overemphasis on the stylized or expressionist films that, as we know, in the context of overall film production are the exceptions, elevated (by complex cultural, often even commercial, but at any rate historically quite comprehensible factors) to the status of an avant-garde cinema, a cinema revelatory of hidden truths, a cinema of exceptionally creative geniuses. It is as if in the films of the fantastic a taste elite had recognized itself in this art cinema with a frisson, that very frisson which then gave it the air of superiority to declare almost every other film to be banal, kitsch, and the result of opportunistic speculation. No other cinema, in short, has had as hostile an educated public to contend with as the German popular cinema of the teens during the 1920s, and the German mainstream of the 1920s during the 1950s and since.

This clearly does not mean that the films canonized as the classics of the period do not have more to offer than to be rationalized as mere by-products of an intellectual debate of legitimacy or as coded allegories of the filmmaker's self-understanding, however ironic or complicit the films are about their own ambiguous position between high culture and the mass market. On the other hand, it is important to be aware of instances of mediation, of discourses and forms of ideological coherence, which only such historicizing research can reconstruct. For instance, it is surprising to find how many films, especially in the early 1920s, were pro-

duced to coincide with the opening of new picture palaces in Berlin. This points not only to the relation between real estate and film production, but also to how carefully a specifically bourgeois audience was solicited in metropolitan Berlin. Renowned critics would be invited to speak before the film, and the ambiance was that of an important theatrical opening. By the late 1920s, press and advertising campaigns had been perfected, especially for a *Großfilm,* so that the press book for *The Nibelungs* or *Metropolis,* for example, gives valuable clues to marketing strategies and envisaged audience appeal. Indeed, Fritz Lang's interviews and essays in the illustrated magazines and the weekly press throughout his German career were always conscious of what cultural prejudices he had to flatter in order to "play game."[48]

The conclusion to be drawn from the parallels which Eisner makes between literature, painting, philosophy and the cinema is that the classic German films from the 1920s are self-consciously middlebrow, while the film community itself often liked to give itself a highbrow image. The point is worth making, in view of the arguments, of whether the German cinema is part of mass culture, the avant-garde, or located somewhere else in the spectrum of political right and left, modernism, modernization and tradition. What needs to be documented in the German example from the early teens to the mid-1920s are some of the struggles and the arguments advanced, in order to make the cinema "respectable," but also to make it competitive in the battles for national and international audiences and markets.[49]

The films of the German fantastic cinema thus seem to encode in their encounter with the social reality of the Weimar Republic not the street battles, inflation, unemployment, but something else, though no less historical. A double perspective opens the texts of the fantastic toward society: on one hand, that of the artist-intellectual whose changing relations to the modes of cultural production, such as the cinema, are condensed into the neo-Romantic motifs of the sorcerer's apprentice and that of the producer confronting the product of his labor/desire as an alienated self-image.[50]

On the other hand, the films open up a perspective toward a class of spectators whose precarious social position as students, clerks, young men with frustrated ambitions and vague resentments make them members of the petty-bourgeoisie, whose engagement with the class struggles takes the form of avoiding class struggle, by imagining themselves above it and outside. Which is to say, a class who compensates for its fear of proletarianization by dreaming of the bypass or detour around social conflict in the shape of personal fantasies of success.

It is as if the cinema entered the public sphere of the early 1920s not by a mimesis of class conflicts or the movements of a collective unconscious, but as that form of social relation where a shared stock of narratives and images intervened to displace the traumas brought about by inflation and political unrest, into effects of disavowal and symbolic substitution. But films are, finally, not (only) social versions of the psychoanalytic cure, working through the traumas of the (patriarchal) collectivity. They also act upon another side of the collective unconscious: that of commodity relations, where the "surface-effects" of consumption substitute for status and disavow or pass on class. It is this emergent social reality of Weimar culture, with its emphasis on women and the feminine, which the fantastic cinema attempted (in vain) to stem, by inserting itself as a quasi-magical power, as fetish objects of fascination, into the changing gender relationships which increasingly shaped Weimar society as it consolidated itself economically. In this sense, the films of the fantastic and of social rise were also the last stand of the male artistic community to legitimate a cultural gold standard, to which the Weimar demiurges — creative and critical — still felt allegiance, before this very same gold standard was recuperated, indeed made productive, in the cinema experience becoming accepted as a social experience, i.e. the *Zeitgeist* of the *Angestellten* and "kleinen Ladenmädchen." By 1927, going to the movies was part of the general lifestyle of Germany's Golden Twenties, part of the new culture of consumption, which not only changed the films that Weimar made, but also the expectations that Kracauer's (female) public had of them. Social rise continued to be a film subject — if anything, more than ever — but in comedies, musicals and revue films. Mobility no longer needed the fantastic to hide from itself its bad conscience, nor the anxious male and his dummy-double to warn about the sorcerer's apprentice playing with fire as he tried to be the alchemist of class and status. Now it was enough that the movie stars modeled the right erotic mores, along with the clothes — and that the man of her dreams was up on the screen to fan the flames of passion. After all, Weimar cinema knew all about mobility: not least thanks to inflation, it had itself made the steepest social rise of all.

Notes

[1] John Willett, *The New Sobriety. Art and Politics in the Weimar Period* (London: Thames and Hudson, 1978), 10.

[2] Ibid.

[3] Theodor W. Adorno, "Der wunderliche Realist. Über Siegfried Kracauer," in Adorno, *Noten zur Literatur III* (Frankfurt am Main: Suhrkamp, 1965), 94.

[4] Siegfried Kracauer, *From Caligari to Hitler. A Psychological History of the German Film* (Princeton, NJ: Princeton UP, 1947).

[5] For a full account, see Martin Jay, *The Dialectical Imagination: A History of the Frankfurt School and the Institute of Social Research* (London: Heinemann, 1973).

[6] S. Kracauer, *From Caligari to Hitler,* 11.

[7] Siegfried Kracauer, "The Little Shopgirls Go to the Movies," in Kracauer, *The Mass Ornament. Weimar Essays* (Cambridge, MA: Harvard UP, 1995), 291–94.

[8] Cf. S. Kracauer, *From Caligari to Hitler,* v.

[9] Walter Benjamin, "Ein Außenseiter macht sich bemerkbar," in Benjamin, *Gesammelte Schriften III* (Frankfurt am Main: Suhrkamp, 1972), 220 (trans. T. E.).

[10] Ernst Bloch, *Heritage of Our Times* (Berkeley: U of California P, 1991).

[11] Siegfried Kracauer, "Die Angestellten," in Kracauer, *Schriften I* (Frankfurt am Main: Suhrkamp, 1971), 282f. (trans. T. E.).

[12] Ibid., 286–88.

[13] The Berlin Adlon has in the meantime been rebuilt in the old style. It reopened in 1997 to great national and international attention.

[14] S. Kracauer, "Die Angestellten," 289.

[15] See feminist film theory about the typically male "subject-positions" in narrative cinema generally, which makes the woman the object of the (camera's) look, itself a rationalization of male scopophilic narcissism and castration anxiety. For a classic formulation, see Laura Mulvey, "Visual Pleasure and Narrative Cinema," *Screen,* vol. 16, no. 3 (1975), 6–18.

[16] Patricia Mellencamp, "Oedipus and the Robot in *Metropolis,*" *Enclitic,* vol. 5, no. 1 (1981), 25.

[17] When Walter Lacquer says the opposite about the cinema ("one looks in vain among German films for the father son conflict so prominent on the stage") he indicates either a very literal understanding of the motif, or that he has not looked very far, even in Kracauer: Walter Laqueur, *Weimar: A Cultural History 1918–1933* (London: Weidenfeld and Nicolson, 1974), 238.

[18] See Peter Gay, *Weimar Culture: the Outsider as Insider* (London: Secker & Warburg, 1969), 113–19.

[19] Patrice Petro, *Joyless Streets* (Princeton, NJ.: Princeton UP, 1990).

[20] See Heide Schlüpmann, *Unheimlichkeit des Blicks* (Frankfurt am Main: Stroemfeld, 1990); for the period prior to Weimar, see Andreas Huyssen, "Mass Culture as Woman," in Huyssen, *After the Great Divide* (Bloomington: Indiana UP, 1987).

[21] S. Kracauer, "The Little Shopgirls Go to the Movies," in *The Mass Ornament*, 291–304.

[22] See Thomas Elsaesser, "Dada/Cinema?" in *Dada and Surrealist Cinema*, ed. Rudolf Kuenzli (Cambridge, MA.: MIT P, 1996), 13–27.

[23] Thomas Elsaesser, "Film History and Visual Pleasure: Weimar Cinema," in *Cinema Histories, Cinema Practices*, ed. P. Mellencamp and P. Rosen (Metuchen. NJ: University Publications of America, 1984), 47–84.

[24] Noël Burch, "A Parenthesis on Film History," in Burch, *To the Distant Observer* (London: Scolar Press, 1986), 74–75.

[25] Harald Szeemann, *Junggesellenmaschinen / Les Machines Célibataires* (Venezia: Alfieri, 1975). See also Constance Penley, "The Avantgarde and its Imaginary," *Camera Obscura*, no. 2 (1977), 3–33.

[26] See Sabine Hake, *The Cinema's Third Machine* (Lincoln: U of Nebraska P, 1993), for an account of the debate in English and a commented bibliography.

[27] Lotte Eisner, *The Haunted Screen* (London: Secker & Warburg, 1969), 113.

[28] See Raymond Williams, *The Country and the City* (London: Hogarth, 1985).

[29] Corinna Müller, *Frühe deutsche Kinematographie* (Weimar/Stuttgart: Metzler, 1994).

[30] See Frank Kessler, "A Highway to Film Art?" in *Before Caligari: German Cinema 1895–1920*, ed. Paolo Cherchi Usai and Lorenzo Codelli (Pordenone: Bibliotheca dell'Imagine, 1990), 438–51; also Kristin Thompson, "Stylistic Expressivity in *Die Landstrasse*," in *A Second Life: German Cinema's First Decades*, ed. Thomas Elsaesser (Amsterdam: Amsterdam UP, 1996), 256–63.

[31] Thomas Elsaesser, "National Subjects International Style: Navigating Early German Cinema," in *Before Caligari*, 338–55.

[32] See Thomas Elsaesser, "Filmgeschichte — Firmengeschichte — Familiengeschichte. Der Übergang vom Wilhelminischen zum Weimarer Film," and Heide Schlüpmann, "Wahrheit und Lüge im Zeitalter der technischen Reproduzierbarkeit. Detektiv und Heroine bei Joe May," in *Joe May*, ed. Hans-Michael Bock and Claudia Lenssen (Munich: edition text + kritik, 1992), 16–18 and 48–49.

[33] Ennio Simeon "Giuseppe Becche and *Richard Wagner*," in *A Second Life*, 219–24.

[34] On German-Danish film relation in general and Asta Nielsen in particular, see Hans Michael Bock, ed., *Schwarzer Traum und Weisse Sklavin* (Munich: edition text + kritik, 1993).

[35] Paul Wegener, "Neue Kinoziele," in *Kein Tag ohne Kino*, ed. Fritz Güttinger (Frankfurt am Main: Deutsches Filmmuseum, 1984), 341–50.

[36] Guido Seeber, "Doppelgängerbilder im Film," *Die Kinotechnik*, no. 1 (191): 17.

[37] *The Student of Prague* actually had as its end-motto a poem by the French Romantic Alfred de Musset.

[38] For the cultural battle over the cinema, see Anton Kaes, ed., *Kino-Debatte. Texte zum Verhältnis von Literatur und Film 1909–1929* (Tübingen: Niemeyer, 1980).

[39] See Kristin Thompson, "Dr. Caligari at the Folies Bergères," in *The Cabinet of Dr. Caligari: Texts, Contexts, Histories,* ed. Mike Budd (New Brunswick: Rutgers UP 1990), 121–69.

[40] See Helmut Schanze, "On Murnau's *Faust:* A Generic *Gesamtkunstwerk?*" in the present volume.

[41] The following two sections are reworked and expanded from an earlier essay, "Social Mobility and the Fantastic," in *Film and the Fantastic,* ed. J. Donald (London: British Film Institute, 1989), 25–32.

[42] Raymond Durgnat, *A Mirror for England* (London: Faber & Faber, 1970); also Kevin Brownlow, *Behind the Mask of Innocence* (Berkeley: U of California P, 1990).

[43] A more detailed reading of this scene and the overall construction of space in *The Student of Prague* can be found in Leon Hunt, "The Student of Prague," in *Early Cinema: Space Frame Narrative,* ed. Thomas Elsaesser (London: BFI Publishing, 1990), 389–402.

[44] See Leonardo Quaresima, "*Homunculus:* A Project for a Modern Cinema," in *A Second Life,* 160–66.

[45] Otto Rank, *The Double: A Psychoanalytic Study* (New York: New American Library, 1979).

[46] See Anton Kaes, ed., *Kino-Debatte.*

[47] Apart from *Kino-Debatte,* one can find useful material in Ludwig Greve et al., eds., *Hätte ich das Kino. Die Schriftsteller und der Stummfilm* (Stuttgart: Ernst Klett, 1976); and in Jörg Schweinitz, ed., *Prolog vor dem Film* (Leipzig: Reclam, 1991).

[48] For a collection of statements by Lang, see Fred Gehler and Ullrich Kasten, eds., *Fritz Lang: Die Stimme von Metropolis* (Berlin: Henschel Verlag, 1990).

[49] Evidence about planning and preproduction of a film like *Metropolis* suggests that its expensive special effects work and other production values were undertaken also to allow Ufa to invest in new filmmaking technology, with the purposes of making the film suitable for US export and of bringing the infrastructure in line with that of Ufa's potential or actual competitors.

[50] To return to the quotation from Lotte Eisner: one can now argue that the Romantic project of transforming historical experience into inwardness, and inwardness into phenomenological and sensuous immediacy of contemplation has been accomplished by the cinema, but with a vengeance. For it shows this transformation to have been an act of repression, and history returns in the form of the uncanny and fantastic. Romanticism wedded to technology has produced a reified and thoroughly mediated form of immediacy.

II. Revolution, Crime, and the Uncanny

Revolution, Power, and Desire in Ernst Lubitsch's *Madame Dubarry*

Marc Silberman

SINCE THE FOCUS OF OUR DISCUSSION has been properly framed by the demand for "new perspectives on expressionist film" within the context of the older parameters established by Siegfried Kracauer's and Lotte Eisner's foundational studies, I begin with a brief summary of their assessments of Ernst Lubitsch before I suggest some alternative or counter readings of his 1919 feature *Madame Dubarry*.

Kracauer actually assigns Lubitsch a prominent place in his genealogy of the Weimar cinema, devoting two thirds of chapter 4 to his comedies and "historical pageants" under the heading "The Shock of Freedom."[1] Within the larger structure of the study's linear chronology this chapter introduces the second of the four major divisions, that is, the "postwar period" following upon the pre-1918 "archaic period." Thus, Lubitsch assumes for Kracauer a key, even a pivotal position in defining those crucial early years of the Weimar cinema that gained it international and commercial success. What is that position? First of all, writing in the mid-1940s, with full awareness of Lubitsch's post-Weimar, Hollywood reputation, Kracauer clearly appreciates his "amazing career," even referring anachronistically to the "Lubitsch touch" and to the "charm" of his comedies.[2] While the film critic's taste privileges the director's origins as a comic actor and director, the film historian reserves his analytical rigor for the epic and historical dramas, characterizing Lubitsch as a "true disciple of Reinhardt" and a master of the "fertile misunderstanding" that grounded his international appeal and the move to the Hollywood Warner Bros. studios in 1922.[3] Second, the major theses of Kracauer's study are all elaborated within his review of Lubitsch's films in chapter 4 and pertain in particular to *Madame Dubarry*. He criticizes Lubitsch's focus on psychological conflict and private passions rather than on historical fact, so that history emerges "as the work of unscrupulous wire pullers."[4] As a result, the central visual and structural device of contrast-

ing the individual with the masses emphasizes entertainment values and a pseudo-realistic style at the expense of enlightenment about social and political developments. Furthermore, he imputes to Lubitsch both a "nihilistic outlook on world affairs" that regards history as meaningless and a fundamental cynicism and melodramatic sentimentality that is symptomatic for the Weimar cinema's antirevolutionary and antidemocratic tendencies.[5] Thus, Kracauer — as is typical for his methodological approach to Weimar films — collapses the film story with political history and subordinates form to content.

Eisner too situates Lubitsch prominently in her discussion of German expressionist cinema. Next to theater director Max Reinhardt, who in Eisner's view figures as a kind of *eminence grise* for the entire period, Lubitsch is the only film director who merits mention in a chapter heading, that is, chapter 4 which is devoted to "Lubitsch and the Costume Film."[6] Like Kracauer, she considers Lubitsch to be the most important mediator of Reinhardt's innovative theater techniques to the new medium, but then qualifies his "generally superficial adaptation of Reinhardt's effects" as typical for the German cinema's mediocre *mise en scène* and indifference toward acting.[7] While she presents no sustained critique of *Madame Dubarry,* she does recognize its genre characteristic as pseudo-historical tragedy, where history serves as pretext for a complicated love story, and thus she simply avoids Kracauer's concern with socio-political verisimilitude.[8] Instead Eisner focuses on Lubitsch's collaboration with a new kind of female star, Pola Negri, and the way he promotes a visual style with attention to period detail, surface splendor, and elliptical editing that successfully exploits double meanings and ambiguity.

My own work on *Madame Dubarry* began over ten years ago. In what follows I will draw on two related readings I presented in the opening chapter of my book on the history of the German cinema as well as in an article on images of the French Revolution in the Weimar cinema.[9]

To begin with, I disagree with Kracauer and an entire tradition of film historiography after him that criticizes Lubitsch for instrumentalizing history as "an arena reserved for blind and ferocious instincts, a product of devilish machinations forever frustrating our hopes for freedom and happiness."[10] While *Madame Dubarry* plays off political revolution as a discourse, Lubitsch is uninterested in events and historiography. As a representation of the French Revolution the film narrative is, of course, wrong in its details, privileging the anecdotal over the flow of events and collapsing the political into the play of eroticism and vanity. Yet, as an imaginary construct, it presents a fantasy that interrogates power relations as a process involving sexual roles and repression, re-

vealing the ambivalence that accompanies social upheaval and the search for a new self-, gender, and national identity. As such, I propose the film can be situated within the rupture and dislocation in postwar Germany of 1919. Lubitsch does not examine these tensions through plot but rather in the interplay of narration and *mise en scène*.

Lubitsch was a major contributor to the articulation of cinematic address, a central factor in the elaboration of Hollywood's classical narrative structures. He devised numerous "tricks" for positioning the spectator by foregrounding the look through point-of-view shots; he also developed a highly economical system of punctuation between shots dominated by principles of symmetry, variation, inversion, and doubling. Indeed, Lubitsch was one of the first German directors to be called to Hollywood because of his achievements in these areas. There he perfected the interplay between the complete and the incomplete, the seen and the unseen — and later with the advent of sound cinema the heard and the unheard — in order to codify the process, or activity, of spectatorship. In this regard *Madame Dubarry* deserves particular attention. Inaugurating the period of Weimar cinema, the way it plays off narrative logic against *mise en scène* already suggests a number of characteristics that will come to distinguish the German cinema of the Weimar period as a national alternative to the emerging Hollywood model.

Typically in *Madame Dubarry* historical event is displaced to the margins and historical ornament dominate the *mise en scène*. Not simplicity or documentary directness, but aesthetics and artifice dominate the film's visual style. Although political events and tensions shimmer through, Lubitsch structures the film around plot (narration), character (acting), and spectacle (appearance), adapting more from the conventions of popular literature than historical narratives or historiography. For example, the film draws details from the traditional social drama's plot structure that was familiar to the audience of the time both through popular novels and the cinema: a conflict between rich and poor in which the former are portrayed reductively as lazy, erotic, and decadent and the latter as honest, unerotic, but exploited. Thus, although Lubitsch was not pursuing political aims, like all his films produced in Germany, *Madame Dubarry* engages the relations of the powerful to their subjects. The common denominator among his comedies, vaudeville extravaganzas, and historical spectacles is the interplay of the look, of desire, and of power.

The film's fictional plot revolves around sexuality and desire. Counterposed to each other are the male obsessions of possession and voyeurism on the one hand and female objectification through spectacle and display on the other. Lubitsch quickly establishes the framework for their

interplay. It is no coincidence, for example, that the narrative opens in a dress shop.[11] Jeanne, whose meteoric rise into the world of wealth and noble titles depends on her beauty as exchange value and her eroticism as promise of untold pleasures, makes explicit the connection between the fashion store and patriarchy. Both are ideological edifices that engage relations of power and rely on a system of repressive authority. The first shots in Madame Labille's store portray Jeanne as an energy that must be tamed so that the store's commodity circulation can function. This same energy, however, will enable Jeanne to cross all social thresholds as she liberates herself from patriarchal notions of sexual identity in order to become a narrative agent able to control the look of the (male) Other. Moreover, the representation of this energy coincided with the production company's (Ufa) concern about the film's circulation as commodity by means of Pola Negri's star personality: a mix of innocence and sensuality that has more to do with the changing gender relations in the Weimar Republic than with historical verisimilitude. This personality, revealed most effectively in Jeanne's adeptness at role-playing and in games, becomes increasingly obvious in contrast both to the male characters, who are calculating and motivated by considerations of self-interest (Armand's anger, Diego's and Dubarry's instinctual drive, Choiseul's hunger for power, Louis's masochism), and to the other female characters, who are associated with authority (Mme. Labille), death (Mme. Paillet), and failure (Countess Gramont). The dress shop, itself a world of costume and masquerade, is the ideal point of departure, then, for a film narrative that will focus on woman as the site where appearance and spectacle intersect.

Meanwhile Armand is the site where sexually motivated fears and desire meet generational and class conflict, structuring the plot through a series of confrontations between him and his Other. The first in this series is Don Diego. Along with all the aristocrats he is associated with qualities such as wastefulness and libertine sexuality. Jeanne triggers the conflict between Armand and Diego when she must decide whose invitation to accept for a Sunday afternoon. In the first of several role-playing situations that allow Jeanne a measure of self-control, she introduces a game of chance by counting the ribbons on her bodice to determine the winner. Chance and desire do not coincide, however, when Armand wins this game the first time around, so she begins to count once again, reversing the order in Don Diego's favor and giving in to desire and curiosity. This decision, this assertion of female sexuality, activates a chain of encounters in which Jeanne, the medium of circulation, mediates male desire.

Jeanne enters a hierarchical social organization as object, exchanged and used by men as a kind of currency in the circulation of male desire. Her positioning as the absolute object of the commodity form is based on her appearance, on characteristics of excessive beauty, ornament, costume, and masquerade. She is a proto-femme fatale, a male fantasy of aggressive sexual allure combined with inaccessibility, a signifier of both desire and fear of that desire. A crucial scene, one presented as a game situation, illustrates the dialectical tension of passivity and activity inherent in the figure. Furious with Jeanne because she failed to extract money from the king's finance minister, Choiseul, the debt-ridden Dubarry instrumentalizes her beauty during his evening card games in order to attract the attention of the king's chamberlain, Lebel. The intricate play of point-of-view shots and looks across the card table visually foregrounds Jeanne both for the spectator and for Lebel as the site of visual fascination. She is appearance on display, framed or sometimes masked in shots that heighten the voyeuristic quality but also emphasize the relation between male and female as one between their looks. At the same time, this drama of the look, which links the narrative aesthetics inherent in the visual medium to the historical event of revolution, plays on the spectator's response to the promise of erotic desire, to that which is never seen, shown, or possessed.

The play of appearance engaged by the *mise en scène* allows Jeanne to negotiate the social organization as narrative agent because it confuses the very absoluteness of the distinction between subject and object. Thus, in her excessiveness she is the object of the male gaze but she appropriates in turn and controls the look for herself. The first sequence in Mme. Labille's dress shop charts out the terms of excess and control through a series of shot/reverse shots that will be elaborated in the course of the film. Jeanne, laughing and playful while working on her hats, is repeatedly reminded to behave properly by Mme. Labille's reprimanding stare, a vested authority subsequently born by Choiseul and later by Citizen Paillet and the executioner as representatives of revolutionary justice. Jeanne too is invested with a look, at this point purely intransitive: she peeks at herself in the mirror before leaving the store to see if she looks attractive, interrupted once again by a reverse shot of Mme. Labille's contemptuous stare, which puts an end to her narcissistic self-apprehension. The next sequence introduces the logical extension of Jeanne's narcissism by reproducing the spectator's position as an onlooker from within the film. As she walks in the street, men turn to look at her, positioning Jeanne as the object of their desire and binding specularity (being-looked-at) to sexuality (desire for the female). The

terms of patriarchal discourse have been explicitly and efficiently established within a few moments of the film's first shot. Yet, as the rest of the film will show, Jeanne's sexual identity cannot be contained within these terms. She learns, very quickly, that her look too has a transitive power, disrupting social barriers and leveling thresholds of desire. The look, then, begins to emerge as the most forceful language of communication, an ideal vehicle for seduction in a silent film about changing gender relations in the modern world.

This process of appropriating the look for her own purposes begins when Don Diego arrives at the dress shop to reimburse Mme. Labille for the hat his horse accidentally crushed. In a series of eye-line cuts between close-ups of Jeanne's and Diego's faces we see how she becomes aware of the impact her appearance makes on this cavalier. Later, when she enters his house for the Sunday afternoon tryst, she has a moment to survey the richly appointed surroundings. Her look takes possession of the space as the camera pans slightly to the left and then back. The implication of her look as a mark of agency becomes clearer in the mirror scene that follows Count Dubarry's interruption of their flirtation. Peeking over the top of the screen behind which Diego has concealed her, the camera frames her in a large mirror hanging above the two men seated at the table across from her. She and Diego mischievously flirt with each other via the mirror while Dubarry concentrates on his meal until the latter, looking up from the table, sees her and, fascinated by her image, also throws her a kiss. The camera cuts to a medium shot (without the mirror) as Jeanne tumbles down from her perch, collapsing the screen and upsetting the ruse of concealment.

Jeanne flaunts her desire, and this positions her as an agent, not only as an object of the look: she entices men to seduce her through her look. At the same time, her power rests in her ability to complicate if not reverse the spectator/spectacle opposition of patriarchal discourse. Women's desire unsettles (men), and the disorientation caused by the collapse in this mirror scene enables Jeanne in an emblematic sense to cross a social and sexual boundary. Increasingly the spectator watches not only the object Jeanne, framed by the camera, looking in mirrors, pinned down by a male gaze, but also the subject Jeanne looking at men or at men being seduced by her beauty, so that the men too become objects of spectacle. The play of control and loss of control constructs, then, an imaginary relation that oscillates between visual pleasure and anxiety. Jeanne is the vehicle who in her innocence confirms patriarchal logic and at the same time she is the outsider or Other who violates it by becoming

the most powerful woman in France albeit through the absolute commodification of her body.

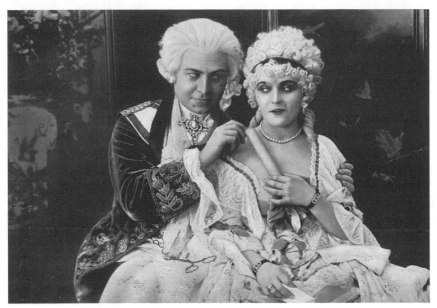

Pola Negri as Madame Dubarry in
Ernst Lubitsch's *Madame Dubarry* (1919)

Woman as innocent and tempting source of pleasure: Lubitsch's female protagonists are always strong, aggressive women whose strength derives not from manipulative calculation but from an instinctual talent for artifice and the play of appearances. Appearance becomes a real factor in this constellation, and conflicts in Lubitsch's films are carried out between this scandalous power of female artifice and the representatives of social order who fall prey to its seduction. Jeanne, the simple girl of the folk, rises to the position of the king's mistress. She literally makes Louis into her slave, as the sequence following the king's seduction does not hesitate to show. Louis kneels before her, kissing her feet as she languishes on the bed, while the affairs of state wait upon her whim, as Choiseul complains. The camera then frames Louis watching Jeanne with great delight as she dresses behind a screen, until she forbids him to watch. Next the king manicures her fingernails (while two maids look on and laugh), obeying her orders to sit down or exit her chamber as she wishes. Jeanne's assumption of the master's role makes manifest the vulnerability of male control when exposed to the fascination of the

erotic and, because this is not a comedy, it explains why she must be eliminated at the end of the film.

Jeanne tries to extend this control not only over the king but also over Armand. At the apogee of her power Jeanne sends for her original lover, whom she has saved from execution for the murder of Don Diego, and at her bidding he is led blindfolded to her chamber. Just as Louis is politically blinded by Jeanne, so Armand is unseeing and unknowing in the romantic tryst she plans. The past, however, cannot be reactivated; rather it has a tendency to return, and then with a vengeance, as a symptom of that which was repressed. When Armand discovers that his beloved Jeanne was his protector but also has become Countess Dubarry, the king's mistress, he demands that she choose between him and Louis, which she refuses to do, just as she had refused in that original game of counting ribbons on her bodice:

> JEANNE: You know that I love only you. Ask of me what you will, but not that!

He leaves her, gives himself up to helpless weeping, and eventually leads the mass revolutionary rebellion. Armand's repression of desire and rejection of sexuality allows him to identify fully with the bourgeois revolution. When Jeanne later confronts him (notably in a male disguise, another example of her control of appearance) and elicits a promise from him not to let his comrades destroy her, she asks what wish of his she may fulfill in return:

> ARMAND: My only wish is that you disappear from my memory.

History has caught up with the love story, transforming excessive desire into the immediacy of aggravation, rupture, and erasure contained in the sign "French Revolution." Thus, Jeanne comes to symbolize in her very power the most vulnerable point in a moribund system of authority and identity based on exchange: Choiseul hates her because she has undermined his own power; Armand turns against her out of jealousy because he cannot possess her; the masses call for her downfall because she represents what all men desire and what all women want to be. Hence, aggression is played out on Jeanne, the site where the stability of the entire system is threatened. Arrested by the police, Armand gains his freedom from Choiseul on the condition that he join him — in an ironic parody of class collaboration — to drive out the excess female sexuality threatening the kingdom (Jeanne). Meanwhile the king is stricken by smallpox when playing blindman's bluff in the garden — Jeanne, of course, fastens the blindfold on him — and the entire system of power

relations turns against the social outsider and female threat. The revolution erupts in Paris, the masses storm the Bastille as well as the king's residence, and Jeanne, her hiding place divulged by her former servant, is brought before the Revolutionary Tribunal where Citizen Armand now reigns as judge.[12] Although her look can still awaken his desire, he condemns her to death, but — closing the circle of attraction and (self-) destructive repression — he makes one last, desperate attempt to help her escape from prison. Discovered by his comrades, he is shot, and Jeanne is executed on the guillotine while the crowd cheers.[13]

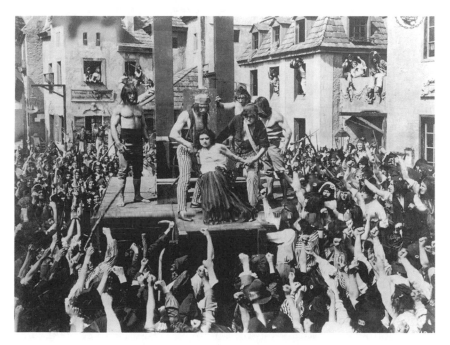

Still from the execution scene in
Ernst Lubitsch's *Madame Dubarry* (1919).

The national and international reception of *Madame Dubarry* is a familiar story and confirmed Ufa's immediate postwar strategy to expand its market and therefore its commercial viability by attracting new audiences. Lubitsch's film proved to be the first to address the real and potential needs of this broader mass audience successfully. Familiar plot devices from popular genres, a fascination with the wealth and decadence of the aristocracy, opportunities to exploit visual spectacle: all were formulaic elements designed to appeal to the viewing dispositions and imagination of the traditional working-class cinema public on whom the

social dimension of this voyeurism was certainly not lost. Concurrently, the possibilities of identifying with Jeanne's social mobility as well as Armand's indefinite class position as student, lieutenant in the king's guard, citizen leader of the revolution and chair of the Revolutionary Tribunal, and the projected triumph of bourgeois rationality and repression offered a middle class public fantasies of economic and political power that were, in the real context of Germany in 1919 under the influence of the Bolshevist Revolution, just beginning to assert themselves. Lubitsch's balance of extravagance and suggestiveness in acting, visual images and plot reversals, always just at the edge of the probable and the proper, promised something to both audiences.

For today's spectator Lubitsch's film also raises germane questions about the historical nature of patriarchal discourse on woman as amoral, unknown, and unknowable, a disintegrative force. Jeanne is specifically the hyperbolized figure of excess female sexuality, ignoring or negating all socially acceptable boundaries. Her desire is uncontainable and ultimately fatal to her and the society around her, yet at the same time its promise makes her into the most desirable object to possess. The constant play of the gaze, mirror images, and looks mediated through someone else's eyes suggests that the activity of watching, the position of the spectator, is the object of desire rather than the object itself. This radical formalization of visual elements suggests that the Weimar cinema must be recognized not only, as critics have argued, for the way it negotiates social anxieties in a popular entertainment format but also for a specific contribution by the German cinema to the historical and technological possibilities of spectatorship. The Weimar cinema specialized in the effects of seeing and being seen, formulating power relations as an instrument of perception and representation. *Madame Dubarry*, then, marks an important advance in the cinematic discourse of sexuality and desire. The collapse of appearance and reality as two separate spheres explains further why *Madame Dubarry* can serve neither as a commentary upon history nor as a critical object in the realist cinema. It contradicts the illusion of immediacy through the foregrounding of the image.

For this reason it would be a misreading of *Madame Dubarry* to claim (based on this film, at least) that Lubitsch is either reactionary or misogynist. He clearly distinguishes between the hierarchy among the nobility based on class and wealth and the revolutionary claim to power based on the look. In neither case does the director suppose a moralistic attitude or place the spectator in a position of contempt. The revolution can either undo the established reign of power or serve it, and when it betrays the power of the look as a revolutionary weapon, Lubitsch turns

against it. Thus, the film invites the spectator to assume a position that recognizes both political revolution and the patriarchy as ideological discourses, while on the level of narration Lubitsch advances the reign of the look as the mediator of power relations.

To conclude, I want to suggest three areas we might consider to broaden the discussion on Weimar cinema. First, while the shortcomings of a narrow socio-political approach to the cinema are generally recognized, even the more sophisticated analyses focusing on narrative structures often lead to questionable conclusions about the conservative nature of an overly emphatic aesthetic or stylized sensibility. I hope my comments on *Madame Dubarry* demonstrate in a paradigmatic way that attention to the combined quality of narrative, *mise en scène*, camera, spectator, in other words of all filmic elements, can upset explicit meaning and plot, transforming what may appear to be an affirmation of the status quo (in Kracauer's sense) into parody and social criticism. Second, German cinema of the 1920s evolved within and contributed to the modernism that characterizes the Weimar period in general. The familiar crises of identity, authenticity, subjectivity, representation, etc. crisscross cinema production too and constitute in my view a fruitful context for a reassessment of this productive period while connecting to endeavors in other fields of cultural criticism.

Finally — to return to the bookends that prop up our discussion, to Eisner and Kracauer — both of them are concerned with an aspect I did not mention at the outset. I am referring to the national dimension of Lubitsch's films. In Eisner's case this emerges in her curious, not to say embarrassing tendency to qualify Lubitsch's comedic talents as specific to "a certain Central European vulgarity," referring of course — from her own assimilated German-Jewish, middle class background — to Lubitsch's biographical roots in the Polish ghetto, among the so-called "Ost-Juden." From her perspective, writing in the early 1950s, Hollywood succeeded in transforming this coarse ethnic humor into a more elegant, refined, polished sort of wit, and the "Lubitsch touch" was the product of developing his Germanness, understood to be "his Berliner's presence of mind, his taste for realistic detail, and his Jewish liking for the suggestive implication."[14] Kracauer is interested in a different aspect of the national, in Lubitsch's ability to have designed his films for mass consumption that could address both German and non-German audiences.[15] Although he does not develop this issue, *Madame Dubarry* and its reception especially in the United States was the catalyst for an intense and ongoing debate among film and culture critics in the early 1920s, embedded in the discussion of how German culture could compete with

and learn from America while not losing its own German "soul."[16] In several film critiques written in 1931 and 1932, Kracauer discusses three Hollywood sound comedies by Lubitsch. He laments the draining away of national specificity that results in a lack of substance he characterizes as a zero degree or complete derealization of content.[17] Yet in his review of *The Man I Killed* he suggests finally the following:

> A study ought to be written about the strange, not yet understood significance of national forms of expression that the sound film uses today. The film portrays a German family environment that was produced in Hollywood by American actors and now returns belatedly to that country from which it came forth. Its origin is thus refracted multiply; but the distortions it must withstand awaken a premonition of future possibilities. Undoubtedly the thoughtless commodity circulation introduced by the sound film anticipates a time in which national characteristics do not only mark mutual limits but also harmonize them.[18]

Today we live out the future possibilities that Kracauer could hardly imagine in the early 1930s, a global cinema market that continues the anxious debate about the status of national, international, and multinational competition. And the premonitions inscribed in the Golden Age of German Cinema might still have a thing or two to teach us.

Notes

[1] Siegfried Kracauer, *From Caligari to Hitler: A Psychological History of the German Film* (Princeton, NJ: Princeton UP, 1947), 47–58.

[2] Ibid., 23, 125, 141.

[3] Ibid., 48, 51.

[4] Ibid., 51.

[5] Ibid., 52.

[6] Lotte Eisner, *The Haunted Screen: Expressionism in the German Cinema and the Influence of Max Reinhardt* (Berkeley and Los Angeles: U of California P, 1968), 75–87.

[7] Ibid., 75, 77.

[8] Ibid., 82

[9] Marc Silberman, *German Cinema: Texts in Context* (Detroit: Wayne State UP, 1995), 3–18, including extensive bibliographical references on Lubitsch and on the film *Madame Dubarry;* and Marc Silberman, "Imagining History: Weimar Images of the French Revolution," in *Framing the Past: The Historiography of German Cinema and Television,* ed. Bruce A. Murray and Christopher J. Wickham (Carbondale and Edwardsville, IL: Southern Illinois UP, 1992), 99–120.

[10] S. Kracauer, *From Caligari to Hitler,* 52–53.

[11] Lubitsch, the son of a Berlin textile merchant, had discovered the clothes store as a model for relations of exchange in his early slapstick comedies (for example, *Schuhhaus Pinkus,* 1916) and continued to invoke it well into the 1940s (*The Shop Around the Corner,* 1940).

[12] The fact that this servant/slave, who is presented to Jeanne as a wedding gift by one of the king's lackeys, is dressed as a Moor and in blackface draws on a standard light-opera motif, comparable to Jeanne's "game" of counting ribbons on her bodice or melodramatically falling over Louis's casket as it is being carried out of the palace. Yet this figure possibly suggests as well a subtext of imperialism and racism within the film, even though the role is unique for Lubitsch's film output and hardly worked out within the narrative. That the Moor betrays Jeanne seems to indicate less the emancipatory promise of the revolution for oppressed and colonized races than the more general positioning of an Other between various agents of power (Jeanne, the nobility, the Republicans). This may have biographical implications for Lubitsch as a Jew in Germany who experienced exclusion.

[13] Some versions of the film include a last scene where the executioner (in an ironic flaunting of the protagonist's penchant for display) shows Jeanne's severed head to the crowd and then throws it to them like a football.

[14] L. Eisner, *The Haunted Screen,* 79–80.

[15] S. Kracauer, *From Caligari to Hitler,* 53.

[16] See Thomas J. Saunders, *Hollywood in Berlin: American Cinema and Weimar Germany* (Berkeley and Los Angeles: U of California P, 1994), 200–210.

[17] "The Smiling Lieutenant" and "Amerikanische Komödie: One Hour with You," in Siegfried Kracauer, *Kino* (Frankfurt am Main: Suhrkamp, 1974), 192f.

[18] "The Man I Killed," in S. Kracauer, *Kino,* 193–94.

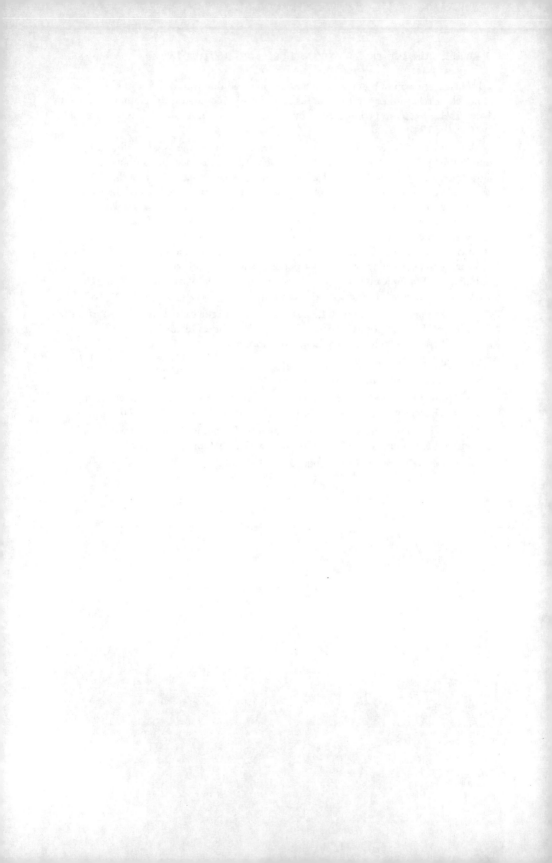

"Bringing the Ghostly to Life":
Fritz Lang and His Early Dr. Mabuse Films

Norbert Grob

> *Not only does Mabuse have 1000 eyes,*
> *he has many faces. . . .*
> *He is no individual.*
> *He is a genuine mass media myth.*
> Frieda Grafe

I.

FRITZ LANG WAS FAMILIAR WITH work on series productions.[1] He actually began his career as a writer for the *Stuart Webbs* series.[2] Following this he quickly became acquainted with Joe May and his film series. His first film script for May became the ninth episode in the *Joe Deebs* series, entitled *Die Hochzeit im Exzentrikerklub* (Wedding in the Eccentric Club).[3] From the very outset the appeal of dramatic elements was of particular importance in this series: the inclusion of special effects, the speed of movements and chases, even the exclusivity of the scenes: underground caves; adjacent rooms concealed by revolving walls; hidden trapdoors; rapid changes of location and situation.

Detective films were extremely popular in the early 1910s:[4] fantasies about crime, illicit trade and the fight against it — thrillers featuring Sherlock Holmes, produced by Rudolf Meinert and Richard Oswald. Joe May's detective films featuring Stuart Webbs and Joe Deebs continued in this style, with strange happenings taking place around the central figure of the cultivated man who uncovers the truth behind the mysteries. According to Heide Schlüpmann, "a transformation" took place in the detective film in 1914: "It is acclaimed by contemporary observers as a change from sensationalistic motion pictures working with crude effects to films containing psychology and logic."[5] The "strictly logical" structure of Joe May's first Webbs film, *Die geheimnisvolle Villa* (1914) was used as a promotional device. "Only realistic sensations!" "Psychological structure!" "Extremely interesting through to the end!"

Thomas Elsaesser established that the plot of Joe May's second Webbs film, *Der Mann im Keller* (1914), is developed "from a network of complicated relations and connections between several persons," in contrast to the earlier detective films based more on sensationalism and "changes of location and spectacle." Elsaesser refers to Max Mack's *Wo ist Coletti?* from 1913 as an example. What is already important here, according to Elsaesser, is technology which appears in the form of a modern pocket torch, and various "means of communication and transport," which plays a significant role for Fritz Lang too.[6]

For the early detectives crime was temptation and provocation, a danger to be relished as well as a challenge. It offered them the opportunity to confirm their own abilities — to draw far-reaching conclusions from small, relatively insignificant details. They were films with puzzles, which were solved gradually, without everything becoming absolutely clear and unambiguous in the end. These detectives were artists of observation and fantasy, elegant in appearance and aristocratic in behavior. For Schlüpmann the early detective is "someone who brings enlightenment in a double sense, a combination of humanism and combat technology."[7] A trace of the demonic, in the antiquated sense, lies in their obsession with unraveling mysteries, with solving the unsolvable: "demoniac indeed seems the abyss which cannot be filled, the yearning which cannot be assuaged, the thirst which cannot be slaked."[8]

In the main, these detectives are careful to distance themselves from the aberrations which surround them. Melodrama is also involved where they are personally drawn in to the shadowy events, like the young clergyman in Dieterle's *Das Geheimnis des Abbé X* (literally, the Secret of Abbé X, translated as Behind the Altar, 1927), who seeks to explain how his brother disappeared without a trace and falls in love with his brother's wife in the process.

The subject matter could ultimately consist of anything, from an isolated extreme act to a typical, everyday felony. The central element in most films, however, was murder. As is the case in the detective novel, as E. M. Wrong emphasizes in *Crime and Detection,* murder is more mysterious and dramatic than anything else.[9]

> The battle between detective and criminal in a potentially endless series of encounters, mysterious locations borrowed from the gothic novel and death-defying situations taken from adventure novels, made up the loose and flowing form of these works, in stark contrast to the precision of an Agatha Christie mystery or even the economy of a hard-boiled Dashiell Hammett novel. The early detective films owed a great deal to the cinema of attractions, the form of early cinema made up of spec-

tacular visual moments strung together loosely. Even *Dr. Mabuse, the Gambler* still reveals this rather loose form of a series of sensational adventures and episodes held together by a central conflict.[10]

In Lang's two-part film *Die Spinnen* (Spiders, 1919–20),[11] which retains a more naïve charm because it presents the adventures of Kay Hoog and his war against the secret organization as pure action cinema, the attractions of external forms dominate, the attraction of bodies is particularly important, and that of objects too. What counts is how tension is created through movement and rhythm.[12] In the first film *Der goldene See* (1919), events are set in motion by a map indicating lost treasure which is found in a bottle during a regatta: desire on the one hand and a thirst for adventure on the other. The map is stolen and a high-speed chase begins which leads ever further south from San Francisco to Mexico.

Carl de Vogt as Kay Hoog in the first
part of Fritz Lang's *Spiders* (1919).

In pursuit of this hidden treasure the spiders threaten and coerce, abduct and blackmail, fight and kill, until a deep rift cuts through the story which seems impossible to heal. Only the adventurer Kay Hoog, "a committed idler,"[13] attempts to defy the evil, over many continents, above and below ground, in caverns, caves, chambers and shafts,[14] by train, plane, balloon and boat, in the search for the missing Inca treasure. A curious game is set in motion in which it is never particularly clear who is actually chasing whom — the adventurer the villains or vice versa — a confusing game which serves only to augment the tension and excitement.

> Not only does Lang have no fear of cheap sensationalism, stereotypical characters and genre — he actually constructs his cinema upon them. He points out from the very beginning that cinema, unlike the corporeal, physical presence of the theater, works only with effects, images and sequential shots.[15]

For Klaus Kreimeier, Lang's *Spiders* is "a large-scale colonial film for a motherland that has lost its colonies and thus holds on to them in its dreams all the more tenaciously."[16] Initially, *The Golden Sea* is concerned merely with the struggle for the legendary Inca treasure. This struggle, however, is staged as a drawn out stringing together of attractions, tending at times more toward the artistic or clownesque, at others toward the menacing or mysterious. Everything continuously falls into rapid movement. Everything constantly collides: avarice and exotic cultures, spirit of adventure and strange mechanical worlds, morals and boundless desires. Fist fights, sword fights and shoot-outs continually take place. Everything is constantly intensified in mysterious parallel worlds: in isolated, invisible spaces in which all the surrounding elements can be seen and heard, however, and even in subterranean caverns and grottoes. Contemporaries regarded this as sensationalism which "leaves the viewer in eager expectation of the next episode, and uses all the means at its disposal to suggest this continuation," as an adventure fairytale in the spirit of "Karl May" and "guter alter Lederstrumpf."[17] However,

> the conciseness of the presentation corresponds with the sensationalism of the plot. The fact that it did not give rise to trivial, filmic jargon can be attributed to Lang's reliable and trained eye for architectural and ornamental detail, his skill in discovering backgrounds which bring together and blend both nature and man.[18]

Even when viewed from a modern day perspective the attractions still burst with exciting, fascinating, beguiling features. They offer sensations

as appealing in their own right, as visual pleasures which are clearly and readily allowed to develop and celebrate their own form of expression. They unfold the stimulating magic which appears so often in entertainment cinema, as a reproductive art form, in place of originality. Georg Simmel considered the special thing about these attractions to be their "immediate presence," the "acceleration of life to a point which has neither past nor future, amassing life with an intensity which frequently makes the substance of the event appear relatively unimportant by comparison."[19]

The spiders are a secret society lead by Lio Sha, a mysterious, beautiful woman with absolute power over her underlings who keeps them under audio and visual surveillance by means of technical aids. This already determines how world domination is to be achieved through the spreading of criminal energy. When on one occasion Lio Sha observes the managers of her organization through a magic mirror, Lang explicitly reveals the extent to which she uses control, at times discreetly, at other times directly, in order to secure her power. Here, Kay Hoog's defiance remains relatively ineffective (in this respect also similar to the *Mabuse* films).[20] He quarrels, fights and wrestles with anyone who stands in his way, yet his attack against his agile adversary ends only in a short-lived triumph. Even after he has saved Lio Sha as she threatened to fall victim to an Indian ritual, he is forced to accept that his victory is burdened with losses. This is Lang's early indication of the ambiguity of the events — of defeats in victory, injustice within justice and guilt in innocence. Already in the serialized detective films of the 1910s suspense often remained, leaving questions open which the film declined to answer. "As an unabashed sensation-film, *Spiders* introduces the repertoire of plot situations and images of intrigue and mystery from which Lang will continue to draw throughout his career."[21]

Lang loved to place his heroes in unavoidable situations, whether brought about by fate or by society. He loved their revolt and their struggle against this. He believed, as he once explained, "that one has to fight for that which one understands to be right, even against the odds, even when ultimately threatened with death. The struggle, the revolt is important."[22]

The first rule, with reservations, is: the more broken the hero, whether policeman or gangster, lawyer or wrongly accused, the deeper the trouble into which he gets, and thus the more complex the film. Together with the secret of an unsolved crime comes the adventure of a person in difficulty, whose behavior reveals his true identity and nature.

> Kay Hoog is a promethean type, albeit tailored to suit Lang. Nature-
> boy and dandy, a teutonic Dorian Gray, whose unfulfilled desires rain
> down in acrobatic daydreams. . . . Hoog is the itinerant knight who
> changes his apparel before the chamber door of the evil enchanting
> fairy.[23]

Furthermore, in the second part of Lang's *Spiders: Das Brillantenschiff*
(The Diamond Ship, 1920), the secret organization around Lio Sha
functions as a small, closed society within a large, more open society.
World domination is once again the theme. Power is once again sup-
posed to be achieved by means of a "material object,"[24] in this case a
diamond head of Buddha from the Ming era which, "according to an-
cient legend promises rule over Asia."[25] Once again, the struggle between
Lio Sha's secret organization and Kay Hoog takes place in countless
underworlds and parallel worlds, which reflect externally what remains
unreflected, overlooked and repressed in the real world: illegal drug
addiction, secret sexual yearning, forbidden desires. Once again, the
action takes place all over the world, from the land of the Aztecs via
China to Tierra del Fuego. Lang finds a significant image for Kay Hoog's
obsession with not allowing the criminal spiders to escape, which is at the
same time both a framework and a symbol: "Kay Hoog in his digs, with
bed, bar and books, all of which can be folded up and away, a happy
childhood fantasy."[26]

The mood of these early detective and adventure films is already in-
dicative. The concrete form prevails, even if the events themselves still
have such surreal or unreal traits. Thus the incomprehensible, and the
uncanny too, appear in the accustomed guise of common everyday oc-
currences. On the other hand, as I wish to demonstrate, where demonic
or menacing, forbidden or subversive features creep in, natural, everyday
events take on alien or even grotesque dimensions.

II.

Gradually, the great chain of events got underway with diabolic and
Faustian, spine-chilling and sinister characters: cinematography of illusion
and forbidden fantasy. The more refined the construction of the drama
and the characterization of the horror, the more fragile the naturalness
of familiar order. In my opinion, a subversive moment results from the
fact that films encourage one to consider the unconsidered, imagine the
unimaginable, to permit the forbidden — at least in one's imagination —
to treat it as something comprehensible, something to which one can
relate. With Fritz Lang, the early signs already being apparent in *Spiders*

and then fully developed in the *Mabuse* films, as well as later in *M* (1931), a fascination for tyranny and chaos is formulated, for propagandists of crime, visionaries of omnipotence, sexual offenders, for the protagonists of darkness. This in turn questions the consensus in favor of civilization, law and morals, logical rationality and personal freedom. Lang's view of criminal action suggests understanding, and in *M* even sympathy with the monster. Gilles Deleuze considers it "unique" that Lang "brings . . . a human dimension to evil — whether in the form of a hypnotic genius (*Mabuse*) or in the form of an irresistible urge (*M*)."[27]

The spiders climb every house, every façade and every roof acrobatically; demonstrating that no one and nothing can stop them.[28] The omnipotent supremacy of secret organizations is thus asserted, against which Kay Hoog scarcely has a chance. A vision of chaos which cannot be subdued by decree. Important from the very outset is that for Lang, stories and subjects tended instead to constitute material with which to reveal his precise, cold, pitiless view of the world. His visions are based on the mythical luster of things. They emphasize simplicity in order to recount more ambiguously and evasively the adventures of those driven by and embroiled in the affair.

This is intensified in *Dr. Mabuse,* where the world is dragged into a host of crimes "which benefit nobody, which have one purpose alone, to spread fear and terror."[29] The gang which forms around Mabuse, the blind counterfeiters and nonchalant robbers and murderers who terrorize an entire society, represent an all-embracing counter-society: *a picture of the times* as a kaleidoscope of anarchy, terror, perversion, of enormous temptation and universal uncertainty.[30] As Kurt Pinthus points out, in *Dr. Mabuse, der Spieler* (Dr. Mabuse, the Gambler, 1922) Lang squeezes together everything

> which these last few years have offered us in terms of overexcitement, depravity, sensation and speculation: crimes planned scientifically; the frenetic activity of the stock market with a suspiciously rapid alternation between boom and bust; eccentric gambling clubs; hypnosis, suggestion, cocaine, seedy dives in which pleasure-seekers and bac players take refuge; . . . morbid, emotionally and sexually dependent individuals and all those rootless souls whose unscrupulousness is taken for granted because they have nothing to lose but this life which, without corruptness, would be all the more desperate.[31]

Lang's *Mabuse* series[32] comprises three films, the first of which is made up of two parts: crime films extending beyond the realms of the real world. What are of course meant are fantasies which are sparked off in the real world but which go one step further, or which take a jolt

downwards or a jump to the side in order to undermine commonly accepted rules and conventions and depict an oppressive or unfamiliar view.[33]

> Illicit energy and speculative machinations drive the dramaturgy of Lang's "contemporary vision" dynamically onward. It is no longer about the classical motive behind the crime, or robbery and money-making, but about global conspiracy, the manipulation of entire systems and political destabilization. Lang comments on the inflationary crisis with a sardonic undertone, by making pleasure in destruction the subliminal theme.[34]

An additional constant, which is true of crime films in general, is that the world is friendly and peaceful only at first glance. Below the surface, however, lurk black depths of danger and secrecy, malice and hate, rivalry and war.

People caught in the cogs of the system: the way they mount opposition and rebel, protest and struggle — and nonetheless fail to reach their goal in the end. This was Lang's central theme throughout. He was interested in the point at which an event or situation becomes inescapable, and every escape route turns out to be another trap. The point at which people are forced to act. "What makes them tick?" With Lang this is the six million dollar question. In *M* (1931) for instance, the situation appears on the one hand clear and unequivocal, in spite of the many cornered rooms in the houses, the confusion on the streets and the pronouncedly artificial buildings. The victims and their surroundings are revealed, the perpetrator and his seemingly gentle nature, the police and their vain efforts, the rings of organizations and their endeavors to safeguard their own order within society. Yet Peter Lorre then stands before his strange judges and asks: "What do you know already?" A deep chasm appears here, which suddenly makes the horrific comprehensible as the reality of a demonic force comes to light beyond the background of rationality. "I constantly have to walk the streets and constantly sense that someone is following me. That someone is me!" The child murderer as a sufferer who is then compelled to mete out the worst on others. "Who knows what goes on inside me? The torment within! How I'm compelled to do it. Don't want to! Have to!"

Lang does not embellish what happens, he dissects it. Like a researcher who examines what interests him under the microscope he examines the fate of his heroes with X-ray eyes, understands them in the first instance as "human *concepts*. Consequently also the more humane, the less individual."[35] Each view remorselessly exposes the situation.

Every movement of the camera ruthlessly forces its way to the core. And every step creates another vibration, which accentuates the whole. There is no wind to rustle the leaves. Nowhere to play freely. For Lang, the "conceptual cineast,"[36] fate and great misfortune are all that exist. His Mabuse "is also a personification of the desire for power as a pleasure in itself, a kind of l'art pour l'art, an end in itself. He takes his place at the round gaming tables, does his rounds in the city and ends up going round in circles in order to barricade himself in his madness and escape the law, the avenger."[37]

What Lang later expresses very emphatically in his first sound film is already perceptible in *Dr. Mabuse, the Gambler:* the multiple encapsulation of reality, the intense power of the unintelligible, which allows façades to be unexpectedly torn apart. Lang's films function like a spiral. After a while, an image, a motif or a situation recurs, only in a slightly different form. The unexpected emerges from the obvious. The small changes drive events onwards. With every turn one penetrates deeper, below the unambiguity of superficial attraction. The films use images to correct and transform other images. They reveal their truth by constantly showing other surfaces under the surface, until they expose the very core of everything: the unknown in the wholly familiar.

> Lang creates an image of the new "empty" and standardized space and time of modernity, based on uniform measurement and systematic interrelation, in a manner unmatched in any earlier film . . . and unmatchable in any other art form. The dominant mechanisms employed are the pocket-watch, the railway and the telephone — interacting with the cinematic device of parallel editing.[38]

Thus with Lang, *what* is presented never outweighs *how* it is presented. In response to the question as to what distinguishes a good filmmaker, he once replied that a good filmmaker had to have something *universal:*

> the greatest strength of every art form: the painter's eye for pictorial composition, the sculptor's awareness of contour, the musician's sense of rhythm and the poet's intensity of ideas. In addition, however, he requires something which constitutes his own skill: *Tempo!* . . . And tempo means tightening, intensifying, elevating and bringing to a peak. Giving tempo to a film does not mean allowing events to rush into one another, or chasing from one image to another. It simply means continuing to keep the strings of the instrument we master vibrating precisely.[39]

III.

Lang's *Dr. Mabuse, the Gambler* is without doubt the first masterly crime film of German cinema. This is due to the remarkable construction of the film and especially in the way he presents his story with such formal richness. The naïve sensationalism which remains prevalent in the *Spiders* is abandoned and replaced by complicated dramaturgical twists, exceptional visual devices, well-defined characters and also by diverse period references (to which cinema literature constantly refers). According to Eisner, what is "vividly represented" is

> that chaotic epoch of the post war years, the depression at having lost the war, the revolution which was nipped in the bud, the inflationary plight which destroyed all values, the hopelessness of unemployment and its opposites — uncontrolled hedonism, the greed of the war profiteers and speculators. . . . After death and deprivation comes the longing to enjoy life, to abandon oneself to all pleasures and perversions. Sex, opium, cocaine, gambling dens, in order to forget.[40]

In her book on Lang, Eisner quotes from a number of contemporary articles and concludes that these "contemporary reviews . . . illustrate how strongly critics felt that the film reflected their own age."[41]

Countess Told confesses to public prosecutor von Wenk, Mabuse's adversary, that she needs life: "the intense breath of the unusual, sensation, adventure." For Klaus Kreimeier this is a reference to "a bored upper class" who "cultivate their desire for the unusual and the extravagant in the bizarre decoration of their drawing rooms," as well as "a late reflection of that nervous sensuality" in which "weariness and feverish exultation . . . join together enigmatically."[42]

As Lang himself admitted, film was turning more toward a sophisticated public and no longer to "audiences who were only interested in the 'sensational'" which "remained discretely in the background." "The vein of success" lay "in exploiting film as a contemporary image" and "in utilizing film as a witness of the times."[43] Nevertheless, the first aesthetic attraction results from the numerous masks behind which Mabuse conceals himself — in the first act, for example, as a respectable doctor, a sailor staggering along the streets, a stockbroker, a psychotherapist and as the ruler of the underworld.

After the disclosure of Mabuse's disguise, "a circle of still portraits of Mabuse in various disguises,"[44] the initial robbery and stock market sequence already develops a furious pace which signifies an all encompassing danger: the ambush in the train following a glance at a watch (that is to say, in accordance with a specific plan); the robbery and jetti-

son of the bag containing the secret contracts from the train directly into the car; the communication of this information from a telegraph pole directly to Mabuse's telephone; Mabuse's imperious gesture to one of his accomplices and the latter's despair at his inability to resist; Mabuse's meandering path to the counterfeiter's workshop in which the blind are sorting bank notes; the stock exchange coup brought about through deliberate misinformation by means of the special edition of a newspaper.

Everything this film stands for is closely assembled in these opening scenes — even in the context of the crime film genre: a celebration, a festival of chaos as an aesthetic alternative to organized societies and their maxims of tranquility and order, as well as an escalation of malevolence which — at the level of fantasy — allows the unpredictable, open and possible to triumph over the fixed, closed and factual.

> The crime film enabled Lang to engage in contemporary criticism, (the criminal sees society's weak points better than others) and to give a spatial dimension to his stories (the action is no longer limited to a room or a street but extends to embrace the whole of the city). In the process, the audience is required to adopt the role of a criminologist, filtering out from a wealth of signs and fragmentary observations those which are essential and useful — an epistemological process, the structure of which corresponds to the experience of life in an urban environment.[45]

Lang characterizes his Dr. Mabuse as a monster, merciless on the outside yet vulnerable within, as demonstrated by his feelings for countess Told and his madness after defeat at the hands of public prosecutor von Wenk. For Siegfried Kracauer he was "a contemporary tyrant," "an unscrupulous master-mind animated by the lust for unlimited power," "a creature of darkness, devouring the world he overpowers."[46] Enno Patalas describes him as a "subversive" who is attracted by "the constantly changing game with power," "the undermining of public order. Politics, business and psychology" are for him "the staging of cumbersome subject matter." The only thing of interest to him is "the game with humans and human fate."[47] Anne Waldschmidt called Mabuse "the incarnation of evil as a principle, thus without identity or history. He is the projection surface for the malady of his time and thus becomes its chronicler."[48] Georges Sturm depicts him as a creation of the "city, which perverts civilization and attracts vice," as a "Proteus in the labyrinthine city, in its hidden corners, alleys and backyards."[49] And for Fritz Göttler he is a combination of "criminal stupidity and great genius," of "naiveté and megalomania."[50]

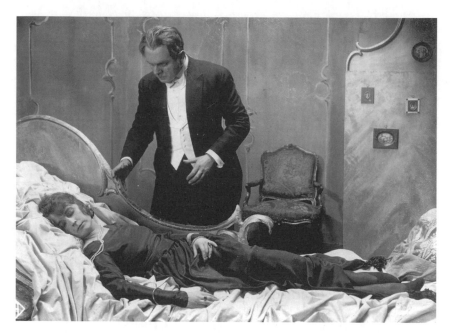

Rudolf Klein-Rogge as Dr. Mabuse in the first part
of Fritz Lang's *Dr. Mabuse, the Gambler* (1922).

This scrupulous superior disposition, which plays with humans and
human fate, reveals itself above all in "a gigantic duel"[51] with his antithe-
sis, public prosecutor Dr. von Wenk, at whose side stands the beautiful
countess Told, whom Mabuse so greatly desires. In a section of dialogue
between them Mabuse states: "There is no such thing as love, only de-
sire. There is no such thing as happiness, only the will for power." He
drives his mistress, the dancer Cara Carozza, to suicide, "Do I really
mean nothing to you anymore? Am I merely a tool?" abducts the count-
ess, ruins her husband by encouraging him to cheat at cards and then
leading him into total isolation, and hypnotizes the public prosecutor to
lead him to self-destruction by driving his own car into a quarry. Here,
to an even greater extent than in his role as a hypnotizing card player or
persuasive stockbroker, he abandons the part of the all-powerful tyrant
and manipulator and becomes a protagonist in crime himself, a man of
action, someone who destroys life, relations and relationships with relish.

Mabuse's diabolic nature which Cara also refers to on one occasion
relates both to the power which controls events as well as that which lies
behind arrangements (when he allows a desert caravan suggestively into
view in the theater, for example), as well as the determination to take

direct action himself. In one instance this is concentrated in a single image, which Rudolf Arnheim read as a paradigm of a filmic *"qualification of movement:"* in Mabuse's face which initially "appears small against a black background . . . and with rapid movement, becoming larger, is projected forwards until it becomes huge, occupying the entire screen."[52] An indication of the authority, strength and power of this man as well as the suggestive force with which he suspends the laws of gravity and the space-time continuum. A dot becomes larger, forms a circle until it occupies the framework of all that is visible — determining and dominating everything.

Kracauer points out how frequently "circular ornaments" are to be seen. "Both the tricky floor in a new gambling club and the chain of hands formed during a spiritualist séance are shown from above, in order to impress their circular appearance upon the spectator. Here, as with *Caligari,* the circle denotes a state of chaos."[53] Under no circumstances is the film expressionistic, although this is frequently claimed to be the case. Lotte H. Eisner listed the few moments in which cameraman Carl Hoffmann and architect Otto Hunte orientated themselves on expressionist forms: the scene in the restaurant "with its flame walls, where Wenk and his friend . . . have dinner,"[54] the "richly contrasting lighting" of the "pitch black alleyway where the murder of the young millionaire Hull is carried out," or the scene in which count Told staggers "through the rooms which house his exotic and expressionistic art collection to the flight of steps, carrying a burning candelabra"; or even the images of Mabuse "by the hearth under the picture of Lucifer."[55] To these should be added what Herbert Ihering observed: "the distribution of contrast in outdoor images at night," the "lighting architecture of the closed room," and "the way in which the indistinct remains precise and the defined faint."[56] Lang's and Hoffmann's play with light and shadow never seem purely experimental, but always atmospheric or dramatic, in order to heighten the impact of the respective scene. This is made even more intense by the dynamic effects of the editing. "Expressionism is a game," according to a section of dialogue for Mabuse. "And why not? Nowadays, everything is a game!"

Important, and with Lang self-evident, is the power of objects which surround individuals and are placed on an equal level to them; at times threatening them, at times advancing the action around them. According to Frieda Grafe, for Lang objects generally "carry the plot forward. They usurp the place of subjects. Their configuration, their staging convey relations; those between people become secondary."[57] The mythical rest in Lang's images — unexplainable in words and unable to be reduced to

definite meaning, this subversive visual excess is revealed above all in peripheral details: in the singular play of events, in casual yet meaningful gestures, in brief, incidental actions, in all these isolated signs which offer clues to the invisible behind the images. The decorative, however, is never sacrificed in favor of the picturesque. It merely aids "the search for truth beyond plausibility."[58]

In the opening sequence of Lang's *Testament des Dr. Mabuse* (The Testament of Dr. Mabuse, 1933) the world of objects is shown as all-powerful, representing a universe in itself (the claustrophobic quality of the scenery is augmented at the sound level by the muffled boom of several concealed machines): half-filled bookshelves, cans and cardboard boxes, paper left lying around — the scene is located in the adjoining room of a printing works, empty bottles which wobble and clink — thus bringing the rhythm of the roaring machines next door into the picture; stained walls, and all sorts of bits and pieces around a large chest which apparently contains something important.

In the meantime, like an object amongst other objects, appears a man in his early thirties in a tattered, filthy suit, with an often contorted face, wild hair and extremely nervous movements. The camera finds no space for itself in the dim, dirty room. Even when brought into movement in order to capture the frightened man, with often glaring eyes, it constantly collides with the boundaries determined for it by the "object-things" — thus also expressing how little freedom this man has to escape from his threatening environment.

Returning to *Dr. Mabuse, the Gambler,* here too there is a scene in which objects dominate, constituting a decorative arrangement in which people merely serve as an addition and do not carry the plot. In gaming halls, along the sides of which intricately decorated booths are installed which accommodate the players, trolleys drive back and forth over rails. They carry the stakes to the gaming table in the center of the room, which are then taken and placed by an elegant croupier. This arrangement allows immediate action to be taken during police raids. The gaming hall is transformed into a dance hall, simply by lowering the area around the gaming table and replacing this with parquet flooring. There appears to be no difference here between people and objects, as though the manipulator in the background were realizing a secret plan, which is executed beyond the realms of consciousness of those affected, as though the only thing that existed — amongst the mad craving for pleasure — was the joy of purely and simply obeying. Naturally, Lang produces not only visual attractions here. He wants his concept to directly unite everything that can be visualized; he wants to broaden the expression of his

art and, "with the aid of the living image," create something completely
new, "perhaps a new art form."[59] Idea and illusion, image and script,
object and ornament, everything becomes an essential element in con-
fusing fictions. In 1926 Lang stated:

> Perhaps never before was there a time which sought new forms through
> which to express itself with such reckless determination. The funda-
> mental upheavals in the fields of painting and sculpture, architecture
> and music speak eloquently enough for the fact that people today are
> looking for, and also discovering their own means of shaping their
> imagination. Film has an advantage over all other forms of expression:
> its independence from space, time and location. What makes it richer
> than the others is the natural expressiveness of its creative means. I
> maintain that film . . . will become more personal, stronger and artistic
> the quicker it abstains from handed down or borrowed forms of expres-
> sion and launches itself at the infinite possibilities of pure film.[60]

Lang's new forms in *Dr. Mabuse, the Gambler* also include the fact that
newspaper reports — in contrast to what Enno Patalas pointed out was
still the case in *Spiders* — no longer constitute "information for the
audience" but become elements in the plot. Thus, Mabuse puts out
"headlines in order to manipulate the stock market. He creates facts in
view of the expected press echo which bring new facts in their wake."[61]

Lang produces something similar to binary arcs of tension in his Ma-
buse films, already evident in the constant interchange between rational
and irrational moments, the use of state of the art technology and the
belief in the power of hypnosis[62] and parapsychology. This is particularly
the case in the obsessive, demonic will to commit criminal acts which is
opposed by the fanatical representative of law and order in the shape of
public prosecutor von Wenk. The struggle between the two is a constant
ebb and flow. At the end, when Mabuse uses hypnosis to debilitate the
public prosecutor without ultimately triumphing over him, demonic
power is at an end too. Mabuse becomes the victim of his own obsession
with control. Lapsed into madness, he sits in the middle of the forged
bank notes with which he planned to turn the economy upside down,
like a child lost in thought, playing with paper. According to Georges
Sturm: "Ultimately, Mabuse loses his mind; the more faces he has, the
more faceless he becomes. Occupying all the space he ends up with none.
In the game with identities he loses all identity."[63]

Siegfried Kracauer saw in this cinematography of horror and its key
figures the anticipation of Nazi ideology, and agents of enlightenment
in the heroes who fought against it:

> He [the detective], the single-handed sleuth who makes reason destroy
> the spider webs of irrational powers and decency triumph over dark in-
> stincts, is the predestined hero of a civilized world which believes in the
> blessings of enlightenment and individual freedom.[64]

This view undoubtedly adheres too closely to the rational moment of
enlightenment, and also too closely to the saving power of realistic repre-
sentation. With Lang in particular it is evident how, through filmic ar-
rangements, the invisible side of reality — the rules and conventions
behind everyday incidents — can be uncovered. Moreover, Kracauer
omits the emotional intentions behind the stories, which is precisely what
determines the lack of constraint of popular visions: the obsessive nature
of the chase as well as the dark, mysterious element in crime. In addition,
the imagination of the audience, fired by the adventurous exploits of the
protagonists, is not taken into consideration. Behind the mask of the
detective, policeman, and lawyer, as well as the crook and gangster too,
similar and even more daring feats are committed in the imagination of
the cinema audience than those which are encountered during the course
of the respective film.

Kracauer's classification of Mabuse as one of "the fictitious tyrants"
who, in his opinion, "anticipated the rise" of Hitler is undoubtedly
wrong. Frieda Grafe referred to the fact that Mabuse does not rule "from
above," and neither does he exert the pressure "which is transmitted
through systems." Rather, he is "a madman" who "plots upheaval in
order to carry himself alone to the summit of power." He is "the insane
individual, a concept of entirely occidental provenance who, for the last
time, with great intensity" dreams of "ruling alone." He is "driven by
desires and lusts which society, to continue to function, is unable to
accept."[65]

IV.

As has already been mentioned, *Dr. Mabuse* is based on an idea by the
author Norbert Jacques who, in 1950 in his autobiography *Mit Lust
gelebt* recounted how, after a brief encounter with a mysterious stranger,
the idea came to him to create his ambassador of darkness, his propagan-
dist of corruption, his mastermind of crime.[66] He fantasized about the
remote aura of a strange man, the evil characteristics of a tyrant.

> Was this stranger who . . . had hardened in his profound isolation and
> allowed his features to freeze in an expression of disdain and dismissal
> . . ., was he a hero or a villain? Was he capable of leading the way out
> of the mud and fire into which evil elements sought to cast time, or had

he come to submerge the world in iniquity? The impact of the stony guest had assumed such an intensity that he unexpectedly became a reality to me.[67]

For Lotte H. Eisner, Lang's *Mabuse* was "a human being and not a monster," that "is subject to sudden changes of mood and consumed by the desire to rule by money." Eisner was the first to indicate that Mabuse reacts with obvious emotion, that he "suffers a nervous breakdown every time he loses at the tables; he gets drunk when he thinks he is winning."[68] Hans Schmid later characterized this emotional trait as the ambivalence of excess:

> With Mabuse everything is extreme. Ice cold and calculating one moment, he then suddenly makes mistakes, declares himself a Titan (we may assume that Chronos is implied here) and drinks the night away with his cronies after having raped the countess, an act which expresses impotence rather than power.[69]

Lang later recalled how, in the 1920s, he attempted to bring the ghostly and unreal to life.[70] This indicates on the one hand his pleasure in the extraordinary, also expressed through lighting and décor. On the other hand it shows that Lang was very conscious of his preference for depravity, for the charm of the individual who craves power and who, as Eisner writes, plays "games with human life as with pawns on a chessboard."[71]

Frieda Grafe linked this element in Lang to the fact that Dreyer during this period also attempted to film the uncanny in normal, everyday life, and to use commonplace architecture in order to "make the corpse behind the door come to light."[72] Lines, façades and contours, however simple and clear they may appear, at the same time create intermediate spaces which transcend reality.

Lang held on to the idea of the mysterious, tyrannical Mabuse for over thirty-nine years; doubtless also an indication of how little the trivial construction of the whole concerned him. "When the Germans suggested I shoot a third *Mabuse* film I said to them: "What should I do, the guy is dead!" In the end, Mabuse was given a son. If necessary he will be given a daughter and perhaps even a grandson too . . ."[73] Old stories told over and over again formed the basis of Lang's great art, his "uncompromising"[74] style. For him, stories are never more than material which allow him to cast a precise and critical eye at the world and realize his remote *mise en scène*. Lang's visions are based on the ambiguity of estimating time and conceiving figures in space, hence the greater emphasis on their vague, inimitable account of the enigma of fixed anchorage in the world. Smaller, unremarkable things therefore serve to clarify

that the dialogue lacks words and the action finds few gestures to express. The "claim to truth" of Lang's method "is based" above all "in the fact that it is truer to the artificial, contrived, historical character of social reality than all illusions of the two-dimensional reproduction of reality."[75]

Even after his great mythical and visionary films, after *Der müde Tod* (Destiny, 1921), *Die Nibelungen* (The Nibelungs, 1922–24), and *Metropolis* (1925/26), Lang quite naturally constructs his films around trivial, stereotype elements; on familiar yet unexpected plots; on places and characters which seem recognizable from other films; on well-known, linear productions, cliché dialogues and happy endings. The well-known, preformed and in every respect familiar serves him as an effect which brings his work closer to the audience. At the same time it ensures speed. It sets the steady course on which everything remains comprehensible. However, the trivial subjects also help to repress the literary in favor of the pictorial, which means, in favor of visual refinement, all the accelerating camera movements and space-opening pan shots, fades, time-lapse tricks, double and multiple exposures.

In *The Testament of Dr. Mabuse,* in which an insane Mabuse seizes mental and spiritual possession of his therapists, Lang's formal experiments are resumed, in order to intensify the action through dramatic images and sound. Movement is created once again during the car journey by strips of light flashing over faces. Speed and atmosphere develop during the two car chase by constant changes in point of view shots. A particular illusion of space is created, and a feeling for distance and speed. A double exposure reveals that a man who believes himself to be at a safe distance has long since been possessed by the "terrible logic of crime." The film is also "about broken communication,"[76] about the fact that all signs, although materially present, still have to be deciphered before they are understood: for example a scratch on a window pane first has to be tilted and turned around before it can be read, because it has been written back to front as well as from right to left.

Tension is produced by omitting the plot; by observing the results of the plot, for example when a man is shot while sitting in his car at a red light by a crossroads, the success of the attempt is revealed by the fact that the car remains standing when the light turns to green, whilst all around the other cars pull away rapidly. Some of the transitions in sequence appear like revelations, for instance when the police inspector asks himself what could possibly lie behind all the events and a superimposition then reveals the actual force behind them. Or when, whilst still puzzling over the man behind the scenes, a cut divulges the secret —

with a view of the cardboard figure which stands for Mabuse, surging in water and fanned by shredded curtains.

Dark fantasies come to light here too which, use the "state of total insecurity and anarchy" to aim directly at the audience, to break open their all too easily accepted conventions and rules. Fortunately, as Lang claims, it is his job to commit crimes in order to entertain. The word entertainment, however, should be understood in the cathartic sense. In his Mabuse stories Lang plays with fragmented narrative techniques, different styles of scene and alternating forms of montage in order to depict a sinister, confused world, "the mirror puzzle of all the symptoms of co-existence come apart at the seams."[77]

Ernst Bloch's interest in detective novels was concerned in particular with this fantasy of the unfathomable in everyday life, fantasy beyond the commonplace: "Something is suspect, this is how it begins." In detective novels, something always happens which remains incomprehensible (and fascinating as a result) even if the individual details of the event are comprehensible. A tension which often arises between what appears to happen and what actually happened. This brings a second meaning to the images which tells of the actual state of affairs: crude and garish, comical and shocking fantasies. According to Ernst Bloch:

> First of all there is the suspense of *guessing*, it points . . . secondly to *exposing, uncovering*, with the particular nuance of the esoteric which often reveals the most important information; and thirdly uncovering then leads to events which must first of all be brought out of their *unnarrated, pre-recounted state* . . .[78]

Hence the reason why even the earlier *Dr. Mabuse* films of the *Golden Age of German Cinema* repeatedly, though not incessantly, puncture the customary order of things. They provoke the audience to view the world in a different light, to depart from conventional ways of thinking and yearn for imaginative freedom. Nevertheless, the old maxim still applies: those who are fascinated by monsters must take care they do not become monsters themselves.

Translated by Julian Rayner

Notes

[1] The idea of the serial in cinema is in no way limited to the series produced during the course of film history. This becomes particularly obvious in lighthearted entertainment films, in particular in the gradually developing cinema genre. Here, from the very outset, serialization was an element of production reality. Many examples could be used to demonstrate the extent to which this element pervades the entire history of film. Lang's *Spiders,* for example, has drawn many variations in its wake over the decades — through to *James Bond* and *Indiana Jones.* One could also regard the *Dr. Mabuse* series as a continuation of Feuillade's *Fantômas* in France and as a model for the *Dr. Fu Manchu* films in England as well as several Hollywood gangster films, such as LeRoy's *Little Caesar* or Hawks' *Scarface.* In this sense, serialization should be understood as a feature of the variation of existing, already developed narrative fantasy, characterization of figures, camera work, lighting etc. on a constantly progressing, constantly changing level.

[2] According to Ludwig Maibohm his first book, *Die Peitsche,* was filmed by Adolf Gärtner. Ludwig Maibohm, *Fritz Lang* (Munich: Heyne, 1981), 14.

[3] This first film script already demonstrates "Lang's love of light fiction and popular cinema." Anton Kaes, "Film in der Weimarer Republik. Motor der Moderne," in *Geschichte des deutschen Films,* ed. Wolfgang Jacobsen, Kaes and Hans Helmut Prinzler (Stuttgart / Weimar: J. B. Metzler, 1993), 44.

[4] "In 1918/1919 the most popular films were detective series named after their Anglo-Saxon heroes: Sherlock Homes, Stuart Webbs, Joe Deebs, Joe Jenkins, Harry Hill, Tom Shark and Miss Clever. Similar to the successful French film series, particularly Louis Feuillade's *Fantômas* and *Les Vampires,* German detective films were concerned less with crimes and misdemeanors than with adventure, luxury, speed, technology and urban, 'modern' lifestyle." A. Kaes, "Film in der Weimarer Republik," 39 (trans. J. R.).

[5] Heide Schlüpmann, "Wahrheit und Lüge im Zeitalter der technischen Reproduzierbarkeit. Detektiv und Heroine bei Joe May," in *Joe May,* ed. Hans-Michael Bock and Claudia Lenssen (Munich: edition text + kritik, 1991), 46.

[6] Thomas Elsaesser, "Filmgeschichte, Firmengeschichte, Familiengeschichte. Der Übergang vom Wilhelminischen zum Weimarer Film," in *Joe May,* ed. H. M. Bock and C. Lenssen, 17.

[7] H. Schlüpmann, "Wahrheit und Lüge im Zeitalter der technischen Reproduzierbarkeit," 49.

[8] Leopold Ziegler quoted by Lotte H. Eisner, *The Haunted Screen* (Berkeley: U of California P, 1973), 3.

[9] E. M. Wrong, *Crime and Detection* (Oxford: Oxford UP, 1926).

[10] Tom Gunning, *The Films of Fritz Lang. Allegories of Vision and Modernity* (London: BFI, 2000), 89.

[11] The *Spiders* was originally intended to comprise four films. Although the scripts for the two final parts (*Das Geheimnis der Sphinx, Um Asiens Kaiserkrone*) were written, they were never filmed.

[12] Fritz Lang: "I simply had the desire to make adventure films. I was young at the time and loved everything exotic. I also wanted to make use of my travel souvenirs." Fritz Lang in Alfred Eibel, *Fritz Lang* (Paris: Présence du Cinéma, 1964), 10 (trans. J. R.).

[13] Enno Patalas, "Kommentierte Filmographie," in *Fritz Lang*, ed. Peter W. Jansen and Wolfram Schütte (Munich: Carl Hanser Verlag, 1976), 83 (trans. J. R.).

[14] In the second part of the *Spiders* (in *The Diamond Ship*) Kay Hoog discovers a secret, underground city underneath San Francisco's Chinatown. "This subterranean space contains the repressed and dangerous elements of an exotic society: opium dens, caged tigers, criminal meetings and oriental guards with weapons whose intricate blades resemble insignia. The idea of a secret city of vice which existed within the everyday city was a basic trope for the modern metropolitan experience." T. Gunning, *The Films of Fritz Lang*, 93.

[15] Frieda Grafe, "Für Fritz Lang. Einen Platz, kein Denkmal," in *Fritz Lang*, ed. P. W. Jansen and W. Schütte, 8 (trans. J. R.).

[16] Klaus Kreimeier, *Der Bürger und die politische Macht. Fritz Langs deutsche Filme III*. Film für den WDR (Köln) vom 31 March 1971 (trans. J. R.).

[17] Anon. *Der Film*, no. 41 (1919): 43.

[18] Peter H. Schröder, "Orientalischer Irrgarten und Großberlin," *Filmkritik* (December 1965): 672 (trans. J. R.).

[19] Georg Simmel, "Das Abenteuer," in Simmel, *Philosophische Kultur* (Berlin: Wagenbach, 1983), 35 (trans. J. R.).

[20] Kay Hoog is the first dandy cast as an adventurer: "He is well-versed in all the arts, rides like a cowboy, swims, climbs with great daring and skill, and even takes a parachute jump from the basket of a hot air balloon which beforehand he had audaciously climbed up to from a rope as the balloon was already making its ascent." *Der Kinematograph*, no. 666 (8 October 1919): 26 (trans. J. R.).

[21] T. Gunning, *The Films of Fritz Lang*, 94.

[22] Fritz Lang in conversation with Gero Gandert. In Enno Patalas, ed., *M*, Cinemathek, vol. 3 (Hamburg: Marion von Schröder Verlag, 1963), 128 (trans. J. R.).

[23] Peter H. Schröder, "Orientalischer Irrgarten und Großberlin," 671–72 (trans. J. R.).

[24] Jean-Paul Sartre, "Der Blick" in Sartre, *Das Sein und das Nichts* (Reinbek: Rowohlt, 1962), 348.

[25] *Der Film*, no. 7 (1920), 44 (trans. J. R.).

[26] E. Patalas, ed., *M*, 86 (trans. J. R.).

[27] Gilles Deleuze, *Das Zeit-Bild. Kino 2* (Frankfurt am Main: Suhrkamp, 1991), 183 (trans. J. R.).

[28] A motif which, incidentally, Thorsten Näter took up again a while ago for his film *Die Mandarine von Marzahn* (1997, for *Die Straßen von Berlin*).

[29] *The Testament of Dr. Mabuse* (trans. J. R.).

[30] "Lang recognizes that Dr. Mabuse could only have been invented in Germany, the country of *Kadavergehorsam* (absolute obedience), where Nietzsche's idea of Superman was born." Lotte H. Eisner, *Fritz Lang* (London: Secker & Warburg, 1976), 61.

[31] Kurt Pinthus, "Dr. Mabuses Welt," *Tagebuch* (6 May 1922). Quoted in Norbert Jacques and Fritz Lang, *Dr. Mabuse, der Spieler. Roman/ Film/ Dokumente,* ed. Günter Scholdt (Ingbert: Werner J. Röhring Verlag, 1987), 186 (trans. J. R.).

[32] Erich Pommer's production company, Decla-Bioskop, had a contract with Ullstein to make screen versions of the publisher's successful books (Uco-Produktion), in order that both the book and the film could serve as publicity for one another. When Decla-Bioskop was taken over by Ufa in 1921 the contract also passed to Ufa. Jacques' serialized novel *Dr. Mabuse, der Spieler,* which first appeared in the *Berliner Illustrierte Zeitung,* was promptly accepted as the ideal material for cooperation between magazine, book and cinema. Thus it was possible to publish the last installment in the *Illustrierte* together with photos from the film. Fritz Lang himself was made aware of the book by Thea von Harbou, who was friendly with Norbert Jacques, and spread his story in newspaper reports at the time.

[33] Fritz Lang: "We departed . . . from the book to a great extent and used only the essential features. My aim, as always, was to represent the times. I think I am right in remembering that a director friend of mine sent me a book from America about Al Capone. That probably influenced me a little. I also incorporated an incident which caused a great sensation at the time: the defensive battle between the encircled car thief, Chavrol, and the police in Paris." Fritz Lang in conversation with Erwin Kipfmüller. Quoted in Günter Scholdt, ed., *Dr. Mabuse Roman-Film-Dokumente,* 175 (trans. J. R.).

[34] Claudia Lenssen, "Gefährliche Parallelwelten," in *Filmmuseum Berlin,* ed. Wolfgang Jacobsen, Hans Helmut Prinzler, and Werner Sudendorf (Berlin: Nicolai, 2000), 71 (trans. J. R.).

[35] Jacques Rivette, "Die Hand," in Rivette, *Schriften zum Kino.* CiCiM, vol. 24/25 (1989), 112 (trans. J. R.).

[36] J. Rivette, "Die Hand," 113 (trans. J. R.).

[37] Georges Sturm, "Mabuse, ein Bild der Zeit, ein Spiel mit dem Bild. Zu den vier Mabusefilmen von Fritz Lang," in *Dr. Mabuse, Medium des Bösen III. Testament des Dr. Mabuse,* ed. Michael Farin and Günter Scholdt (Reinbek: Rowohlt, 1997), 339 (trans. J. R.).

[38] T. Cunning, *The Films of Fritz Lang,* 96.

[39] Fritz Lang, "Moderne Filmregie," *Die Filmbühne,* no. 1, April 1927, 4, quoted from: Zum Selbstverständnis des Films IV. *Filmkritik* (December 1965): 675 (trans. J. R.).

[40] L. H. Eisner, *Die dämonische Leinwand* (Frankfurt am Main: Fischer, 1980), 245 (trans. J. R.).

[41] L. H. Eisner, *Fritz Lang,* 58.

[42] Klaus Kreimeier, *Der Ästhet und die Wirklichkeit. Fritz Langs deutsche Filme 1.* WDR (17 March 1971) (trans. J. R.).

[43] Cf. M. Farin and G. Scholdt, eds., *Dr. Mabuse, Medium des Bösen III*, 259 (trans. J. R.).

[44] L. H. Eisner, *Fritz Lang*, 58.

[45] A. Kaes, "Motor der Moderne," 62–64 (trans. J. R.).

[46] Siegfried Kracauer, *From Caligari to Hitler. A Psychological History of the German Film* (Princeton, NJ: Princeton UP, 1947), 81 and 83.

[47] Enno Patalas, ed., *M*, 89.

[48] Anne Waldschmidt, "Doktor Mabuse oder Bilder des Schreckens vom deutschen Menschen der Nachkriegszeit," in *Die Ufa 1917–1945. Das deutsche Bilderimperium. Ufa-Magazin*, no. 2, ed. Rainer Rother (Berlin: Deutsches Historisches Museum, 1992), 2.

[49] G. Sturm, "Mabuse, ein Bild der Zeit, ein Spiel mit dem Bild," 338 (trans. J. R.).

[50] Fritz Göttler, "Eine Mona Lisa des Verbrechens. Die Sechzigerjahre und das Vermächtnis des Dr. Mabuse," in *Dr. Mabuse, Medium des Bösen III*, ed. M. Farin and G. Scholdt, 397 (trans. J. R.).

[51] S. Kracauer, *From Caligari to Hitler*, 82.

[52] Rudolf Arnhcim, *Film als Kunst* (Munich: Hanser, 1974), 124 (trans. J. R.).

[53] S. Kracauer, *From Caligari to Hitler*, 82–83.

[54] L. H. Eisner, *Fritz Lang*, 61.

[55] L. H. Eisner, *Die Dämonische Leinwand*, 245 (trans. J. R.).

[56] Herbert Ihering, *Von Reinhardt bis Brecht*. Vol. 1 (Berlin: Aufbau-Verlag, 1961), 427 (trans. J. R.).

[57] Frieda Grafe, "Für Fritz Lang," 48 (trans. J. R.).

[58] Jacques Rivette, "Die Hand," in Rivette, *Schriften zum Kino*, 110 (trans. J. R.).

[59] Fritz Lang in Hermann Treuner, ed., *Filmkünstler — Wir über uns selbst* (Berlin: Sibyllen-Verlag, 1928). Quoted in P. H. Schröder, "Orientalischer Irrgarten und Großberlin," 871 (trans. J. R.).

[60] Fritz Lang, "Wege des großen Spielfilms in Deutschland," *Die Literarische Welt* (1 October 1926) (trans. J. R.).

[61] E. Patalas, ed., *M. Cinemathek*, 90 (trans. J. R.).

[62] "The hypnosis which Mabuse stages in *Dr. Mabuse the Gambler* has nothing in common with hypnosis as pre-Freudian therapy, it is a fair-ground magicians' stage game and comes from variety entertainment, as Weltmann reminds us. For the doctor hypnosis is a technique with which to gain power over others, in order to obstruct, destroy and control the will of one's adversary. He seizes the consciousness of his victim in order to manipulate him, in order to turn him into a . . . puppet to the point where the victim becomes part of his game and . . . allows himself to be compelled to evil acts." G. Sturm, "Mabuse, ein Bild der Zeit, ein Spiel mit dem Bild," 354–55 (trans. J. R.).

[63] Ibid., 351 (trans. J. R.).

[64] S. Kracauer, *From Caligari to Hitler*, 19.

[65] F. Grafe, "Für Fritz Lang," 35–36 (trans. J. R.).

[66] Cf. Norbert Jacques, *Mit Lust gelebt* (Hamburg: Hoffmann & Campe, 1950), 364f.

[67] Ibid., 351 (trans. J. R.).

[68] Lotte H. Eisner, *The Haunted Screen. Expressionism in the German Cinema and the Influence of Max Reinhardt* (Berkeley: U of California P, 1973), 240.

[69] Hans Schmid, "Herrschaft des Verbrechens," in *Dr. Mabuse, Medium des Bösen III.*, ed. M. Farin and G. Scholdt, 369 (trans. J. R.).

[70] Fritz Lang quoted by F. Grafe, "Für Fritz Lang," 64 (trans. J. R.).

[71] L. H. Eisner, *Die dämonische Leinwand*, 245 (trans. J. R.).

[72] F. Grafe, "Für Fritz Lang," 64.

[73] Fritz Lang in *L'Express*, no. 525, quoted in *Filmkritik* (July 1963): 311.

[74] Cf. François Truffaut, *Die Filme meines Lebens* (Munich: Carl Hanser Verlag, 1976), 76.

[75] F. Grafe, "Für Fritz Lang," 23.

[76] E. Patalas, *M*, 102.

[77] A. Waldschmidt, "Doktor Mabuse oder Bilder des Schreckens vom deutschen Menschen der Nachkriegszeit," in *Die Ufa 1917–1945*, ed. R. Rother, 8.

[78] Ernst Bloch, "Philosophische Ansicht des Detektivromans," in Bloch, *Verfremdungen I* (Frankfurt am Main: Suhrkamp, 1963), 43 (trans. J. R.).

Murnau — a Conservative Filmmaker?
On Film History as Intellectual History

Thomas Koebner

IN MARCH 1922, within a couple of days, two movies premiered which
could not have been more different. The first tells a horror-fantastical
story from the last century (around 1840). A vampire from the legendary
East, the distant Transylvania, comes to a city on the Baltic Sea to bring
about confusion, pestilence, and death. The second film is a rural drama
which tells the story of the rise and fall of a social climber. One of the
peasant's sons is possessed by ambition. With the help of several women
whose love he does not return, he climbs up the social ladder. He plans
to become a millionaire by owning soil which does not bear fruit because
an oil well is hidden underneath. But as all his actions are devoid of love,
and because his disappointed wife prefers death in cold waters to living
at the side of an egotist, he breaks down and finally ends in the farm-
house. Here, he is cared for by his brother and a young woman who has
always waited for him.

The films were produced one shortly after the other by the same di-
rector Friedrich Wilhelm Murnau. The script for the first film, *Nosferatu.
Eine Symphonie des Grauens* (Nosferatu. A Symphony of Horrors, 1922),
was written by Henrik Galeen. The script for the second film, *Der bren-
nende Acker* (Burning Soil, 1922), was written by Willy Haas, Thea von
Harbou, and Arthur Rosen. Their respective share in the script cannot
be determined exactly. All the scriptwriters were not without experience
in the genre in which they anchored their stories. Henrik Galeen had
already outlined the second *Golem*-film, *Der Golem, wie er in die Welt
kam (The Golem, How He Came into the World*, 1920), for Paul Wegener
and was a specialist in the department of romantic horror. Thea von
Harbou, on the other hand, companion to and author for Fritz Lang,
was a national-conservative author as early as the First World War. Al-
though influenced by Fritz Lang, she was able to skillfully process con-
temporary colportage material into film scripts. Shortly after Murnau's
films, around the end of April, beginning of May, both parts of Lang's

Dr. Mabuse, der Spieler (Dr. Mabuse, the Gambler, 1922) had their premiere in Berlin. In the same year Murnau shot a second movie based on Harbou's script: the film version of Gerhart Hauptmann's novel *Phantom.*

What then is so exciting about the simultaneity of phenomena, the coinciding of the production of *Nosferatu* and *Burning Soil,* the two films which I will discuss in the following? Could one not simply take these two films as exemplary for the wide spectrum of the director F. W. Murnau, and rather make a respectful bow to the director's artistic versatility? Or is it likely that Murnau adjusted to the stylistics and the ideological prerequisites of scripts and production companies? In his study on Thea von Harbou, Reinhold Keiner points out that *Burning Soil* had been produced with the money of the Deulig film company, which, since its foundation, had pursued a conservative political program, and since 1921 catered for the rural population. For the production of *Burning Soil,* Keiner says that Deulig-Film undoubtedly gave guidelines that were followed by all involved in the production, including the director.[1] However, there exists no detailed information on these guidelines. The thought of the ideological determination of the product by the orderer is familiar with regard to the ideology of the product; in this special case, however, presumably like in many others, it is sheer speculation. The program of Deulig-Film in that half year consisted of productions which were not particularly striking for conservative marks with regard to matter and genre: *Das Mädchen aus dem Goldenen Westen, Die Kreutzersonate (The Kreutzer Sonata), Die Geliebte des Königs, Das Diadem der Zarin,* etc.

After all, it obtruded the minds of later-born commentators to assign *Burning Soil* to a political position. It is obvious that it is a strangely biased story which elucidates glamour and misery of a peasant's story of success, while *Nosferatu* is protected from the suspicion of such bias by the fact that it goes back to an eerie Biedermeier and the fantasy horror. The coinciding of these two productions could be explained by a conservative basic attitude, if one acknowledges the flight from time and the turning away from modernity as a common denominator. This remains to be discussed. Or is Murnau's background responsible for his apparent distance to current affairs and larger issues? The reminiscence of the Westphalian landscape with its farms must have won Murnau's sympathy for the simple life. It is overlooked that already at the age of three, Murnau had to leave his place of birth, Bielefeld, and move to Kassel where he spent his childhood and youth. Being the son of an upper middle class and wealthy family and appropriating aristocratic manners

which were striking to his noble and bourgeois pilot colleagues during the First World War, one cannot ascribe to him a class-specific proximity to the peasantry. One has to assume that Murnau, who in his outer demeanor bore elegant and noble, even dandified traits, held a certain distance to the ideological conglomerate of blood and soil.

A study of both films helps firstly to disclose a stylistic and maybe even thematic mutuality, which approximately connects to Murnau's personality, and secondly to discover elements of the contemporary which make clear that both films were exposed to the scrutinizing eyes of a German urban audience and found emphatic approval. According to the coverage in the German journals *Der Film* and *Der Kinematograph*, *Burning Soil* even aroused enthusiasm in Paris, in the same year 1922 when people could buy James Joyce's *Ulysses* at Sylvia Beach's Paris bookstore.

From an almost indefinable chronicler's perspective *Nosferatu* tells a double story: a private and a public one. In the private story, the young aspiring realtor Hutter from Wisborg is married to a young woman, Ellen, and together they have friends from the wealthy, even rich bourgeoisie. Their relation is affectionate: kisses on the forehead — they are not a passionate couple and have no children. For a profitable transaction, he needs the signature of a certain Count Orlok who lives far in the East. Hutter undertakes an arduous and wearisome journey, while his wife awaits him yearningly. Meanwhile she has a strange telepathic relation with Orlok, the vampire, after he has seen her picture in Hutter's locket. From this point on a strange only partly coded triangular relationship develops. Ellen calls out Hutter's name when Nosferatu or Count Orlok tries for a second time to throw himself onto Hutter in order to drink blood from his throat while he is sleeping or while he is absorbed by a gloomy spell. In his craving for blood Nosferatu makes no difference between men and women. If one wants to understand his blood-lust as a puritan code for sexual appetite, one has to concede to him a reckless bisexuality, hetero- and homo-eroticism. Ellen's interruption — the editing makes us believe — causes Orlok's menacingly upright shadow to sink down, the vampire turns away and leaves the room and Hutter behind. To await her love in a cozy, snug little place on the seashore, Ellen chooses, of all places, an old sand-covered sailor cemetery. Why then is she waiting for her love on the seaside when she knows that he left on horseback and that he will presumably return on horseback? Over the sea, however, comes Nosferatu. The final sequence of the private drama shows more and more clearly that Ellen sees herself caught between two men. She reads in a book on vampires about the mission of salvation which a virtuous woman can fulfil by keeping the vampire with

her until the cock crows. The vampire will then perish in the sunlight. Reading this, she finds herself in the role of the victim. She sends away her devoted husband who keeps guard at her bedside and falls asleep in his armchair while doing so — why is he not lying next to her? Is she already a marked woman, a nunlike heroine, who preserves herself for only one man? She opens the window; a signal for the vampire that he has permission to enter her room. She awaits him in a white nightgown and with eyes wide with terror. The plan works out, Nosferatu stays with his love and perishes into smoke in the morning sun. Meanwhile Ellen can only struggle to her feet one last time before she sinks down exhausted, her heroic deed has cost her life. Mourning helplessly, her husband stays behind.

Max Schreck as Count Orlok in
F. W. Murnau's *Nosferatu* (1922).

From the vampire's perspective, Ellen is the beautiful woman he desires; he succumbs to her from the moment he sees her picture. To be close to her, he chooses the ruin across the street from her house. When he waits behind the window grate of the "desolated house" (as it says in the script) for a sign from Ellen, illuminated by a pale lime-colored side light, he resembles a mortal lover who stares at the house of his sweetheart, hoping to catch a glimpse which may encourage him to go over to her. He slowly loosens his hands, clutched around the iron bars, revealing every single movement of the fingers. He then slowly moves to the side of the window to finally reach the object of his desire. These shots can be compared to a typical series of scenes in a romance novel — only in this case, the lover is of a terrifying appearance: a hunchback of Notre Dame, a fiend, not a gentleman as in Bram Stoker's novel, rather a deadly pale fellow with a ghostly grimace, as if invented by Alfred Kubin. It is a figure of terror, an ill-bred Mephisto with the front teeth of a rodent (not equipped with big fangs), a master of rats and mice from the German tradition.

With regard to dramaturgic aspects, the public story told in *Nosferatu* could be considered a subplot although here too the Nosferatu-world becomes the ruinous instance which hits the inhabitants' public life — parallel to the marriage of the Hutters. There is the realtor Knock who sends out Hutter in the first place, who speaks of Count Orlok as his master and who has a great share in his death; there is the close but not compelling relation between the vampire and the pest. As befitting for a vampire, he has to carry the soil he was buried in with him. Additionally the coffins loaded on board the ship in Varna on the Black Sea carry rats. The effect is shown several times during the film. Coffins are forced open with axes or turned over, producing a swarm of long-tailed rats, carriers of the pest. During the journey, the crew fall ill and die, leaving only the vampire to take over as captain of an empty ship. When Nosferatu sails into the harbor of Wisborg by night, he is not the only one to leave the ship to get close to Ellen, the rats too go ashore. After the notabilities of the city have inspected the sailboat and read out the log in the city hall, they discover the entry "danger of pestilence" — and instantly disappear into their houses. The terror of the epidemic, which is forewarned by the town clerk's drum beating, makes them close their windows hurriedly. But they cannot prevent the pest from spreading through the alleys. An old man with a top hat walks from house to house to paint white crosses on almost every other front door, a sign that black death has raged here too. Ellen watches a long parade of coffins being carried through the street. This parade motivates her to devote herself to

the evil nightmare in order to free all the others. It is amazing that — apart from Knock, Nosferatu's devoted intimate, different than the ignorant husband Hutter — Ellen seems to be the only one to know that the spreading of the fatal epidemic has to do with the vampire's presence.

The fact that vampires feed on other beings is explained by a so-called "Paracelsian," a partly natural scientist who, with certain medical cynicism, utters delight in the diabolism of those carnivores or "border crossers" of natural realms. This curious interlude, situated late within the story, additionally draws attention to the inconspicuous development of the connection between vampirism and the plague during the film. The pest does not necessarily link to Nosferatu; as a component of the public story, it emphasizes the fear of a dread inconceivable and invisible for most of the inhabitants. When Knock escapes from prison after knocking down a guard, a satirically staged hunt for the scapegoat develops. Murnau mixes this hunt, occasionally referred to as pogrom, with inserts which should evoke comic relief from the general mania. As the persecuted is not responsible for the pest, Murnau can emphasize the desperate and blind raging of the mass fear. When Nosferatu finally dies in the sunlight, the pest suddenly stops raging too — as is stated in the last insert. A miracle of salvation that brings cure to almost everybody. Only the end establishes the analogy between vampire and pest.

Murnau seems to have been interested in at least two things: the extraordinary devotion of a martyrlike woman for a man, who according to common opinion does not demonstrate many amiable traits, who is rather a demonic outsider, sending away her husband from her bedside; and the panic which takes hold of a community when it is exposed to a great unexpected threat. On the one hand, the film discloses a complicated love affair in which the magic attraction of the transcendental seems to be superior to the worldly testimonies of fidelity. On the other hand, *Nosferatu* depicts, romantically obscured, a relatively abstract, although fatal mischief which intimidates everybody. One neither sees victims of the pest, nor the fumigation of the houses — only solemn pallbearers alone or in long processions. And one sees the rats, natural unvarnished documented realities, like the mountains with the castle, the wind in the foliage of the trees, the horses on pasture (the alleged wolves which are actually hyenas should be obliterated in this context). The plague itself, the illness is left out of the frame — not because Murnau wanted to spare the audience the disgusting sight, but probably because for him the pest is a kind of *code,* a code for the fear of the unstoppable doom that takes hold of everybody. In his ambivalent appearance, Nosferatu personifies a fantastic undead from the realm of repressed obses-

sions who teaches fear and trembling to the sailor on the ship, Empusa, and Ellen. Empusa, terrified by witnessing the vampire's visionary resurrection from his coffin in the hold, flees on deck and over the rail to miserably drown in the ocean. Ellen, however, despite her desires and longings, destroys the strange lover. This happens much more actively in the script than in the film, in which Hutter's wife acts in a rather somnambulistic fashion — and stays remarkably passive. In frame 172 — which has never been shot (on the page it reads in Murnau's handwriting "cancelled") — Galeen's script celebrates Ellen's martyrdom in a perverted lovers' night:

> Nosferatu raises his head. He looks drunk with pleasure. Ellen's eyes are full of terrible fear. She must not allow Nosferatu just to go. She puts her arms round him; he cannot resist and bends his head over her again.[2]

Murnau apparently felt this strong unambiguous ecstasy of pain and lust as too radical, too obvious. He softened and obscured the sexual signs, moved the event into the semi-dark of allusions, took away the character of a predator from Nosferatu, often conjured in the script, stylized him to be a wanderer from the hereafter, to be a bald-headed old man, appropriated poetic metaphors for the visual narration — for example he had the shadow of the monster's hand fall onto the region of Ellen's heart and clench his fist there. In this way, Murnau takes away the signs of the origin of Stoker's Victorian creation, of a free-thinking Dracula, whom women cannot resist, to whom they succumb. Instead he turns them into terrible embodiments of teeth baring desire. He also takes away the signs of the contemporary from the film which in its private core is a somber melodrama.

In her recent study Margit Dorn points out that Galeen and Murnau particularly excluded one of Stoker's figures: the merciless vampire hunter van Helsing.[3] Indeed, the principle of resistance is neglected in this German film. The alternative is rather, either to long for Nosferatu by merging with him, as Ellen (Greta Schröder) chooses, or to withdraw from his influence and resist his seduction, as shown by Hutter (Gustav von Wangenheim). The fact that Ellen takes up a kind of magnetic rapport with Nosferatu, just as Dr. Mabuse does with his hypnotized victims, cannot be ruled out. In several films of the 1920s, somnambulists reappear, tempting the border of death as if under a strange spell, demonstrating no free will or resistance, bearing great resemblance to Dr. Caligari's "remote-controlled" Cesare. The figures in Murnau's *Nosferatu* have a share in the pandemonium of reduced characters typical for the

time, who do not seem to wake up from their nightmares. According to Siegfried Kracauer one could refer to them as objects of a tyrant. In two respects, however, the emphasis needs to be placed differently than in Kracauer's study *From Caligari to Hitler.* Often a relation to the respective tyrant is revealed that could be categorized as identification with the aggressor, even as mutual desire that drags down both like a "folie à deux," an illness to death. This could be valid for Murnau's *Nosferatu* and partly also for Lang's *Dr. Mabuse.* What Kracauer ignores, is that often the objects of the hypnotic terror, of the suggestive power, the somnambulists, to stick with this term, move into the center of interest in those films — not the so-called tyrants! Then however one had to presume that this perspective derives from the great tradition of naturalist compassion dramaturgy — and is not just characteristic for the postwar depression.

Some more words about the alleged symbolism of the rats: the intimate friendship with Hans Ehrenbaum-Degele has probably left traces in Murnau's memory. His friend's father, a Jewish banker, seems to have taken care of young Murnau as kindly as did the mother, opera singer Mary Degele. Impromptu travels and a certain unsettled and unconventional lifestyle were not unusual for Murnau's family. His own father was exemplary. Those experiences should have immunized Murnau against the Zeitgeist-anti-Semitism. To consider the rats in *Nosferatu* as symbols for a Jewish threat from the East therefore seems to be rather absurd. The contemporary reviews lack any reference to a Jewish theme. Such a blunt imagery of abhorrence only spread during the Third Reich. It was a scientific fact that rats were carriers of the pest. The fear of the plague and anti-Semitism, therefore, do not go hand in hand. On the other hand, it seems exaggerated to identify the pest with the recently ended war, although it can be taken as mutual fact that in both cases people die randomly and in great numbers without regard to merit or guilt — without any individual resistance leading to a predictable success. Murnau intentionally wanted to turn back time in his story to a premodern period which needed more terse and fantastic notions of dread, probably to escape the maelstrom of contemporary identifications. This method of *alienation* should be taken seriously.

With *Burning Soil* too, to start with the *mise en scène,* the laconic discretion Murnau uses to tell the story up to the point when people disclose or disguise their feelings catches the eye. Three women love Johannes, the peasant's son, who distances himself so far from his origins that he does not even rush back to his father's deathbed. There is the coquettish daughter of a landowner who, just for her pleasure, goes for

a ride with him, her father's secretary. Then there is the count's young second wife whom Johannes marries after the count's death and who does not seem to have any prejudices against the bourgeoisie or even peasantry. Finally there is Marie, undauntedly waiting for her hero in her father's house. Johannes however abuses their love. He plays with the daughter of the landowner, deliberately marries the widow, because she has inherited the "Teufelsacker" from which oil will soon gush out, making him a rich man. As for poor Marie, he does not care for her at all. As long as Johannes pursues his career, he seems to be darkly obsessed. He even manages to have a banking syndicate support him with a lot of money for the exploitation of the oil well, and a minister congratulates him — in the city, in a monumental representational room with exquisitely decorated high walls, so high that the ceiling is not visible. In his manor house with the high hall and the small library, with elegantly proportioned ancillary rooms, he has to confess to his wife and the count's daughter that he has never loved either, that only ambition has driven him. He falls into apathy, conscious of his guilt. In revenge the count's daughter sets the oil well on fire. He, however, does not want to rescue it anymore, he does not care for his possessions any longer. The situation worsens, there is no end to the "ordeal of Job." His wife commits suicide in the wintry ice water and her corpse is carried into the paternal farmhouse. Now Johannes breaks down silently and falls onto the floor next to her. Marie and his brother, who remained a farmer, lead him into the room with the four-poster bed, where his father had died. He has come home to the small rural dimension, after his misspent life has fallen apart.

With this didactic piece, Murnau seems to be less interested in petite-bourgeois moral (the warning of arrogance and greed for riches) and more interested in hardship and the crisis of existence. The single-stranded character of career-obsessed Johannes is played by Wladimir Gaidarow, a Russian actor from the Stanislavski school. He has a narrow head with fine features and dark hair, totally unrural, a distinct contrast from the burly, ponderous brother (Eugen Klöpfer), a romantic decadent type, who makes an impression with his wild gestures of desperation and lethargic gestures of a weary and tired disgust for life — especially when he finds out that his wife has sold the "Teufels-acker" to his brother and along with it, unbeknown to her, the oil treasure. In the end Johannes seems to be hollowed out when he realizes and admits that nothing but misanthropic ambition kept him in motion and his expressions of love were willful deceit. The fact that in the end he is gently led into the farmhouse where his father's bed waits for him like a bier gives a double

meaning to the ending: this homecoming (two women committed suicide because of him) does not have to open up a new life for him — the signs of his nearing death are just too obvious. Murnau shows the protagonist in his delusion and later as a man destroyed from the inside: not only a man to whom the affection of women at best means shallow benefit and who therefore feels guilty (maybe a dramatized allusion to Murnau's own homosexual identity), but a man who is subservient to a wrong mission. The analogy to the "tempted" and "lied-to" Germans who were sent to war for wrong ideals imposes — in the postwar era this is a widespread topos of mastering the wartime-experiences from a perspective often pacifist or ready for revolution (for example in the widely noticed plays of Ernst Toller, especially in *Die Wandlung*). Without wanting to overrate the biographical references, it still should be mentioned that Murnau's closest friend, Hans Ehrenbaum-Degele, was killed in the war and that after 1918 Murnau was granted lifetime right of residence in Mary Degele's villa. Therefore, the fatal destruction of a young man driven by questionable illusions was not only a scheme of thought for Murnau, but it also constituted his own experiences. In a recently published semi-documentary novel "Nosferatu in Love," Jim Shepard declares that the loss of his friend Hans whom Murnau tried to replace in vain and with growing feelings of guilt, constitutes the main trauma of his life.[4]

Looked at in this way, for Johannes the destruction of his old misspent existence does not lead to a breakthrough to his true nature, but to a paralysis, to the decay of his personality. By no means can one speak of an initiation into a better condition. The optimism of modernity and its trust into the human potential of development, even after a catastrophe, is not shared in *Burning Soil*. Murnau, a melancholic in Germany, does not want to believe in the renewal after the apocalypse, does not want to appropriate the metaphysical idea of the chance of a second birth, of resurrection, an idea so important for the dramaturgy — unless later in the form of the fantastic farce in the long happy ending of *Der letzte Mann* (The Last Man, translated as *The Last Laugh*, 1924) or in the atmosphere of the new world in the American films which do not want to refuse the happiness in the ending, especially in *Sunrise*. The contemporary elements in *Burning Soil* thus are not revealed at first sight, but by comparisons of structure, by parallels in the patterns of life, which have to be made visible by means of relative abstraction.

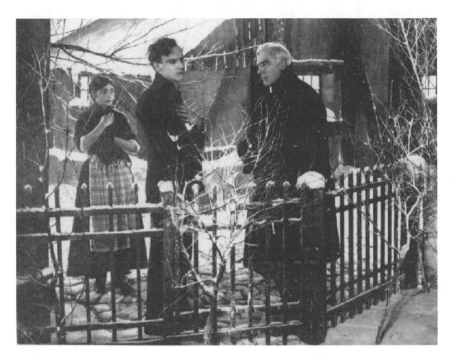

Winter scene in F. W. Murnau's *Burning Soil* (1922).

The contrast between the peasant's and the nobility's world is very important for the narration in *Burning Soil* (the hero changes sides twice), and therefore also for the *mise en scène*. In the great world with its high halls there is no closeness between people, rather calculation, fraud, secrecy, and emotional deprivation. While in contrast, the hand-maids sit around a fire place somewhere in the basement of the manor house close together, irradiated by the fire, a center of warmth. The peasants and the servants, young and old sit even closer together around the table in the living room of the farmhouse when they take their meals. There is a third scene, the city, but no look is cast from the windows of the palaces, though there is one cast from the windows of the manor house: at the snow covered "Teufelsacker" and the small church on the horizon. For the whole length of the story, how much time ever might have gone by, it is wintertime: a time of cold winds and an iced inhospitable nature. Only the bedroom of the farmhouse gets some brighter light in the end, falling onto the decorated green in the vase, as if the sun is shining for the first time. Could Murnau be satisfied with such a simple, ideologically connotated contrast: the cold life of the nobility against

the cozy, warmhearted peasant's life? Or did he want to uncover the apparent, deceitful nature of this idyll only carefully? Not at all, for him the farmhouse remains a site for catharsis. After all, Johannes' dead wife is lying on the floor of the farmhouse, a warning, discovered too late by the rescuers and carried into the house, before her once unscrupulous husband falls on the floor next to her as if hit by a stroke — thus the scene also becomes the stage where the truth is disclosed and the pain finally emerges from seclusion (where if not here, in which spacious hall of the aristocratic milieu should this happen?).

It would be precipitate however to assume a mental relation between F. W. Murnau and a poet of the people like, for example, Ludwig Ganghofer, to name just one popular representative of rural and regional novel. For Murnau does not combine a distinct critique of other classes, of urban mentality with his conception of an innocent rural sphere — this would be a sign for the agrarian-Romantic conservatism. He presents the old unloved count and the bankers almost matter-of-factly, not as winning characters, but as types who grew up in their specific order of values. The stereotypic conflict of town and country which asks for strong, almost polemical evaluations: for the country, against the town, Elysium versus Babylon, cannot be discovered in Murnau's films, not even in *Sunrise,* where the city renders possible the reconciliation of the young couple and even a second happiness. Such an aggressive, programmatic declaratory praise of country life before the background of the rotten culture of a city, such an accentuated antimodern reaction remains unfamiliar to Murnau.

How then can Murnau's position be outlined? Rather as that of a romantic, whose longing for nature unites with the sympathy for the simple life in an Arcadian scenery; thus the position of a sentimental artist for whom Friedrich Schiller's description in his essay "Über naive and sentimentale Dichtung" (On naïve and sentimental poetry, 1795–96) suits perfectly: he, the sentimental artist "*reflects* on the impression the objects make on him, and this compassion is only based on this reflection, in which he himself is put and puts us." He "therefore always has to deal with two conflicting ideas and emotions, with reality as limit and with his idea as the infinite" — thus he arouses "mixed emotions" and will rather tend either toward the "satirical" or toward the "elegiac."[5] Murnau is a poet of "lost innocence" — this is valid until his last film *Tabu* — in which ideals always appear to be transient, bygone. There the mood of death origins which overshadows Johannes' homecoming as well as the rescue of Hutter and his town Wisborg from the stranglehold of Nosferatu and the pest. The harmony of the world, if ever it existed,

does not return. The last scenes of Murnau's films ooze away in melancholy — at least in 1922. In his skepticism toward a certainly limited reality the sentimental elegist resembles the political conservative. But already the lack of class conceit distinguishes him: in Murnau's films the simple people move into the center, the representatives of the ruling class and the games of the powerful do not interest him.

Notes

[1] Reinhold Keiner, *Thea von Harbou und der deutsche Film bis 1933* (Hildesheim: Olms, 1991), 122.

[2] Lotte H. Eisner, *Murnau* (London: Secker & Warburg, 1973), 269.

[3] Margit Dorn, *Vampirfilme und ihre sozialen Funktionen* (Frankfurt am Main: Lang, 1994), 79f.

[4] Jim Shepard, *Nosferatu in Love* (London: Faber and Faber, 1998), passim.

[5] Friedrich Schiller, *Sämtliche Werke* (Munich: Hanser, 1959), vol. 5, 720–21 (trans. T. K.).

III. The Art of Expressionist Film

The Double, the Décor, and the Framing Device: Once More on Robert Wiene's *The Cabinet of Dr. Caligari*

Dietrich Scheunemann

Introduction

A PROJECT INTENDING TO DEVELOP new perspectives on the cinema of the early years of the Weimar Republic cannot get well under way without presenting a fresh look at the epitome of expressionist film, Robert Wiene's *Das Cabinet des Dr. Caligari* (The Cabinet of Dr. Caligari, 1920). However, such an undertaking encounters major difficulties for several reasons. It cannot ignore the central role which the film has played in more than eighty years of the reception of expressionist films as well as the cinema of Weimar as a whole. This reception has become an integral part of the film and prefigures its perception today. Two books have in particular determined the direction of inquiries, Lotte Eisner's *Haunted Screen* in which *Dr. Caligari* serves as reference point for the identification of expressionist features in other films of the 1920s, and Siegfried Kracauer's account of the cinema of Weimar in which *Dr. Caligari* does not only form part of the suggestive title of the book, but also acts as the main pillar of the overall construction of its argument. It is in the analysis of this film that Kracauer develops the basic assumptions of his book that the films of Weimar reflect a "general retreat" of the "German soul" into a shell, that they show the "German collective soul" wavering between "tyranny and chaos" and offer a "premonition of Hitler."[1] And it is here that Kracauer begins to unfold his one-dimensional, linear construction of the film history as a simple parallel to the social and political history of the Weimar Republic.

Replacing Kracauer's *grand narrative* with an alternative model of historiography that emphasizes the diversity and nonlinearity in cinema history and its nonsynchronicity with the political history of Weimar is one of the measures called for. The present volume tries to respond to

this need through its overall structure and the range of its investigations. With regard to *The Cabinet of Dr. Caligari*, however, this in itself will not be enough to achieve a fresh assessment of the themes and the style of the film and its place in cinema history. Encouraged by the retrospective claim of one of the scriptwriters, Hans Janowitz, that exposing the "authoritative power of an inhumane state" had been the "subconscious intention" of the scriptwriters, Kracauer took it for granted that the film presented "an outspoken revolutionary story" stigmatizing the "omnipotence of a state authority" that had manifested itself in "universal conscription and declaration of war."[2] Although the film's images offer little support for such an interpretation of its story and its main characters, there is hardly a contribution to the discussion of *Dr. Caligari* that has not taken up this argument. Even in articles that reject Kracauer's thesis of a "revolutionary or anti-authoritarian tendency," the quest for the rebellious spirit of the film, if not in political, then in psychological terms, is reintroduced into the inquiry.[3] The first, urgent task of a fresh assessment of *Dr. Caligari* is therefore to establish more clearly and more reliably the very themes of the film and its main motifs.

Kracauer's political interpretation of *Dr. Caligari* is not only short-sighted in itself, but it has also obstructed a meaningful discussion of the function of the film's expressionist style. Not surprisingly, his assessment of the artistic design of the film starts on the most cursory level. "In the film *Caligari*," he states, "expressionism seems to be nothing more than the adequate translation of a madman's fantasy into pictorial terms."[4] In spite of the enlightening comments made by Rudolf Kurtz and Eisner on this subject, critics have continued to rely on this narrow understanding of the execution of the sets up to our days. In their otherwise so enlightened and enlightening book on *Film Art* David Bordwell and Kristin Thompson follow this line of interpretation without adding a question mark to it. "The expressionist stylization functions to convey the distorted viewpoint of a madman," the authors maintain.[5] That this observation hardly scratches the surface of the meaning of the expressionist style and represents in itself an attempt to rationalize and thus avoid the horror of the story remains unseen. Kracauer himself must have felt that there was more to the expressionist design in *Dr. Caligari* than his initial assessment suggested. Referring to an article on expressionism and cinema by Carl Hauptmann he explains that the expressionist style "had the function of characterizing the phenomena on the screen as phenomena of the soul."[6] This comment echoes Kurtz's understanding of the film. In his book on *Expressionismus und Film* from 1926 Kurtz had pointed out that the events seen on the screen occur "wholly in the darkness of

the soul."[7] Unfortunately, the observation became just another occasion for Kracauer to reiterate his political diagnosis of "that general retreat into a shell which occurred in postwar Germany."[8] Clarifying the nature and the function of the expressionist style in *Dr. Caligari* in following up remarks by Kurtz and Eisner seems to be as necessary as providing a more solid assessment of the film's main thematic concern.

There is a third interrelated aspect that requires a stringent reassessment in view of the weight and the function that has been attributed to it in previous interpretations. It is the effect which the framing story in *Dr. Caligari* exerts on the main story of the film. Kracauer's critique of the reactionary political stance of *Dr. Caligari* is based on his diagnosis that the framing story as realized in the film "perverted, if not reversed," the antiauthoritarian intentions intrinsic to the script. The planned "revolutionary film," he concludes, was turned into a "conformist one."[9] Critics widely agree that the discovery of the script in 1977 has severely undermined this diagnosis. Yet, it has continued to serve as an unchallenged starting point in several more recent discussions of the film indicating that some conclusions which the analysis of the script suggests have yet to be drawn.

The framing story has obtained a privileged place not only in the discussion of the film's political stance, but also in the analysis of its expressionist design. Fritz Lang's suggestion to use a different, "normal" style in the design of the framing story in order to distinguish more clearly between normal sight and "the distorted world of the madman" plays a major role in this context.[10] Lang's suggestion has not only encouraged the most superficial interpretations of the meaning of the expressionist style, but has also lead critics to consider the style of the framing device as "normal" or "realist," which is rather at odds with the filmic realization of the relevant episodes. Kracauer has adopted this reading as far as the first episode of the film is concerned, using it in support of his political critique. He has noticed, however, that the final episode contradicts all expectations of a return to a "realist" style. "Expressionist ornaments overrun the film's concluding episode," he states, and wonders whether this does not call into question the two main pillars of his overall interpretation of the film. "In consequence," he argues, "the *Caligari* style was as far from depicting madness as it was from transmitting revolutionary messages."[11] In his book on *German Expressionist Film* John Barlow complicates the issue further. He questions the assumption that the first episode provides "realistic" images and argues that "there is not a great difference between the frame story and the main story." He thus dismisses the clear distinction between "normal" and "distorted" sight

which has survived in most commentaries on the film. Yet, in a twist of his argument Barlow still maintains that it is the "contrast between levels of reality, between the frame story's and the main story's, that determines the basic structure of the movie."[12] On the basis of a reassessment of the film's main thematic concerns and new observations regarding its expressionist style the present contribution will attempt to resolve some of the inconsistencies which still prevail in the assessment of the framing device in terms of both its stylistic design as well as in its assumed political effect.

The material conditions for such an undertaking are better than ever. Not only has the script been rediscovered in 1977 and has been made widely available through its publication in 1995, but also the film has been restored in a tinted version that includes the original, highly stylized intertitles. No doubt, the fact that neither Kracauer, nor Eisner, had the whole range of materials at their disposal has clearly and adversely affected the discussion of the film. It is hoped that by taking full account of the script and the effects of the colors and the stylized intertitles and by discussing the film in a revised historiographic framework some greater clarity about the thematic concerns of *Dr. Caligari*, the meaning of its expressionist design and the role of the framing device for the reception of the film can be obtained.

The Return of the *Doppelgänger*

Only "years after the completion of the screenplay," Janowitz writes early in the 1940s, had he realized that a "subconscious" antiauthoritarian intention had been at the bottom of the script.[13] In view of such a half-hearted assurance it is rather surprising to see how stringently Kracauer followed Janowitz's retrospective interpretation of the film's story and its main characters. Caligari had been described by Janowitz as an embodiment of the "authority of the state gone mad by the misuse of its powers." The director of the asylum, Janowitz emphasizes, "stands for the authoritative power" of the state, while Cesare is identified as his "instrument," his "tool, who in our explanation stands for the subdued army of a compulsory conscription."[14] Kracauer did not only adopt this interpretation, but clearly expanded on its implications. "The character of Caligari," he points out adding a further twist to Janowitz' description, embodies "unlimited authority that idolizes power as such, and, to satisfy its lust for domination, ruthlessly violates all human rights and values."[15] In a corresponding move Cesare is now characterized as "Caligari's innocent victim," as a portrayal of the "common man who, under the pressure of compulsory military service, is drilled to kill and to be

killed."[16] It was the ascription of these widely unfounded characteristics to the main protagonists of the film that supported the assumption that a critique of "the authoritative power of an inhuman state" was at the heart of its original story.[17] The fact that the myth of a "revolutionary meaning" of the film's story was upheld unchallenged for almost a quarter of a century and has been supported even beyond that time is quite astonishing. It seems that the great reputation which Kracauer's book gained on the grounds of its wealth of information and its political approach to film criticism were responsible for it. Ironically, the authoritative power of the book made critics susceptible to overlook how far Kracauer's speculations about the critique of state authority in *Dr. Caligari* were removed from the very images to be seen on the screen.

However, it seems in 1970 the time was ripe to question the supposed antiauthoritarian, "revolutionary" stance of *Dr. Caligari* and to open the debate about alternative interpretations of the film's main motifs and characters. Walter Kaul started this process in quite emphatic terms. "Never," he maintained in his *Bestandsaufnahme 70,* "would an audience have seen a representative of the authorities in Caligari," and he continued: "Never does this film contain a 'revolutionary' parable."[18] Although Kracauer's assumptions had found its supporters and proved to be more resistant than Kaul might have hoped, a great number of critics from Barry Salt and Frieda Grafe to Siegbert Prawer, Jurgen Kasten and Uli Jung, and Walter Schatzberg have taken the revised assessment on board.[19] Not the script was revolutionary, Grafe remarked, but "the function of the décor."[20] But what then is the meaning of this sinister character who appears out of the dark in old-fashioned outfit and with nervous, rapid steps, if not a critical representation of the insane power of state authority? And what is the significance of this shadowy figure Cesare if not that of Caligari's victim and tool? What, finally, is the meaning of the plot if not an "anti-tyrannical" parable as Michael Minden still maintains in an article from 1988?[21]

The space of Dr. Caligari's origin is not the state, the war, the government, not even the town hall — he is, as the first scene shows, rather opposed to such powers. The first scene does provide a critical representation of state authority, of the arrogance and petty forms of domination which one might associate with the bureaucratic habits of Prussian administration. But the action indicates sharply the hostility which Dr. Caligari develops toward the representatives of the town's authorities. The set, the high chairs of the officials as compared with the low bench on which Caligari has to wait, underlines the critical intention of this scene in which Caligari is the humiliated victim rather than the emissary

of state authority. He will not fail to exact his horrific revenge, but he does so as an adversary, not a representative of state authority. So, the antiauthoritarian stance which Janowitz remembers twenty years after the completion of the script as one of the ingredients that fed into the composition of the story finds expression in this scene. However, it is not Caligari, but the town clerks who act as the agents of state authority.

The characteristics of Dr. Caligari, also established in the first scene, are quite different. He is introduced as a showman who asks for the permission to exhibit a somnambulist on the fairground. The dark, old-fashioned costume which he wears, his abrupt gestures and staccato moves, also the reference to the fairground, a sphere outside societal conventions and respectability, and the fact that he intends to exhibit a somnambulist — all these factors contribute to create an air of mystery and black magic around this character. By presenting his visiting-card to the town clerk, however, the mysterious showman reveals himself to be a scientist at the same time, a therapist and director of an asylum as the audience will eventually learn. The viewer can hardly miss to recognize the nature and origin of such a character. Dr. Caligari is a *Doppelgänger*, an offspring of a gothic tale, a late descendent of those split personalities of nineteenth-century Romantic literature who are haunted by their shadows and alter egos, form dangerous alliances with magic forces, create artificial beings who eventually escape their control, and usually end in self-destruction. Dr. Caligari, showman and scientist, is a cousin of the advocatus Coppelius in E. T. A. Hoffmann's *Sandmann* (1817), who is presented to the reader in similar terms: as a "primitive bogeyman and a pioneering man of science" at the same time.[22] Caligari is a close relative of Cagliostro and Faust, of Frankenstein and William Wilson, of Dr. Jekyll and Mr. Hyde, and of Dorian Gray.

The film foregrounds its central motif of the *Doppelgänger* in a significant way — by duplicating it. Cesare is another embodiment of the same motif, not a tool or a victim of Caligari, as Kracauer suggests, but the personification of Caligari's impulsive drives. He acts out his master's urge for revenge, his lust for murder. He is fed by Caligari, literally and metaphorically, only to emancipate from his master-magician when he becomes aware of the beauty of Jane, also a well-known Romantic-gothic motif. Not accidentally, this is the moment when he dies of exhaustion. And the film introduces another twist in its play with doubles. Cesare, the double, is given his own double, the dummy, that takes his place when he is away on his master's missions. From Kurt Tucholsky who in an early review underlined the diabolical and dialectical construction of the film's main character by presenting him as a "Bürgerteufel,"[23] and

Eisner who inserted a few observations on *Doppelgänger* in her book on the *Haunted Screen,* to Thomas Elsaesser, Kasten and Prawer, critics have alluded to the Romantic tradition of the film's story. Eisner even called the demonic huckster Coppelius "a premonition of Dr. Caligari."[24] While the relationship may not be so direct as Eisner suggests, pursuing the tradition of this motif in some greater detail may help to uncover *Dr. Caligari*'s actual place in cultural history.

In his book *The Doppelgänger* Andrew Webber outlines the major function which the motif of the double assumed in Romantic literature. According to his investigations the motif acted as a "challenge to received ideas of identity" and a challenge at the same time to the grand prospects of civilization which enlightened philosophy had left behind.[25] The *Doppelgänger* appears in history as a crystallization of the Romantic backlash to enlightenment thought, to its goalposts of a harmonious subjective identity and the progress of mankind through the individual's education and cultural refinement. What the *Doppelgänger* shows is "what is conventionally discounted or repressed in the cultural heritage of the Enlightenment: the destructive potential of desire, the prevalence of the unknowable, and the corruptible condition of subjective identity."[26] Not surprisingly, the *Doppelgänger* "went underground" in the later nineteenth century in which forms of realism and naturalism with their positivist scientific underpinnings prevailed.[27] However, in fin de siècle Vienna and the Prague school of neo-Romantic writers the motif resurfaced. Not accidentally, Nabokov locates the awakening of the *Doppelgänger* in his novel *Despair* in the vicinity of Prague. Here, Hanns Heinz Ewers and Gustav Meyrink, in conjunction with the draughtsman Alfred Kubin, were instrumental in reviving the Romantic tradition of the *Doppelgänger* in their own writings and through a number of new, illustrated editions of the "classics" of the genre.[28] Ewers eventually completed Friedrich Schiller's fragmentary *Doppelgänger* story *Der Geisterseher.*[29] And both Ewers and Meyrink emerged as the scriptwriters of two of the most significant *Doppelgänger* films of the German prewar cinema, *Der Student von Prag* (The Student of Prague, 1913) and *Der Golem* (The Golem, 1915) both playing in Prague. There are a few points of particular interest to be noted here.

The first follows from the observation that the return of the *Doppelgänger* in literature as well as in cinema is a prewar phenomenon. Attempts to explain its revival historically as a reflection of war experiences or of "social uncertainties" of the postwar era, let alone as an anticipation of the rise of fascism, can hardly be upheld in the light of this observation.[30] Although the social and cultural history of the later 1910s has

certainly reinforced the trend and has generated a mood highly conducive to its further development, the cause for the *Doppelgänger's* return has to be found somewhere else. The specific "mysterious atmosphere" of Prague, which is also referred to by Janowitz as one of the sources of the story of Dr. Caligari, provides certainly one other clue relevant for the motif's revival in literature as well as its introduction to film. However, apart from the particular cultural atmosphere of the city of Prague, it seems that the nature of the new medium of cinema has to be accounted for in this context as well. The innumerable films on Dr. Faustus which emerged in particular in early French cinema since the Lumières' *Faust et Mephisto* from 1896 and Georges Méliès' *Le Cabinet de Méphistophélès,* the many film versions of Dr. Frankenstein's story that came out since 1910 in the United States and the films on Dr. Jekyll and Mr. Hyde produced in the States in 1911 and twice in 1920 seem to indicate a certain affinity between the exploration of the properties of the new medium cinema and the return of the *Doppelgänger* as a dominant motif. Such a link should come as no surprise. It renews an important aspect of the tradition of the *Doppelgänger's* sway in the Romantic era.

Since its first appearance in the works of Jean Paul the motif of the *Doppelgänger* was associated with the illusionist qualities of optical instruments, the "optical anamorphosis" achieved by the use of distorting lenses in Jean Paul's case, the "laterna magica" as a projector of double images in the case of Schiller's *Geisterseher,* or the pocket telescope that Nathanael buys from Coppola which so dramatically changes his visual perception in Hoffmann's *Sandmann.* The *Doppelgänger* did not appear in the tales of the Romantics without the optical instruments required for the projection, reflection and distortion of images. And in a diary note, Hoffmann clearly establishes the connection between the use of replicating instruments and the motif's primary function to question a unified concept of identity: "I think of my self through a replicating glass."[31]

Both Ewers and Meyrink were aware of the close connection which their favorite motif had with optical instruments. While Ewers put his trust in the tradition of mirror images, Meyrink included laterna magica projections in his novels. The subtitle which he added to the manuscript of *The Golem,* "Ein Guckkasten" (a show cabinet),[32] clearly underlines the relevance of projection and visual perception for this novel. However, while the authors of the literary *show cabinets* were still caught up with the traditional means of projection, a new machine with greatly advanced technical possibilities for the production of double visions had of course emerged. It was Paul Wegener, the lead actor of both films, *The Student of Prague* and the *Golem,* who recognized the particular potential which

cinema offered for the production of double visions. In a series of talks he made this insight the centerpiece of his proclamation of the "new aims" of cinema. "When I got involved in cinema for the first time three years ago," he noted in an article from 1916,

> I did so, because I thought that I had an idea which could be realized in no other art form. I recalled those funny photographs where a man plays cards with himself or a student crosses swords with himself I knew that this could be achieved through a split of the image area, and I said to myself that this must also be possible in film and here it would provide the possibility to show E. T. A. Hoffmann's fantasies of the *Doppelgänger* or the mirror image in reality and thus to achieve effects which were not attainable in any other art.[33]

Wegener was convinced that the future of cinema lied in the full exploitation of these specific possibilities of its photographic technique. He also concluded that cinema's potential for special effects achieved through splitting the screen and making use of mirror effects should determine the choice of its *sujets*. The "new aims" of cinema which Wegener pursued echoed other contemporary efforts to remove film from its traditional environment of the fairground and turn it into a recognized art form. However, while the French *film d'art* movement relied on famous theater actors to ennoble the cinema and the German *Autorenfilm* tried to raise its reputation in the first instance through employing writers of repute, Wegener promoted a way for cinema to gain reputation as an art form through exploiting its very own technical possibilities.

Not surprisingly, Wegener found a strong ally in Guido Seeber, the cameraman of both *The Student of Prague* and *The Golem*. In an article on "Doppelgängerbilder im Film" (Double Images in Film) Seeber presented a range of methods for the production of double images in photography as well as cinema.[34] He explains in great detail and clearly as a technician of great craftsmanship, how to achieve the best illusionist effect of double images in the different media. While in photography, as he points out, the effect of the *Doppelgänger* is best achieved through the use of a mask installed behind the lens, in cinema the use of a mask attached to the camera seven centimeters in front of the lens is preferable. Seeber thus provided all the necessary technical expertise for the presentation of the *Doppelgänger* in cinema, which Wegener promoted because in his view it offered the most convincing way of establishing film as a genuine, independent art form in its own right and on the basis of its own technique.

The Cabinet of Dr. Caligari continued with the revival of doubles and double visions of which Ewers, Meyrink and Wegener had made a highly successful ingredient of German cinema since 1913. The film offers a particularly complex configuration of the traditional motif by combining the presentation of the split personality of Dr. Caligari as a sinister showman and a caring scientist with an embodiment of his repressed desires in Cesare. Far from being Caligari's victim, as Janowitz and Kracauer had maintained, Cesare personifies Caligari's hidden urges to take revenge on the town clerk for his humiliation, to give in to his lust for murder and to satisfy his desire for Jane having previously lured her in his tent to no avail. This reading of *The Cabinet of Dr. Caligari* as a complex *Doppelgänger* story rather than a politically motivated anti-authoritarian fable is backed up by anecdotal evidence which Kracauer provides, but fails to evaluate. As Janowitz reports, a "vision of horror" which he had endured in an amusement park at Holstenwall in Hamburg in October 1913 had a significant impact on the creation of the story. Attracted by the beauty and the laughter of a young girl Janowitz becomes a witness of a murder. During the funeral ceremony he recognizes the "average bourgeois" whose uncanny shadow he had seen at the fair and who, as he senses, was the murderer of the beautiful girl.[35] The imagined or real encounter with a *Doppelgänger*, a bourgeois who visits the fairground to satisfy his lust for murder, became the basis of the story. The name of the little town in which the story unfolds, Holstenwall, bears witness to this relationship.

In terms of its theme and central motif *The Cabinet of Dr. Caligari* does not signal a new beginning, a new epoch in cinema history. The film may have played a role in encouraging the motif's continued use and intensified treatment in German cinema in the postwar years. However, a periodization of German cinema that were to follow thematic orientation would have to place the threshold of a new era in the year 1913 rather than 1920. Apart from *The Student of Prague* and *The Golem* who introduced the motif into cinema, *Der Andere* (The Other, 1913) and the serial *Homunculus* (1916–17) stand out as further examples of this trend with quite telling titles. *Lilith und Ly* (1919), the story of a statue brought to life and eventually turning into a vampire, also preceded the making of *Dr. Caligari*. None other than Fritz Lang had written the script for this film.[36] And *Dr. Caligari*, shot in late 1919 and premiered in February of 1920, was soon to be followed by the remarkable remake of *The Golem* that appeared in October 1920; by Murnau's *Januskopf* (1920), which was based on the story of Dr. Jekyll and Mr. Hyde and for which none other than Janowitz supplied the script; by *Nosferatu: Eine*

Symphonie des Grauens (Nosferatu. A Symphony of Horror, 1922), introducing the embodiment of the "half-dead" into cinema; by the cabinet of wax figures brought to life through the dreams of an author in *Das Wachsfigurenkabinett* (1924); by *Faust* (1926), whose main protagonist is hardly imaginable without his alter ego Mephistopheles; by the remake of *The Student of Prague* from 1926 in which Werner Krauss and Conrad Veidt now played the parts of Balduin and the mysterious Scapinelli; and last but not least, by Lang's *Metropolis* (1927), presenting not only the obsessive inventor Rotwang, a distant relative of Caligari's, but in its very center Maria as double in one of the motif's traditional configurations, as virgin and vamp. The *Doppelgänger* motif clearly emerges as a central theme of German cinema between 1913 and 1927. The artistic styles, however, employed to bring the shadows, doubles and mirror images to light were vastly different.

None of the literary revivals of the *Doppelgänger,* including the works of Ewers, Meyrink and Kubin, shows any expressionist traits in the style of writing. Neither do the first filmic presentations of the gothic motif occur in expressionist guise. *The Student of Prague* and *The Golem* both rely on realist-illusionist photographic representation. The *Doppelgänger* can therefore not be seen as an agent of the expressionist art movement. Its return represents the renewal of an uncanny, gothic motif by neo-Romantic writers. Ewers has made this explicit through the subtitle of his script, "Ein Romantisches Drama." There is no reason to assume that the intentions guiding the writing of the script to *The Cabinet of Dr. Caligari* were in any way different. Janowitz grew up in Prague, the very place of the *Doppelgänger's* return. The theme is taken from the treasure trove of the Romantic literary tradition. In its style of writing the script of *Dr. Caligari* shows no expressionist features at all. The fact that Janowitz suggested Kubin as art director for the film, adds further support to the assumption that the authors did not plan an expressionist work of art, let alone a story of political or social critique, but a gloomy gothic tale about the machinations of a mysterious, sinister *Doppelgänger.* Kubin had not only written a novel of his own full of double visions and automatic puppets, but he had gained a great reputation as illustrator of *Doppelgänger* tales. He had executed the illustrations to Hoffmann's *Sandmann,* Dostoevski's *The Double,* novellas by Edgar Allan Poe, and Meyrink's novel *Der Golem.* Had he been commissioned with the design of the sets for *Dr. Caligari,* as the authors had suggested, the birth of expressionist film might never have happened. As Eisner assumes, "Kubin's *Caligari* would certainly have been full of Goyaesque visions,"[37] of nightmarish visions of torture and gloomy

hallucinations. It would have lacked, however, any trait of expressionist abstraction.

The Expressionist Design

A magic lantern, distorting and duplicating lenses and a telescope providing exploded views of objects and people were the optical instruments accompanying the appearance of the *Doppelgänger* in the Romantic era. Their implied function was not at all to give a false, untrue, contorted picture of characters and events, rather the opposite: to sharpen the perception and to enhance visual acuity beyond the limits of what the natural eye can see. The *Doppelgänger* is not the product of a mere fancy; in the eyes of the Romantics it is the truthful reflection of the duplicity and ambiguity of individual subjectivity and a veritable projection of the existence of irrational and supernatural forces in life. Through the use of a mask and double exposure of the film strip, Wegener and Seeber developed a corresponding mode of enhanced visual perception for cinema. The image showed more than the eye could ever hope to see. The fact that the production of the image was based on photographic technique with its aura of authentic representation only enhanced the uncanny nature of the double image. Surprisingly, *The Cabinet of Dr. Caligari* refrained from employing distorting optical instruments as well as trick photography. The means by which it introduced a heightened perception of reality and a truthful projection of the uncanny nature of characters and events is the expressionist design of the film.

As we know from the narrations of production details, expressionism entered the film through the design of the sets. It is through the curved walls, oblique windows, slanting doors and strange radial patterns on the floor that the film establishes its nightmarish atmosphere. Eisner agrees with Kurtz that the "curves and slanting lines" cause a specific psychic reaction in the spectator.[38] Different from straight lines and gentle gradients they create "states of anxiety and terror,"[39] thus preparing the spectator for the perception of corresponding displacements and distortions in the main characters and the events of the film. Eisner adds the observation that a "variation of the shots," i.e. the attempt of producing emotional responses through cinematic means such as camera movement and unusual angles of shooting or editing, remained "absolutely secondary."[40] As opposed to *The Student of Prague,* where the new medium of film explored particular possibilities of its genuine photographic technique and found that they were exceptionally suited to promote a revival of the popular *Doppelgänger* theme, *The Cabinet of Dr. Caligari* employs

expressionist abstraction to achieve the same end. The effects of mystery and claustrophobia, of fear and terror are created with their help.

As compared with Wegener's pursuit of new aims of cinema the concept chosen for the making of *Dr. Caligari* appears rather modest and restrained in cinematographic terms. With the exception of the iris which is used to great effect to underscore the uncanny atmosphere of the film, there is little splendor in cinematography to be accounted for. However, what the film lacks in cinematographic adventurism, it possesses in abundance in its artistic design. The overriding objective is nevertheless the same in both cases. Both directors explore new avenues of establishing film as a recognized art form. Nothing was so important for the future of cinema at this point in its history in Europe than to advance the medium to a more widely accepted form of artistic expression and thus to win over the large middle class audiences. The strategies developed by the *film d'art* and the *Autorenfilm* movements to the same end had not proven to be very successful. Different from the approaches of these movements, but different also from Wegener's attempt to achieve the status of a genuine art form for film on the basis of its illusionist photographic technique, the production team of *Dr. Caligari* agreed to adopt a style of modern painting for the artistic design of the film.

According to Hermann Warm, the art director, it was Walter Reimann who suggested that the uncanny story of Dr. Caligari should be presented in expressionist style. As Warm remembers he himself had recognized when reading the script that the design of this film had to

> deviate from the usual naturalist style. The film images had to be given a fantastic, graphic design turned away from the real. The images had to be visionary, nightmarish.[41]

These remarks have often been taken as evidence for the fact that Warm has suggested that *Dr. Caligari* be made in expressionist style.[42] However, what they indicate is not more, not less than Warm's intention to depart from the conventional "naturalist" style of filmmaking. Beyond that, the remarks seem to refer to an early stage in the planning process implying a design in the style of Kubin's eerie graphic illustrations rather than a style of modern painting. Reimann however suggested exactly this, and Warm was not at all reluctant to set the record straight:

> Reimann, who used the technique of expressive painting in his pictures, succeeded in having his suggestion accepted that this theme had to have an expressionist design of décor, costume, acting and staging.[43]

Legend has it that Warm, Reimann, and also Walter Röhrig were "affili-
ated with the Berlin *Sturm* group" and "promoted expressionism in
every field of art."[44] However, as Kasten has already pointed out, there
is no evidence for upholding the assumption that any of the three artists
had any affiliation with any expressionist group.[45] The monograph of the
Deutsches Filmmuseum on Reimann arrives at the same conclusion.[46]
Reimann was a painter of theater sets working in this profession since
1902. He introduced some expressionist features in pictures that he
painted between 1916 and 1920. However, as Kitty Vincke demonstrates
in a discussion of his paintings, the sets for *The Cabinet of Dr. Caligari*
represent without doubt the most remarkable and most elaborate work
Reimann has done in the expressionist style.[47] What follows from these
observations is the insight that the expressionist style of *Dr. Caligari* did
not emerge from any grouping within the expressionist art movement;
neither was it a genuine reflection of the nature of the story. The expres-
sionist style was imposed on a neo-Romantic, gothic theme. Its strategic
function was obviously twofold: to exert a desired emotional effect on
the audience which would strengthen the impact of the gloomy tale, and
at the same time to ensure that with this film cinema advances to a more
widely accepted art form.

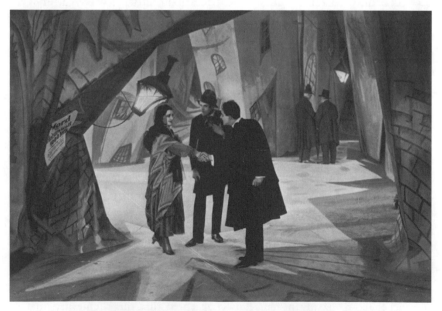

Expressionist décor in Robert Wiene's
The Cabinet of Dr. Caligari (1920).

Expressionist painting had seen its heyday before the war, and expressionist writers were just about to announce the end of this movement,[48] when expressionist features were introduced into cinema. Nonetheless, critics still perceived the transposition of forms, principles and procedures of expressionist art onto film as a radical, revolutionary move. "Something completely new," noted Tucholsky in his review in *Die Weltbühne,* calling for more of such films.[49] "A sensational experiment," wrote Herbert Ihering in *Berliner Börsen-Courier,* only regretting that the film seemingly offered such a trivial justification for its daring expressionist exploit.[50] Also René Clair and Sergei Eisenstein, although pursuing different goals in their own cinematic work, clearly pronounced the striking advance in the art of film which *Dr. Caligari* represented on the grounds of its expressionist décor. "And then came *The Cabinet of Dr. Caligari,*" Clair remembers, and "toppled the realist dogma which had been considered as final."[51] Eisenstein, although mocking the "dumb hysteria of action" and the "assortment of painted canvases" in *Dr. Caligari* later in the 1940s, confirmed Clair's assessment in 1922 by praising the film as a welcome alternative to the dominant "naturalistic tendency in Western cinema."[52] Referring to *Dr. Caligari* as a new direction in cinema which offers a "counterbalance" to naturalist-illusionist trends, Eisenstein clearly made it an ally of his own attempts to overcome naturalist and realist conventions in theater and cinema.[53] What the range of responses shows is the fact that not the revival of the traditional motif, but the application of an avant-gardist art concept to the new medium of film constituted *Dr. Caligari's* most valuable contribution to the history of cinema.

Clair's and Eisenstein's assessment of the particular merit of *Dr. Caligari* also draws attention to the affinity between the neo-Romantic motif of the film and its expressionist design. What they have in common, and this explains the choice of this style for the film, is their anti-realist stance. As Barlow rightly observes, a "general revolt against representation," a revolt against "everything that seemed impressionistic or mimetic," was sweeping the continent.[54] And no other style of contemporary painting has taken the abstraction from the real and from realist images as far as expressionist painting has done. In his artistic credo Ernst Ludwig Kirchner, the leading painter of the expressionist group *Die Brücke,* has made it clear that abandoning all mimetic concepts of art and replacing them with depictions of the "sensual experience" of the artist was at the heart of the new art movement.[55] Kirchner also points to the decisive reason for this development in painting. The task of "exact representation," he states, can now be left to photography:

> Today photography takes over exact representation. Thus painting, re-
> lieved from this task, gains its former freedom of action. The instinctive
> intensification of the form in the sensual experience is transposed onto
> the plane canvas. The technical tool of perspective becomes a means of
> composition. The complete transformation of the experience into artis-
> tic activity creates the work of art.[56]

This credo is of particular value not only because it provides a convincing
explanation for the general shift in the direction of contemporary paint-
ing, but also because it highlights the new function which the "tool of
perspective" adopts in expressionist art. Relieved from the task of organ-
izing an illusionist space, as the traditional one-point perspective had
done since the days of Alberti and Leonardo, it could — given the fact
that this function had been taken over by photographic representation —
aspire to other artistic aims. No longer a tool for the designation of
spatial proportions, perspective could now be used as a compositional
means for denoting "sensuous experience," inner "drives" and "inner
necessities."[57] The seemingly "distorted perspective" in the design of the
Caligari sets made ample use of this new function.

Along with perspective, line, plane, and color, the traditional means
of the painter to "imitate nature," were now turned into compositional
means of nonrepresentational functions of art. "We no longer cling to
the reproduction of nature," Franz Marc confirms the point which
Kirchner had made. Instead, he declares, it becomes the task of the artist
to reveal "the mighty laws which hold sway behind the beautiful exte-
rior."[58] And in his seminal essay on "Expressionism in Literature," Kasi-
mir Edschmid, although referring to writing, explains in quite similar
terms that the artists of the new movement would not "make a photo-
graph," but offer "a vision." "The world is there. It is senseless to repeat
it," he maintains.[59] To discover the true "essence" of things behind their
"façade" is proclaimed as the aim of all expressionist art. It is easy to see
that the story of a caring scientist who pursues his scientific obsessions
as a showman on the fairground where he unleashes his lust for murder
and revenge in and through the figure of a somnambulist is an extremely
rewarding *sujet* for such an art concept.

In the light of the antirealist stance of both the uncanny motif and
the abstract design of the film, the question must arise whether a critical
approach to *The Cabinet of Dr. Caligari* that is based on the assumption
that "film is essentially an extension of photography and therefore shares
with this medium a marked affinity for the visible world around us"
provides a useful access to the film.[60] It seems inevitable that such ap-
proach will encounter difficulties in the basic tasks of profiling the film's

sujet and assessing its style. As Kracauer's misguided search for direct reflections of the visible world in the show cabinet of *Dr. Caligari* illustrates, a wider notion of film and also of its alliance with other arts is called for if one wishes to avoid missing the very "essence" in content, form and meaning of the film. The fact that another film critic of great reputation, André Bazin, as firmly rooted in realist conceptions of cinema as Kracauer, joins the ranks of the "anti-Caligarians" by calling it a "failure" on the grounds of the "deformities of lighting and décor" only confirms this point.[61] In dealing with Romantic *sujets* and expressionist art design, a realist preconception of the art of film appears to encourage unsubstantiated speculation and misguided judgment.

The antirealist stance of expressionist painters and writers is of particular interest also in another respect. In the light of the rejection of photographic imagery and "exact representation" it is rather surprising, a seeming contradiction in terms, that a genre of expressionist film has emerged at all. However, the contradiction may help to explain why a genuine expressionist cinema developed rather late as compared with painting and literature, and it may also help to explain why *The Cabinet of Dr. Caligari* as opposed to other films of the decade with similar motifs did not seek to achieve its uncanny effects through trick photography and illusionist cinematic techniques, but first and foremost through the design of its sets. Realist-illusionist photography and abstract expressionist design are mutually exclusive. Once agreement had been reached that the film's artistic design should be in the expressionist style, it was only consequent to avoid any illusionist trick photography, but to try instead to achieve the uncanny effects through the creation of distorting sets in which the contours of windows, doors, roofs, and trees act not as representations of the visible world, but as ciphers of "sensual experiences," "inner urges," and "inner necessities."

As Eisner has observed, the expressionist sets are supported in their function by other elements of the artistic design of the film. The dark costumes of Caligari and Cesare, their sinister facial expressions as well as their brusque gestures and movements help creating the film's foreboding atmosphere. However, as Eisner also observes, "a lack of continuity," a "break in style," is apparent in the execution of these aspects.[62] Eisner bemoans that the façade of the asylum does not show any distortion. Not all chairs in the film have extended arms or legs. Some of the actors "remain locked in a naturalistic style."[63] The next expressionist film, Karl Heinz Martin's *Von morgens bis mitternachts* (From Morn To Midnight, 1920) shows a more coherent molding of all its facets in expressionist style starting with the fact that its very theme and central

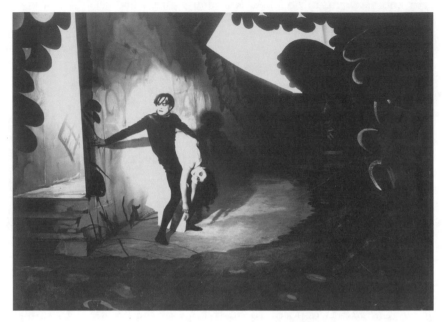

Cesare abducting Jane in Robert Wiene's
The Cabinet of Dr. Caligari (1920).

motif were of expressionist origin. Following Eisner's example, other
critics have also noted stylistic inconsistencies in *Dr. Caligari* as a draw-
back of its artistic form. But what appears as a defect at a first glance
takes on a surprising effect in the context of an interpretation that em-
phasizes the ambiguous nature of the film's main motif of the double.
The inconsistencies in the style of acting, in the design of the costumes,
in the depiction of the asylum's façade and the furniture add — involun-
tarily, one might assume — a further element of ambiguity to the film's
presentation.

There is only one aspect not showing any inconsistency in its design,
an aspect however which Kracauer does not mention at all and Eisner
refers to only in a marginal note appearing only in the English version of
her book. These are the intertitles of *The Cabinet of Dr. Caligari* in their
original form. Apparently, Kracauer and Eisner both relied on prints with
the usual typed lettering. Republished by the Deutsche Kinemathek in
Berlin in their brochure *Caligari und Caligarismus* in 1970 and rein-
serted in the tinted reconstruction of the film by the Bundesarchiv in
Koblenz in 1984, the original titles have become accessible in recent
decades. Their contribution to the artistic design of the film is signifi-

cant. Carried out in bold, irregular, hand-painted characters on a zigzag shaped background the titles indicate from the very beginning that this film departs from the usual realist or naturalist mode of filmmaking and employs unconventional artistic means to convey its theme. Their presence from the very beginning to the end challenges every distinction between a "normal" style of the frame and the "expressionist" style of the rest of the film. Through their jittery shape and the erratic design of their background the titles contribute to heightening the uncanny atmosphere of *Dr. Caligari* and creating an uneasy mode of perception. At the same time the titles also support the film's claim of advancing the medium to a recognized art form — by importing stylized letters into the titles and by achieving a unity of composition through the application of the same expressive principles to titles and images alike.

Another characteristic feature of the intertitles in *Dr. Caligari* is, as Walter Bloem has observed, their astonishing brevity. Bloem singles out the title consisting of the single word "Nacht" as "the best title ever created" in early cinema.[64] It appears twice in *Dr. Caligari,* first introducing the scene of Alan's murder and then at the start of the scene of Jane's abduction. Its "absolute brevity," Bloem remarks, and the fact that it "wraps whole scenes up in its magic" instead of repeating in a descriptive style what the scene shows anyway makes it in his view a model for effective captions.[65] The use of extremely short titles in succinct staccato style in several other instances shows that this was indeed a conscious element of stylization. The first appearance of Dr. Caligari is accompanied by a laconic "Er" (him) which in combination with the dark image of Caligari emerging from the portrayal of the huddled medieval town creates a mysterious aura around the main character from the onset. The following scene in which Dr. Caligari encounters the authoritarian town clerk is twice interrupted by the sharp command "Wait" to which Reimann has added three exclamation marks. Brevity, repetition and the exclamation marks clearly accentuate the clerk's authoritarian attitude to which Caligari will respond in a horrific form. "Brevity, force and conciseness of expression" have been identified by Walter Sokel as the characteristics of expressionist prose style.[66] In the film, the intertitles thus adopt expressionist principles not only in their graphic design, but also in their literary style.

Eisner seemingly assumed still in 1979 that the script of *Dr. Caligari* was written in an "expressionist language."[67] The publication of the original script in 1995 makes it possible to examine the case. The result is disappointing, though not unexpected. As Prawer has pointed out, the script shows no "consciously expressionist stylization" of its language.[68]

The story of Dr. Caligari was written in a calm, unemotional, impressionist idiom. The availability of the script also makes it possible to compare the titles as originally planned with those presented in the film. The difference is striking. None of the titles in abrupt telegram style referred to above was proposed by the script's authors. They preferred a conventional narrative style. The titles in staccato style are obviously an outcome of the production process, a result of the effort to extend expressionist principles across all aspects of the film's composition. Unfortunately, English-language prints of *The Cabinet of Dr. Caligari* have not preserved this feature, but have transformed the staccato style back into conventional narrative. "With it, came a scoundrel . . ." it reads instead of "Him." "I told you to wait" instead of "Wait!!!"[69] By reintroducing a calm narrative style, the titles of these prints certainly come closer to the mood of the original script by Janowitz and Mayer, but they eliminate the film production team's attempt to integrate the titles into the overall expressionist design in literary style as well as in their shape. Through their brevity and exclamatory nature and their presentation in jittery, irregular characters on jagged background the titles have been made a particularly effective and integral part of the expressionist design of the film supporting its artistic claims as well as contributing significantly to the creation of its eerie atmosphere.

The insight into the many facets and succinct functions of the expressionist design of *Dr. Caligari* should ensure that the "philistine" interpretation of the expressionist style as a means of representing the distorted vision of a madman, which has survived in monographs on expressionist film as well as in general introductions to the art of film and histories of cinema, can be laid to rest. A reading of the distortions of the sets as an expression of a madman's vision is not only challenged by the observed inconsistencies in the artistic design; such a reading is in itself the doubtful attempt to rationalize the film's uncanny nature, to find a "realist" explanation for the obsessive drives of Dr. Caligari and the murderous nightly excursions of Cesare. It means that the challenge which their representation poses to the viewer's notion of subjective identity and his or her belief in the rational organization of social life is indeed eliminated.

The Function of the Framing Device

Kracauer's diagnosis of *Dr. Caligari* as a revolutionary film turned conformist, and his and other critics' reading of the film as "a madman's fantasy," are both crucially dependent on a particular interpretation of

the framing story of the film. This interpretation relies again not so much on observations based on the images of the film, but on the "true inside story" which Janowitz had written on the genesis of the film in the early 1940s and which he had made available to Kracauer. In this document Janowitz, the scriptwriter, blames Wiene, the director, for having changed the script by putting "our drama into a 'box' that obscured its clarity."[70] The "box" — that is the framing story of Francis sitting on a park bench and telling the story of Dr. Caligari to an older man, both of whom are revealed at the end of the film as inmates of an asylum. Janowitz notes that he and Mayer "strongly protested" against this plan of turning their drama into a "tale told by a mentally deranged person," that they expressed their "dissatisfaction in a storm of thunderous remonstrances"; but it was in vain.[71] Wiene had his version of the script approved by the production department. What Janowitz withheld was the fact that the original script of *Dr. Caligari* had included a framing story, a story which would have given the film a surprisingly idyllic, peaceful beginning and ending.

The publication of the original script in 1995 makes it possible to assess the actual differences in the conception of script and film, and also the role which the framing device plays in this context. What the script shows first of all is that it was not Wiene's idea to add a framework to Caligari's story, as readers of Janowitz' and Kracauer's accounts might easily assume. The scriptwriters Janowitz and Mayer themselves had "put the drama into a box." This box however suggests a wholly different mood than the one governing the film's framing story. In the script the opening scene takes place on the terrace of a country house where Francis and Jane, happily married, entertain some guests with punch. Seeing two gypsy carts passing by in a distance, Francis remembers in a melancholic mood the gruesome story that had happened in Holstenwall. Soon he is urged by his guests to tell the story. The script breaks off with the twenty-second image. This image shows a plaque put up by the town of Holstenwall at the place where Caligari had once put up his tent. The plaque bears the inscription: "Here stood the Cabinet of Dr. Caligaris. Peace to his victims — peace to him."[72] Different from the framing story as realized in the film, this frame reassures the audience from the start that whatever the disturbances of the story it will end well. The fact that the people of Holstenwall eventually express their sympathy not only toward the victims of Dr. Caligari, but also toward Caligari himself, gives a clear indication of the authors' main intention. It was directed toward presenting "the tragedy" of an obsessed scientist rather than the critical fable of a tyrant. Both elements offer, as Prawer has pointed out, "little

support to Kracauer's thesis of a revolutionary or antityrannical tendency" of the film's initial plan.[73] Just the opposite. Comparing the original scenario with the first and last scenes as realized in the film makes it clear that Janowitz and Mayer had wrapped up the disturbing story of Caligari in a reassuring frame, while Wiene's revision made the frame very much an integral part of the disturbing story, thus achieving a different, much more unsettling impact on the audience than the original story might ever have had.

There is another contributor to the story of the framing device: Fritz Lang, who was originally commissioned to direct the film, but then summoned to do the second part of *Die Spinnen* (Spiders, 1920).[74] Lang's recollections about his contribution to *Dr. Caligari* vary. In a letter to the Deutsche Kinemathek, the last authoritative version about his involvement, he writes as follows:

> My only contribution, if one can call it one, was not the suggestion of a framing story, but to make one scene normal (the scene where the two men sit on a bench and tell each other the story).
>
> The reason for this suggestion was not to propose a change of any of the ideas of the film, but to avoid that the audience be perplexed by the new artistic conception and to give it the possibility to understand from the very beginning through the contrast between the first "normal" scene and the following that the expressionist style represents the distorted world of the insane.[75]

Lang has always insisted vis-à-vis his critics that his own films — including *Dr. Mabuse, Metropolis* and also *M* — were not made in the expressionist style. "Expressionism is just a game," was the clearly dismissive comment which he inserted in *Dr. Mabuse*.[76] It is therefore not surprising to find that Lang, far from any temptation of becoming an expressionist filmmaker, could so easily make such a bold statement about the meaning of the expressionist style in *Dr. Caligari*. Still, his comments are of interest in another respect.

If Lang, as his statement indicates, had confined his recommendation to rendering only the first scene of the film "normal" and reducing its function to providing the audience with a smooth transition into the unusual style of the rest of the film, then his plans would not have attributed the far-reaching, all-determining role to the framing device which Kracauer and other critics have assigned to it. According to Lang's plans the device would not constitute a frame at all. What he has suggested is little more than an establishing scene that offers the audience a gateway into unknown territory, into an unusual style. However, as Thomas Möller has pointed out in his discussion of the reception of *Caligari*, "no

frame can simply suspend that lion's share of the action which it sur-
rounds."[77] In other words: neither the introductory scene nor the revela-
tion at the end of the film that Francis is an inmate of an asylum wipes
out the uncanny story of Dr. Caligari. It does not make the audience
forget or suppress its experience with this story. For the same reason
Noël Carroll has maintained that in much *Caligari* criticism the framing
story has been given "too determinant a position in terms of establishing
the meaning of the film."[78] What these observations suggest is firstly to
assign a more modest role to the framing device in interpreting *Dr.
Caligari,* and secondly to establish more precisely the frame story's
relationship to the film's main story. Both these aspects have been ob-
scured for decades, partly due to Janowitz and Kracauer's misleading
information about the frame's genesis and purpose and partly due to the
fact that neither a reliable print of the film with the original intertitles
nor the original script had been available for more than half a century.

In the light of the unearthed material one can only praise Wiene that
in making the film he neither followed the scriptwriters' intention of
wrapping the story up in a highly idyllic framework, nor did he follow
Lang's recommendation which would have resulted in a degrading use
of the film's expressionist style for the purpose of depicting a madman's
view of the world. What Wiene did instead, assisted in particular by
Reimann, transcends the scriptwriters' as well as Lang's recommenda-
tions in terms of both the thematic and artistic refinement of the film's
composition. He introduced expressionist stylization into the film right
from the beginning. Before we see any image appearing on the screen,
the irregular, boldly painted letters of the opening credits and their
zigzag shaped background make it clear that we are about to watch a
film that presents its story and communicates with the audience in a
strongly stylized and thoroughly gloomy manner. As the stylized letter-
ing also embraces and even penetrates the opening scene in which the
two men are sitting on the bench preparing for the story to be told, it is
difficult to uphold any interpretation that is based on the distinction
between supposedly "normal" images in the first scene and the "mad-
man's vision" determining the rest of the film. Wiene has undermined
such a categorical distinction between the opening and the following
scenes through other means as well. The pale faces of the two men, the
ghostly appearance of Jane and the rounding evocation of spirits which
are "all around us" further contribute to creating an eerie, uncanny
atmosphere.

Strange enough, under the impact of authoritative comments and
interpretations this scene has been described as "normal" and "realist"

by numerous critics. Kaul who was the first to oppose the legend of the "revolutionary" trend of the original story, was the first to voice his doubts here again. It is undeniably to Wiene's credit, Kaul maintained, that he made the framing device "not in a pronounced realistic, but in a tempered expressionist style."[79] To be more precise and reflect the composition of the scene out of disparate, heterogeneous elements, one should perhaps characterize it as a patchwork, as a pastiche of ghostly appearances, evocative words, and expressive graphics. As an amalgam of neo-Romantic and expressionist stylization the scene assembles and displays artistic trends of its main motif and its design. Instead of displaying a mood opposite to that of the main story and thus encouraging the spectator to maintain a clear distinction between a "normal" and an "insane" perception of the world, the scene confronts the audience with the eerie atmosphere and the uncanny nature of the story to follow.

It is in the concluding episode that the audience learns that Francis, the young private tutor at the center of the film, is an inmate of an asylum whose director is none other than Dr. Caligari. The double twist turning the private tutor into a madman and the sinister showman into a caring scientist has played a key role in Janowitz and Kracauer's attempt to establish the alleged subversion of the scriptwriters' intentions. The same scene has also repeatedly served as a key to providing a seemingly innocuous explanation for the expressionist style of the film's sets. "In Caligari," John Barlow maintains, "the frame story is an explanation of the distorted images in the tale told by Francis: he is mad and the distortions are the visions of a madman."[80] On the basis of a comparison between film and script and a more than fleeting glance into the nature of expressionist abstraction, it seems that it is time to abandon both these key roles which the last episode has played for so long in the reception of the film. Reading *Dr. Caligari* as a reworking of the Romantic *Doppelgänger* motif, in which even Francis is now included in his double role as private tutor and inmate of an asylum, and noticing that the expressionist stylization is not at all discontinued when the film otherwise allegedly sets its record straight, suggests that the double twist in the final episode fulfils quite different functions. It does not subvert the main story, but heightens its uncanny effect. It does not offer an explanation for the distorted images, but increases the confusion about the perspective from which the film's story is told.

Jung and Schatzberg have observed that the double twist in the concluding episode creates considerable uncertainty for the perception of the audience. Far from providing a simple inversion of the main story's meaning, it produces a confusion about the main characters' identity,

also raising the question, "who is actually insane and who is sane."[81] The film does not provide a clear answer to this question. Through further twists in the characters' roles and further shifts of the narrational perspective in the final scene it enhances instead the uncertainties and confusions built up before. And the film leaves it open whether the final outlook of Dr. Caligari, in which he indicates that he might now be able to cure Francis, is indeed a reassuring denouement or whether it is not rather another gruesome twist of its uncanny story. By increasing the uncertainties about the identity of the characters instead of resolving them as the original script had proposed, and by confusing the perspective from which the story is told, the film pursues a compositional strategy which is much more in line with its main motif than the scriptwriters had suggested. The motif of the *Doppelgänger* with its characteristic features of a split personality, transitions from one state of mind to another and a change of attitude and perspective on the surrounding calls for a composition that supports its unstable nature. The *Doppelgänger* claims its toll, and the film responds to this challenge in style. E. T. A. Hoffmann had revised the initial version of his story on the advocate and hawker Coppelius by introducing unmarked and unnoticeable shifts in the narrational perspective of the second version. The effect achieved was significant in particular in terms of reader orientation. In its second, final version the story deprives the reader of the uncomplicated grasp of the events which the first version provides. Instead, the reader is drawn into an undifferentiated presentation of things experienced and things imagined. The story blurs the difference and distinction between experienced reality and imagination and thus challenges received notions of both. It is this same effect that *The Cabinet of Dr. Caligari* achieves through its shifts in character identification and narrational perspective in its framing story. Wiene thus composed the second, revised version of the story which Janowitz and Meier had initially supplied.

Cinema as a Ghostly Machine

In her article on "The Woman, the Monster, and *The Cabinet of Dr. Caligari*" Patrice Petro has drawn attention to instances of "narrational instability" in the film beyond the framing story.[82] And Anton Kaes has outlined the consequences which such instability has for the reception of the film and its place in cinema history:

It is exactly this fundamental ambiguity and double meaning which distinguishes this film from others and makes it an example of self-reflective modernity. By leaving it open what might be hallucination and what reality, it mirrors properties of a medium that in spite of suggesting the greatest possible proximity to nature is essentially based on illusion and a trick of the senses. Caligari's spectators are sitting in his tent just like the spectators in a movie theater. The cabinet is nothing else than the cinema itself.[83]

Petro reads the narrational instability in *Caligari* as a reflection of "male identity in crisis and male symbolic defeat" which in her view organizes "so much" of Weimar history as well as the history of the cinema of that period.[84] While such a reading of the film is too close to Kracauer's approach in terms of generalization and universal speculation on history to offer a comfortable avenue for further interrogation, Kaes's remarks do not only provide an illuminating comment on the film's making and effect, but by alluding to the medium's properties they also open up an issue of great importance for the understanding of *Dr. Caligari* and for locating this and other films in Weimar's cinema history.

Wegener had already made the point that not the film images' proximity to nature, but the illusionist qualities of cinema had inspired his experiments. Wiene went a step further. In an article in the *Berliner Börsen-Courier* from July 1922 he refers to the "unreality, the ghostly nature" of the film image.[85] To illustrate this he tells a story of some peasants in Transylvania who saw a film for the first time and rushed out of the theater in a state of panic because they believed that they had seen ghosts. The story provides an illuminating contrast to the well-known legend relating to the first screening of the Lumières' *L'Arrivée d'un Train* (Train Entering a Station, 1895). While here, as legend has it, the spectators hid under the tables because they believed that a real locomotive was approaching, the peasants knew better. They realized that what they saw on the screen were the shadows of people who were not there, the images of bodies and objects that were absent. Not the illusion of a real locomotive's approach, but the absence of people and objects which they saw frightened them.

It is quite intriguing to find that this notion of the cinema image as a shadow of absent people is shared by eminent critics of the time. In his "Reflections on the Aesthetics of Cinema" from 1913 Georg Lukács has made the absence of the living person the main criterion in distinguishing cinema from theater.[86] And Walter Benjamin's deliberations on the "loss of the aura" in his seminal essay "The Work of Art in the Age of

Mechanical Reproduction" highlight the same issue. While the stage offers the actor the chance "to operate with his whole living person," Benjamin argues, in cinema the "projector will play with his shadow before the public."[87] In more recent days Christian Metz has taken this aspect of the filmic image up and has based his definition of the cinema's *signifier* on the same observation. What unfolds on the cinematic screen, he writes, may be "more or less fictional, but the unfolding itself is fictive" in any case: "the actor, the décor, the words one hears are all absent."[88] While in theater one might see Sarah Bernhardt, in cinema "it would be her shadow" that would offer the speeches to the spectator. Metz therefore concludes that "every film is a fiction film."[89]

In the light of these distinctions Kaes' statement that Dr. Caligari's cabinet "is nothing else but the cinema itself" needs to be given a rider. It is not the cinema per se which starts its show in Dr. Caligari's tent. It is the specific notion of cinema as a ghostly machine creating shadows and doubles of absent people that is at the heart of the filmic realization of the story. Wiene has made this explicit by emphasizing that "the technology of film anticipates the depiction of unreality."[90] It is this specific understanding of the filmic medium that has encouraged a cinematic realization of the script that displays the unreal, uncanny and ghostly effects of the medium and increases these effects through twists and shifts of characterization and perspective up into the framing story. The expressionist design is an important part of this concept and strategy. A critical approach based on the belief that "films come into their own when they record and reveal physical reality,"[91] necessarily fails to note this core interest of the cabinet of Dr. Caligari. In this cabinet the filmic medium anticipates the uncanny theme, while the theme at the same time highlights fundamental features of the medium. Far from constituting an assembly of tyrants, the doubles and dummies, shadows and artificial creatures populating films of the early years of Weimar are first and foremost representatives of this notion of cinema.

Notes

[1] Siegfried Kracauer, *From Caligari to Hitler. A Psychological History of the German Film* (Princeton, NJ: Princeton UP, 1974), 67–72.

[2] Hans Janowitz, "Caligari — The Story of a Famous Story" (Excerpts), in *The Cabinet of Dr. Caligari. Texts, Contexts, Histories,* ed. Mike Budd (New Brunswick, NJ.: Rutgers UP, 1990), 224f.; S. Kracauer, *From Caligari to Hitler,* 64.

[3] Cf. in particular Mike Budd, "Introduction," in *The Cabinet of Dr. Caligari,* ed. M. Budd, 1–5; Patrice Petro, "The Woman, the Monster, and *The Cabinet of Dr. Cali-*

gari," ibid., 205–17; and Noël Carroll, "The Cabinet of Dr. Kracauer," in N. Carroll, *Interpreting the Moving Image* (Cambridge: Cambridge UP, 1998), 17–25.

[4] S. Kracauer, *From Caligari to Hitler,* 70.

[5] David Bordwell and Kristin Thompson, *Film Art. An Introduction* (New York: McGraw-Hill, 1993), 461.

[6] S. Kracauer, *From Caligari to Hitler,* 71.

[7] Rudolf Kurtz, *Expressionismus und Film* (Berlin: Verlag der Lichtbildbühne, 1926), 65 (trans. D. S.).

[8] S. Kracauer, *From Caligari to Hitler,* 71.

[9] Ibid., 67.

[10] Fritz Lang, "Ein Brief von Fritz Lang," in *Caligari und Caligarismus,* ed. Walter Kaul (Berlin: Deutsche Kinemathek, 1970), 23.

[11] S. Kracauer, *From Caligari to Hitler,* 70.

[12] John Barlow, *German Expressionist Film* (Boston: Twayne Publishers, 1982), 45, 48.

[13] H. Janowitz, "Caligari — The Story of a Famous Story," 224.

[14] Ibid., 225.

[15] S. Kracauer, *From Caligari to Hitler,* 65.

[16] Ibid.

[17] H. Janowitz, "Caligari — The Story of a Famous Story," 225.

[18] Walter Kaul, "Bestandsaufnahme 70," in *Caligari und Caligarismus,* ed. W. Kaul, 9 (trans. D. S.).

[19] Cf. Barry Salt, "From Caligari to who?" *Sight and Sound,* vol. 48 (1979): 119–23; Frieda Grafe, "Doktor Caligari gegen Doktor Kracauer oder Die Errettung der ästhetischen Realität," in F. Grafe and Enno Patalas, *Im Off. Filmartikel* (Munich: Carl Hanser, 1974), 159–62; Siegbert S. Prawer, "Vom 'Filmroman' zum Kinofilm," in *Das Cabinet des Dr. Caligari. Drehbuch von Carl Mayer und Hans Janowitz zu Robert Wienes Film von 1919/20,* ed. Helga Belach and Hans-Michael Bock (Munich: edition text + kritik, 1995), 11–45; Jürgen Kasten, "Das Cabinet des Dr. Caligari," in *Der expressionistische Film* (Münster: Maks Publikationen, 1990), 39–51; Uli Jung and Walter Schatzberg, "*Caligari:* Das Kabinett des Dr. Wiene," in *Filmkultur zur Zeit der Weimarer Republik,* ed. U. Jung and W. Schatzberg (Munich: K. G. Saur, 1992), 71–89.

[20] F. Grafe, "Doktor Caligari gegen Doktor Kracauer," 163.

[21] Michael Minden, "Politics and the Silent Cinema: *The Cabinet of Dr. Caligari* and *Battleship Potemkin,*" in *Visions and Blueprints,* ed. Edward Timms and Peter Collier (Manchester: Manchester UP, 1988), 287.

[22] Andrew Webber, *The Doppelgänger. Double Visions in German Literature* (Oxford: Clarendon Press, 1996).

[23] Kurt Tucholsky, in *Die Weltbühne,* 13 March 1920, repr. in *Caligari und Caligarismus,* ed. W. Kaul, 36.

[24] Lotte H. Eisner, *The Haunted Screen. Expressionism in the German Cinema and the Influence of Max Reinhardt* (Berkeley: U of California P, 1973), 112.

[25] A. Webber, *The Doppelgänger*, 3 and 148.

[26] Ibid., 148.

[27] Ibid., 37.

[28] Cf. in particular Gustav Meyrink's *Das Wachsfigurenkabinett* (1907), *Der Golem* (1913–15), *Das grüne Gesicht* (1916); Hanns Heinz Ewers's *Das Grauen* (1907), *Die Besessenen* (1908), *Alraune* (1913), *Vampir* (1920); and the series "Galerie der Phantasten," edited by H. H. Ewers and including works by E. T. A. Hoffmann, Edgar Allan Poe, and also Alfred Kubin's novel *Die andere Seite*.

[29] *Der Geisterseher. Aus den Papieren des Grafen O.* I. Teil, Friedrich von Schiller, II. Teil, ed. by Hanns Heinz Ewers (Munich, Georg Müller, 1922).

[30] Cf. Siegbert S. Prawer, *Caligari's Children. The Film as Tale of Terror* (Oxford: Oxford UP, 1980), 169; and Anton Kaes, "Film in der Weimarer Republik: Motor der Moderne," in *Geschichte des deutschen Films,* ed. Wolfgang Jacobsen, Anton Kaes, and Hans Helmut Prinzler (Stuttgart / Weimar: J. B. Metzler, 1993), 48.

[31] Cf. A. Webber, *The Doppelgänger*, 121.

[32] The manuscript of *Der Golem*, held by the Deutsches Literaturarchiv in Marbach, bears this title: cf. Webber, *The Doppelgänger*, 352.

[33] Paul Wegener, "Neue Kinoziele," in *Kein Tag ohne Kino. Schriftsteller über den Stummfilm*, ed. Fritz Güttinger (Frankfurt am Main: Deutsches Filmmuseum, 1984), 347–8 (trans. D. S.).

[34] Guido Seeber, "Doppelgängerbilder im Film," in *Die Kinotechnik* (1919, no. 1), 12–17.

[35] Cf. H. Janowitz, "Caligari — The Story of a Famous Story," 224, and Kracauer's account based on Janowitz script in S. Kracauer, *From Caligari to Hitler*, 61.

[36] Cf. Georges Sturm, *Die Circe, der Pfau und das Halbblut. Die Filme von Fritz Lang 1916–1921* (Trier: Wissenschaftlicher Verlag Trier, 2001), 147–65.

[37] L. H. Eisner, *The Haunted Screen*, 18.

[38] Cf. R. Kurtz, *Expressionismus und Film*, 54.

[39] L. H. Eisner, *The Haunted Screen*, 21.

[40] Unfortunately the English version of Eisner's book refers to the "diversity of planes" as a matter of secondary importance instead of the "Variation der Einstellungen" (variation of shots) as the German version reads: L. H. Eisner, *The Haunted Screen*, 21; Lotte H. Eisner, *Die dämonische Leinwand* (Frankfurt am Main: Fischer, 1980), 25.

[41] Hermann Warm, "Gegen die *Caligari*-Legenden," in *Caligari und Caligarismus,* ed. W. Kaul, 11f. (trans. D. S.).

[42] S. Kracauer, *From Caligari to Hitler*, 68.

[43] H. Warm, "Gegen die *Caligari*-Legenden," 12 (trans. D. S.).

[44] S. Kracauer, *From Caligari to Hitler*, 68.

[45] Cf. Jürgen Kasten, "Das Cabinet des Dr. Caligari," 43.

[46] *Walter Reimann. Maler und Theaterarchitekt,* ed. Hans-Peter Reichmann (Frankfurt am Main: Deutsches Filmmuseum, 1997); cf. in particular Johannes Kamps, "Reimann, Walter — Kunstmaler," ibid., 10–33.

[47] Kitty Vincke, "Anstelle einer Errettung äußerer Wirklichkeit. Entwürfe von Walter Reimann für *Das Cabinet des Dr. Caligari*," in *Walter Reimann. Maler und Theaterarchitekt*, 51–65.

[48] Cf. the "Nekrologe" by Kasimir Edschmid, René Schickele, Iwan Goll, and Paul Hatvani from 1920–1921, in: *Expressionismus. Der Kampf um eine literarische Bewegung*, ed. Paul Raabe (Munich: dtv, 1965), 173–88.

[49] K. Tucholsky, in *Caligari und Caligarismus*, ed. W. Kaul, 35–36.

[50] Herbert Ihering, in *Berliner Börsen-Courier* (29 February 1920), repr. in *Caligari und Caligarismus*, 36f.

[51] René Clair, *Kino. Vom Stummfilm zum Tonfilm* (Zurich: Diogenes, 1995), 29 (trans. D. S.).

[52] Sergei Eisenstein, "Dickens, Griffith and Ourselves" (1942), in S. M. Eisenstein, *Selected Works*, vol. III, ed. Richard Taylor (London: British Film Institute, 199), 198; "The Eighth Art. On Expressionism, America and, of Course, Chaplin" (1922), in S. M. Eisenstein, *Selected Works*, vol. I, ed. Richard Taylor (London: British Film Institute, 1988), 31.

[53] S. Eisenstein, "The Eighth Art. On Expressionism, America and, of Course, Chaplin," 31.

[54] J. Barlow, *German Expressionist Film*, 17f.

[55] Cf. Ernst Ludwig Kirchner's "artistic credo," in Lothar-Günther Buchheim, *Die Künstlergemeinschaft Brücke* (Feldafing: Buchheim Verlag, 1956), 174.

[56] Ibid., (trans. D. S.).

[57] Cf. the "Programme of Die Brücke" from 1906, in *Art in Theory 1900–1990*, ed. Charles Harrison and Paul Wood (Oxford: Blackwell, 1992), 67f.; and Wassily Kandinsky, "Über die Formfrage," in *Der Blaue Reiter*, ed. W. Kandinsky and Franz Marc, repr. (Munich: Piper, 1984), 142.

[58] From an article in *Pan* from 1912, quoted in Wolf-Dieter Dube, *The Expressionists* (London: Thames and Hudson, 1972), 132.

[59] Kasimir Edschmid, "Expressionismus in der Dichtung," in *Expressionismus. Der Kampf um eine literarische Bewegung*, ed. P. Raabe, 95 and 97 (trans. D. S.).

[60] Siegfried Kracauer, *Theory of Film. The Redemption of Physical Reality* (London: Oxford UP, 1978), ix.

[61] André Bazin, *What is Cinema?* (Berkeley: U of California P, 1967), 109.

[62] L. H. Eisner, *The Haunted Screen*, 25.

[63] Ibid.

[64] Walter Bloem, "Die Schriftsätze," in W. Bloem, *Seele des Lichtspiels* (Leipzig: Grethlein, 1922), 47 (trans. D. S.).

[65] Ibid., 49 (trans. D. S.).

[66] Walter Sokel, "Die Prosa des Expressionismus," in *Expressionismus als Literatur*, ed. Wolfgang Rothe (Bern: Francke, 1969), 157 (trans. D. S.).

[67] Cf. Lotte H. Eisner, "Der Einfluß des expressionistischen Stils auf die Ausstattung der deutschen Filme der zwanziger Jahre," in *Paris — Berlin: 1900–1933* (Munich: Prestel, 1979), 266.

[68] S. S. Prawer, *Caligari's Children. The Film as Tale of Terror*, 197.

[69] Cf. the transcript of the National Film Archive's print in Robert Wiene, *The Cabinet of Dr. Caligari* (London: Lorrimer Publishing [Classic Film Scripts], 1972), 43 and 47. In current American prints the phrasing is shorter. However, it retains the narrative style of the English version and thus also fails to reproduce the expressionist staccato style of the original version.

[70] H. Janowitz, "Caligari — The Story of a Famous Story," 237.

[71] Ibid.

[72] *Das Cabinet des Dr. Caligari. Drehbuch von Carl Mayer und Hans Janowitz zu Robert Wienes Film von 1919/20*, ed. H. Belach and H.-M. Bock, 110 (trans. D. S.).

[73] S. S. Prawer, *Caligari's Children. The Film as Tale of Terror*, 169.

[74] Cf. Rolf Aurich, Wolfgang Jacobsen and Cornelius Schnauber, eds., *Fritz Lang. His Life and Work. Photographs and Documents* (Berlin: Filmmuseum Berlin, 2001), 48.

[75] Fritz Lang, "Ein Brief von Fritz Lang," 23 (trans. D. S.).

[76] In the currently available English-language version of *Dr. Mabuse, the Gambler*, the dismissive comment is not only made by another character, Countess Tolst, but it is also directed against another avant-garde style of modern painting, not expressionism, but cubism: "Don't hold me responsible for the fantastic decorations," the Countess remarks to the incoming chief of the police, "they are my brothers'. He's a cubist." Such a shift makes it possible that the film is advertised as "Lang's silent expressionist classic."

[77] Thomas Moeller, "Der Blick zurück auf *Dr. Caligari*. Die Rezeption einer Legende," in *Walter Reimann. Maler und Theaterarchitekt*, ed. H.-P. Reichmann, 70 (trans. D. S.).

[78] N. Carroll, "The Cabinet of Dr. Kracauer," 19.

[79] W. Kaul, "Bestandsaufnahme 70," 9 (trans. D. S.).

[80] J. Barlow, *German Expressionist Film*, 35.

[81] U. Jung and W. Schatzberg, "*Caligari:* Das Kabinett des Dr. Wiene," 83.

[82] P. Petro, "The Woman, the Monster, and *The Cabinet of Dr. Caligari*," 212.

[83] A. Kaes, "Film in der Weimarer Republik: Motor der Moderne," 47f. (trans. D. S.).

[84] P. Petro, "The Woman, the Monster, and *The Cabinet of Dr. Caligari*," 206 and 215.

[85] Robert Wiene, "Expressionismus im Film," in *Berliner Börsen-Courier* (30 July 1922), repr. in *Das Cabinet des Dr. Caligari. Drehbuch von Carl Mayer und Hans Janowitz zu Robert Wienes Film von 1919/20*, ed. H. Belach and H.-M. Bock, 151 (trans. D. S.).

[86] Georg Lukács, "Gedanken zu einer Ästhetik des Kinos," in *Kino-Debatte. Texte zum Verhältnis von Literatur und Film 1909–1929*, ed. Anton Kaes (Tübingen: Niemeyer, 1978), 113 (trans. D. S.).

[87] Walter Benjamin, "The Work of Art in the Age of Mechanical Reproduction," in W. Benjamin, *Illuminations* (London: Pimlico, 1999), 223.

[88] Christian Metz, "From *The Imaginary Signifier*," in *Film Theory and Criticism*, ed. Gerald Mast, Marshall Cohen, and Leo Braudy (New York and Oxford: Oxford UP), 1992, 731.

[89] Ibid.

[90] Robert Wiene, "Expressionismus im Film," 151 (trans. D. S.)

[91] S. Kracauer, *Theory of Film*, ix.

Film as Graphic Art:
On Karl Heinz Martin's
From Morn to Midnight

Jürgen Kasten

"M ORGENS NOCH AM SCHALTER SITZEND, mitternachts das Hirn
verspritzend" — thus mocked the famous theater critic Alfred
Kerr in 1919 when reviewing the play *Von morgens bis mitternachts*
(From Morn to Midnight) by Georg Kaiser at the Berliner Deutsches
Theater. His rhyming couplet was followed by the verdict that *From
Morn to Midnight* was nothing but an ambitious film. One might assume
that this description indicated that the work was fast-paced, characterized
by rapid changes of scene and therefore reflecting and conveying struc-
tural aspects of the fragmented perceptions of a big city dweller. Not so.
To Kerr, film meant an "imagination of tricks which sound profound
without being profound."[1] The favorite critic of the cultural bourgeoisie
saw film as the epitome of technical tricks, acceleration purely for the
sake of speed, a camouflage and an illusion which moved and seduced
the masses. These attributes ascribed to cinema through Kerr's descrip-
tion of a innovative contemporary work cannot be dismissed entirely. Yet
even in 1919/20 the evaluation already seemed strangely retrograde,
anachronistic and not at all appropriate for the development of modern
media and drama.

The means and devices used in a film, which determine the essence
of the medium cinema, are indeed speed, tricks, effects, faked emotions,
dazzling fantasy, simplified relief, naiveté, even kitsch. All these descrip-
tions were taken from different contemporary evaluations of the play
From Morn to Midnight.[2] A film adaptation, therefore, seemed all but
inevitable. Furthermore, there were other interesting aspects in terms of
a mass media exploitation: a play surrounded at times by scandal and by
1919 performed only reluctantly by a famous author featured even in the
fashion magazine *Elegante Welt;* a play with a racy plot, with money and
erotic seduction, escapist fantasies, eccentric bohemian big city life style,
a smattering of crime, turbulence, and rapid changes of scene. What Kerr

failed to mention was that film was keen on material and aesthetic fashion, and tried to incorporate them into its narrative, presentational and therefore also its entertainment conventions. Around 1920 this was also true of expressionism, the obvious features, topoi, and personalities of which had become fashionable. At the beginning of 1920, expressionism was en vogue. This was illustrated by the commercial success of *Das Cabinet des Dr. Caligari* (1920) as well as the application of the expressionist label to artisan and entertainment areas created in its wake.

In 1920, Georg Kaiser was the most famous representative of expressionist theater. His works *Die Koralle* (1917), *Gas* (1918–20), and *Der Brand im Opernhaus* (The Fire in the Opera, 1919) were among the most popular plays in Germany. At the end of 1919, expressionist plays had made their way onto the big and important stages in Germany. Some significant contemporary plays articulated, perhaps naively and idealistically, but with immense fervor, the necessity for change based on humanist principles, even to the extent of baring one's soul. Works such as Ernst Toller's *Die Wandlung* (The Transformation) had an impact on even the most normal of theater audiences. *From Morn to Midnight* is an expressionist program drama which dates back to prewar times, and yet it appears in retrospect to be the most "timeless" work of expressionist theater. Even though *From Morn to Midnight* no longer seemed relevant to contemporary topics, from 1920 onwards it made its way from the first performances in Munich, Frankfurt, Berlin, and Vienna to provincial capitals such as Dortmund, Hannover, or Zurich too. Because of the success of expressionist plays with an audience which could also potentially be won over by ambitious art cinema, the natural conclusion would be to have such a work put onto the big screen by a well-known expressionist film director. Expressionism, which had been rediscovered through *Caligari*, finally seemed to have found an opportunity to be consistently translated into cinema, both ennobling the medium per se and presenting it as an attraction to the cultural bourgeoisie.

Karl Heinz Martin's film production *From Morn to Midnight* (1920) was his first foray into the mass medium. In 1920 he was considered one of the best directors of expressionist theater. By mid-1919 he had co-founded the *Tribüne,* an avant-garde theater for modern drama. On 30 September 1919, he celebrated a massive success with the first night of Ernst Toller's play *The Transformation*. This production heralded the final breakthrough for expressionist theater in Berlin. Martin became the rising star of the Berlin stage, and after only a few months at the small *Tribüne,* the Berlin theater magnate Max Reinhardt made him the principal director. A few months after making *From Morn to Midnight,* he

staged Kaiser's *Europa* in a monumental production at the Grosses Schauspielhaus in Berlin. At that time, Martin's ability to combine dazzling form and exaggeration with strict choreography and precise enunciation made him the most accomplished director in expressionist theater. Herbert Ihering, one of the most perspicacious and productive contemporary critics, described it as follows: "Martin has shaped the scream, the exultation, with an elementary innate significance. Martin has grabbed and mastered expressionism in its essence, where it is immediately recognized, obsessed by its own intensity, where it goes wild, head over heels, overheating in its own energy."[3]

By September 1918, Karl Heinz Martin had already directed a production of Kaiser's *From Morn to Midnight* at the Hamburg Thalia Theater. Ralph Arthur Roberts, who was to become famous as a sound film comedian, played the cashier, and Roma Bahn played the girl from the Salvation Army, a role she would later reprise in the film. Martin staged the play as a "spiritual experience, totally detached from reality."[4] He put special emphasis on directing his actors in a way which would "put everything into the unreal, something which was particularly conveyed through the puppet-like acting."[5] The stage set, designed by the author himself, was "in its gray details, which had been put in front of a black background, reminiscent of the terribly distorted black and white prints of modern graphics."[6] This stage production of *From Morn to Midnight* was dominated by graphic concentration and a distinct black and white contrast. Later, Martin was to further simplify and radicalize this concept in the film production of 1920.

Like Martin, the production company Ilag-Film was new to the film business. It was founded when inflation had started to accelerate and speculators tried to save or even increase their money by investing in the more reliable commodity of film. The production of consistent expressionist films was to a large extent abetted by the fact that, in an annual output of five hundred films, experiments, outsider aesthetics and outsider topics also had a chance of finding a producer. This chance was greatly increased if they conformed to the new artistic standard of a distinctly stylized and antinaturalistic film, a standard canonized by the success of *The Cabinet of Dr. Caligari*. Nevertheless, these film productions obviously still needed to show commercial potential as well.

Karl Heinz Martin partly accepted these demands, but also circumnavigated them, when the most famous youth actor in expressionist theater, Ernst Deutsch, who since 1917 had also appeared on the big screen, was cast in the title role. Furthermore, he gave the female lead to Erna Morena, one of the best known film actresses of the 1910s. The

whole point of this casting constellation was that Deutsch, as the cashier, embodied the character's rapid aging to the point of senility, and that Morena was cast as a caricature of her previous roles playing a lady in the melodramas of the early teens.

According to the correspondence with his publisher Gustav Kiepenheuer, Kaiser was not particularly interested in the film, although he wrote an exposé for it. A fair amount of script inquiries and propositions were sent to him, some were even publicly announced. The dramatist, who was in constant financial trouble, saw the adaptation of his works mainly as an additional source of income. He was not concerned with new ideas for staging his plays or developing different points of view, nor with their far-reaching popularization. It was only reluctantly that he took part in a script conference for another Gloria Film project in 1920. His interest in the cinema adaptation of one of his most famous works, however, noticeably increased when the producer Rudolf Kurtz, who was also well-known in literary circles, promised him that Karl Heinz Martin would be at the helm.[7] Kaiser made a preliminary contract with Kurtz and wrote to his publishers: "If Martin is the director of my films, we will have to sign a contract with Ilag."[8] He quite obviously appreciated Martin. The question of who was actually in a position to grant adaptation rights, and further royalty differences between the author and his publishers, meant that the contract between Kiepenheuer and Ilag was not signed until shortly after shooting had started in May 1920. For that purpose Martin had invited Kaiser to come to Berlin on 23rd April. A month later the director told the author that shooting had finished. The final version was completed in June 1920.[9]

The play tells the story of a cashier who, when intoxicated by the encounter with a beautiful lady, embezzles some money and leaves his stuffy, petty bourgeois world for the big city B. Here, he wants to use his new material prosperity to enjoy "the rush of impending great events." When he realizes that "one always buys less than one pays for, and that the more one pays, the lesser the goods become,"[10] he chooses his own death as the final stage of his new life. In this chain of cause, effect, and consequence, Kaiser describes the individual attempt of a petty bourgeois subject to break out and gain a human existence. However, the escape from this claustrophobic world, caught up in norms and rituals, to a seemingly sensual, upper-class existence, stimulated and directed by money, does not lead to the desired aim of a human way of life. The concept of this human way of life, however, remains strangely vague throughout.

In 1921, Kaiser formulated a confusing, yet in the play itself concisely translated intention as to the desired effect of his work. He did not want to stage the idealistic escape attempt striving for human values, but the "misconception of being human as an individual, a no, a bend in a road leading straight into a wall: that is *From Morn to Midnight*."[11] According to this point of view, the expressionist utopian dream of escape, as exemplified by the cashier, is basically rendered *ex negativo*. Kaiser all but trashes the idea of an individual escape attempt from within an unchanged society. He does not necessarily criticize the cashier's failed attempt to stage an escape with obvious yet inappropriate means and aims, but the virtual imprisonment in the social circumstances. Above all, however, Kaiser criticizes the central defining value of capitalist society: money. Its seductive power and its inherent mythology are copiously illustrated, but the underlying economic correlation is almost totally excluded.

Martin and his coscriptwriter, producer Herbert Juttke, showed an astonishing lack of interest in rendering the motifs and the conflict of the play in the kind of spectacular cinematic incidents one might expect. Furthermore, the authors avoided supplying a psychological background to the conflict of the fraudulent cashier, a factor which distinguished *street films* such as *Die Strasse* (The Street, 1923), *Phantom* (1922) or *Asphalt* (1928). Here, a petty bourgeois hero is lured by a seductive woman into the seedy pleasures of a big city, falls victim to his circumstances, sees the error of his ways, and returns to the bosom of his family. Kracauer, however, made the mistake of comparing *From Morn to Midnight* to these *street films*. His assumption that the disillusioned cashier ultimately commits suicide in order to escape the police[12] complies neither with the text of the play nor the film itself. It is quite possible that he never actually watched *From Morn to Midnight* and only knew it from a few references in contemporary literature, or just barely remembered this strange film when in exile in the early 1940s.

Silvio Vietta, a literary critic and contemporary expert in expressionism, expected a film adaptation of *From Morn to Midnight* to keep the superficial cinematic promise the play seemed to make. His idea aimed at putting the main character into "the concrete environment of the big city amusement and pleasure industry," i.e. to allow the cashier to lose himself in Alexanderplatz, in seedy side street bars and in the busy traffic in Potsdamer Platz, and to record this in kinetic images which suggest the disparity of reality and frenzy. In so doing, the "pace of a metropolis which had been portrayed in a naively fascinating way in previous *big city films*," should be illustrated and used "as a factor of the dissociation of

the ego." Karl Heinz Martin made a point of not following this obvious, yet fairly superficial leitmotif, however. Vietta criticized this as "uncinematic," and as "contradicting the immanent laws of the medium."[13]

In the process, Vietta overlooked the fact that Martin utilized the cinematic possibilities of defining seemingly disparate experiences with superimposition, double exposure, split screen or stop motion in a way which was particularly innovative and left the possibilities of the theater far behind. He also used the laconic quality, the pace, simultaneity and abrupt changes of scene offered by a film presentation which can be accelerated at will. He was obviously interested in trying out cinematic devices capable of expressing the visionary spiritual effect which expressionist theater strove for, in order to visualize and describe the workings of the soul and to demonstrate a deeply felt emotion beyond the linguistic expression on which theater was reliant. In order to achieve this, the medium of film obviously offers interesting representational techniques. Even more interesting than the deployment of these techniques to represent the introspective conflict of the protagonist, however, is the visual style concept of *From Morn to Midnight*. Martin chose principles which consistently refer to and use the characteristic properties of the medium film. These include two-dimensionality, hence the conscious avoidance of the suggestion of a three-dimensional space, the immense contrast of black and white and the graphic line as the principle of the construction of space and matter. Hardly ever before and very rarely afterwards has a director taken a piece of narrative cinema and put it into the tradition of the fine arts with such emphasis, or tried to transpose their creative means into the new visual medium with such consistency.

The seven successive acts which Martin used in his Hamburg stage version of the play are dissolved into parallel scenes in the film production. The narrative structure of the play is thus fragmented. Two acts in particular, those taking place in the bank and in the hotel with the lady, are put into parallel montage. The two scenes added by Martin and Juttke, in which the son buys a painting in a bric-à-brac shop, are also edited in a parallel plot development. The director makes use of a particularly interesting cinema technique when he shows a flashback in which the cashier, just before he steals the money, remembers his family life. The split screen shows a member of the family which the cashier simultaneously parodies in the other half. After the crime the cashier's actions are also told through parallel narratives. In the second part of the film, every stage in the cashier's big city flight is also accompanied by other scenes, first those of the police chase and then the appearance of the Salvation Army. By dissolving the different stage units, Martin not

only achieved a cinematic narrative structure, but also one which comments on the nucleus of the plot. It is unfortunate, however, that this is interrupted by the adverse effect caused by numerous explanatory intertitles, which seem to have been inserted by the production company.

In the film, the stages of a seemingly fascinating life in a big city include a gambling den in a cellar bar whose patrons are obviously petty criminals. Living in a twilight world and with their physical deformities they stand in glaring contrast to the bourgeois world of the lady and the bank manager, but also to the petty bourgeois world from which the cashier and his family originate. He can only escape from this underground trap with the help of the Salvation Army girl, who in turn coldheartedly betrays him to the police in order to collect the reward that has been placed on his head. This betrayal is anticipated in a deviation from the original play. Martin used a number of superimpositions of the female characters wearing death masks. The motif of the cashier's own anticipated death appears in the snow field scene, a seemingly weightless interval which marks the transition from an ordered life in a small town to the frenzy of a big city. This is the first instance in which the cashier follows a hallucinated apparition. He catches sight of a skeleton in a tree and seeks a conversation. In this scene, the skeleton throws back the cashier's hat in a gesture that is both joking and inviting. When the hat appears in the tangle of the candelabra in the final scene in the Salvation Army bar, however, it fulfils a different function. The cashier finally sees it as a portent of death, as the final stage of a movement which was characterized by a frantic standstill. On realizing this he commits suicide, and not, as Kracauer assumed, through fear of imprisonment.

On the one hand, the transposition and frequent use of the death motif is an indication of the cashier's distorted perception. Its use as a leitmotif, on the other hand, also indicates the stages of recognition. In this context, the cashier's relationship with women is particularly important. He suspects the "meaning, aim and purpose" of human existence in such relationships. Where "girl and man" live together, they create "plenty within the void." "Girl and man" signify the "completed beginning."[14] When fixation with the value of money prevent the cashier from discovering the desired renewal of human dignity, the faces of the women he meets along the way all turn into death masks, even though he believes he can perceive in them models of a dignified life. Particularly drastic is Kaiser's illustration of the betrayal of the Salvation Army girl with whom the cashier wants to start a new life. Since her own values are also materialistically orientated, the cashier's hallucination turns her face into a dead man's skull.

Subjective camera perspectives, mainly from the cashier's point of view, and visionlike superimpositions and double exposures illustrate his exaggerated perception. Martin used common cinema techniques which, with their immediate, almost banal contrasts, fit neatly into the concept of image and décor, which itself works with a combination of deliberately simple forms and dazzling contrasts. Lotte Eisner's evaluation, however, which regards the clouding of the cashier's perception as nothing short of bizarre, is incorrect, or rather exaggerates the cinematic concept: "We can see objects and people as they are conceived by the cashier, whom chance has torn from his honest, humdrum world and who is led astray by vague, ambitious yearnings. The forms take on importance for him, become gigantic and . . . lack proportion or any logical connection with the context."[15] She described it as a fantastic exaggeration, which in fact contradicts Martin's attempt to show a simplified structural relationship between people, money and objects. The director was not interested in the bizarre, as found in films like *Caligari* or *Genuine* (1920).

"The film image has to become graphic." This motto, attributed to Hermann Warm, one of the set designers of *Caligari,* was supposed to authenticate the decorative concept of the film.[16] Unfortunately, this convenient formula is responsible for the fact that the actual décor principles realized in *Caligari* went by and large unrecognized. In 1920 the architect H. de Fries gave an appropriate description in an article in an architecture magazine: "Concrete space, colorful physical effects, emphasized evaluations of perspective. Modeling of light and shadow, dynamic composition, in short: three-dimensional space as a highly vivid and active organism." By contrast, the concepts of décor and image in *From Morn to Midnight* seem almost diametrically opposed, despite a partially shared basic gesture which uses deformation and simplification: "colorless and nonphysical effects, no evaluations of perspective, but simply the effect of a two-dimensional background."[17] If Warm's motto of expressionist film architecture ever found consistent expression, it was not in *Caligari* but in the décor by Robert Neppach for *From Morn to Midnight*. Only there did two-dimensionality fulfil the role of a stylistic and structural principle.

In *Caligari,* some relics of naturalistic form deliberately remained in place, and despite all the distortions, space was still suggested as having three dimensions. In *From Morn to Midnight* they were all but erased. Rudolf Kurtz later described it as follows: "Figurines, landscapes, interior furnishings — everything is geared toward a linear graphic effect, toward the effect of movement of surfaces and lines, light and darkness."[18] *From Morn to Midnight* is characterized by forms of décor in which static

shapes dominate. They are basically reduced to very simple lines which no longer suggest any kind of three-dimensional space. They are also no longer capable of describing a typical, individual living space. Instead, they are intent on showing abstract movement, typical structures of the outer world and different states of inner recognition in linear relationships. By deliberately avoiding any kind of three-dimensional illusion, *From Morn to Midnight* undoubtedly provoked cinema audiences and their viewing habits. For although film is a two-dimensional medium, it has always tried, especially in its popular manifestations, to develop techniques for a subtle three-dimensional layering of the image. German silent cinema classics in particular have revealed in outstanding works such as those directed by Paul Wegener, Fritz Lang, or F. W. Murnau a wealth of three-dimensional, perceptible forms of representation. Even though *From Morn to Midnight* also displays its creative designs within the image, its parameters are not of a three-dimensional but clearly of a linear-graphic nature.

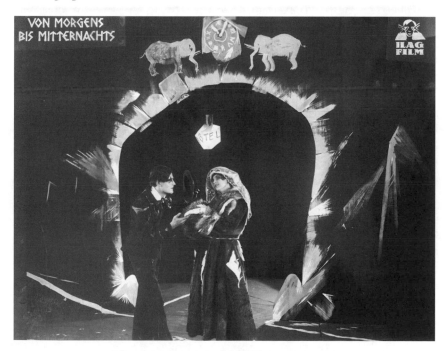

Hotel entrance in Karl Heinz Martin's
From Morn to Midnight (1920).

All exterior locations, such as the hotel entrance, the town gate, the suggestion of a street with a streetlight are sketched out with a few glar-

ing white lines and deliberately left two-dimensional. The décor is enveloped in the darkness of the studio, which represents the nondescript blackness of the surrounding world. Indoors, white contours clash with the black wall surfaces they delineate. They mark the contrast between light and darkness which the exterior décor has created by isolating a location within the nondescript blackness of the surroundings. Whenever a distorted, three-dimensional impression is created, such as a busy, dazzling hatching that marks the edges of suggested walls, it is immediately destroyed. The white hatching is so glaring that it tears up three-dimensional space rather than defining it. The negation of three-dimensional space is depicted by the interiors of the bank, their dissolved material structure lacking any kind of surrounding, symbolizing a dehumanized, flat materiality. The abstract nature of an exploitative bank is underlined through grotesquely exaggerated objects such as the chicken wire at the cashier's desk, the gigantic, angular telephone or the glowing bell buttons used by the director to ring for his personnel.

There are only two exceptions to the principle of two-dimensional décor and image: the snowfield scene halfway through the film and the Salvation Army premises in the final scene. The escape into the big city via the snowfield seems to hint at the possibility of development. However, the flattened depth of the three-dimensional space, the sharp black and white contrast and the coldness of the wintry motif already turn this seemingly hopeful scene into an allusion to the cashier's downfall. Similarly in the final scene at the Salvation Army, three-dimensionality is never quite achieved. Once more, space is not what it seems to be. The black foreground is immediately followed by the white background in such a way that any illusion of depth is impossible. The mere suggestion of three-dimensionality in the Salvation Army bar cannot provide the cashier with the fulfillment he was hoping for. Only the lost and lonely white cross stands out for him. Only in death can he perceive the world as three-dimensional.

The material world of *From Morn to Midnight* seems like a hallucination and as such is characterized as deliberately banal as well as fragile, unfinished and unstable. The architect Robert Neppach used the dazzling simplicity of the painted décor to illustrate the nature of things, social and human relationships. Here, the bank reveals itself as a life-sucking dungeon, the fence at the cashier's house accentuates a prison, itself trapped in its own location. The unreal, painted rays of light on the hotel staircase leading to the lady's room simultaneously illustrate desire and the absence of any kind of basis for it. Central characteristics of expressionist painting and graphics, such as the demand for abstraction,

condensed emotional tension and simple motifs and forms, influenced Neppach's décor to a far greater extent than the rather ornamental décor of *Caligari*.

The architecture magazine mentioned earlier described the décor of *From Morn to Midnight* as "defining the processes of real life [. . .] to such an extent and with such power that they were incredibly exaggerated and rendered unreal in their ecstatic accumulation."[19] The possibility that very simplified and extremely exaggerated cinematic representation could render more structures of reality visible than a realistic depiction has to this day been ignored. Strong contrasts, distorted forms and perspectives are, however, capable of indicating structures of reality without depicting a different, fantastic nature, and condense them to such an extent that "the fabric of the outer world" becomes discernible.[20]

Light, costume and makeup design corresponded to the graphic concept and the sharply contrasting emphasis on light and darkness. Even the cashier's clothes, contoured with stripes of white paint, seem torn, appearing to mirror his mental constitution. Even if the characters have not quite discarded their "organic form" completely, Rudolf Kurtz had a point: they "are parts, formal elements of a decorative thought process, they are part of a three-dimensional image, are torn by flecks of light and stripes which have been painted onto them."[21] The cashier's makeup also complies with the graphic black and white contrasts. His white face, his panda eyes, the black contour lines along his brow and the bridge of his nose and a rampant moustache characterize a person who is socially deformed and yet thirsty for life. The remaining characters also have their respective social characteristics painted on their faces in drastically emphatic and exaggerated physiognomic detail.

Even the most dazzling light effects are not used to form three-dimensional space but accentuate lines and details of graphic image composition in accordance with the décor of the set. The use of light in *From Morn to Midnight* only amplifies the principles that have already been formulated in the decorative forms. Light is mainly employed to exaggerate once more the bright white lines and their flat contours. Shadow contrasts are mostly avoided, since they appear three-dimensional, cover white lines and require a stronger basic light which in turn would soften the desired contrast between light and darkness. Maybe the filmmakers tried to avoid any similarities to shadow-laden, eerie-fantastic films such as *Der Student von Prag* (The Student of Prague, 1913), *Der Golem* (1915), or even *Caligari*.

The main stylistic problem in almost all explicitly antinaturalistic films is how the actor, who can only artificially exaggerate his natural

physiognomic traits to a certain extent, can be integrated into the image composition. In no other film in the tradition of narrative cinema outside the fantasy genre has this been done so obviously as in *From Morn to Midnight*, where the actors have also formally become part of the concept of décor and image. Ernst Deutsch in the role of the cashier dissolves his movements into tense and then suddenly explosive gestures; he emphasizes, lengthens, or accelerates single details and never presents an organic, overall sequence of movements. The black, mimic lines on his face, mainly his cheekbones and his eye sockets, which essentially characterize the gaunt face of the actor, are painted onto a chalky white face, giving him the appearance of a wood cutting. The ambivalent role of the cashier; the change from an initially geriatric appearance, full of burning inner intensity in the first part of the film, to a younger exterior filled by the advancing senility of the desired inner fulfillment, was portrayed to its fullest extent by Ernst Deutsch. His amazing ability to "age so suddenly and terribly"[22] had already been noted in his rebellious youthful roles in expressionist plays. Deutsch's manner of acting almost totally deconstructs a formalistic, normal sequence of movements. His shoulders are tensely raised, so that his head seems to be planted directly onto his body, his arms are limp and his whole body posture is hunched. All the more striking then are his ecstatic eruptions, such as during the lady's appearance, when his head suddenly jerks out of his hunched shoulders to grab her hand with greedy, lustful desire.

Again and again the inorganic movements of the cashier display sudden acceleration. They tend to reappear at regular intervals. The mechanization of his movements becomes very obvious, without suggesting that he is a puppetlike figure, guided by strange powers. It is meant to illustrate the structural aspects of inner experience in rhythmically recurring gestures. Thus, every time the cashier meets a female character and her face is superimposed by a skull, he displays his shock by putting his deformed, clawlike hand to his head. Other rhythmically recurring gestures appear in Deutsch's fidgety fingers and hands. He counts money in a tense, nervous manner; he greedily touches the lady's hand with his own distorted claw; he steals the money, digs nervously in the snow to obliterate his tracks, or timidly touches the wooden leg of a prostitute. It is very unusual for narrative cinema to display such formalistic, rhythmically recurring and symbolic gestures which are capable of reflecting dramatic stages and experiences in a radically simplified and exaggerated manner.

Karl Heinz Martin also used images composed with the help of cinema technology to a great extent, whenever they could be integrated

into the artificial style concept, such as the footage of the six-day race, with the rush and ecstasy of the spectators addicted to entertainment. Different camera perspectives show several terraced rows of seats in historical structure, where the social stratum of the privileged class, the bourgeoisie, the petty bourgeoisie, and the proletariat is illustrated and the accelerated rhythm of the movement of the camera suddenly becomes a vertiginous ride in a paternoster. The race itself has an accentuated cinematic form. The cashier says in Kaiser's script: "I see a circle and a gaudy wavy line."[23] It is displayed in a totally darkened room which illustrates an abstraction of a racetrack as an elliptical warped strip of dazzling light. The cyclists appear racing through this set in laplike intervals. The whole scene was filmed through a mirror or a convex lens, giving an unreal, distorted impression of the race. Lotte Eisner described this scene as follows: "The cyclists are transformed into an anamorphosis, they are stretched and through the magic of light and with the help of a distorting lens they become sparkling facets."[24] She was the only one to notice the groundbreaking technique of this scene, in which the radical stylization of the image through the use of cinema technology anticipated the camera and montage experiments of avant-garde films by Walther Ruttmann and Hans Richter.

This montage, which consistently avoids fluent editing techniques such as fade-in and fade-out, gives the film the same jerky, bumpy rhythm that is evident in the movements of the fugitive cashier. This is particularly obvious in the export edition found in Japan, which for decades was the only available copy. There are no intertitles. The film thus displays a hard, disjointed, yet mercilessly progressive, almost delirious rhythm. Unfortunately, this particular edition of *From Morn to Midnight* which manages to render the main character and the play sympathetically, has only been shown far away from its initial place of reception in Germany. The Filmmuseum in Munich only recently rediscovered the censor card of the film, which states that the version intended for release by the production company contains over 120 intertitles, which often seem out of place in their awkward retelling of different aspects of the plot.[25] Not only do they eclipse the visual rhythm, they also compromise the effect of the image.

Being an adaptation of a stage play, *From Morn to Midnight* is often regarded as filmed theater. The distinctly flat, painted décor, the primitive forms and radical simplifications of which seem to resemble a stage set where the scenes of the action are only sketched out with an assortment of lines, Ernst Deutsch's exaggerated acting style, which strongly emphasizes mimic and gesticulatory details, and the arrangement of the

different scenes in tableau form seem to point toward theatrical means of production. Indeed, Martin did to some extent make use of it in its exterior form. Yet what remains unnoticed in such an evaluation is the way in which Karl Heinz Martin adopted these means in the context of a different medium in order to mark a particular cinematic texture. He picked up the latent antinaturalism resulting from the two-dimensionality and the restrictions of the black and white medium and elevated them to the visual style principle of the cinema adaptation of *From Morn to Midnight*. All means of representation, spatial and decorative design, light, actors and their interpretation of the roles, were subjected and adapted to this style and modeled accordingly. It was a radically simplified concept which concentrated on linear effects and contexts. The result was a cinematic texture which basically marked the limit of artificial stylization in narrative cinema. Yet despite the stylistic coherence, the audience did not want to follow. *From Morn to Midnight* may have enriched the development of cinema-aesthetics, especially that of image composition and stylistic coherence mentioned above, nevertheless a public showing never took place in Germany in the 1920s.

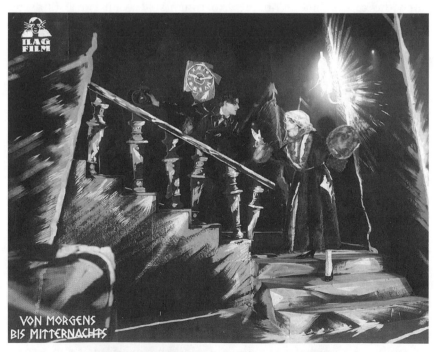

The lady and her son in Karl Heinz Martin's
From Morn to Midnight (1920).

Rudolf Kurtz blamed the radical use of real human beings as a design element in the construction of the film image for the reluctance of cinema owners to show *From Morn to Midnight:* "This moving around of human beings which only serve as formal elements, obstructs any access to the film."[26] The effect of coldness and strangeness resulting from the unusual, artificial formal restrictions, the denial of three-dimensionality and object arrangement as well as the similarly inorganic and rhythmic-mechanical acing style was a deliberate calculation. It sums up rather precisely the intentions of this production: to illuminate frozen and grotesque images of society with the same dazzling light as desperate, and hence equally distorted, attempts to break out of a world which is unwilling to change. The fact that *From Morn to Midnight* was withheld from the contemporary viewing public is certainly not due to the rigid cinematography, which corresponded with the conventions of cinematic narrative at the time, neither can it be explained by mistakes in different takes, where the camera jumped the axis of action. It was the radical stylization of décor, actors and light, as well as stylization characterized by cinematography and montage in a film dominated by natural motifs, which seemed to represent a mode of production which was not acceptable to the general public.

The fact that the film was ignored by commercial distributors and cinemas set an early limit on the marketability of rigorously abstract tendencies in narrative cinema.

Translated by Eva Viktoria Ballin

Notes

[1] Alfred Kerr, in *Berliner Tageblatt,* 2 February 1919. Reprinted in Kerr, *Mit Schleuder und Harfe. Theaterkritiken aus drei Jahrzehnten* (Berlin: Henschelverlag, 1981), 148–50.

[2] Cf. reviews of the stage reception of the play 1917–1921 in Ernst Schürer, ed., *Georg Kaiser: Von morgens bis mitternachts. Erläuterungen und Dokumente* (Stuttgart: Reclam, 1975), 55–72.

[3] Herbert Ihering, "Regisseure und Bühnenmaler" (1921), in Ihering, *Der Kampf ums Theater und andere Streitschriften 1918 bis 1933* (Berlin: Henschelverlag Kunst und Gesellschaft, 1974), 101.

[4] *Hamburger Nachrichten,* 30 September 1918.

[5] *Hamburger Echo,* 1 October 1918.

[6] *Hamburger Nachrichten,* 30 September 1918.

[7] Rudolf Kurtz had previously published articles in *Aktion* and had become the director of a film factory. In 1926 he wrote the famous contemporary study *Expressionismus und Film.*

[8] Gesa M. Valk, *Georg Kaiser in Sachen Georg Kaiser. Briefe 1917–1933* (Leipzig: G. Kiepenheuer, 1989), 127.

[9] Cf. *Lichtbild-Bühne,* no. 20, 1920, 29, and no. 29, 1920, 35.

[10] Georg Kaiser, *Von morgens bis mitternachts,* in Kaiser, *Werke in drei Bänden,* vol. 1 (Berlin: Aufbau-Verlag, 1979), 180 and 216.

[11] E. Schürer, ed., *Georg Kaiser: Von morgens bis mitternachts,* 53.

[12] Cf. Siegfried Kracauer, *From Caligari to Hitler. A Psychological History of the German Film* (Princeton, NJ: Princeton UP, 1974), 124.

[13] Silvio Vietta, "Expressionistische Literatur und Film. Einige Thesen zum wechselseitigen Einfluß ihrer Darstellung und ihrer Wirkung," in *Mannheimer Berichte aus Forschung und Lehre,* edition 10, 1975, 297.

[14] G. Kaiser, *Von morgens bis mitternachts,* 216–17.

[15] Lotte Eisner, *The Haunted Screen. Expressionism in the German Cinema and the Influence of Max Reinhardt* (Berkeley: U of California P, 1973), 29.

[16] This sentence goes back to a formulation by Walter Röhrig: "The cinematic work of art must become a living graphic." Cf. Illustrierter *Film-Kurier,* no. 6 (1920): 4.

[17] H. De Fries, "Raumgestaltung im Film," in *Wasmuths Monatshefte für Baukunst,* 3–4 (1920/21): 78.

[18] Rudolf Kurtz, *Expressionismus und Film* (Berlin: Verlag der Lichtbühne, 1926), 69.

[19] H. De Fries, "Raumgestaltung im Film," 63.

[20] Herman G. Scheffauer, "The Vivifying of Space," in *Introduction to the Art of the Movies,* ed. Lewis Jacobs (New York: Noonday Press, 1960), 83.

[21] R. Kurtz, *Expressionismus und Film,* 69.

[22] Julius Bab, *Schauspieler und Schauspielkunst* (Berlin: Oesterheld, 1926), 178.

[23] G. Kaiser, *Von morgens bis mitternachts,* 190.

[24] Lotte H. Eisner, "Le cinéma expressionniste. De l'aube à minuit" in *L'expressionnisme dans le théâtre européen,* ed. Denis Bablet and Jean Jacquot (Paris: Editions du Centre national de la recherche scientifique, 1971), 220.

[25] Cf. Filmmuseum München, ed., *Von morgens bis mitternachts* (Munich: Filmmuseum Munich, 1996).

[26] R. Kurtz, *Expressionismus und Film,* 69.

Episodic Patchwork: The Bric-à-Brac Principle in Paul Leni's *Waxworks*

Jürgen Kasten

PAUL LENI'S FILM *Das Wachsfigurenkabinett* (Waxworks, 1924) marks the end of certain phenomena in style and motif in the films of the young Weimar Republic. Regarding the motif, Kracauer classes this film, which was first screened in 1924, as the last of the "Tyrant Movies."[1] Similarly, virtually all analyses dealing with expressionist cinema name *Waxworks* as the last of that particular style. Neither evaluation is entirely wrong, yet both are problematic nonetheless.

The production of this film spanned several years, from its conception in 1920 to the end of filming in late 1923. During this period the aesthetic standards and motifs of German films changed considerably, affecting ambitious art films as well as off-the-peg movies for mass consumption. Some of these changes have been incorporated into *Waxworks;* they are reflected in style and décor as well as in the narrative. The subject matter was most likely developed at the height of the short era of expressionist films. This is reflected in the title, in some of the conflict situations and in the cast. Henrik Galeen's script was finished in October 1920. At that time, all genuine expressionist films (apart from *Raskolnikov,* 1922/23) had been finished, screened, or were at least in mid-production. The director and film architect Paul Leni, who wanted to film Galeen's script, was particularly interested in exotic and oriental topics which, at the end of 1920, were en vogue with the postwar audience, thirsty for new cinematic attractions and visual experiences. They would have held a great appeal for the film designer Leni, who liked to give uncanny-mystical topics a playful air and vice versa. In 1920 he wanted to direct *Gespensterschiff* (The Ghost Ship, script by the authors of *Caligari,* Carl Mayer and Hans Janowitz) and *Die sechs Nächte des Harun al Raschid* for the newly established Gloria-Film. Neither film was ever realized. The script for *The Ghost Ship* contains a sketch by Leni, showing the bulbous domes of an oriental town and a house squeezed into the town wall.[2] Such a design is also the architectural starting point

of the first episode about Harun al Raschid in *Waxworks*. The production of this film, however, moved at a snail's pace. By 1922, Galeen seemed to have given up hope and had written and sold a script with a similar title and topic. Leni tried to stop him, but lost his case at the district court in Berlin. He therefore had to reacquire the rights to the material, and to be on the safe side, he also bought the topic and title rights of Gustav Meyrink's novella *Das Wachsfigurenkabinett*. This work, however, never found its way into the script or the film itself. In mid-1922, *Waxworks* had already appeared in advertisements and had been heralded at the export fair of German cinema.[3] The filming did not start until June 1923 and was finished in September of the same year. It therefore coincided with hyperinflation and the subsequent collapse of the German economy.

This should explain the fact that the film ultimately did not acquire the slightly unusual structure of four episodes, as planned in the script and mentioned in the advertisements.[4] Only two episodes were realized properly, while the third part about Jack the Ripper has to be seen as a kind of improvisation, albeit one of remarkable visual concentration. The lack of hard currency during the collapse of the economy in the autumn of 1923 was most certainly responsible for the fact that the film could not be realized in the way that the script and Leni himself had intended.

Siegfried Kracauer regards Leni's film as the "culmination of the tyrant films."[5] The fact that *Waxworks* was made toward the end of the period of the galloping inflation — an experience which seemed to nourish the longing for authoritarian rule — fits in neatly with Kracauer's theory, even though the history of its production dates back to 1920. At first glance, the conflict situations of all three episodes of *Waxworks* are characterized by a couple being threatened by a despotic ruler of peculiar disposition. Kracauer's thesis of the inner conflict of the German collective soul, torn between the fear of chaos on the one hand and the acceptance of a tyrant on the other, might just be plausible in the light of the *Zeitgefühl* of 1920s Germany. In trying to prove the latter with the help of contemporary, artistically ambitious "style films," however, Kracauer blurs the characters and the conflict situations, as well as the dramaturgical arrangements and important aspects of the purpose and function of motifs and *sujets* of *Waxworks*.

The three episodes are embedded in a narrative framework which stresses their fictional, yarnlike character. Harun al Raschid has a rather obvious, comical-burlesque overtone, Ivan the Terrible perishes in the web of his own tyranny and Jack the Ripper is only a static threat within what is obviously an hallucination. The psychologically perverse charac-

ters illustrate the clearly stated desired effect of the film: "to translate the horror of the collection of curios (i.e. the waxworks) into gestures and movement."[6] The production account from November 1923 clearly states that it is all about people subjecting themselves to the horror of the waxworks, conscious and fully aware of its function as a place of scary entertainment.

The realistic hustle and bustle of the fun fair in the framework of *Waxworks* serves to enable the episodes to emerge convincingly from a totally different world of fantasy. The characters are introduced via the wax figures, and the manual process of writing down their stories is shown at great length and detail. The narrative structure of the film is therefore unambiguous. A blurring between incidents in the framework narrative and the different episodes is virtually impossible. Thus the uncertainty and ambiguity as to who is supposed to be mad and who is normal — which characterized *Das Cabinet des Dr. Caligari* (The Cabinet of Dr. Caligari, 1920) and still has traces in *Genuine* (1920) — is clearly missing.

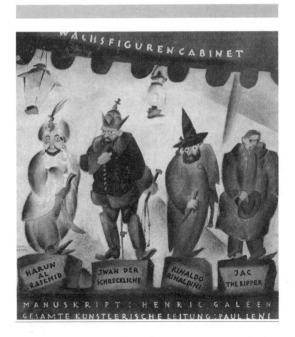

First advertisement of Paul Leni's *Waxworks* (1924)
in *Der Film*, 8 August 1922.

Each of the episodes in *Waxworks* is different in terms of motif, *sujet,* décor and therefore also in tone and mood. While this enables the film to produce many visual stimuli and display various, kaleidoscopic facets, it creates problems where the continuity of style is concerned. The first episode about Harun al Raschid is a veritable burlesque or comedy. Henrik Galeen's script teems with comic elements such as a marital squabble, a testosterone-fueled husband, the appearance of a paternal lover, the hiding of said lover in the oven, and a happy ending which is both breathtaking and mischievous. Even the *Doppelgänger* motif introduced by Harun al Raschid's wax figure does not evoke the same threatening associations as the dummy which Caligari places in Cesare's coffin in order to conceal the murderous crimes the somnambulist has to commit. When Assad cuts off the hand of the caliph's dummy, the real Harun al Rashid is meanwhile flirting with the culprit's wife. Thus Assad's escape, which ends with a jump from the highest cupola of the palace straight into a palm tree, resembles a slapstick chase rather than alluding to the leaden heaviness which descends on the hunted Cesare in *Caligari.*

The second episode about Ivan the Terrible displays coarse and bizarre traits and touches upon gothic-Romantic horror. The Tsar uses every available instrument of power in order to gratify his perverse urges and desires. He is delighted by the panic and pain of tortured prisoners. This liberal and unrestrained depiction of sadistic practices evokes in its compulsive excesses a reminder of similar motifs of unbridled sexuality in so-called *black expressionism* and in the literature of *black Romanticism,* which was influenced by the writings of the Marquis de Sade.[7] In *Waxworks,* however, the posture of the paranoid Tsar — straight upper body, bent at the hip like a broken pencil — leaves no doubts as to his impending punishment. When his preparer of poison takes revenge, Ivan himself becomes the victim, and through the very torture devised by him he descends into madness. The couple captured and imprisoned earlier are thus able to escape the cruelty of the psychopathic Tsar. The possibility of such a happy ending represents the dramaturgical guideline of the measured gothic-Romantic surplus of motifs, where "cruel incidents had to be alleviated by showing endearing counter traits."[8]

In the third episode about Jack the Ripper (in the English export edition, the title had to be changed to Springheeled Jack, due to objections from the board of censors in London) the topic of physical-sexual gratification is accentuated only indirectly. The infamous murderer appears as the static symbol of a threat, since he is portrayed without any character traits or indeed motives for his appearance. The Ripper charac-

ter is born out of a nightmare experienced by the writer, which is no longer located on the level of a fictional story. Instead, it arises in a hallucinated dreamscape. This change in fictional levels is once more conveyed to the viewer when the sleepy writer gazes at the wax figure of Jack the Ripper and then begins to write. He promptly falls asleep and, together with the show booth owner's daughter — who in keeping with the logic of the plot has also nodded off — journeys into the dreamscape. Dream and reality are clearly distinct and the transition into the hallucination is indicated through a long superimposition.

Only on one occasion is there a surprising jump from a fictional level into reality: when the writer is stabbed by the Ripper's knife, the film jumps straight back to the reality of the narrative framework. This results in an effect which does not increase the fearful atmosphere, but rather smoothes out the tension and dissolves the threat. It is also very comical. Once again the film shows in its choice of filmic techniques that the scene has to be understood as an hallucination. The murderer is only present through a double exposure which, as soon as it stabs the writer, disappears abruptly. The fact that the writer still reacts as though he were killed by a knife in reality has a different reason: having dozed off in the middle of writing his story, he finally flops across the table and stabs himself in the chest with his pencil. After the scene has faded out, the show booth owner's daughter explains to the writer what the viewers have already gathered from the visual organization of the whole episode: it was only a nightmare.

The double happy ending of the third episode and the jolly melodrama of the closing sequence reveals the true motives of the film. *Waxworks* plays with its motifs and hardly takes its "tyrant topic" seriously. The play-in-a-play character of the fictional inner plot was already obvious on the opening night: "the whole film is an artistic caprice, a graceful play fizzing with wit."[9]

A few months before the premiere of *Waxworks*, Paul Leni published an article on the role of "Architecture in Film." Film architecture has above all to convey the "characteristic colors of the moods" and to "go beyond the surface and touch the heart of the matter." Leni, however, drops this demand, which seems to return to the expressionistic postulate of concentrating on the essential features of what is to be represented, in favor of the architecture of mood. While his intentions might be discernible: "to create entirely stylized architectural features which never even come close to reality,"[10] his remodeling and reshaping of concrete forms and objects is very subtle. They mainly follow a playful, decorative concept and are thus very different from the exaggerated and foreshort-

ened acute shapes in *Caligari* or even *Von morgens bis mitternachts* (1920). The scenes of the narrative framework are mostly set in realistic, three-dimensional forms, and according to the construction architect Fritz Maurischat the exteriors of the fun fair were built "weatherproof with wooden frames, wire network and mortar."[11]

It is virtually impossible to discern a unified tendency in the styles of the different episodes. The first part is dominated by stout, rotund shapes which illustrate burlesque motifs and those inspired by fairy-tales. The baker's living room has the bloated puffiness of rising yeasty dough, while the rooms of the caliph's palace, with their rotund and curving architecture, are also reminiscent of the consistency of bread, cakes, and pastry. Mysterious ovals and stairwells open up the swollen sturdiness of leaning, curving walls. When Assad crawls into one of these openings he ends up in a tunnel, the fibrous and bulbous curves of which are reminiscent of a digestive tract.

The architectural structures of edible and digestible objects invite a multitude of symbolic interpretations. They reflect Assad's profession as well as Harun al Rashid's penchant for physical pleasures. They symbolize the consuming character of Assad's jealousy, while the tunnel-like openings hint at the caliph's sexually motivated visit at Zarah's. The imaginary, rotund shapes are, however, in no way representative of a threatening architecture. On the contrary, they emphasize the joyful atmosphere of a "spherical world theater."[12] Emil Jannings in the role of Harun al Rashid takes this even further with his pronounced overacting. His immense, corpulent body, swathed in baggy robes, allows him only comical, clumsy movements. Like a fat, funny, spinning top with the greasepaint mask of a caliph and a mischievous smile, Jannings rolls through picture-book scenes of the orient.

Fritz Maurischat pointed out that Leni wanted to use décor and costumes in order to create transitions between the episodes.[13] In the second episode, the bulbous domes of the Kremlin and the Boyar castle are similar to the basic elements in oriental architecture, but they also add the local color of Russia. The actual visual concept of this episode, however, reveals a design that is somewhat different from the round shapes of the first part. It is dominated by a horizontal narrowing of the visual space which itself is defined by a striking depth. The bottom part of the foreground is blocked by staircases or other objects, while the upper part is weighed down by heavy ceilings or crouching portals. In the huge ballroom where the Boyar wedding is held, for example, heavy cross beams are suspended perilously from the ceiling. The oppressive heaviness of the room is emphasized by the low camera angle and

the immense definition of depth in the shots of the long, drawn-out ballroom.

In the Kremlin, a three-dimensional expression of a dark underworld of despotic power, staircases and doorways are ominously low. The bent and misshapen postures of the people moving through these structures illustrate the nature of the constricting architecture. The tyrannical Tsar himself is haunted by these rooms. Conrad Veidt, with his tall ascetic shape, the acute angle of his bent upper body and the stern lines of his chiseled face, is a strong contrast to the tubby, mischievous Jannings in the role of Harun al Rashid. Where in the first episode décor and actors seem inflated, the second part emphasizes the restricting lines and edges of the rooms and the thin figures and shapes within.

The third, fragmentlike episode is yet again different in its design. It is dominated by broken, dissolving shapes and forms. A distorted and intentionally deformed expressionistic architecture is used as a three-dimensional encryption of nightmarish fears. The starting point is the panopticum, where the back wall suddenly vanishes and the view is drawn toward the stalls and booths of the fun fair. Only this time they are not three-dimensional models, but distorted pictures on a large canvas. Running away from the mass murderer, the couple reach an alleyway where the sturdy, leaning houses appear from a drastically foreshortened perspective. The distorted houses, painted on canvasses suspended at oblique angles, have diamond and trapezoid shaped windows and doors. Another street seems to appear out of the ray of light coming from an open door, behind which the counter-diagonal line of a banister is visible. In this episode, Paul Leni totally dispenses with any discernible physiognomy of space. This is most obvious in the fashion salon where the couple's flight ends. Its only contours are outlined by oblique, black curtains. The former film press officer, Heinrich Fraenkel, explains this abstract room design in his — admittedly often anecdotal — film historic memoirs with the economical restrictions of a production which had not been fully financed: "in his despair, he [Leni] finally decided to film the scene in front of this black velvet curtain."[14] Similar to the design of the *Caligari* décor, financial constraints seem to have provoked the most consistent style in décor and image.

In 1924, Frank Warschauer spoke in *Weltbühne* of the "not at all strange, artisan-expressionistic space" in *Waxworks*.[15] The artisan-inspired look was indeed intentional, as Fritz Maurischat confirmed: Leni "tried to get away from expressionism and instead to express the adventurous-mystical side of things."[16] Décor and production design are given the playful-bizarre note of a "naiv-grotesque, fantastic-magical style."[17] The

episodic character of the patchwork of motifs and the different moods was met by Leni with a "decorative joy of a co-ordinated jumble of styles."[18]

When Paul Rotha published his film history of the immediate post-expressionist era in German cinema in 1930, it contained an assessment of the principles of image composition which was both fundamental and intriguing. He described a "simplification of detail, a centralization of incident into small units of space and time decorated by a fantastic touch." This tendency for a simplified, fantastic-decorative design, however, was not characterized by the expressionistic foreshortening and distortion, but by a "natural feeling for decoration . . . in the Düreresque and Baroque styles."[19] This melange of different formal tendencies and styles becomes particularly apparent in *Waxworks*. Around the same time, another phenomenon became more and more apparent. Film directors turned to creating the illusion of three-dimensional volume with the help of relatively simple means. In *Waxworks* — with the exception of the fun fair stalls — this is still mainly achieved through painting. The use of graphic ornaments and lines, however, has already been reduced to a minimum.

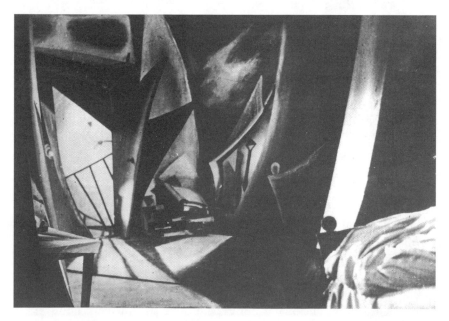

Set design by Paul Leni for the episode on Jack the Ripper (1924).

The simulation of space and the illusion of three dimensions is far more sophisticated in *Waxworks* than it was in *Caligari*. This is mainly due to one important technical feature. The introduction of stronger spotlights, especially the use of more concentrated lighting systems, allows the light to play a much more important role than in the expressionist films of 1920. The principles which had been indicated by painting light and shadows could now be illustrated in a three-dimensional and atmospheric fashion. This is particularly obvious in *Waxworks*. Often only a small part of the scene is lit up, as is evident, for example, in various shots in the introductory narrative framework: a part of the entrance to the waxworks, a part of the spinning merry-go-round, the white hat of a reveler or the bright cufflinks of the poet looking for work. The inside of the waxworks is left in total darkness; the origin of the diffuse, waxlike sheen on the hair of the owner is obscure. The contours of body parts such as a cheek or a shoulder are briefly lit up, creating "around the heads of the characters . . . inside the dark tent a pale halo of phosphorous."[20] Together with the waxy shimmer on the faces of the dummies this achieves an unreal, three-dimensional atmosphere. This "background, kept in mysterious darkness,"[21] also marks the most important dramatic actions in Assad's bakery, in the rooms of the palace, the poisoner's kitchen, the torture chamber or the Tsar's bedroom, as well as in parts of the Ripper episode. Shreds of light give a menacing structure to dark, fathomless rooms and light up the moving contours of people within.

This striking chiaroscuro is also evident in the Russian episode. Ivan's light-colored gown, or the white wedding dress of the Boyar daughter, contrast with the vast, dark walls, pierced in places by blinding flecks of light. Glass vessels, pieces of equipment and hourglasses in the poisoner's kitchen — all of them tools of terror — are illuminated by the same, bright shreds of light which light up the fearful face of the panic-stricken poisoner himself. In 1926, Rudolf Kurtz summed up these effects as follows: the light seems to be

> distilled out of a thousand springs, it gives rise to feverish nightmares in a three-dimensional void, underlines each curve, runs along broken lines, creates fathomless depths, and conjures up blackness on leaning brickwork.[22]

This technique, where light envelops and coats the shapes of space, objects and bodies, creates an unreal and yet three-dimensional atmosphere. The simplistically juxtaposed chiaroscuro, painted or illuminated, of earlier expressionist films is virtually absent in the first two episodes.

In the Jack the Ripper episode, however, Paul Leni falls back on dazzling light effects. Together with the extensive décor of the painted and tilted backdrops, the light not only emphasizes the white, jagged shapes painted onto the floor, but also creates geometrical patterns of its own, which seem to "shatter the architecture to dazzling smithereens:"[23] the darkness of the background is pierced by small, window-shaped shreds of light, or a triangle of light standing out of the dark suggestion of receding rows of houses. The scenes in the fashion salon, which are simply filmed against the backdrop of black velvet curtains, pierced only by pencil-thin rays of light, are particularly impressive. The fleeing couple and Jack the Ripper are only visible through small cones of light on their upper bodies. In all episodes of *Waxworks* the general stage lighting is kept to a minimum. Only fleeting shadows are visible. They barely stand out against the surrounding darkness, so that the silhouette-like characters themselves sometimes look like walking shadows.

Light sets the scene for this atmosphere of insomnia, where the night simultaneously fights with sleep and wakefulness. The Austrian Joseph Roth, who himself was to become an author of dark mystical novels, saw this particular mood as the motif and structural element which holds the whole of *Waxworks* together: "the film wafts by like a dream of several parts; . . . but what keeps it together is the night where these dreams unfold."[24] The night, emphasized by a graphically striking intertitle, was an integral part of the imaginary world of turmoil, threat, and terror in *Caligari*. In *Waxworks,* however, the night has been assigned a different symbolic meaning: it is an element which stimulates the fantasy of a Romantic poet in love and

> implies that such fear is a normal activity of romantic dreamers, shocking enough but not really different from the amusement-park diversions the film depicts.[25]

Not only have the tyrants lost their potential to evoke fear and terror in a kind of ironic alienation effect, but also the night, a frightening symbol of horror where psychopathic tyrants populate the narrow alleyways, has once more been reclaimed by lovers and their activities — even if they only entertain each other with scary tales of horror.

A contemporary critic praised the "exceptional technical realization of the dream image and its suggestive effect."[26] The shots of the poet's nightmare and his hallucination of Jack the Ripper consist almost exclusively of double, sometimes even multiple exposures. The abstract shapes and distorted perspectives of the painted décor are filmed in long and medium shots and then superimposed with medium shots or semiclose-

ups of the fleeing couple and the appearance of the Ripper. Only two shots of the escape are not double exposures. This is where the couple think they have escaped from the serial killer. When Jack corners them in the fashion salon, this "omission" is compensated for, and he is shown in four successive shots as if he were omnipresent.

In the third episode, the director did not utilize décor and representation, as did all the other expressionist films, but chose to tap the technical possibilities of the medium in order to "free the movement value of shapes and forms in space from their conventional restraints."[27] The double exposures were not only supposed to show the ghostly image of Jack the Ripper, they also served to exaggerate and distance the distorted architectural shapes. This combination of painted and cinematographic alienation has to this day remained a popular representational device for depicting dreams and various kinds of phantasmagoric visions.

Contemporary critics recognized in *Waxworks* that "Leni's film in its precious weirdness had been conceived out of a kind of bric-à-brac state of mind."[28] The unorganic proportions of the three episodes — the first takes up sixty percent, the third only a mere five percent of the film as a whole — and the lack of transitional links in terms of motifs, décor and style, emphasize the disjointed, bric-a-brac character of the film, the casual chaos of which gives the stylistic impression of "charming, nice craft objects."[29] This by no means excludes the vocabulary of expressionistic form, however. It had already become available for artisan and advertising purposes, and Leni used it mainly in a decorative fashion. This comes as no surprise in view of the aesthetic development of German cinema and other art forms until 1923. The late completion of the film, and a further one-year delay until its première in 1924, would have all but destroyed any chance for a purely expressionistic film to have a commercial impact.

The contemporary critic C. Haensel even maintained that this distancing from the fantastic antinaturalism of the inflation cinema did not go far enough. Ignoring the playful use of motifs and forms, he criticized the untimeliness of artificial tendencies in image stylization and fantastic-gothic motifs when *Waxworks* was finally released:

> Have we not learnt anything about film since the appearance of *Caligari*, in all these long years in a changing world? . . . We really are enlightened by now about the fun fair of life with all its theoretically possible allegories and symbols.[30]

Haensel considered the expressionist era of cinema so far in the past that he combined his criticism with a plea for a film-historical re-encounter

with *Dr. Caligari*. Ufa, which had acquired Decla in 1920, recognized this too and in 1925, it rereleased the first expressionist film — already considered unique in its mystic-fantastic motif and style — with even greater success than the first time round.

Fritz Maurischat even maintained that the first two episodes in *Waxworks* were "basically realistically staged incidents."[31] The fact that they do not reflect realistic actions or phenomena becomes quite obvious in view of the initial exposition of motifs, however. Maurischat's claim may be easier to understand in relation to the assumption that the future of artistic narrative cinema might lie in the "anti-naturalistic film."[32] This assumption had appeared in several literary magazines shortly after the release of *Genuine* and proved to be quite wrong. The future of both the conventional and the artistic film was a realistic or near-realistic design to which, occasionally, fantastic elements would be added through special preparation or camera work. "These elements of fantasy do not alter reality, but they re-arrange reality in a different way," said Frank Warschauer in his review of *Waxworks* in *Weltbühne*. This film is still at the crossroads of the old *Caligari* principle "in that they [writer and director] mainly try to achieve fantastic effects with the help of the old means by altering and changing reality."[33] In the style films prior to 1923, artistic, reality-altering stylization appeared mainly in décor and representation, i.e. through antinaturalistic design elements in the scene itself.

However, Leni at least hints at the new cinematographic fantasy techniques in the frame narrative and the third episode. Later he successfully developed these mixed forms of stylization in an individual scene and its subsequent cinematographic treatment in American films such as *The Cat and the Canary* (1927) and *The Man who Laughs* (1928) as a style of "uncanny décor."[34] Finally, one other important feature of *Waxworks* which is somewhat untypical of expressionism (which even in the medium of film never spawned a comedy) as well as the German style and "tyrant" film becomes very apparent: Leni incorporated funny, sometimes even parodistic elements into the grotesque-bizarre framework. Yet to this day, nobody has attempted to interpret the designs on power displayed by some characters in these US films as an expression of "longing for tyrants" by filmmakers and spectators.

Translated by Eva Viktoria Ballin

Notes

[1] Siegfried Kracauer, *From Caligari to Hitler. A Psychological History of the German Film* (Princeton, NJ: Princeton UP, 1947), 84.

[2] Cf. *Paul Leni. Grafik. Theater. Film*, ed. Hans-Michael Bock (Frankfurt am Main: Deutsches Filmmuseum, 1986), 146–48.

[3] A first advertisement appears in *Der Film*, vol. 20, 1922, 31.

[4] Henrik Galeen, *Das Wachsfigurenkabinett* (Munich: edition text + kritik, 1994).

[5] S. Kracauer, *From Caligari to Hitler*, 86.

[6] *Filmwoche*, 2 November 1923, 58.

[7] For *black expressionism* see Günter Rühle, *Theater für die Republik im Spiegel der Kritik* (Frankfurt: S. Fischer, 1967), 24–25; Jürgen Kasten, *Der expressionistische Film. Abgefilmtes Theater oder avangardistisches Erzählkino* (Münster: Maks, 1990), 109–10 and 135–37. For *black romanticism* see Mario Praz, *Liebe, Tod und Teufel. Die schwarze Romantik* (Munich: Deutscher Taschenbuch Verlag, 1981), especially chapter III: "Im Zeichen des göttlichen Marquis," 96–166.

[8] *Filmwoche* (2 November 1923): 59.

[9] *Lichtbild-Bühne*, no. 134 (1924): 40.

[10] Paul Leni, "Baukunst im Film," in *Der Kinematograph*, no. 911 (1924): 15.

[11] Fritz Maurischat in *Paul Leni*, ed. Bock, 166.

[12] *Film-Kurier* (14 November 192).

[16] Cf. F. Maurischat in *Paul Leni*, ed. Bock, 167: Maurischat maintained that such functions would have also supported the décor forms in the unrealized episode Rinaldo Rinaldini.

[14] Heinrich Fraenkel, *Unsterblicher Film. Die grosse Chronik von der Laterna magica bis zum Tonfilm* (Munich: Kindler, 1956), 124. A similar tendency had been noted toward the end of the silent film by Paul Rotha, *The Film Till Now. A Survey of World Cinema* (London: Vision, 1951), 79.

[15] Frank Warschauer in *Die Weltbühne*, no. 50 (1924): 876.

[16] F. Maurischat in *Paul Leni*, ed. Bock, 166

[17] *Lichtbild-Bühne*, no. 134, 1924, 40.

[18] *Film-Kurier*, 14 November 1924.

[19] P. Rotha, *The Film Till Now*, 257 and 259.

[20] Lotte Eisner, *Die dämonische Leinwand* (Frankfurt am Main: Fischer, 1980), 113 (trans. E. V. B.).

[21] *Der Kinematograph*, no. 927, 1924, 19.

[22] Rudolf Kurtz, *Expressionismus und Film* (Berlin: Verlag der Lichtbildbühne, 1926), 80.

[23] Ibid.

[24] Joseph Roth in *Frankfurter Zeitung* (12 December 1924); also in Roth, *Werke*, vol. 4 (Köln: Kiepenheuer & Witsch, 1976), 491.

[25] John Barlow, *German Expressionist Film* (Boston: Twayne, 1982), 108.

[26] *Neue Preußische (Kreuz-)Zeitung* (16 November 1924).

[27] R. Kurtz, *Expressionismus und Film*, 80.

[28] *Film-Kurier* (14 November 1924).

[29] *Berliner Tageblatt* (16 November 192).

[30] C. Haensel in *Deutsche Allgemeine Zeitung* (22 November 1924).

[31] F. Maurischat in *Paul Leni*, ed. Bock, 170.

[32] Cf. Reviews of *Genuine* in *Das Tagebuch,* no. 37 (1920): 1220, or in *Freie Deutsche Bühne,* vol. 3 (1920): 58–59.

[33] Frank Warschauer in *Die Weltbühne,* no. 50 (1924): 876.

[34] L. Eisner, *Die Dämonische Leinwand,* 114 (trans. E. V. B.).

IV. THE STREET, THE VAUDEVILLE, AND THE POWER OF THE CAMERA

Entrapment and Escape: Readings of the City in Karl Grune's *The Street* and G. W. Pabst's *The Joyless Street*

Anthony Coulson

IN GERMANY PERHAPS MORE THAN in any other European society the experience of modernity was synonymous with the rise of the big city. The very scale and speed of simultaneous industrialization and urbanization in Germany, in the last decades of the nineteenth century, generates in public debate both fear and fascination in the face of the phenomenon of the metropolis. In artistic production, expressionism, drawing on the reserves of the romantic expressive tradition in German culture, bears witness to the particular impact, in Germany, of processes of modernization which seemed to epitomize what the social philosopher Georg Simmel called the overwhelming weight of "objective culture."[1] As early as 1903 Simmel formulated his analysis of the crisis of subjectivity: the predicament of the city dweller, immersed in the crowd and enveloped in a continuum of external stimuli whose persistence and intensity threaten to dictate his or her innermost being. It is no accident that this analysis coincides with the rise of cinema as the dominant medium of the new mass culture, or indeed, that the phenomenon of the city itself commands so much more attention in the literary and visual arts in Germany than in other countries, a concern which becomes a distinguishing feature of Weimar cinema.[2]

Even before the First World War, contemporaries were well aware of the parallels between the concentration of visual experience in the mêlée of the street, or the heightened tempo of sights from the framing windows of the new vehicles of mechanized transport, and the rapid flow of images on the cinema screen.[3] From the start, however, film not only duplicates the structures of urban consciousness and experience: above all, it expresses the longing to transcend them. As Anton Kaes has pointed

out, "the cinema exploited the city-dwellers secret desire to escape the technical-industrial world, although ironically the vehicle for escape was itself a product of this technical world."[4] Through the apparent immediacy of its imagery, the early "cinema of attractions"[5] offers collective compensation for the emotional and material deprivations of city life; it offers release through its visual encounters with raw emotion, with spectacle and sensation, with the exotic and aristocratic, the fantastic and the absurd.[6] Yet, as Kracauer recognized, the compensation of "distraction" is then sought in the same sphere which produced the need in the first place.[7] The screen, with its concentration of visual stimuli, also mimics the source of alienation, the disorientation of urban modernity, and itself promotes the demand for further compensatory thrills and fuller emotional experience. The very "feverish and frenetic heightening of the images"[8] that is the strength of early cinema, the heterogeneity of its variety programs and the openness of its narrative structures, prepares the way, and creates the public, when technology provides the means, for a new cinema.

As film is institutionalized as the voice of urban popular culture, the anarchic freedom and anti-illusionist conventions of the cinema of attractions increasingly give way to a new dominant form, the realist and illusion-enhancing aesthetic which is directed by a commercial and ideological purpose: on the one hand, toward upwards social expansion of the market, with progressive assumption of the cultural respectability of literature and the theater, and on the other, toward conscripting the public into an autonomous realm of screen fiction. In the course of the gradual emergence of the one-hour, then full-length narrative, "the systematic improvement of cinematic techniques guarantee the complete absorption of the spectator into the fictional world of the film and the imaginary flow of linear narrative; the absolute division of screen space and theater space; the institutionalization of private voyeurism in a public space."[9] With the classical narrative mode of cinema, the entrepreneurs of the industry offer the spectatorial gaze the power of command over its images of desire: the medium moves to a system of controlled "compensation" far more sophisticated than the spectacle of early film. While, as Noël Burch pointed out, the eye is left "'free' to roam over the entire frame" and "organize the signifiers as it will (as best it can)" in the "panoramic view" of early film, the cinema of illusion accords with the "canons of the closed autarchic world of the bourgeois novel":[10] where the spectator is seemingly empowered with privileged access, the eye is in fact led to the significations prefigured in the linearity of the narrative. This is the cinema which Hofmannsthal described in 1921 as a "substi-

tute for dreams," fictions without words and therefore supposedly beyond the control of society. In the "limitless gazing" of the urban masses, there is, Hofmannsthal argued, "a sweet self-deception" of "holding sway" over "images which silently and obligingly hurry past," indeed over "entire existences." Here, where the very prestructuring of perception generates the illusion of the power of spectatorship, "dreams are deeds," or are taken to be.[11]

It has been argued that the major German films of the Weimar years are indeed commercial productions which observe the aesthetic norms of narrative cinema, but that they also stand apart in a way that suggests that *Das Cabinet des Dr. Caligari* (1920) may be "much closer to the primitives (or to us) than it is to Griffith or de Mille."[12] However, it is not just the films that adopt the stylistic strategies of *Caligarism* which recall and develop from early cinema what Benjamin, following Simmel, saw as the specifically modernist-urban aesthetic of the medium, namely, the shock-impact of the image rather than its narrative integration.[13] Even before the First World War, what emerges in Germany is a cinema whose narrative structures direct attention to the particular moment of our perception and reading of the image. Where, in Elsaesser's words, "the authority, origin and control of the act of narration [are] constantly fore-grounded," it is the privileged access of the spectator as subject and the supposed certainties of the cinematic eye which are questioned.[14] If we are to do justice to the specific and radical quality of this filmic self-reflection, it is hardly sufficient to explain it as an attempt, on the part of conservative intellectuals, fearful of the masses, to defend the status of high art and literary culture against technological encroachment, or as a symptom, as suggested by Kracauer, of the destabilization of the middle classes, en route to fascist indoctrination. Instead, German cinema can be seen to explore, on a deeper historical level, the implications of that fundamental shift in perception and consciousness which accompanies the social and technological changes of modernity. On the one hand, film is one of a variety of discourses and social and commercial practices that constitute the general "mobilization of the gaze"[15] in the later nineteenth and early twentieth centuries. On the other, the rise of cinema as an instrument of mass entertainment "epitomized a new stage in the ascendance of the visual as a social and cultural discourse."[16] More than any other cultural medium of the metropolis, it reflects and confirms the new visuality of social discourse per se, i.e. the growth of a society increasingly dominated by the mass reproduction, dissemination and inflation of the image — in the press, on the street, in commerce,[17] and on the screen itself, images which must be read and articulated if, in

"an ongoing crisis of vision and visibility,"[18] they are to be raised to the level of conscious perception.

Expressionist concern with the mediation of the image, the translation of the codes of modernity into discourse and understanding, is well illustrated in the ironic commentary on the media themselves implicit in Jakob van Hoddis's two poems of 1911: *Kinematograph* and *Weltende*. The first could serve as a memorial to the spectacle appeal — and limitations — of early film. The poem takes us through the show, a potpourri of Asiatic exoticism, domestic melodrama, and *Kulturfilm*. At the close we, the audience, push our way "yawning and yearning . . . into the fresh air."[19] The jumble of distractions leaves an underlying sense of frustration and pointlessness, just as the equally ironic *Weltende* conveys: here the apocalypse is just a series of sensationalized "happenings," from the banal "most people have got a cold" to the bizarre "roofers fall off and break in two," or so "one reads" in the newspaper — or sees on the screen.[20] The structures of both poems juxtapose images which are reproduced and received at random, and without conscious reflection, in the everyday life of the city. Here, Hoddis's gentle mockery of this proliferation of the arbitrary and the absurd recalls the fundamental expressionist attack on the alienated and fragmented consciousness of modernity and its programmatic demand for a new totality, authenticated by force of the vision which creates it. The expressionist poets, Edschmid writes in 1918, "did not just see. They looked." [21] In expressionist utopianism the world is renewed and made whole in the subjective gaze which invests it with the consciousness of active perception.

Misleadingly, the path taken by German cinema in the Weimar years has been dubbed "expressionist" by association with the particular strategies — marketing as well as artistic — adopted by Wiene's *The Cabinet of Dr. Caligari*. In fact, the systematic study by Jürgen Kasten has confirmed the view suggested by Rudolf Kurtz in the 1920s, that only a limited number of German films of the early Weimar years can be considered purely "expressionist" in this sense.[22] For Barry Salt, many of the characteristic features of major productions either do not fit the mould of *Caligarism,* or can also be found, indeed were initiated, in other national cinemas,[23] while for Andrew Tudor, German silent film simply represents "a widely diffuse collection of not altogether compatible styles."[24] Critics such as Marc Silberman have concluded that the relationship of film and expressionism is to be sought less in common stylistic properties than in "an aesthetically grounded position of rebellion against traditional cinematic forms."[25] It is doubtful, therefore, whether the term "expressionism," at least where it is associated with a

given style or set of motifs, can claim general validity as an account of the specificity of German cinema in these years, certainly not if it implies separating out one small group of films and designating some of the rest expressionist "in parts." Rather, the legacy of expressionism to German cinema would seem to lie in the critical intention which informs its response to the age of the mass reproduction of the image, as in Hoddis's reflections on the media-made world of modernity.

The issue, here, is not one of naturalism versus fantasy, but the foregrounding, and problematizing, of the gaze, the "effects of editing that interiorize and subjectify the reading of the image."[26] It is possible to see that interiorization equally in features allied to the overt artificiality which results from expressionist abstraction and distortion, and in the uncertainties and anxieties of the uncanny — in fantastic or supernatural motifs and in the exaggerated chiaroscuro effects of light and shade. What is implicit in both is the "valorization of vision,"[27] which is inscribed not only in fictions of seeing and being seen, as exemplified in the topos of the *Doppelgänger,* but also in ambiguities of perspective which counter the illusionist certainties of classical narrative. In questioning the apparent objectivity and facticity of the image, German cinema develops what has been termed its own "expressivist" aesthetic,[28] to which expressionist techniques can be seen to contribute. But this expressivist intention does not presuppose an ideological affirmation of the autonomy of the subject.[29] Instead, the prerogative of spectatorial command, promised by the dream factory of mainstream film, is subverted. Perception is inseparable, for fictive character and historical spectator, from the reading of the image, from the articulation of its disparate, repressed, and resistant meanings.

By the late 1920s, and certainly with the advent of the sound film, with its enhancement of the illusionist authority of the screen, the ambivalence that could be won from the very silence of the filmic image has already faded. By then the naturalist norm has generally established itself as the accepted mode of representation. Yet if we survey the development of the expressivist aesthetic in German cinema in the later 1910s and 1920s, we find that underlying critique of the unreflected facticity of the screen image feeds into a variety of production styles and thematic concerns. Stylistically, expressionist conventions are juxtaposed with elements of realism and fantasy. Thematically, the expressionists' fascination with the exoticism of the big city lives on to the end of the silent era and beyond, but leaves its mark particularly in the apparently "naturalist" street films of the 1920s, with their depiction of protagonists entrapped in worlds of poverty and degradation, alienation and conformity, temp-

tation and retribution. Here we can trace a direct line of descent from the poetry of Heym, Zech, Wolfenstein, and Stadler, and the paintings of Meidner, Dix, and Grosz.

On the cinema screen, only months after the premiere of *The Cabinet of Dr. Caligari,* it is Karl Heinz Martin's film adaptation of Georg Kaiser's drama *Von morgens bis mitternachts* (From Morn to Midnight, 1920) which first portrays the provincial and urban alienation of the little man — a bank cashier. Here, the totality of the grotesque, like the layers of hallucination which relativize one another in potentially endless regression in *Dr. Caligari,* imprisons protagonist and spectator alike. There can be only one escape route as the cashier flees from entrapment, and that is to embrace that ultimate image of otherness from which he turns in horror throughout his flight. When Martin adds to his dramatic source the series of confrontations with masks of death, the superimpositions of skulls onto the faces of the women whom the cashier encounters, he exploits the cinematic motif of seeing and being seen, in its most radical form, as the protagonist's premonition of his inevitable end. What the cashier first refuses to look on, the image of his own extinction, is finally affirmed when he retreats, revolver in hand, to the Cross in the Salvation Army hall. His assumption of the role of crucified man represents perhaps the most emphatic enunciation in German cinema of expressionist rebellion, the fundamental negation of the trauma of social enslavement. Here, the hope of emancipation resides in the sheer force of protest to be read in that final shot of Martin's film.

It was perhaps the uncompromising tenor of that protest, and the rigor of its visual conception, which ensured that *From Morn to Midnight* was never shown on the German screen in its day.[30] As the influence of *Caligarism* wanes, two films of the mid 1920s announce in their very titles a new direction: the emergence of a subgenre in which the depiction of the city becomes an explicit narrative program. In the sense that in their fictions they set out to address the concrete social realities of street life, Karl Grune's *Die Straße* (The Street, 1923) and G. W. Pabst's *Die freudlose Gasse* (The Joyless Street, 1925) can be said to signal the end of expressionist subjectivism. A contemporary critic lauded *The Street* for the "Zolaesque greatness" of its "unforgettable variations on the theme of the city street,"[31] while *The Joyless Street* was praised for eschewing the theatrical in favor of "maximizing the psychological probability of the action."[32] Yet in their contrasting explorations of metaphors of entrapment and escape, both films clearly display their debt to expressionist visions of the city. And in the ambiguities of perception and spectatorship in which they engage us, both films also demonstrate the

continuing force of their underlying expressivist concern with the mediation of image and consciousness.

In its motifs and visual language Grune's *The Street* echoes a number of features of *From Morn to Midnight* — primarily, of course, its central plot of the quest of its petit-bourgeois protagonist, referred to in fact by the director as another bank employee,[33] to escape his world and savor the fulfillment of repressed desires. Parallels in detail spring to mind, too, in the depiction of city excitements, but most strikingly in the transformation shots which encapsulate the threatening ambivalence of the look: the superimposition of the skull on the female face. In *The Street* the protagonist also retreats in fear, but here the apparition of death is no premonition of tragic self-destruction. Rather, it characterizes this humble hero's complete incapacity for tragedy. The bitter satire of the expressionist protest has given way to a comedy of the impotence of the little man as he confronts his own mystified images of desire.

In his 1947 study *From Caligari to Hitler* Siegfried Kracauer praises Grune's film for its "militant realism challenging the penchant for introspection," but draws attention to what he sees as the discrepancy between this realist tendency and the — by implication regrettable — remnant of expressionist style in the acting of Eugen Klöpfer in the lead role. The protagonist, he notes, "moves about . . . like a somnambulist"; his gestures "seem to be determined by hallucinations rather than by actual experiences."[34] Given the assumption that the distinction of this film consists in the objectivity of its portrayal, the stylistic divergence must remain insoluble for Kracauer, and perhaps motivates his suggestion that the film as a whole, in failing to shake off the introspective fantasies of the postwar years, relapses with its conclusion, the hero's return to the fold, into an apology for German inwardness and resignation, and a "sad renunciation of life."[35] But in his eagerness in exile to demonstrate how the supposed predisposition of the national psyche to chaos and tyranny sets German cinema marching remorselessly from Caligari to Hitler, Kracauer has also forgotten his own earlier review of the film in February 1924.[36] For here he observes aspects of the portrayal of the city which suggest a different reading of the interplay of expressionism and realism. In this reading the street is less an objective setting to the tale than an active participant, visualized as a metaphor of the blindness of events and, above all, human actions: "situations follow one upon another, blindly juxtaposed and without continuity or consequence."[37]

Grune himself spoke of the "optical noise of a metropolitan street, its gleaming, glittering feverishness"[38] as the inspiration of his film, but in the context of his fiction this becomes more than a document of urban

conditions: the frenzied activity of the street reflects the self-absorption of the crowd, the nervous energy of citydwellers divided one from another by their fixation upon distraction and escape. In this respect Grune's street is indeed "expressionistically stylized urban scenery."[39] The milieu into which the main protagonist plunges is one in which, as Kracauer writes in 1924, figures move ghostlike in and out of the shadows, untouching, unseeing and unknowing. Repeatedly we return to extended shots of the road packed with vehicles that seem on the point of collision, shooting along at angles while pedestrians seek to force diagonal passages through the mêlée, spinning in the center as if caught up in a vortex of energy. Two characters, in particular, are used to develop and reinforce that image of violence and vulnerability: the little girl and her blind grandfather. The indifference of the street to their weakness is captured in the overhead view of the child who has lost her way and stands tiny and motionless at the traffic island, dwarfed by the vehicles that scurry around her. Or, as the blind old man gropes his way along the street, a close, low-angled shot of the crowds that brush past, even when he falls into the gutter, underlines their insulated remoteness. The picture of unseeing haste is complemented by the interior shots of frenetic revelers and obsessive gamblers, a world of distraction in which the subplot of the film is acted out. Here we see, on the one hand, the pimp, his woman and his accomplice, whose various criminal schemes come to nothing but a squalid, almost involuntary murder. On the other, the little girl — the pimp's child — and her grandfather, whose innocence and blindness seem to reveal the hidden frailty of a society without vision or consciousness. As Kracauer observed, it is the child who is "the only thing that truly exists in this pandemonium,"[40] and it is she who becomes the instrument of justice when, in another quite accidental twist of fate, she unwittingly reveals the truth of her father's guilt. Only then is the "hero" extricated from his self-made predicament.

The turmoil of the street and nightlife scenes of *The Street*, therefore, by no means stands opposed to the non-naturalist elements in the portrayal of the main character. Rather, the depiction of the child and the old man, and indeed of the physical reality of the city, impinges upon precisely those issues of perception and consciousness which find expression in the stylizing of the lead role. The very opening shots of the film establish the antithesis between the banality of domestic routine — the wife busying herself preparing the meal — and what comes to the man, as he lies snoozing on the sofa, almost as a dream. What we see through his eyes is very much a cinematic vision: the light from outside casts the shadows of man and woman onto the screening wall above him, whereby

the erotic implications of the encounter suggest the man's projection of repressed desires. When he then moves to gaze out of the window, in quest of the source of this romance, what he sees is not the reality of the random bustle of the street — which is naturally all that is apparent to the sober eye of his wife — but the seductive lure of images of otherness: a brief "cinema of attractions," with a montage of trains, tracks, and traffic, of a guffawing clown and an inviting femme fatale, of splashing water and flashing fireworks at the fair, and the sweet nostalgia of an organ-grinder — one image superimposed on the other, disconnected and confused, just vaguely associated as notions of long-lost, or unknown, fun and frolics. It is the power of that unreflecting, almost unconscious, look of desire that drives this *Kleinbürger* to "rebel." There is little of Karl Heinz Martin's cashier, his real hunger for experience and his desperation to escape about this. What Grune's hero is pursuing, as he rushes down the stairs, are his own sentimental fictions; his "escape" hardly challenges the premises of his humdrum existence, and the certainty of his return to respectability can be foreseen from the beginning. What is striking about his self-deceit is that he casts himself in the role of his first vision. For the part he performs, quasi-theatrically, matches precisely the shadow reflected on the wall, with his hat and umbrella, and above all his strutting, prancing walk. The Chaplinesque, clownlike quality of the figure — Kracauer's somnambulist — reminds us throughout of the dubious presumptions and fragile self-image of this adventurer.

Naturally, the dream soon disintegrates into a succession of panics and embarrassments. He never escapes himself, or his fears and bad conscience. Acting the street gallant has unforeseen hazards: instead of looking and conquering, he finds himself looked upon and threatened, as he discovers when his first would-be pick-up returns his stare, with interest, as a decidedly unappetizing skull. Everywhere there lurks the danger of being seen to be what he wants to be: when he follows the prostitute set to trap him, he struggles in vain to conceal his intentions from onlookers, or he stands petrified under the flashing eye of an optician's sign. However eagerly he identifies with the high life of the city, he is never far from home. Early in the adventure he positions himself before a nude painting in a shop window, as if that were the strategic location that ensured command of the erotic potential of passersby and also assured them of his own. But his illusions as to the power of his audacity and charm are underlined with an ironic cut to the sedate figure of his wife, the one woman he belongs to. Later, the point is echoed when he struggles to win back his gambling losses: the image of his wife,

inserted in the wedding ring he is obliged to stake, painfully reminds him, as she fades from view, how much he stands to lose. Elsewhere, his inadequacies in performing the role he has allotted himself generate scenes of near-slapstick farce, such as the pantomime efforts to eject the elderly couple on the park bench who have placed themselves between him and the prostitute; or his rivalry, in claiming possession of the prostitute, with the man from the provinces, which progresses from contortions to block their eye-contact, to his gauche stampede through the milling dancers in quest of flowers, and then to the outbreak of open, bowler-slapping, umbrella-poking, combat between the woman's two dupes.

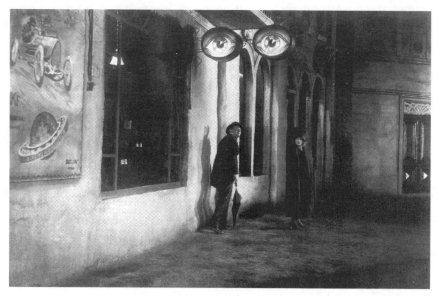

The watching eyes. From Karl Grune's *The Street* (1923).

One moment the adventurer is giddy with excitement, the next he sags with fear and remorse. His progress is never a matter of choice. He is led from one predicament, and imaginary success, to the next: they are all as accidental as the other random events in this city. At the point of perhaps his greatest impotence, when the police burst in to arrest him, he and the grandfather almost grapple together over the corpse at the scene of the murder, each groping blindly toward the other, in the illusion that they are facing the murderer. It is the film's most eloquent image of projected fantasies, of vision without sight. Now the hero finds himself an accused man. Once again, he resolves to take flight — by

hanging himself in his cell. But here, too, events decide otherwise. He is released and sent wearily on his way. His belt remains hanging on the bars of the window, while the wind blows leaves and papers in the early-morning street outside. They are scattered at random, like the last remnants of the fantasies of the night. His one certainty and security remains the motherly solace offered by his patient wife. They stand near the window, as if to take up the story where it began, but this time she stands protectively between him and the light, and clearly he has lost the fancy to look beyond. It is an uneasy reconciliation, yet the best he could hope for. Kracauer is quite correct to point out that the hero's escapade has ended in a rout, that the dream of conquest has collapsed in infantile submissiveness. However, the little man's rebellion never happened, nor was intended, in the first place. Grune's wry comedy is no expressionist protest against the deformation of man, or even against the destructive power of the city.[41] Equally, however, it is no apology for the conformity of the *Kleinbürger*. In its very demolition of its protagonist's mystification of the city and his fantasy of self-abandonment, it offers its own insight into what Heide Schlüpmann termed "a more general 'blindness' in the midst of technically reproduced images."[42] Rightly, Schlüpmann stresses how Grune's film traces its protagonist's self-deception to the spell of the "cinematic apparatus" represented in its opening sequence, but it does not follow that the "deceptive power of the look" manufactured by the cinema of illusion is seen here as "the only possible one."[43] Rather than demonstrating its author's resignation, the conclusion of *The Street* reflects critically on its protagonist's childlike impotence, and on the seductive self-deceptions of a society whose perception of its Other is no more than an unmediated image on the screen.

The ambivalence of the readings of entrapment and escape that G. W. Pabst's *The Joyless Street* wins from its literary source, the tale by Hugo Bettauer set in postwar Vienna,[44] is perhaps all the more striking because its visual language would appear to be quite distinct from the consciously stylized discourse of the entirety of Martin's expressionist caricature and at least substantial elements of Grune's farcical comedy of illusions. Unlike these, Pabst's imagery would seem to embody what Kracauer saw as "the spirit of a photographer" and the stylistic "neutrality" of New Objectivity.[45] Here, apparently, the genre of street film adopts the plasticity of a drama that addresses social conditions and is firmly located in the class structures of contemporary metropolitan life. And this is indeed what makes Siegfried Kracauer warm toward what he calls the film's "unhesitating realism" and the veracity of its portrayal of the pauperization of the middle classes during the inflation years.[46] Yet

Kracauer, to his regret, also sees, particularly in Pabst's treatment of Asta Nielsen in one of the lead roles, a "marked interest in melodramatic motifs" which tends to "drain realism of its inner weight," thereby diluting, if not counteracting, the radical political and social implications of its subject.[47] Lotte Eisner, too, takes issue with what she regards as clichéd pathos in the film's depiction of the city underworld, where "the picturesque triumphs over the tragic." For her *The Joyless Street* "epitomizes . . . Germanic visions,"[48] thereby reiterating innate spiritual dispositions rather than shaping our readings of a particular filmic discourse. Yet it can be argued that Pabst's critique lies precisely in the aesthetic fusion of elements of artificiality and authenticity, melodrama and realism which marks this film's specific interiorization of the look. As Patrice Petro pointed out, the "aesthetic of excess"[49] plays a crucial part in Pabst's portrayal, though it does not follow that the "melodramatic impulse"[50] and its "refusal of censorship and repression"[51] are necessarily addressed to a gendered spectatorship. Where the narrative structures of *The Joyless Street* open up "multiple spaces"[52] of perception and empathy, it is not to invoke the determinate subject position of — male or female — spectator "identification," but to question that privileged positioning of the subject: through distancing and subverting, in our own spectatorial gaze as well, the rhetoric of visual appropriation in which the power structures of this city and society are realized.

In the first shots it is the gloom of an unknown city which presents itself to our gaze, one that invites us to uncover the relations of power and subjugation embedded in its opening image: the street which is the underworld of this city and the object of social forces that have made "joylessness" the inescapable lot of its inhabitants.[53] From the start the camera establishes, then questions, the apparent objectivity of the scene, in a long, overhead shot of four separate figures moving slowly away through the darkness. Initially, perhaps, the impression is one of a quiet homecoming, but then the distortion of relationships becomes evident. Two men walk with difficulty, one with a stick, the other with a wooden leg; between them two young women: one catching up with the first, older man, while the other looks back and moves quickly to one side, as if in fear when she sees who is hobbling behind her. Then, as they turn under an arch, the camera cuts to a street sign: we read the name of the street, Melchiorgasse, illuminated from the side, as each of the four passes below it, as if they are governed by the name, the text society imposes on them. The film is to extend our reading of that sign into the darkness that envelopes each of the figures as they move into and out of the frame.

The Joyless Street is essentially, but not solely, the tale of the two young women, who live in conditions of remorseless hardship. Their families represent two social classes reduced to an underworld existence by the economic collapse: Grete Rumfort, performed by Garbo in her first and only German film, struggles to support her aging father and young sister, her problems compounded by the old man's desperate pride in the respectability of his former status as an imperial civil servant with an honorary title. Marie Lechner, played by Asta Nielsen, hopes to rescue herself from her drudgery and from her brutish father, a working-class casualty of the war, through her love for Egon Stirner. Stirner, however, is a handsome young professional who is intent on making his fortune in a very different world, the city of glitter and glamour inhabited by those who have enriched themselves through exploiting the chaos of the time. The film is structured around the relationship between these two worlds, whereby the deprivation and degradation of the Melchior-gasse is traced to its source, which is the profiteering and purchasing power of high society. It is in the interaction of this society and its underworld that relations of domination and subjection are inscribed into Pabst's narrative, and onto the faces and figures of its protagonists. The polarization between luxury and need is visualized in rapid crosscutting between riotous scenes of dancing and toasting highflyers, on the one hand, and, on the other, the stark images of exhausted and starving figures who stand queuing for meat in the street. That gulf of inequality is then translated into a discourse of power and exploitation. When the banker Rosenow and his Brazilian financier-friend and fellow speculator Canez — whose joint manipulation of the stock exchange is to lead directly to the ruin of Grete's family and, indirectly, to the crime committed by Marie — arrive at the street to savor the merry girls of Vienna's night life, the camera follows the lights of their car as it pans the pale faces of the queuing crowd, forced up against the wall to let the vehicle pass, and reduced to no more than the object of their, and our, spectatorship.

Pabst's visual narrative is permeated with that rhetoric of bondage. Images of command and appropriation regulate social relationships, which are conducted as material, and above all, sexual transactions. Dialogues and deals barter in a variety of currencies: shares, cash, jewels, fur coats, human bodies, and perhaps most drastically, meat. The master of that meat is the lecherous and sadistic butcher, Geiringer, grotesque in looks and appetites, whose threatening bulk is magnified even further by the dimensions of the huge dog at his side. As the street tyrant he exhibits himself at the door of his shop. His swaggering fills the screen,

the posture of the bully whose power matches the authority of the com-
modity he supplies. His signs rule the life of the street, he can dictate his
terms and favor those he chooses. The very thrust of his smoking ciga-
rette-holder is a visual, and sexual, command. When he stares upwards
and out as two prostitutes parade before his cellar window, the shot
reverse shot combination makes us assess, with him, the value of what's
on offer, and then witness, through the woman's legs, his look of glee,
as the window frames what is perhaps the film's most striking image of
acquisitive lust. When Marie Lechner and her homeless friend Else then
try in turn to beg for meat, we follow the butcher's gaze as it passes
upwards over Else's body, a ravishing which preenacts the fate awaiting
her in the meat storage-room. As Else hesitates to follow Geiringer into
the room, the mocking eye-contact he enforces articulates that same
rhetoric of appropriation as he draws her fearful look toward himself
and toward the price he will pay: the slabs of meat hanging behind him.
After her ordeal he hacks her payment from one heavy chunk, which he
hauls out and manhandles as if it were the booty of the body he has just
brutalized.

Other transactions in the street's sex-trade are more refined, but no
less ruthless as abuses of human integrity. The various strands of Pabst's
narrative meet in the central link between city and underworld: the
joyless street's "house of joy," the brothel cum hotel/nightclub that
serves as a clearinghouse for dealings between rich and poor. If Geiringer
rules by brute force, Frau Greifer, the mistress of the brothel, is the
manipulator of masks and appearances. When Grete's father foolishly
imagines his gamble in shares will lead to certain wealth and dispatches
his daughter to purchase a new coat, it is Frau Greifer, in a scene added
to the screenplay by Pabst, who assesses her new customer's marketabil-
ity just as professionally as the butcher prices Marie and Else. Where
Geiringer proffered the chunk of meat, Frau Greifer holds out a glamor-
ous fur, and as Grete shrinks and turns away in modesty, the pimp com-
mands her look just as the butcher did Else's. Invitingly rubbing her face,
a mask of delight, in the other direction, against the line of the fur collar,
Frau Greifer leads Grete on, into the part she knows the girl cannot
resist. While Grete tries on the coat, her benefactress stands approvingly
between her and the mirror, in which Grete sees herself transformed,
wrapped in fur, into the persuasive image of her desire. But having been
seduced by the rhetoric of that image, Grete has unwittingly accepted
the role that Frau Greifer has prescribed for her, without appreciating
that this is a currency which signals her own purchasability. When she
appears at work the next day, the coat not only arouses the admiration

and envy of the other secretaries: in the eyes of her boss, who has already staked his claim on her, the fur tells its own eloquent story. And though Grete may resist his assault, and willingly pays the penalty, the boss knows full well that her colleague Mizzi will be happy to take her place. As the camera focuses on Mizzi's legs, springing eagerly up the stairs to her master's office, it is clear that she, for her part, knows full well what credit she can draw upon.

As, through her father's folly, the family's plight deepens, Grete's innocent enmeshment in the web of exploitation continues. Despite the ignominious, and comic, failure of one attempt to match her with the butcher, Frau Greifer's grip on her protégée tightens. Finally, Grete is obliged to come to a "soirée" at the club, only to discover that this means, of course, a dubious, lightly clad, appearance on the stage. Here, too, we witness her vulnerability in the framing of a mirror-image. As she is forced to undress for the performance, we share in the reduction of her body to an object of voyeuristic possession, watching Frau Greifer's assistant tear the coat from her both before and in a tall triple mirror. Soon after, the violence of that appropriation is intensified in the multiple reflection of the frenzied advances of a waiter, who molests her as she finds herself trapped before the images of her desirability. In the ensuing commotion she reveals her apparent disgrace to the man whose friendship had seemed to be her only hope: the handsome American Red Cross officer — their tenant, before he was ejected by her father — who had been taken to the club to see how low the girls of Vienna could sink. It is only when the father appears with a long-overdue confession of his guilt, that the American's anger is assuaged. Ironically, it is a letter from the bank confirming that Grete gave the rent he paid to clear her father's debts, which redeems her honor in her friend's eyes. Their reconciliation marks the end of Grete's melodrama of virtue under siege, but as she is led out of the brothel her return to society remains ambiguously close to a restoration of commercial propriety, and indeed to a reinscription of the discourse of possession and control which the images of this film have questioned.

Twice in the film, in contrast to Willy Haas's screenplay, the paths of Grete and Marie cross: once in the queue before the butcher's, where they stand side by side, sharing the silent desperation of the starving, but seemingly strangers to each other. The second time, significantly, is at Frau Greifer's, where each is about to be ensnared in the street's machinery of exploitation. While Grete views herself in the mirror, Marie is led through to the room where she sells herself to the speculator Canez. Again, despite their proximity, the film attempts no mediation between

the two women. Their tales progress in parallel and both are variants on a theme of sacrifice, but they remain, particularly in their conclusions, quite distinct commentaries on the hold of this city over its victims, for it is Marie who becomes the true agent of rebellion, of the demand to escape their entrapment, in this drama.

In the butcher's den Marie shrinks behind her shawl, and then flees in fear, to protect herself from the commanding hand which Geiringer thrusts toward her — bearing the meat which Else has paid for with her body. But she does not refuse the dollar bills which Canez holds up before her. In her eagerness to secure Egon's affection with the money he is looking for, Marie is already compromised: she can only rebel against her impotence, and express her love, and resentment, by consciously subjecting herself to her purchaser. That same evening, she witnesses Egon in the next room beg and receive jewels from a society flirt, Lia Leid, in return for services rendered. In the 1997 reconstruction of the film, following the plot of the screenplay, the truth about the events of the night emerges only gradually.[54] At first Marie accepts the protection of her patron, and the jewels and finery he lavishes on her. Front on we see her sitting motionless, seemingly trapped in the role he has imposed on her, a dummy almost, onto which his power is projected. And yet that extravagant image of bondage — which so irritated Kracauer — also hints at the human being, and the conscience, behind the mask.

Marie demands to return to the hotel, and as if to exorcise the memory begins to tell the false story of how she witnessed the crime, culminating in a denunciation of Egon himself as the murderer. But at the same time, despite herself, she also enacts the truth of what happened. As she supposedly demonstrates to her patron how the strangler struck, her hands and arms, bedecked with jewelry, reach out to grasp Canez himself by the neck, betraying the full force of her attack on the symbols of her subjugation, but also, no less, her complicity in that machinery of oppression. Only then, with that self-betrayal, does she begin to resist her exploitation. In removing the jewels and renouncing her "protector," she takes the first step toward deciding to speak for herself and the reality of her desires. Finally, before the investigating judge, Marie revokes her false accusation and clears Egon: this time, when in a second flashback we see her hands reaching out for the neck of her rival, where the jewels given to Egon had hung, it is no performance, but a confession of her longing, sad and futile, to force her way out of bondage. Here, despite her guilt and despite Grete's redemption, it is Marie, perhaps, who

comes closer than any in this underworld to articulating her own conscious will and to determining her own destiny.

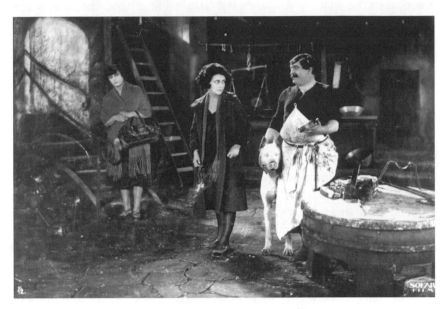

Werner Krauss with Greta Garbo and Asta Nielsen
in G. W. Pabst's *The Joyless Street* (1925).

Beyond the tales of Grete and Marie the street forms the nexus between multiple narratives which cross, diverge, and return at various points of the drama. All that holds them in place is the network of power relationships that deny or repress natural need and desire. Predictably, Marie's rebellion is the prelude to a greater one. At the close of the film a second eruption of passion breaks the silent gloom of the street. Else, who begs Geiringer in vain for meat for her child, takes her revenge: the butcher is butchered. The framing of his lecherous gaze at the window is ironically repeated, but this time his face is a different mask, streaming with blood. Then the mob turns on the brothel. Briefly the storm rages, as the cheated and humiliated drive Greifer's clientele from their street — but perhaps only provisionally. In the 1989 reconstruction, the narrative concludes at that point, and the film ends as it began: with a long shot of the street, a line of silent façades, hiding their stories in the darkness. With no suggestion now that any voice might still be heard, it looks as if a petrified society, rotten beneath, will survive. In the 1997 reconstruction the final scene of Haas's screenplay is added, in modified form. Else escapes arrest, but only to be trapped with her young husband and

child in a fire that perhaps spreads to their garret from the brothel. Although the parents must die in the flames, the child is saved by being let down from the window to the crowd below. Here, too, what may seem like a glimmer of hope for the future must surely recall the opening shots of the film: in the figure of the infant orphan the broken family relationships of the past are perpetuated. Melchiorgasse remains the victim of its oppression and its desperate passion.

Neither conclusion to Pabst's film suggests, then, that the joyless street will truly emerge from the gloom to find its own voice, and yet the same camera which translates the relations of city and underworld into a discourse of domination and appropriation is also able to read into its images a depth of humanity that ultimately resists enslavement. Repeatedly, the facticity and linearity of the rhetoric of power is subverted, and the narrative is broken by moments of static silence, whose eloquence confronts us with unresolved questions. That ambivalence can be seen in seemingly objective elements of the action or *mise en scène,* such as the human relationships revealed in the apparently chance constellation of figures in the opening sequence, or the moment where Grete goes to return her fur coat to Frau Greifer, and we see the two garments, new and old, hanging there together, speaking of the irreconcilable otherness of desire and reality. Yet it is in the close-ups which explore the faces of his protagonists that Pabst most consistently and expressively uses this technique of narrative suspension. Here his camera creates a space between spectator and screen which breaks down the apparent facticity of the image, revealing its true otherness by presenting it as no more than the surface appearance of hidden emotional realities. The very silence articulates the unspoken, and the spectator learns to listen.

Repeatedly, as Grete struggles with misfortune, a moment is frozen. Garbo's face is framed, full-on or from the side, with level or high-angle shots. The camera holds the character as the object of our gaze and as the victim of the rhetorical and material forces which prescribe her existence. Yet at the same time her eyes, or head, move away, and generally upwards, and in that movement, within the stasis, we see a wave of shock, sorrow, despair, or hope, thoughts and feelings in which we recognize both Grete's entrapment and her struggle to free herself. The same technique can be used satirically, too, as Pabst shows in a scene he substituted for another in the screenplay. When the oafish butcher arrives for the tea party which the scheming Frau Greifer has arranged for him with Grete, he is, or believes himself to be, fully equipped to conquer: he preens himself at the mirror, with black locks and moustache greased down, quality suit bursting at the seams, hat, cane and cigar-holder. Yet

all his paraphernalia and conceit come to nothing. As the camera rests in turn on the three faces around the table — Grete dignified but reserved, Frau Greifer bemused and bored, and Geiringer in growing desperation as his eyes bulge with the effort of trying to think of a ploy — the silence is audible. So brutally in command before his meat cupboard, it is the butcher here whose true speechlessness, and impotence, are revealed.

With Marie, too, the rhetoric of appropriation meets its limits. Here, too, the narrative is suspended, as the figure is held full-face and the frame is frozen. In the scenes where, following the murder of her rival, Marie appears as the mistress of the financier, Asta Nielsen's face fills the screen, an unmoving and expressionless mask. It is as if her function was merely to display the extravagant costume and plumage with which the Brazilian has decorated her, merely to serve as an exotic exhibition piece purely at his disposal. And this is indeed the role which Marie accepts at that moment to screen her guilt. Yet while in Grete's case it is the play of her features that opens up the hidden depths of her feeling, Marie's mask reveals its otherness through her very withdrawal, and absence, from our gaze. And although she has outwardly assumed the part that Canez has chosen for her, the barrier that she erects in fact denies him the very possession he claims. While Canez is incapable of recognizing it, it is Marie's very silence which speaks here, through her fixed stare, of the real conflict that is taking place within her. After her confession, the camera again frames Marie's face, now unadorned, as she turns to respond quietly to Egon's first acknowledgment of her love. She turns back, and the shot fades on her, full-face, as she sits poised, calm and withdrawn into herself. As we look into that face, one which resists inspection and appropriation, we learn to read the images of the city, and its cinema, and to hear the voices of those who remain silent and unknown, but living and human, in this joyless street.

In probing beyond the surface images of its city, Pabst's drama, like Grune's before it, evinces far more than "a profound sense of fact."[55] The polarities of alienation and rebellion are in each film balanced with different emphasis: their conclusions contain contrasting elements of protest, critical awareness and utopian hope. Both films assess processes of deception and illusion, recognition and understanding, in their protagonists. The timorous conformity of Grune's "man" stands opposed to the desperate resilience of Pabst's Marie: the one retreats in disorder from the image he has projected of himself; the other learns to resist the image in which society has cast her. It is in their depiction of human beings confronted with the uncertainties of perception and self-perception, and their engagement of the historical spectator in those uncertainties, that

The Street and *The Joyless Street* deviate creatively from the mainstream of classical narrative. In generating that ambivalence of perception they exemplify what we have termed the critical intention which informs the stylistic heterogeneity of the cinema of the Weimar years. The interplay of fantasy and realism manifests itself here not as an eclectic *Nebeneinander* or hotchpotch which pretends to ideological continuity and cohesion, but, as a recent study of the films of Pabst argued, as the "expressive ensemble of a particular aesthetic consciousness."[56] The product of that consciousness is a visual discourse which complements, and questions, the intrinsic referentiality of the camera with its own "reflection upon the intelligible structure of the image."[57] It is in winning their readings of the city from aesthetic reflection upon the image and its meanings that *The Street* and *The Joyless Street* demonstrate the deeper "realism" of the *street-film* and enrich the cinema of the 1920s as a medium of urban modernity.

Notes

[1] Georg Simmel, "The Metropolis and Mental Life," in Simmel, *On Individuality and Social Forms. Selected Writings,* ed. Donald N. Levine (Chicago: U of Chicago P, 1971), 324–39.

[2] Anthony Sutcliffe, "The Metropolis in the Cinema," in Sutcliffe, *Metropolis 1890–1940* (London: Mansell, 1984), 152f.

[3] Harro Segeberg, "Literarische Kino-Ästhetik. Ansichten der Kino-Debatte," in *Die Modellierung des Kinofilms,* ed. Corinna Müller and Segeberg (Munich: Fink, 1998), 198f.; Ben Singer, "Modernity, Hyperstimulus, and the Rise of Popular Sensationalism," in *Cinema and the Invention of Modern Life,* ed. Leo Charney and Vanessa R. Schwartz (Berkeley: U of California P, 1995), 92.

[4] Anton Kaes, "The Debate about Cinema: Charting a Controversy (1909–1929)," *New German Critique,* vol. 40 (1987): 14.

[5] Tom Gunning, "The Cinema of Attractions: Early Film, Its Spectator and the Avant-Garde," in *Early Cinema. Space, Frame, Narrative,* ed. Thomas Elsaesser (London: British Film Institute, 1990), 56–62.

[6] For links between the "aesthetics of astonishment" in early film and sensationalism in other media see Ben Singer, "Modernity, Hyperstimulus, and the Rise of Popular Sensationalism," 92.

[7] Siegfried Kracauer, "Kult der Zerstreuung. Über die Berliner Lichtspielhäuser," in Kracauer, *Der verbotene Blick. Beobachtungen. Analysen. Kritiken,* ed. Johanna Rosenberg (Leipzig: Reclam, 1992), 149.

[8] Max Brod, "Kinematograph in Paris," in *Kein Tag ohne Kino. Schriftsteller über den Stummfilm,* ed. Fritz Güttinger (Frankfurt am Main: Deutsches Filmmuseum, 1984),

36. Translations of German quotations are my own unless a published source is given.

[9] Miriam Hansen, "Early Silent Cinema: Whose Public Sphere?" in *New German Critique*, vol. 29 (1983): 158.

[10] Noël Burch, "Porter, or Ambivalence," in *Screen*, vol. 19 (1978–79): 96–97.

[11] Hugo von Hofmannsthal, "Der Ersatz für die Träume," in *Kino-Debatte. Texte zum Verhältnis von Literatur und Film 1909–1929*, ed. Anton Kaes (Tübingen: Niemeyer, 1978), 151.

[12] N. Burch, "Porter, or Ambivalence," 99.

[13] Walter Benjamin, *Charles Baudelaire: A Lyric Poet in the Era of High Capitalism* (London: Verso, 1983), 132.

[14] Thomas Elsaesser, "Film History and Visual Pleasure: Weimar Cinema," in *Cinema Histories/Cinema Practices*, ed. Patricia Mellenkamp and Philip Rosen (Metuchen, NJ: U Publications of America, 1984), 65.

[15] Miriam Hansen, "America, Paris, the Alps: Kracauer (and Benjamin) on Cinema and Modernity," in *Cinema and the Invention of Modern Life*, ed. Leo Charney and Vanessa R. Schwartz, 363.

[16] Ibid.

[17] On the development of the department store as visual spectacle, see Erika D. Rappaport, "A New Era of Shopping: The Promotion of Women's Pleasure in London's West End, 1909–1914," in *Cinema and the Invention of Modern Life*, ed. Leo Charney and Vanessa R. Schwartz, 132–36.

[18] M. Hansen, "America, Paris, the Alps," 363.

[19] Peter Ruhmkorf, ed., *131 expressionistische Gedichte* (Berlin: Wagenbach, 1976), 58–59.

[20] Ibid., 61. Harro Segeberg sees the shock-effect of this juxtaposed imagery as evidence of a "kinematische Rezeptionshaltung," but misses its media-critical implications; cf. H. Segeberg, "Literarische Kino-Ästhetik. Ansichten der Kino-Debatte," 210.

[21] Kasimir Edschmid, "Expressionismus in der Dichtung," in *Expressionismus. Manifeste und Dokumente zur deutschen Literatur 1910–1920*, ed. Thomas Anz and Michael Stark (Stuttgart: Metzler 1981), 46.

[22] Jürgen Kasten, *Der expressionistische Film*. Münster: Maks, 1990, especially 7–38; Rudolf Kurtz, *Expressionismus im Film* (Berlin: Verlag der Lichtbildbühne, 1926), 61f.; Andrew Tudor, "Elective Affinities. The Myth of German Expressionism," *Screen*, vol. 12 (1971): 143–50; Barry Salt, "From Caligari to Who?" *Sight and Sound*, vol. 48 (1979): 119–23. For a discussion of changing conceptions of filmic expressionism in the 1920s see Leonardo Quaresima, "Der Expressionismus als Filmgattung," in *Filmkultur zur Zeit der Weimarer Republik*, ed. Uli Jung and Walter Schatzberg (Munich: K. G. Saur, 1992), 174–94.

[23] B. Salt, "From Caligari to Who?" 120.

[24] A. Tudor, "Elective Affinities. The Myth of German Expressionism," 149.

[25] Marc Silberman, "Industry, Text and Ideology in Expressionist Film," in *Passion and Rebellion. The Expressionist Heritage,* ed. Stephen Bronner and Douglas Kellner (London: Croom Helm, 1983), 377.

[26] T. Elsaesser, "Film History and Visual Pleasure: Weimar Cinema," 62.

[27] Ibid., 73.

[28] Cf. B. Salt, "From Caligari to Who?" 121–22.

[29] Here I would differ from Silberman's assessment of the ideological implications of spectatorship in Murnau's *The Last Laugh* in *German Cinema. Texts in Context* (Detroit: Wayne State UP, 1995), 32–33.

[30] J. Kasten, *Der expressionistische Film,* 52.

[31] Stefan Großmann, quoted from Ludwig Greve et al., eds., *Hätte ich das Kino! Die Schriftsteller und der Stummfilm* (Stuttgart: Klett, 1976), 327.

[32] Franz Blei, *Die göttliche Garbo* (1930), quoted from L. Greve et al., eds., *Hätte ich das Kino,* 296.

[33] Fred Gehler, "*Die Straße*. Der Film einer Nacht," in *Deutsche Spielfilme von den Anfängen bis 1933,* ed. Günther Dahlke and Günter Karl (Berlin: Henschel, 1988), 93.

[34] Siegfried Kracauer, *From Caligari to Hitler. A Psychological History of the German Film* (Princeton, NJ: Princeton UP, 1947), 120.

[35] Ibid., 122.

[36] Siegfried Kracauer, "Die Straße," *Frankfurter Zeitung, Stadtblatt* (3 February 1924), and *Abendblatt, Feuilleton* (4 February 192).

[37] *Abendblatt* (4 February 1924).

[38] F. Gehler, "*Die Straße*. Der Film einer Nacht," 93.

[39] Heide Schlüpmann, "*Der Gang in die Nacht*. Das Motiv des Blinden und der Diskurs des Sehens im Weimarer Nachkriegsfilm," in *Filmkultur zur Zeit der Weimarer Republik,* ed. Uli Jung and Walter Schatzberg, 50.

[40] S. Kracauer, *Stadtblatt,* 3 February 1924.

[41] Cf. Hanno Möbius and Guntram Vogt, *Drehort Stadt. Das Thema "Großstadt" im deutschen Film* (Marburg: Hitzeroth, 1990), 35: "In Karl Grune's *Die Straße* zeigt sich beispielhaft die expressionistische Kritik an der zerstörerischen Wirkung der großen Stadt."

[42] H. Schlüpmann, *"Der Gang in die Nacht,"* 47.

[43] Ibid., 51.

[44] Hugo Bettauer, *Die freudlose Gasse. Ein Wiener Roman aus unseren Tagen* (Frankfurt am Main and Berlin: Ullstein, 1988).

[45] S. Kracauer, *From Caligari to Hitler,* 168.

[46] Ibid., 167.

[47] Ibid., 170.

[48] Lotte H. Eisner, *The Haunted Screen. Expressionism in the German Cinema and the Influence of Max Reinhardt* (Berkeley: U of California P, 1973), 256.

[49] Patrice Petro, "Film Censorship and the Female Spectator: *The Joyless Street* (1925)," in *The Films of G. W. Pabst. An Extraterritorial Cinema,* ed. Eric Rentschler (New Brunswick, NJ: Rutgers UP, 1990), 32.

[50] Ibid., 31.

[51] Ibid., 38.

[52] Ibid., 31.

[53] Cf. the analysis of this sequence by P. Petro, "Film Censorship and the Female Spectator," 32, and Hermann Barth, "Insinuatio. Strategien der Emotionslenkung in den Anfangssequenzen von G. W. Pabsts *Die freudlose Gasse* (1925)," in *Der Stummfilm. Konstruktion und Rekonstruktion,* ed. Elfriede Ledig (Munich: Schaudig, Bauer & Ledig, 1988), 9–32.

[54] An informative account of the process of reconstruction is given by Jan-Christopher Horak in "*Die freudlose Gasse.* A Reconstruction in the Munich Filmmuseum," in *Cinegrafie 10: Silent Garbo* (Ancona: Transeuropa, 1997), 320–24.

[55] S. Kracauer, *From Caligari to Hitler,* 170.

[56] Hermann Kappelhoff, *Der möblierte Mensch. G. W. Pabst und die Utopie der Sachlichkeit* (Berlin: Vorwerk 8, 1995), 14.

[57] Ibid., 18.

Fragmenting the Space:
On E. A. Dupont's *Varieté*[1]

Thomas Brandlmeier

> *A space that has become active,*
> *that blossoms, ripens and decays.*
> *Contrasting with "space as limit."*
> *Notions of space are generally associated*
> *with passivity. . . .*
> *In contrast to this an active space,*
> *in which volumes would merely be trajectories.*
> *Gone all talk of objects in space.*
> *The object itself becomes space.*
> *Space — if properly understood — comprises*
> *an enormous play of opening up, of circulation,*
> *reciprocal relationships and penetration.*
> André Masson: *Digressions about Space*

> *Time is internal space . . . space is external time.*
> Novalis: *Fragment 236*

NOT ONLY Lotte Eisner and Siegfried Kracauer have been instrumental in determining the assessment of Dupont's artistic achievements. His contemporaries Willy Haas,[2] Hans Siemsen,[3] Herbert Ihering,[4] Rudolf Arnheim,[5] Kurt London[6] and many others had helped to create a received notion of the director's work. Dupont emerges from the writing of these critics as having made only one outstanding film, *Varieté* (Variety, 1925), a work which is, however, deemed to be marred by artificiality and exaggeration.

The plot confines itself to interweaving the motif of rebellion and submission with the familiar theme of the instinct dramas in a rather banal manner. . . . Psychological ubiquity as well as fluidity of pictorial narration: all sprang from *The Last Laugh*."[7]

Kracauer's classification of the film as a variation of the *Triebdrama*, and as stylistically dependent on Murnau, remained unquestioned. While not necessarily inaccurate, this reception of the film is rather blinkered. It overlooks the essential aesthetic novelty of *Variety*.

Dupont's oeuvre bears the mark of a director who adopts the norms of the industry, but who also shows an enduring penchant for doing "crazy things" with the camera. However disparate the loose ends of Dupont's main film may seem, there is nevertheless one consistent stylistic feature in it: the fragmentation of space. The aesthetics of an impending loss which arises from the underlying topic of Dupont's work pervades the film. Extremely diverse realms of life are brought together by him. The world of entertainment, of the *shtetl* and of rural life are combined. The power of social norms puts a terrifying end to any attempt to escape from a given environment. Human beings have the ground pulled from under their feet. Dupont's stories might be banal, however the dramatic function ascribed to the camera is commensurate with the enlightened melodrama. Psychology enters the stage. Questions of perspective come into view. In the cinema this is the hour of the camera. As double agent in the service of the direction and the camera's gaze, it both acts and guides. No one is safe from this unforgiving, incorruptible eye. It shows the actors struggling hopelessly and helplessly within the confinement of their prejudice, their norms, and their emotions.

In conjunction these two elements create a truly revolutionary momentum which has so far been overlooked in the reception of Dupont's films. The strategy, by which this creator of enlightened melodrama carves into, fragments and even atomizes narrative space, constitutes a break with stylistic norms such as they had remained intact in Murnau's *Der letzte Mann* (literally, The Last Man, translated as *The Last Laugh*, 1924). In this, the unity of the optical axis, space and point of view had remained unchallenged. The progressive mobilization of space, as it had first emerged during the Renaissance, reaches a moment of supreme control over time and space in *The Last Laugh*. In *Variety*, however, a dialectical *volte-face* occurs. The fragmentation of space and the loss of a unified point of view are inseparably linked. Space, time, and action are segmented. The seemingly objective appearance of individuality which is still upheld in *The Last Laugh*, deteriorates into an experimental arrangement of anonymous forces. The gyrating and "drunken camera" in *The Last Laugh* thematizes the impending loss of self. In Dupont's film the ego is lost in a gaze which can no longer be controlled. The establishing shot in *The Last Laugh* is organized around a dual axis of motion: leading from the lift to the foyer one axis is horizontal the other vertical. In *Variety* we are confronted with a circular structure which is distorted into an elliptical trajectory through the position of the camera. It encompasses the fairground and is governed by the law of rotational oscillation.

The movement of human beings and objects on the screen proved to be a source of inordinate fascination to contemporary witnesses of the advent of cinema. It would, however, take another thirty years of technical and stylistic developments before the mastery over space associated with the "entfesselte Kamera," and thus the camera which had started to move freely through space was achieved. It was approximately around the same time that editing and filmic point of view reached a comparable degree of perfection. The co-operation between Dupont and his cameraman Karl Freund lead to a mode of seeing which broke with numerous conventions. The commotion in the fairground is shown from clashing perspectives which cancel each other out; the swing boats oscillate against each other making it impossible to gain a sense of orientation. Then, suddenly, the camera is positioned near the ferris wheel and the movement is both upward and downward, the lateral elements are optically distorted and plunge into an abyss. These few takes alone dissolve forms of visual perception which had remained valid for five hundred years and which had dominated the discourse on seeing. The vanishing point and the point of view are no longer fixed, but rather fluctuate incessantly, they become associated with multiple perspectives or they cease to exist altogether. The widened angle of vision achieved through shorter focal lengths engenders a hyperbolic impression of space, in conjunction with the spatially highly restrictive settings, parabolic distortions emerge. As a significant stylistic device in this chamber play of anonymous, lost individuals, this wide-angle effect keeps reccurring throughout the film.

From this angle the radically modern quality of *Variety* comes into view. Thrown out of its customary orbit the visual sense inflects the century old preconditions of the sovereign gaze. First the sixth sense, the sense of balance, looses its stabilizing function. There is not anymore just one, rather there are multiple focal points of vision which render the observer peripheral. This process affects cinematic time. In *Variety* the temporal dimension is realized in entirely novel ways. This becomes most strikingly apparent, when the camera itself emulates a pendulum. The very basis of chronology, the even motions of a pendulum, are now described by the camera itself. Not space, but time and its phenomenology become the object of Dupont's film. With *Variety* the cinematographic analysis of space without an analysis of time is finally rendered obsolete. Not only are cinematographic operations intrinsically tied to the flow of time: in *Variety,* space is continuously dissolved into temporal phenomena.

However, Dupont goes yet further. While the mobile camera — frequently in complicity with point of view — turns space into time, the editing simultaneously elicits the spatial dimensions of time. The film constructs time in space in ever-different ways.

Dupont was always the polemicist. In 1919 he poured scorn on the "aberrations of film directing" and pronounced: "Only few have managed to make the astonishing discovery that — with some exceptions — a dissolve merely serves to bridge temporal elision."[8] The film's framework narrative begins with a fade-in and ends with a fade-out. The narrative is presented through a flashback (introduced through a superimposition of images). The fade-in focuses on the governor of the prison, who is presented as a Godlike figure. He materializes straight out of the realms of cinematographic eternity or rather timelessness. The space around him is made purely of the light from the fade-in. The connection with the prison is only highlighted through the intertitle and the first delirious image, the vortex which whirls the prisoners around. The image of God residing in prison recalls the work of Piranesi. In his *Birth of the Prison* Foucault speaks of *panopticism*.[9] What begins with the apotheosis of the fade-in ends with a fade-out of a prisoner's number tag. The human being carries a stamp which marks him as having fallen foul of human society or — in the case of the artists' gear — as doomed to die on his flight through the big top. The framework narration constructs the space around the narrative time. According to Foucault, narrated time amounts to a confession, it employs "all those procedures by which subjects are lead to engage in a truthful discourse on their sexuality."[10]

The turmoil of superimposed images of the fairground throws the nameless crowd into a stream of narration. The quick succession of moving spaces is also an attempt at escape. This evasive narrative momentum only comes to a halt in front of one of the booths. Here, grotesque actions unfold and the viewers suspect themselves to be in the wrong film. The grotesque and the melodrama organize time and space in fundamentally different ways. Dupont would have been a bad director had he not known how to make use of the dialectical potential of his crossover between genres.

The competition of the booth owners takes place in front of the booths, while an amused crowd of carnevalesque figures undulates between them. The façades are promises of their interiors. Muscle power and female flesh are announced. Ideals like "grace-shapeliness-youth," such as Boss (Emil Jannings) announces them vociferously to his audience, are of course alien to the grotesque. It is the physical, tangible that

it is concerned with. Lads barge into each other, smoking their fags. Kurt Gerron wolfs down a sandwich. The belles with their display of well-rehearsed boredom are hardly awe-inspiring. The show is an act of deception based on mutual consent. Grotesque spaces are not delineated, but rather invade each other. The human mass in search of amusement surges from stall to stall, climbs up the stairs and pushes its way forward into the interiors. "No false modesty, those who sit in front will see most," they are told. The separation between the auditorium and the stage is provisional and fluid. The narrative alternates between acceleration and retardation, just like the surging mass, the brief gags, the change between long shot, medium long shot, and close-up.

In two sequences later on in the film the same setting provides the background for melodramatic action. Boss has found a new act, an exotic dancer (Lya de Putti). Boss compares the slipper-clad feet of his aging wife with the dancer's legs. Legs, and the effect they have, become a kind of leitmotif of the film. In his memoirs Albrecht Joseph recollects Dupont as a leg fetishist.[11] Boss's gaze fixes and isolates the women. The raucous crowd is more interested in the dancer's opulent curves. Boss is isolated, peripheral to the action. He crosses between spaces through a curtain which separates inside and outside. Now the spaces are strictly separated. There is the space for watching and there is a space for looking away. Even the audience's forward surge is no longer a grotesque transgression but a melodramatic violation of thresholds. Strictly linear and parallel, the shot sequence proceeds from long shot, to medium long shot and culminates in a close-up. Boss declares the performance finished. The accelerated time is brought to a halt for an instance. After a close-up, the disappointed crowd breaks up. A melodramatic duration is created by the pseudo-subjective pan which passes over the empty rows of chairs. Taking possession of space in this way is no less a claim to power.

In *Variety,* the characters' control over space is quickly transformed by the moving camera into their lostness in space. There is another, no less ambivalent, form of spatial representation, which recurs throughout the film. This simply is a result of the fact that most characters in the film smoke heavily. Their smoke fills the spaces, but it also hides things. The interior of the caravan is a private space. In this connection Bakhtin speaks of the *chronotope* of the private: "The quintessentially private life . . . was, by its very nature and as opposed to public life, *closed.*" In the cinema the camera becomes a secret listener: "In essence one could only *spy* and *eavesdrop* on it."[12]

Boss spreads clouds of smoke in his caravan. This signals his domination within the space, but also serves to conceal his changing emo-

tions. The sudden flicking away of a cigarette stub provides an antithesis to this. Another fragile balance is represented in the shape of the curtains which open and close. These virtual spaces are unstable, threatening, uncertain. A number of dramatic changes exploit this potential. Boss, who is chatted-up by Lya de Putti, smokes incessantly. Boss submits to her charms, while his wife is listening from behind the curtain, thus replicating the position of the audience. Artinelli, Boss's rival for Lya de Putti's affection, is also portrayed as seducer who blurs reality when he gives her a present or when he entices her into a room.

In the coffeehouse scene Dupont spreads a veritable smokescreen of concealment, secrecy and deception. Here Boss discovers private truth in a public space in the shape of a caricature on one of the table tops. At one point, just before a hand covers the drawing of Boss as cuckold, smoke wafts across it and averts imminent danger. Significantly, it is the fact that he has left his cigarette case which makes Boss turn around and climb the stairs once again. After his fit of rage — presented in a pseudo-subjective shot from the back (Jannings is predominantly filmed in such rear-views, or from the side) — he climbs down the stairs like a man who has been hit over the head. Bakhtin comments on this topic: "Upstairs, downstairs, the threshold the hallway, the landing become spaces where the crisis, the radical change, the unexpected turn of fate unfold, where decisions are made, where the borderline to the realm of the forbidden is crossed, where renewal or downfall take place."[13]

The fight of the rivals at the end of the film borders on a caricature of the familiar motif. Artinelli, nervously chain-smoking, tries to hide and deceive. He offers his rival a cigarette which Jannings rejects, and then, wrapped in clouds of smoke, throws himself unto the bed. When Jannings threatens him with a knife and starts counting to three to get him to defend himself with the other knife Artinelli panics, the cigarette falls out of his hands and his fate is thus sealed.

After leaving his wife and child, Boss lives in a caravan with Lya de Putti. Dupont dramatizes their domestic life in the style of a Samson and Delilah idyll. Boss waits on Lya de Putti, he cooks and washes the dishes. Dupont favors shot transitions, which wrap the action across the cut and which interlace spaces and objects creating a form of filmic cubism. Boss cooks, and lights a cigar. However, the cigar is hidden in the box in which the ginger is kept and he lights it on the gas stove. Boss throws dirty water out of the door of the caravan and splashes his visitors in the process. Boss discusses an engagement in the *Wintergarten* when Lya de Putti opens the window and looks out. Boss does not want to accept the engagement, but Lya de Putti does. She extends a leg with a holed

stocking in his direction. Boss takes the stocking and mends it. She talks him into accepting the engagement. She rewards him by holding her foot out to him. He pulls the stocking over it and caresses her leg working his way upwards. The anthropological space — according to Kant — is the possibility of togetherness.

The dialectics of the grotesque and the melodrama is again employed during the artists' fete. The melodramatic motif of leg fetishism is played out in a grotesque context. In the culmination of a carnevalesque scene Boss plays guitar on Lya de Putti's outstretched leg. The scene ends with Lya de Putti falling into the arms of his rival Artinelli. But the lights go out and we do not see them kissing each other. At a flash the black frames transport us back to the melodrama. The party has come to an end. An empty cloakroom, an empty corridor, black frames and images of emptiness appear before us. The break could hardly be more strikingly realized.

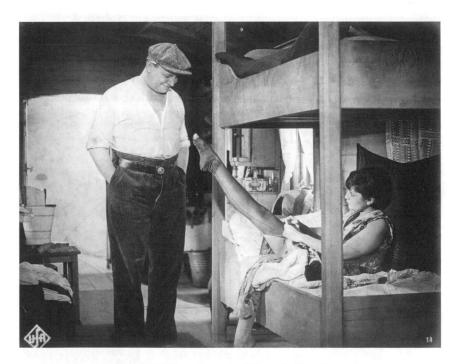

Emil Jannings and Lya de Putti
in E. A. Dupont's *Variety* (1925).

The seduction scene next day employs an intrigue based on space. Artinelli opens the window of his hotel room and puts his shoes in the corridor. He makes sure that Lya de Putti is on her own. He knows that soon she will walk down the corridor. He waits on her and engages her in a conversation. Taking a step backwards from his door he makes her set foot on the threshold. His open window has the desired effect. The draft gives him an excuse to ask her to close the door. The room becomes a trap. Meanwhile Boss is playing cards. The image of a trap is finally complete when the shutters on Artinelli's window come down. Boss wins, the shutters go up again. Fates are sealed within the duration of a game of cards.

Another variation on the construction of time within space occurs during the night of the spring festival. Lya de Putti does not return home, the clocks turns two, three, half past five. The different hues of light from the rising sun behind the curtains. A view from above shows the last whore and the last nightbird as they turn in. The street lighting is still on, but in the diffuse light of dawn it throws no shadows.

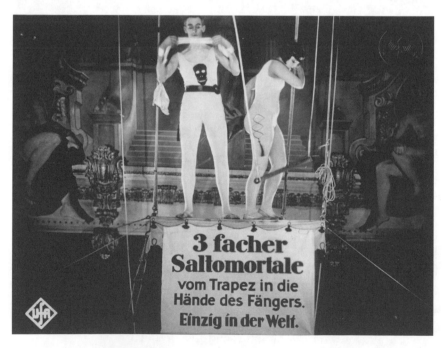

Scene in the Wintergarten in E. A. Dupont's *Variety* (1925).

The acoustic variation on this theme occurs during the performance in the *Wintergarten*. Boss, the trapeze artist, ponders on whether he should let Artinelli plunge to his death. He breaks out into a sweat. His agent in the audience is the only one who knows what is going on. He too starts to sweat. A sea of eyes which are glued onto the spectacle contrasts with the agent, who cannot bear to look. Panic-stricken he leaves. Outside he hears the applause (the sound of applause in a silent film). Relieved, he leaves the space of looking away and returns to the auditorium.

In the melodrama the objects and their inherent power fulfil their dramatic function by becoming associated with obsession. Smoking and playing cards are addictions, substitutes, and symbols. Artinelli presents Lya de Putti with a bracelet. Returning in the early morning she makes herself freshly up but forgets the bracelet. While in Boss's embrace she manages to take it off without him being aware of it. The *chronotope* of concealment will continue to be played through with great routine. In *The Ring* (1927) Hitchcock introduces his variation on this theme.

Boss's social rise is reflected in the change of his clothing. The last relict of his fun fair days is his flat cap. At the height of his hubris he sports a hat. In the scene in the coffeehouse, and thus immediately before the peripeteia, he wears an elegant hat. After having murdered his rival, his state of mind can be gleaned from the state of this hat: it is dented and torn.

The film closes with a superimposition of Boss and prisoner No. 28. Again the iconography of apotheosis is quoted. The absolution is followed by a final shot that all critics have interpreted as somber and devoid of hope. The number 28 has disappeared and not even the pseudo-subjective rear-view of the main protagonist remains. A dark gateway opens onto a poplar framed avenue, but the camera points into the void. There is no vanishing point and no horizon. "The new is necessarily abstract. You do not know what it is, just as you do not know the secret of Poe's pit."[14] The effect of the image is devastating. No path is visible here and in the absence of any directional forward thrust time has been annihilated.

The case of Dupont in film history can be compared with that of Caravaggio or Lucia Signorelli in the history of painting. Experts hold the filmmaker in increasingly high esteem. His contemporaries were blind to many aspects of his work which have become visible with the benefit of greater hindsight and distance. Historical evaluations view Murnau as the "classic of German film," the creator of what is considered to be unquestionably "great art." Next to him Dupont is certainly applauded for his "sensitivity," "talent," and his "visual effects."[15] How-

ever, his radical modernity, his courageous formal innovation, the revolutionary step in the occidental history of seeing which his work represents is ignored. Inevitably, historical evaluations view Dupont within the limitations of their own conceptual framework: the evolution of cinematic expression, a stylized and artificial adoption of the principles of the moving camera, Weimar and its consequences as they are reflected in cinema. I do not wish to enter into a discussion on whose art is of greater merit. No doubt, Murnau had a classical approach to form missing from the work of Dupont. Dupont, on the other hand destroys and goes on to create something new and frightening. Murnau has rendered the walls of perception transparent. Dupont, however, is the crack in the foundations.

Translated by Ursula Boeser

Notes

[1] This essay is a revised and extended version of previous attempts to gauge the radical modernity of Dupont's *Variety*. For an earlier version see Thomas Brandlmeier, "Zeiträume. Drei Anmerkungen zu Dupont," in *Ewald André Dupont. Autor und Regisseur*, ed. Jürgen Bretschneider (Munich: edition text + kritik, 1992), 35–44.

[2] Haas calls Dupont an "ingenuous technician" whose intelligent choices "are abstractions which react to a given scene, rather than inform the film in its entirety." He continues: "His technical achievements surpass the work of any of his predecessors. The film is highly inspirational." In *Film-Kurier* (17 November 1925).

[3] Siemsen is primarily put off by the element of phantastic invention in *Variety:* "Such an assembly of grotesque animal-like faces is not to be found anywhere. An audience such as this is simply unthinkable. Not even in a meeting of German nationalists would you come across anything like it. . . . The visitors of this fun fair are monstrous products of a mind which has been poisoned by literature." In *Weltbühne* (8 December 1925).

[4] Ihering praises the brilliance of the film, but not without adding: "A new device is almost flogged to death." In *Berliner Börsen-Courier* (17 November 1925).

[5] Arnheim also ranks *Variety* amongst the "very best films." Nevertheless, in his view Dupont is merely an "acceptable director" without a style of his own. In *Das Stachelschwein*, no. 6 (1926), and *Medium*, no. 9 (1975).

[6] In 1930 Kurt London voiced his disappointment with Dupont "who acquired fame through silent film." He even describes his work as "primitive." In *Der Film* (20 September 1930).

[7] Siegfried Kracauer, *From Caligari to Hitler. A Psychological History of the German Film* (Princeton, N.J.: Princeton UP, 1974), 126f.

[8] E. A. Dupont, "Abwege der Filmregie," in *Film-Kurier* (29 July 1919).

[9] Michel Foucault, *Discipline and Punish. The Birth of the Prison* (London: Penguin Books, 1991), 195–228.

[10] Michel Foucault, *Dispositive der Macht* (Berlin: Merve, 1978), 154 (trans. U. B.).

[11] Albrecht Joseph, *Ein Tisch bei Romanoffs* (Aachen: Alano, 1991).

[12] Mikhail M. Bakhtin, "Forms of Time and of the Chronotope in the Novel," in *The Dialogic Imagination*, trans. Caryl Emerson and Michael Holquist (Austin: U of Texas P, 1992), 123.

[13] Mikhail M. Bakhtin, *Literatur und Karneval* (Munich: Hanser, 1969), 73 (trans. U. B.).

[14] Theodor. W. Adorno, *Aesthetic Theory*, trans. C. Lenhardt (London: Routledge & Kegan Paul, 1984), 30.

[15] Lotte H. Eisner, *The Haunted Screen: Expressionism in the German Cinema and the Influence of Max Reinhardt* (Berkeley: U of California P, 1987), 277–82.

On Murnau's *Faust:*
A Generic *Gesamtkunstwerk?*

Helmut Schanze

THE TITLE OF THIS ESSAY, "On Murnau's Faust," resembles a gigan-
tomachia. First, "Murnau" — the giant of early Weimar cinema.
There is Rohmer's hyperbolic dictum: "The greatest film of the greatest
film author."[1] Second, "Faust" — the giant in despair, the European
myth from Marlowe to Murnau, from the *Volksbuch* to film, the audio-
visual mass medium. Third, it is important not to forget "Goethe"
amidst this gigantic ensemble.[2]

Murnau's *Faust* is one of the milestones in the history of cinema,
one of the milestones in the history of adaptation of literature and thea-
ter to the new medium of film,[3] a milestone in the interplay of different
media, and a milestone in Murnau's cinematographic work. It ends his
German period and opens, in some respects, his American period, begin-
ning with *Sunrise* (1927), an adaptation of Hermann Sudermann's novel
Die Reise nach Tilsit (1917), and a film which is regarded as one of the
one hundred masterpieces in film history.

Moreover, *Faust* belongs, on the one hand, to a series of eerie Dop-
pelgänger films in early Weimar cinema, and on the other hand, with its
realist love story of Faust and Gretchen, to the paradigmatic melodrama,
which seems to be in fact Hollywood style. The film in question is also
one of the master examples in Lotte Eisner's *The Haunted Screen,* but it
shows elements of a classicist ordering of the moving camera as well.
Following Eisner, it is detached from core expressionism.[4] The silent
vision of Dr. Faust, set by Robert Herlth and photographed by Carl
Hoffmann, may be seen as *cinéma pur* and as *cinéma impur* at the same
time. It is not a strict adaptation of a literary work, but is significantly
bound to text and speech, even as a silent movie. It seems to be a color
film, but its colors oscillate between black and white, as did the masks of
Mephisto in Gründgens's famous staging in the 1950s. The Nouvelle
Vague and *Cahiers du Cinéma* found their ancestor in Murnau and his
Faust. Additionally, the film has to be considered as a pioneering work
of contemporary special effects cinema, as Joe Hembus has pointed out.[5]

Murnau's *Faust* provokes a myriad of ambivalences and ambiguities, historically, systematically, and aesthetically. The myth of Faust has attracted the new medium since its beginnings: Georg Seesslen has listed more than fifty adaptations. Two of them were filmed in 1887, and it seems to be significant that the two French inventors, Louis Lumière and Georges Méliès, are in one line with Murnau, the famous filmed theater production of Gustaf Gründgens, and the openings of the two main German television channels in 1954 and 1962 respectively.[6] In my recent book on *Faust*, I tried to follow the traces of the metamorphosis of Faust from the *Volksbuch* and Marlowe to the digital Faust.[7] In Lotte Eisner's view, Murnau's *Faust* is the "climax of the chiaroscuro," a remembrance of Rembrandt's "Magician," a chaos of artificial fog, a directed symphony of light.[8] In Fritz Göttler's comments in his filmography, however, *Faust* balances between "classicism and kitsch." It is considered to be "not a *Gesamtkunstwerk*" at all, rather a naïve joke made with the features of the cinema.[9]

My paper can only provide a brief outline of the different views of this film. My key thesis, however, will be that those differences and ambivalences are due to the making of this film determined by a trend toward a *Gesamtkunstwerk*, following Richard Wagner's Romantic concept of a synthesis of all arts, but staging its dissolution at the same time.

Thomas Koebner once used the term "Atelier-Ästhetik," the aesthetics of the studio. I would like to use this term in a broader sense. Murnau's *Faust* is a set of differences, a deconstruction of lines; as such, it is to be contextualized in an open textual and visual structure. It crosses the boundaries of the arts, of new and old forms of art, of images and sound, of darkness and light, of art and human nature. Murnau's "découpage intégral" (Rohmer) is rooted in literary history, the history of the visual arts, as well as in the history of cinema itself. The complex ratio of the magic of cinema emerges from its basic structure: the myth of Faust.

However, if one takes a close look at Murnau's *Faust*, it may also be described along the critical terms of Brecht's film theory. He depicts film production as "Abbauproduktion," a unity of destruction and production. The credits indicate that the production is that of an advanced film industry, a work of a labor division, a specific media tailoring. Murnau's *Faust* may be seen as a paradigm of a collaborative effort in many respects: to literature, to the visual arts, to theater, and even to music. Literature had to supply the book. It was written by Hans Kyser, using motifs by Goethe, by Marlowe, the popular tales and a manuscript by Ludwig Berger, titled *Das verlorene Paradies*. These manifold credits to

literature seem to be overcomplicated. Literature and its traditions are split into pieces, or motifs, and then bound together again by a scattered myth. Kyser's manuscript is, at a first glance, little more than an argument, or a scheme. It is eclectic in the true sense of the word, not a work of genius. It is, more or less, a de-forming reading of the myth. The works used are reduced to their elements, and those elements are loosely combined.

Kyser, who was in fact one of those few German writers who were successful in writing film scripts, formulated his credo in an essay published in 1928, in the year after his experiences with Murnau and his fellow writer Gerhart Hauptmann, whom he greatly admired. In his essay he separates *cinematographic* writing from *poetic* writing: He who writes a film manuscript has to see life in its visual structure. One should not say objective like the eye of the camera, for the camera is only an instrument of cinematographic viewing. It records the thousand forms of life and the abundance of light and the deep meaning of the rhythm of all motions. "The productive film author," Kyser writes,

> uses the eye of the camera as moment of motion, and his inner view, which deconstructs the sequence of events in dramatic pieces of pictures. He groups the plot into scenic elements, he divides them up following inner rules of suspense and contrast, he sacrifices the intermediating members of the illustration, to follow the rhythm of the pictures; he divides the mimic play of the individual picture in its elements of a psychology of expression, he is leaping over time and space, in leaving the set, he opens the landscape of the world, to give room for the plot, which should never be a theater missing the fourth wall, but life.[10]

A closer look at the treatment, included in Kyser's essay, gives insight into the raw poetry of the plot. I cite from the famous "Flight on the cloak":

> Der alte Faust ist mit dem schwachen Ruf: "Gib mir die Jugend!" auf seinem Lager wie entseelt niedergesunken. Mephisto bläst in den alten Kamin. Flammen und Rauch steigen auf. Bubo, die Urhexe, erscheint. Sie beschwört mit grotesken Bewegungen den von Mephistos Mantel verhüllten Faust.
> Schon verschwindet sie. Mephisto reißt den Mantel von Faust. Ein blühender Jüngling, wie ihn der geheimnisvolle Spiegel Mephistos gezeigt, steht Faust da.

Mephisto verbeugt sich vor ihm wie ein Reisemarschall,
breitet zu seinen Füßen seinen Mantel aus und spricht
einladend:
Titel: "Auf meinen Mantel tritt und um dich kreist die
Erde!"
Nur einen Schritt macht Faust und
schon reißt es ihn fort durch die Lüfte.
Ein Stundenglas wächst ins Bild.
Und aus ihm erscheinen kreisend, heransausend, sich
hebend
und überstürzend Landschaftsfragmente:
Hügel, Täler und Wälder,
Felsenwände, Bergseen, stürzende Wasserfälle,
Türme gotischer Kirchen.
Darüber Faust, von Mephisto umfaßt auf dem Mantel
schwebend.
Nun erscheinen schneebedeckte aus großer Höhe
gesehene Alpengipfel.
Brandung schäumt gegen Felsenriffe.
Unendliches Meer öffnet sich,
Schiffe im Sturm.
Das Stundenglas blendet durch, in dem die Sandkörner
rieseln.
Südliche Landschaften reißen sich auf mit Säulengängen
und weiten Plätzen,
Palmen jagen heran,
Faust darüber im Zaubermantel,
Phantastische große Vögel fliegen ihnen entgegen,
Silhouetten von Städten und dunklen Zypressengärten,
Mondlicht schimmert,
Entgegen durch die Nacht flammt ihnen ein Feuerwerk
von Sternen und sich drehenden Sonnen,
Die Terrasse eines italienischen Schlosses wird sichtbar,
erfüllt von tanzenden Mädchen, im schwebenden
Rhythmus auf und ab,
Festliche Menge durch einen Regen von Feuerkugeln.
Faust starrt begehrlich hinab. Mephisto weist mit der
Hand hinunter, sprechend:
Titel: "Das Hochzeitsfest der Herzogin von Parma!"[11]

Kyser uses rhythmic prose, and the basic imagery of *hypotyposis,* once the only way to write motion pictures. Syntax is neglected, a cascade of concepts is jotted down. Kyser gives verbal fragments of landscape, he describes the light and opens views from above. Mephisto serves as the man with the pointer of early cinema. Thus, cinematographic elements penetrate the treatment itself. What seems to be expressionistic writing is in fact already an adaptation of literature to the new medium. These cinematographic aesthetics are aesthetics of divisions, following Nietzsche's idea of the double nature of the arts. Its method goes back to the very roots of art, visual and written, the Dionysian and the Apollonian. The rhythm of the images, the Dionysian procession, precedes the Apollonian wording. In a film manuscript, the written words are intended to be superseded by the visual.

Fragmentation, divisions, and combinations seem to be the characteristics of a production that makes use of literature in an autonomous manner. For Kyser it was irritating that Gerhart Hauptmann, an author of great renown, was asked to write intertitles for Murnau's film, which had been shot on the basis of Kyser's script. Although Hauptmann's contribution was criticized as dull from the standpoint of literature, a closer look will reveal his vision.

Hauptmann opens his couplets with a prefatory word:

> Ein *Faust* in Bildern, warum denn nicht?! —
> Nicht Goethes unsterbliches Weltgedicht:
> Ein Bildersturm, ein Wirbelwind
> Drin Dämonen und Geister zu Hause sind.
> Die teuersten Schatten fegt er daher
> Unter Feuerbergen, Gebirgen und Meer,
> Einen Riesendämon, der tigerhaft
> An winzigen Mäuslein übt seine Kraft.
> Und endlich zieht Euch ein Ringen in Bann
> Zwischen Ormuzd und Ahriman,
> Zwischen Finsternissen und Licht —
> Damit sei es genug — mehr sage ich nicht![12]

Since prefaces are significant as addresses to the muses and the public, this foreword may be read as a poetic gate to the film: Hauptmann's vision of the moving image as a "storm of pictures," a "whirlwind" or "vortex" is a strictly cinematographic one. The "whirlwind" indeed became the favorite metaphor of writing on cinema.[13] And the description "between darkness and light" illustrates the haunted dimension of the screen's black and white in a raw, simplistic view of the world. Lit-

erature is divided up: on the one hand it is the product of the craftsman, on the other the creation of the true poet. And in the end, Hauptmann's artificially popular verses were sold at the box office of the cinema.

Brecht, in his *Threepenny Lawsuit,* vigorously took the viewpoint of literature and theater, the latter often an enemy of the cinema. Murnau's point of view, in fact, was even more radical. He used the elements of literature, but also of visual art, of pictures in the true sense of the word. In Barriatúa's filmography there is one leading topic: the images of visual arts, which are brought to life by the cinematographic sorcerer Murnau.[14] Barriatúa follows Eisner's suggestion: the opening of Murnau's *Faust* is more than a remembrance; it is a citation of Rembrandt's *Magician, looking at a light apparition,* which was presented in an engraving by Lips as front page of Goethe's *Faust* in 1790. Murnau uses the Faust iconography as created by Delacroix, Kaulbach, Cornelius, Retzsch, and von Kreling in the nineteenth century. And he uses Cranach, Altdorfer, and Baldung to establish a sixteenth-century environment.[15] This is a type of *Abbauproduktion* too, not only of literature, but also of images.

Murnau uses artificial reproductions for his cinematographic presentation, often criticized as postcard-style. The forms of literature, visual art and theater are seen as content. Cinema, as Hofmannsthal has stated, "calls up images."[16] The picture is made of pictures, and their differences. Murnau's astounding tricks are designed to show the show. He realizes the dreams of literature. His *mise en scène* is theatrical, as well as psychological in terms of inner dreams. He used, and thus deconstructed, even the form of theater. One should remark that the way Goethe used allegorical figures for creating the second part of *Faust* comes very close to Murnau's idea of the figure. Murnau studied these figures very closely. He once played two minor roles in a staging by Max Reinhardt, his teacher: the character of the Astrologus and the figure of the Habebald. Goethe named the second an "allegorical scoundrel."

In making the second part Goethe used the latest phantasmagoric apparatus, a precinematic device, and so-called "Philostrat paintings," basic constellations of antique and renaissance paintings. In the end he also drew on Christian figures of the Saints and of the Glorious Mary depicted in mediaeval paintings by van Eyck and famous frescos in the churchyard of Pisa.[17]

In the age of cinema the Faustian myth became a play of darkness and light, and this play indeed replaced all the words from Marlowe up to Goethe. Even the advertising of the film follows the raw black and white manner. It is designed as a woodcut, in a decoupage style, follow-

ing the techniques of sixteenth-century block printing. It follows the Salzburg *Jedermann* imagery and its artificial archaism.

Advertisement for F. W. Murnau's *Faust* (1926).

A city of wood and paper was built on the set, but it became super-fluous after the shooting. Reinhardt's famous "Faust City" in Salzburg was the attraction of the 1931 Salzburg Festival. It topped Murnau's setting.

Robert Herlth has described the manic, and magic, ways in which Murnau directed his *Faust*. He controlled every detail to perfection. Carl Hoffmann's camera work was renowned for its devoted professionalism. He shot those moving images which Hofmannsthal in 1921 perceived as the essence of film: "Traveling through the air, with the devil Asmodi, who untiles all roofs, uncovers all mysteries."[18] Koebner has cited *Faust* for its desperate view on an ill-treated earth.[19]

With regard to the concept of the *Gesamtkunstwerk*, the moving image had to be completed in its performances by music to become a true symphony of the arts. The score was written by Walter R. Heymann. The

original music used an orchestra, but was also available as a piano score and for smaller cinema orchestras. Even music is part of the aesthetics of divisions.

Given the fact that Hauptmann's verses were in the hands of the audience, and the music was performed in front of the screen, the critics concentrated on Murnau's picture, even when using poetical, pictorial, theatrical and musical metaphors in describing the new art. The concentration on the moving image gives a comforting limitation which points out the artificiality of the production.

The first screening took place on 14 October 1926 in the Ufa-Palast at the Zoo in Berlin. "Tout Berlin" was present. Kurt Pinthus, the editor of the expressionist anthology *Menschheitsdämmerung* and of the *Kino-buch,* one of the earliest critical admirers of the new medium, noted that the stupendous cinematic power of innovation absorbed the theme completely.[20] This is an observation which was grasped in the 1960s by the theory of the Nouvelle Vague. In his book on Murnau Eric Rohmer writes: "The matter of this film is its form, nothing is to be perceived but its *figure,* in the geometric meaning of the word, purified from all intellectual associations."[21] Faust becomes an immaterial figura, weightless, he flying on his cloak through a picturesque landscape.

A day after the première Willy Haas expressed his reservation about what he perceived as Murnau's forceful attempt to equal Goethe in universality, but he also emphasized Murnau's particular ability to dissolve the action into a "musically rich art of the apparatus."[22] He thus refers to the Aristotelian *opsis* and *melodia* of the new *Gesamtkunstwerk.* Eric Rohmer, in his famous analysis, speaks of "a kind of visual opera."[23]

Musical and verbal add-ons seem to reconstruct the lore of the *Gesamtkunstwerk,* the dream of a romantic, who is also, in the words of Lotte Eisner, a classicist. Split up in its basic forms, his *Gesamtkunstwerk* demonstrates in the end of the era of silent film the individual powers of the different arts. Murnau's *Faust* is a split image, the fallen angel of expressionist film. The diagram in which Brecht outlines the structure of *Abbauproduktion* reveals the very elements of cinematographic production which are to be used as content of the work.

Murnau's *Faust,* seen as kitsch by some art critics, could be described as a generic *Gesamtkunstwerk. Mise en scène,* shooting and montage form an assemblage of pieces of art, a diversity within a technical unity. One may deplore the loss of the aura, but, following Rohmer, Murnau produces the rim of the pictures, the pure figure of Faust.

The question whether *Faust* belongs to the "haunted screen" of German film, or to the tradition of melodrama is to be answered in a

double-sided way. On the one hand, the myth of Faust is the German haunted myth, and Murnau's *Faust* is even more original in this respect than Goethe's version. The myth of Faust is closely related to magic arts, even to the early history of illusionist images. But cinematographic magic surpasses the magic images of the Gutenberg age, the images of the printed book. The figure of Faust, already in Marlowe's famous monologue, tries to escape the world of the letter, but he is bound to the signs of the magic word. Goethe's Mephisto is the man of the magical machinery. The phantasmagoric apparatus, the fog imagery, is used twice in *Faust II, on scene* by Mephistopheles at the emperor's court, and *as scene* by Goethe in the Helena act. In fact Murnau also exploits the fog machinery extensively. Thus the cinematographic sorcerer Murnau comes close to Goethe and his techniques and to its figurations as well. The precinematographic apparatus now comes to itself.

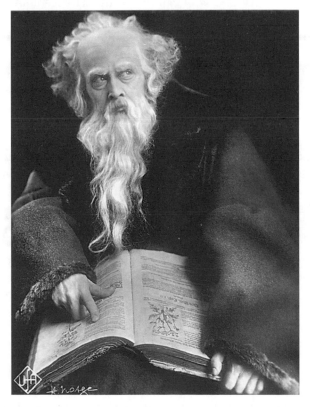

Gösta Ekman as Faust in F. W. Murnau's *Faust* (1926).

However, on a second look, this film, its staging and its shooting, also uses the classicist tradition of German literature. It begins, in certain perspectives, a classical age of film itself. Murnau's *Faust* is a sister work of *Der Letzte Mann* (The Last Laugh, 1924) as well as *Sunrise,* his first American film. The ways of deconstructing literature, art and even theater by using their elements and showing them, is more radical than any of those more or less naïve haunted pictures in Kracauer's *From Caligari to Hitler.* It ends the Romanticist trends in early Weimar cinema and reaches out for a construction of reality, thus paving the way for the figurations of "Neue Sachlichkeit" and even the Nouvelle Vague. As Klaus Kreimeier has pointed out, Kracauer has spoken about films, but he has focused on the epoch. Eric Rohmer, on the other hand, took a close look at the film and its surface. He discovered pure figures, and not the drama. Both views, following Kreimeier, are deficient, but correspondent.[24]

Seen in retrospect, *Abbauproduktion* is the significant artistic method of the avant-garde in the 1920s. What Brecht has discussed was his own defamiliarization technique which used all forms at hand as material. In his cinematographic work, most extensively in *Faust,* Murnau experimentally treated the given artistic forms as material. The film industry, its self-referential attitude, and its denial of its roots was the critical point of an anticinematographic movement that had learned so much from early film and its forms of production.

In the 1960s, when cinema itself was threatened by the dominance of television, the common roots both of modern literature and film were discovered anew. Film theory noted the connections of graphics. The criticism inspired by Kracauer had taken an overall view by analyzing the problem of neo-Romanticism from an outside view of society. Rohmer's book on Murnau's *Faust,* even in its hyperbolic conclusions, is a document of close viewing. It is a theory in the various senses of the word: view and opinion, perception and idea, intuition and approach. In its aesthetics of divisions the generic *Gesamtkunstwerk Faust* should be considered *neo-Romantic* and *modern classic* at the same time.

Notes

[1] Cf. Rainer Gansera, "Der Faustfilm und die Franzosen," in *Friedrich Wilhelm Murnau 1888–1988,* ed. Klaus Kreimeier (Exhibition catalogue: Bielefeld, 1988), 78.

[2] Cf. Helmut Kreuzer, "Zur Geschichte der literarischen Faust-Figur," in *Faust und Satan — multimedial: LiLi,* vol. 66 (1987), 7–28.

[3] Cf. Jacques Aumont, "'Mehr Licht!' Zu Murnaus *Faust,*" in *Literaturverfilmungen,* ed. Franz-Josef Albersmeier and Volker Roloff (Frankfurt am Main: Suhrkamp, 1989), 59–79.

[4] Lotte Eisner, *The Haunted Screen. Expressionism in the German Cinema and the Influence of Max Reinhardt* (Berkeley: U of California P, 1973), 292.

[5] Cf. Klaus Kreimeier, ed., *Friedrich Wilhelm Murnau 1888–1988* (Exhibition catalogue: Bielefeld, 1988), 44.

[6] Cf. Georg Seeßlen, *Faust. Gustaf Gründgens Meisterwerk. Materialien zu einem Film von Peter Gorski* (Duisburg: Atlas Film + AV, 1992), especially 102–30. Ernest Prodolliet, *Faust im Kino. Die Geschichte des Faust-Films von den Anfängen bis in die Gegenwart* (Freiburg: Schweiz Verlag, 1978), 33–52.

[7] Helmut Schanze, *Faust-Konstellationen. Mythos und Medien* (Munich: Fink Verlag, 1999).

[8] L. Eisner, *The Haunted Screen,* 285–93.

[9] Fritz Göttler in *Friedrich Wilhelm Murnau.* Mit Beiträgen von Frieda Grafe, Wolfgang Jacobsen, Enno Patalas, Gerhard Ullmann (Munich: Hanser, 1990), 182.

[10] Hans Kyser, "Das Filmmanuskript," in *Die Literatur,* vol. 31 (1928); extract reprinted in *Hätte ich das Kino. Die Schriftsteller und der Stummfilm,* ed. Bernhard Zeller (Munich: Kosel, 1976), 224–25 (trans. H. S.).

[11] *Hätte ich das Kino,* 258–59:

> The old Faust utters weakly: "Give me youth!" sinking lifeless onto his bed.
> Mephisto blows into the old hearth. Flames blaze and smoke rises. Bubo, the old witch, appears. With grotesque movements she conjures up Faust who is wrapped in Mephisto's cloak.
> She disappears in an instant. Mephisto tears the cloak from Faust. Faust stands before him, a boy in the bloom of youth, just as Mephisto's magic mirror had shown him. Mephisto bows before him like a travel guide, spreads his cloak at his feet and invites him:
> Title: "Step on my cloak and the earth will circle around you!"
> Faust takes a single step and
> is carried up through the air.
> An hourglass appears in the picture.
> And out of it emerge, circling, coming nearer, rising
> and rushing, fragments of a landscape:
> Hills, valleys and forests,
> Rocks, mountain lakes, waterfalls,
> Steeples of Gothic churches.

Above it Faust, clasped by Mephisto, hovering on the cloak.
Now snow-covered peaks of the Alps come into view.
Breakers crash against the rocks.
Endless sea emerges,
Ships in the storm.
The hourglass in which grains of sand trickle shines trough.
Southern landscapes open wide with colonnades
and broad squares,
Palm trees rush to the fore,
Faust above it in the sorcerer's cloak,
Large exotic birds fly toward them,
Silhouettes of cities and dark cypress gardens,
Moonlight gleams,
Through the night fireworks of stars and revolving suns are ablaze,
The terrace of an Italian castle comes into view, full of dancing girls, in floating
rhythms up and down,
A festive crowd through a rain of fireballs.
Faust stares longingly down. Mephisto points downward and says:
Title: "The wedding of the Duchess of Parma."

[12] Bernhard Zeller, ed., *Gerhart Hauptmann. Leben und Werk* (Stuttgart: Turmhaus-Druckerei, 1962), 280–81:

> A *Faust* in pictures, why ever not?! —
> Not Goethe's immortal world poem:
> A storm of pictures, a whirlwind
> in which demons and spirits are at home.
> It sweeps the most precious shadows away
> Under volcanoes, mountains and seas,
> A giant demon, like a tiger
> Exercising his power over tiny mice.
> And finally you are enthralled by a fight
> Between Ormuzd and Ahriman,
> Between darkness and light —
> That's enough — I'll say not more!

[13] Cf. Lewis Jacobs, *The Rise of the American Film. A Critical History. With an Essay: Experimental Cinema in America, 1921–1947* (New York: Teachers College Press, 1968), 192; also Dietrich Scheunemann, "Zwischentitel im frühen Film," in *Text und Ton im Film,* ed. Paul Goetsch and Dietrich Scheunemann (Tübingen: Gunter Narr, 1997), 22.

[14] Luciano Barriatúa, *Los Proverbios chinos de F. W. Murnau. Filmoteca Española,* 2 vols. (Madrid: Instituto de la Cinematografia y de las Artes Audiovisuales, 1990).

[15] Cf. J. Aumont, "'Mehr Licht!' Zu Murnaus *Faust,*" 68.

[16] Hugo von Hofmannsthal, "Ersatz für die Träume," in *Kino-Debatte. Texte zum Verhältnis von Literatur und Film 1909–1929,* ed. Anton Kaes (Tübingen: Niemeyer, 1978), 150.

[17] Helmut Schanze, "Christlich-kirchliche Figuren. Zur poetologischen Bedeutung mittelalterlicher 'Bilder' für Goethes Spätwerk," in *Kunst als Kulturgut. Die Bilder-*

sammlung der Brüder Boisserée — ein Schritt in der Begründung des Museums, ed. A. Gethmann-Siefert and Otto Pöggeler (Bonn: Bouvier, 1995), 206–11.

[18] H. v. Hofmannsthal, "Ersatz für die Träume," 151.

[19] Thomas Koebner, "Film als neue Kunst," in Thomas Koebner, *Lehrjahre im Kino* (St. Augustin: Gardez!), 1997, 39.

[20] Cf. *Friedrich Wilhelm Murnau 1888–1988,* 44f.

[21] Ibid., 80.

[22] Cf. Fred Gehler and Ullrich Kasten, *Friedrich Wilhelm Murnau* (Augsburg: AV-Verlag Franz Fischer, 1990), 109.

[23] Erich Röhmer, *Murnaus Faustfilm* (Munich: Hanser, 1980), 9.

[24] Klaus Kreimeier, "Das Drama und die Formen. Versuch über einen Melancholiker," in *Friedrich Wilhelm Murnau,* 90.

V. Avant-Garde Film

"Painting in Time" and "Visual Music": On German Avant-Garde Films of the 1920s

Walter Schobert

THE FOLLOWING TEXT written by Walther Ruttmann and enclosed in a letter which Ruttmann sent to his former wife's sister in 1917 is the first document indicating the emergence of an avant-garde film in Germany:

> The content of every film drama is conveyed to us through the eye and can therefore become an artistic experience only if it has been conceived optically. But the art of the poet does not use the experience of the eye as its base, and when a poet gives shape to his work he does not address himself to our eye. So his creativity lacks the most fundamental requirements for film. And in this lack lies the main reason for the painful disappointments which every new "author's film" produces. People have become stuck in the wrong direction; in search of art they have contented themselves with artistically dressing-up and preening the cinema, instead of creating something self-contained by proceeding from its essence. The fact that up to now nothing has been achieved is the result of a thorough misunderstanding of this essence!

For cinematography belongs to the group of visual arts, and its laws are most closely related to those of painting and dance. It uses the following means of expression: forms; surfaces; brightness and darkness with all their inherent moods; but above all the movement of these optical phenomena, the temporal development of one form out of the other. It is visual art with the novelty that the root of the artistry cannot be found in a final result, but in the temporal growth of one revelation out of the other. The main task of the creator of films lies therefore in the work's total optical composition, which for its part also makes quite specific demands in the treatment of the individual links.[1]

The value of this letter to the research of the German film avant-garde is twofold. Apart from being the earliest known documentation of this movement it is the most precise and concise description of its ideas

and its practice. It is a kind of declaration of intent, outlining the aims of filmmaking for Ruttmann, Eggeling, and Richter. Ruttmann's text makes it explicitly clear that he was not only the leading theoretician and practitioner during the first period of the avant-garde, but that he was also the earliest.

It can no longer be doubted that Ruttmann was the first artist to put the idea of abstract film into practice. Many had the idea, but nobody before Ruttmann had implemented it. The German Hans Stoltenberg claimed that he had thought of making such films as early as 1909, but his brochure *Reine Farbkunst in Raum und Zeit: Eine Einführung in das Farbtonbuntspiel* (Pure Color Art in Space and Time: An Introduction to Colorplay) was not published until 1920. The painter Leopold Survage created a series with the promising title *Le Rhythme Coloré*, which consisted merely of a series of paintings. The honor of having completed the first abstract film lies with Walther Ruttmann. He first showed *Lichtspiel Opus 1* (Film Opus 1) in Frankfurt at the beginning of April 1921. The official premiere took place in Berlin on 27 April 1921. The film was here accompanied by a piece of music composed specifically for the film by Max Butting. The critic Bernhard Diebold, who had called for the creation of "Augenmusik," hailed Ruttmann as a "Kinarch," a master of movement.[2]

It should be made clear that the identity of the first avant-garde filmmaker is of great importance to history and particularly to art and film history: It was Ruttmann, and not Richter, although the latter was able to take the title for himself in cinema history through the skilful and influential manipulation of film historians, by playing with facts and dates. Richter was helped by the fact that he outlived Ruttmann by many years and was able, in his role of teacher and author, to make his claim widespread. This claim was certainly given added credibility by the fact that Ruttmann did not go into exile, but played a rather dubious role in the Nazi film industry. Finally, it is no accident that Kracauer and Lotte Eisner, who otherwise worked with an impeccable attention to historical detail, played the roles of chief witnesses in the attempts to minimize Ruttmann's historical and artistic importance: they had both also chosen the path of exile.

This is not the place to describe and explain in detail the rocky relationship between these two protagonists of the avant-garde, but justice and historical exactitude demand that Ruttmann be recognized as the first avant-gardist. It must also be made clear that *Rhythmus 21* (1921), which at that time did not yet include the year in its title, but rather bore the title *Film ist Rhythmus,* was never shown in public in 1921, even if

it was ready and consisted of more than the first attempts to animate constructivist paintings. The most decisive factor, however, one which has occurred repeatedly in the history of art, is simply that the time was ripe for certain ideas and experiments. And it is no accident and no less decisive that it were three painters who put them into practice.

The First World War unleashed great traumas and upheavals and led to the collapse not only of the old political and social orders, but also of the artistic ones. Old systems of values and morals were destroyed, and artists felt that the time had come to seek new means and forms of expressions. Many "isms" emerged, groups, movements, styles, directions. And many artists were no longer satisfied with the old panel painting. They wanted to break up the panel and not confine themselves to the organization of space. Ruttmann, Eggeling and Richter wanted to set form, color and surface in motion. They wanted to paint with the medium of time. Once again it was Ruttmann who formulated the theory, in his 1919 essay "Malerei mit der Zeit" (Painting with the Medium of Time). The very title is a program!

> The object of our attention is now the temporal development and the constantly evolving physiognomy of a curve, rather than a rigid series of individual points. This change is where the reasons for our desperate helplessness toward the manifestation of the visual arts must be sought. . . . How can we save the situation? Not a new style or any thing of that kind. Rather a new method of expression, one different from all the other arts, a medium of time. An art meant for our eyes, one differing from painting in that it has a temporal dimension (like music) and in the rendition of a (real or stylized) moment in an event or fact, but rather precisely in the temporal rhythm of visual events. This new art-form will give rise to a totally new kind of artist, one whose existence has only been latent up to now, one who will more or less occupy a middle-ground between painting and music.[3]

The fact that Ruttmann's point of departure as a painter differed from that of Eggeling and Richter had obvious consequences for the films which they made. What they share is a search for graphic forms reduced to simple lines and varied in a strict rhythm. Richter, closely associated with the Dadaist movement, produces simple geometrical images consisting of constructivist squares and rectangles in the same manner as he had painted them in his scroll sequences. Ruttmann's figures, by contrast, seem far less mathematical; they are more playful and dancelike, lighter and more impressionistic.

Hans Richter: "Orchestration of Colour."
Scroll picture *Rhythm 23* (1923).

Walther Ruttmann: Forms from an absolute film.

On the whole Ruttmann's films are certainly easier to watch and to consume. And in any case, they found their way into the cinema and soon achieved commercial success. Ruttmann quickly became a highly esteemed collaborator in motion pictures and won contracts for advertising films. Examples include the sequence from Lang's *Nibelungen* (The Nibelungs, 1924) and *Das Wunder* (The Wonder, 1925) made for the advertising genius Julius Pinschewer, who did not fail to put the avant-gardists to work. Clearly neither he nor the artists with whom he collaborated such as Lotte Reiniger and Guido Seeber (at Kipho) saw any contradiction between pure art and the trivialities of commercial advertising.

Eggeling and Richter, who by this time were no longer working together, did not achieve this wide appeal, and familiarity with their films remained limited to artists' circles. Richter even seems to have preferred his work as a publicist to his endeavors as a filmmaker: during this period he published the magazine *G*, which was a lively forum for artistic developments of the time and which was probably the first art journal in the modern sense of the term (one of its issues was dedicated to film). Richter's film work did not find a wider audience until the famous matinee presented by the *Novembergruppe*, an association of painters and musicians. The matinee took place in Berlin's Ufa-Palast on May 3rd, 1925, under the title "Der absolute Film." The showing was a success with the public — so much so that it had to be repeated — but not with the critics. Rudolf Arnheim, who was to become a famous film theorist, then a young film critic made the following comments:

> If the piano player was playing loudly and with wild abandon, on the screen all was colorful, nervous, excited. If he slowed down, hesitatingly, the rectangles collapsed into a pale mass. The theme of the following *Diagonal Symphony* was a cleanly drawn cross, somewhere between a pocket comb and panpipes, which was warped around for ten minutes in a melee of lines, creating variation rather than ingenuity. Yet more amusing was the third example of an art form enriched by moving components: Ruttmann's film-games. Forms like comma-shaped bacilli slithered around the screen. They swelled up, burst, rolled together, split up again, and hacked at each other in gleeful haste. The absolute forms behaved themselves in a very human way and thus greatly exceeded the intentions of their creator. At the same time, however, they produced a cheery mood. two spongy forms are cute and cozy flirters, and a gaunt rectangle runs restlessly here and there like a man whose wife is taking too much time to dress. A domestic scene in the realm of mathematical embarrassment showing how easy it is to imitate our most basic traits.[4]

This matinee was the first public showing of abstract German films in the land of their origin. At the same time, it marked the end of this direction in the film avant-garde. For years afterwards no such films were made in Germany. At the end of the decade Oskar Fischinger did return to the path established by the three pioneers, but with different intentions. Their works were often shown again, particularly forming the basis of the score for modern composers such as Hindemith and Eisler, who wrote often mechanical musical accompaniments for them, performed at chamber music events in Donaueschingen and Baden-Baden.

Neither Ruttmann nor Richter ever made an "absolute" film again. How can this be explained? We have no statements or other forms of testimony from the two filmmakers themselves, but the answer may very well lie in the other films shown at the matinee: Léger's *Images Mobiles* and Picabia and Clair's *Entr' Acte,* both produced in 1924. These productions must have opened Ruttmann's and Richter's eyes to the fact that one could make abstract, non-narrative films not only with animated images, but also with real photography.

A second reason may have been the encounter with the film which dealt with a revolution and which itself began a revolution that changed the entire concept of filmmaking: Eisenstein's *Battleship Potemkin* (1925). This film revealed to all concerned that they had not even been aware of the most important means of cinematic expression: montage. The discovery of montage must have stunned the avant-gardists in particular since it showed them that the kinetic arts of which they were so proud were still incomplete.

Once again, it was Ruttmann who reacted first with *Berlin. Die Sinfonie der Großstadt* (Berlin. The Symphony of a Great City, 1927). This film has consistently been regarded as a documentary film and has been classified as an example of "Neue Sachlichkeit" (The New Objectivity), a misjudgment provoked by the fact that Carl Mayer, having provided the idea for the film, withdrew his name from the project. In addition, a similar resolution of Bauhaus master Moholy-Nagy was in existence and undoubtedly provided the model for a series of similar films. The false judgement led Kracauer and an entire later school of film historians to decry the work as superficial, politically irresponsible and dangerous. They defamed it as a "cross-section film," and even as a predecessor of Leni Riefenstahl's productions for the Nazis.

But we must not lose sight of the fact that *Berlin* is anything but a documentary film. It is an abstract film like its maligned predecessors, and the fact that *Opus IV* is explicitly quoted at the beginning is certainly no mere coincidence. *Berlin* is a radical experiment in montage and it

DER ABSOLUTE FILM

EINMALIGE FILMMATINEE
veranstaltet von der
NOVEMBERGRUPPE
in Gemeinschaft mit der
KULTURABTEILUNG DER UFA

P R O G R A M M

Dreiteilige Farbensonatine Reflektorische Farbenspiele	Hirschfeld-Mack Bauhaus Dessau
Film ist Rhythmus	Hans Richter Berlin
Symphonie Diagonale	Viking Eggeling Berlin
Opus 2, 3 und 4	Walther Ruttmann Berlin
Images mobiles	Fernand Leger und Dudley Murphy, Paris
Entr' Acte	Scénario de Francis Picabia adapté et réalisé par René Clair

Poster of the matinee of the
Novembergruppe: *Der absolute Film* (1925).

takes merely its raw material from images of the city of Berlin, arranging them chronologically in the pattern of one whole day in the life of the city. Richter was to do the same thing years later in *Everyday*, which had as its theme the stereotypical routine of an ordinary employee. Richter

was once again imitating Ruttmann, although he, of course, was not scolded for being superficial. He had already made abstract montage films, such as *Filmstudie* and *Inflation*, and in *Vormittagsspuk* (Ghosts before Breakfast, 1928) he dedicated himself to surrealism. At any rate, and certainly with the help of Edmund Meisel's music (without which the film should not be shown) Ruttmann's contemporaries understood *Berlin* correctly. To quote Ruttmann once again:

> During the long years of my production of films from abstract materials I could not rid myself of the desire to construct something from living materials, to create a film symphony from the millions of actual and already existing sources of motion energy animating the organism of the large modern city.
>
> In the Berlin film I only allowed the image to speak, the absolute image, being seen and developed in an abstract way out of the filmic aspect. I organized the image motifs in a rhythmic way, so that they worked without the plot and yielded oppositions and contrasts among themselves. My intention was to achieve a self-contained art form.[5]

Berlin. The Symphony of a Great City remains the most important film of the German avant-garde of the 1920s and Walther Ruttmann its most important director. In the third and final period, in which "sound enters the picture," Ruttmann remained the leading creative personality, boldly and courageously realizing what many others could only think and dream of. While the Soviet filmmakers as well as theorists were still considering how to use sound to save the art of montage from naturalistic superficiality, a concern which resulted in their publishing their famous "Statement on Sound" in 1928, Ruttmann was already breaking new ground. A simple comparison of the Russian director's manifesto and Ruttmann's program notes to *Melodie der Welt* (World Melody, 1929) makes this quite evident.

Eisenstein, Pudovkin, who visited Ruttmann in Berlin and gave an enthusiastic account of his work, and Alexandrov wrote in their manifesto:

> It is well known that the principle (and sole) method which has led cinema to a position of such great influence is montage. The recognition of montage as the principle means of influence has become the indisputable axiom upon which world cinema culture rests. . . . Sound is a double-edged invention and its most probable application will be along the line of least resistance, that is in the field of the satisfaction of simple curiosity. In the first place there will be commercial exploitation of the most saleable goods, that is, of talking pictures — those in which the sound is recorded in a natural manner, synchronizing exactly with

the movement on the screen and creating a certain "illusion" of people talking, objects making a noise, and so on. . . . Sound used in this way will destroy the culture of montage, because every mere addition of sound to montage fragments increases their inertia as such and their independent significance; this is undoubtedly detrimental to montage which operates above all not with fragments but through the juxtaposition of fragments. Only the contrapuntal use of sound vis-à-vis the visual fragment of montage will open up new possibilities for the development and perfection of montage. The first experiments in sound must aim at a sharp discord with the visual images. Only such a "hammer and tongs" approach will produce the necessary sensation that will result consequently in the creation of a new orchestral counterpoint of visual and sound images.[6]

Ruttmann's comments in his notes to *World Melody* were as follows:

If it [the sound film] has the courage from the every outset to be original, and if the trust its producers have in it is great enough, so as to ensure that it won't be degraded into a mere method of reproduction whose stunning novelty would ebb in the shortest time imaginable. This ebbing is bound to take place if the film-maker thinks that for longer than six months the audience will have fun ascertaining that its favorite star is speaking exactly when his or her lips move.

But how should we proceed?

We should try to bring it home that the only possible way to make a sound film is by using counterpoint. This means that the picture on the screen cannot be intensified and augmented by sound which runs parallel to it. To do that would mean nothing less than an undermining of the work, in much the same way that repeated protestations of innocence do exactly the opposite of what they are intended to do, or that a weak excuse supported by two different reasons is completely unconvincing. A sound film formed by counterpoint would play both modes of expression against each other; it would forge a mental link between picture and sound. It could go like this:

You hear: an explosion. You see: a woman's horrified face.

You see: a boxing match. You hear: a frenzied crowd.

You hear: a plaintive violin. You see: one hand tenderly stroking another.

You hear: a word. You see: the effect of the word in the face of the other person.

This is the only way for sound and image, whose respective materials are so totally different, to complement and augment each other. Their running parallel to each other would result in the film's having all the vivaciousness of a wax museum.[7]

World Melody was the first German feature-length sound film (or light and sound film, to be exact), in which the optical recording method was used. Ruttmann does not employ sound merely as acoustic illustration to complement the images. Rather, in complete accordance with the manifesto, he attempts to bring the sound into play as an independent means of expression alongside the visual montage. He wishes to give the sound a logic and rhythmic power of its own, to utilize it as "counterpoint." It is important to point out that sound in this film basically means Wolfgang Zeller's music and other sounds as well, but not the human voice, which is scarcely used at all. This unnaturalistic use of sound is successful only in a few scenes, but these exerted a great influence on Vertov's *Enthusiasm — Symphony of the Donbas* (1931) and on Pudovkin's *Deserter* (1933), whose harbor symphony is a direct quotation.

World Melody was produced by the HAPAG shipping company, which was interested in its advertising potential. The structural principle of the film is a journey around the world, and Ruttmann creates an associative montage which becomes a symphony not of a mere metropolis, but of the entire world. In this production the principle actually remains somewhat ineffective: certainly *World Melody* contains many striking observations, but it sometimes tires itself out with a superficial treatment of the idea that customs, rituals, and conventions are similar all over the world. This adds up to a comfortable and often arbitrary universalism which does make things too easy for itself by refraining from any form of analysis.

But this experiment should really be judged in the light of Ruttmann's intentions, which were concerned not with the content, but with the avant-garde treatment of sound. He had already been engaged as a film director by Tobis to collaborate in the tests for the light-sound system which the three German engineers Vogt, Engl and Massolle had invented in 1921–22. Ruttmann's films have been lost. Contemporary sources lead us to believe that he was only interested in the technical aspect of these films, synchronization, for example, and that they could not therefore be considered forerunners of the acoustic avant-garde film.

In his next work, *Weekend*, Ruttmann began a much more radical and bold experiment. *Weekend* was a film entirely without pictures, an abstract montage of sound, an aural composition for radio. Since tape recording did not exist at the time, Ruttmann made this ten-minute jewel with optical sound recording. The film was highly praised, twenty-five years later, even by his arch enemy Richter:

Under the title *Weekend* he put together a short study in sound of about 100 meters. In my opinion this is the boldest experiment that has ever been undertaken in this field. Once again, Ruttmann proves himself a true poet of great imaginative power. His study was made up not of images, but solely of sounds and noises-making it suitable for radio transmission. It tells the story of a weekend, from the train leaving the station, through the tender whispering of lovers, until their separation among the crowds stumbling homewards. This modest, simple story finds its form in an atmospheric symphony of noises and fragmentary voices, in which even silence becomes audible. If I had to chose among all of Ruttmann's works, this dynamic study would win the prize. Ruttmann has managed to translate the principles of the "absolute film" into the poetry of sound with playful ease.[8]

This praise is all the more valuable in the light of Richter's usual dislike and undervaluing of Ruttmann's work and a praise for an artist whose productions were unique at the time. Unlike in the previous two periods of the German avant-garde, Ruttmann now had no colleagues. No one even came near to conceiving or producing anything similar. Richter himself was making films which were mere variations upon his previous work (although we should add that on the occasion of the 1929 "Foto und Film" exhibition in Stuttgart Richter wrote one of the most beautiful books ever produced on the subject of film, a book which is still of relevance today). Moholy-Nagy was working in the Bauhaus at this time, but only his *Lichtspiel, schwarz-weiss-grau* (Play of Light, black-white-gray, 1930) belongs to the film avant-garde in the strictest sense. Moholy-Nagy was more productive in photography and the theater and did not work in the field of sound at all.

The only avant-gardist besides Ruttmann who seriously involved himself with the challenges presented by the new medium and whose work would not have been possible without the sound film, was Oskar Fischinger. When Ruttmann, like Richter, turned to documentary and industrial films in 1931, Fischinger became the last representative of the avant-garde in Germany. He had already belonged to "the scene" for a long time, was a longtime acquaintance of Ruttmann and was well known to the Frankfurt-based critic Bernhard Diebold, who encouraged them both. It is impossible to confirm whether Fischinger was present at the premiere of *Opus I*, but during that period he constructed a machine to cut wax and thus invented a new way of producing animation pictures. He sold the machine to Ruttmann. He himself turned to film preferring to experiment with animated films rather than with abstract films. He collaborated with the musician and synaesthete Alexander

Laszlo, who presented at that time his *Farblichtklavier,* or color organ. The pictures, probably colored spotlight projections, were Fischinger's. Shortly afterwards he made his *München-Berlin-Wanderung* (Munich-Berlin Walk, 1927) which would later inspire New York avant-gardist Jonas Mekas.

Unlike the other pioneers, Fischinger consistently based his work on sound, as the collaboration with Laszlo indicates. His contribution to the avant-garde could be summarized as the repeated attempts to provide the adequate cinematic forms for standard popular or classical music, to transpose the music into movement, form and color: in current terminology, he sought to create "visual music." Thus Fischinger was the forefather of a movement which spawned the productions of the Whitney brothers and other members of the American West-Coast avant-garde, as well as today's video clips and computer animations.

The complete harmony between his abstract forms and music lends Fischinger's films a pleasing, accessible element which makes them easier to watch than a silent Opus film by Ruttmann (which of course is also accompanied by music). But it would be incorrect and unjust to defame Fischinger's work as belonging more to the "applied arts." He developed a careful application of graphics and always sought the right form. The ease of consumption of his films lies in the music, and this ease of consumption is the root of the films' success, both with the public and with advertising companies, always open to new ideas. Some of Fischinger's most beautiful films are advertising films. In this sense he is again Ruttmann's successor. Fischinger was also the pioneer of color film. Unlike Ruttmann, who laboriously colored his films by hand, Fischinger used the coloring techniques of the Hungarian born Gaspar, a three-layered process which offered extremely bright, vital colors. Fischinger's films benefited immensely from this process, to the popularity of which he also greatly contributed.

It was Oskar Fischinger who bore the banner of the avant-garde between 1930 and 1935. He continued to work, creating with *Komposition in Blau* (Composition in Blue, 1934–35), one of his most beautiful films, while Ruttmann became a compliant handyman for the Nazis, Richter went into exile, and the avant-garde film was given what Erwin Leiser called a "place of honor next to degenerate art."[9] In 1936 Fischinger too left Germany. The Fatherland was now rid of the avant-garde. The exiles sought disciples in the United States, where Richter taught on the East Coast and where Fischinger struggled to eke out an existence on the West Coast. Germany had to wait for a long time for the avant-garde to return. Not until the end of the 1960s did filmmakers

like Herbst, Nekes, and Dore O create a modern German avant-garde film movement.

Notes

[1] Walther Ruttmann, "Art and the Cinema," in Walter Schobert, *The German Avant-Garde Film of the 1920s* (Munich: Goethe-Institut, 1989), 6–8.

[2] Bernhard Diebold, "Eine neue Kunst," in Schobert, *The German Avant-Garde Film*, 101.

[3] Walther Ruttmann, "Painting with the Medium of Time," in Schobert, *The German Avant-Garde Film*, 102–3.

[4] Rudolf Arnheim, "Der absolute Film," in *Das Stachelschwein*, no. 14 (1925), 56–58.

[5] Walther Ruttmann, "Berlin. Die Sinfonie der Großstadt," in Schobert, *The German Avant-Garde Film*, 82.

[6] Sergei Eisenstein, Vsevolod Pudovkin, Grigori Alexandrov, "Statement on Sound," in S. M. Eisenstein, *Selected Works*, vol. 1, ed. Richard Taylor (London: BFI, 1988), 113f.

[7] Walther Ruttmann, "Sound Films? — !" in Schobert, *The German Avant-Garde Film*, 82.

[8] Hans Richter, "Der avantgardistische Film in Deutschland," in *Cineaste. Sonderheft Deutsche Filmtage Göttingen 1953*, 18f.

[9] Hans Richter, as quoted by Erwin Leiser, in "Hans Richter — Maler als Filmpionier," in *Hans Richter 1888–1976. Dadaist, Filmpionier, Maler, Theoretiker* (Berlin: Akademie der Künste, 1982), 40.

Ruttmann, Rhythm, and "Reality": A Response to Siegfried Kracauer's Interpretation of *Berlin. The Symphony of a Great City*

David Macrae

IN THE FILMIC IMAGES created by Walther Ruttmann in *Berlin. The Symphony of a Great City,* expressively rhythmic montage is a visionary element which attains an elevated status in relation to the objective environments it presents. In the firmly held opinions of Siegfried Kracauer, it is a complete reversal of this equation which must be ideologically adhered to. Kracauer's revered psychological history of German film, *From Caligari to Hitler,* remains a landmark work of film theory which has long extended its broad influence across the contours of twentieth-century screen interpretation. Lauded for the ambition of its scale, the fusion of social, economic, ideological and psychological perspectives, *From Caligari to Hitler* was indeed a remarkably original elevation of the role of film into the multiplicitous arena of contexts and catalysts.

Yet Kracauer occasionally allowed the generalized question of context to obscure the particularized questions of creation. He claims that "Ruttmann's rhythmic *montage* is symptomatic of a withdrawal from basic decisions into ambiguous neutrality."[1] At the heart of Kracauer's analytic ambiguity in relation to the work of Walther Ruttmann, is the conspicuously limited exploration of the nature of reciprocity in the relationship of filmic images themselves and the apparent objectivity of the immediate experiential environment. This theoretical territory, therefore, appears ripe for further exploratory analysis.

It is certainly the case that in Ruttmann's film both the pure expressivity of rhythmic montage and the apparent objectivity of mimetic photographic documentation — somehow connected with an automatic "duty" of social commentary — are innate inhabitants of the same visual sphere. It is inevitable that within this visual sphere the fully communicative and expressive impact will be delivered via the collective vibrancy of the collision of rhythm and object throughout the whole of Rutt-

mann's presentation. The key point here is that in Kracauer's interpretation the essential vitality of the film's communication/expression fusion, or object/rhythm relationship, is ignored in the stubborn insistence on an impossibly untarnished means of mimetic documentation, and the additionally impossible myth of automatically attendant "responsible social commentary." The implications of Kracauer's assumptions about the ideological "duties" of the film are that the core structures of expressive rhythmic montage — which form the film's foundations — are undermined by the integrally flawed supposition that the depth and idiosyncrasy of human social and environmental experience must be invariably encumbered with the quantified details of an "authentic reality." He states "human beings are forced into the sphere of the inanimate. They seem molecules in a stream of matter."[2] In total contrast to the myopic perspective of Kracauer's presumptive "realism," is Ruttmann's directly visionary sense of dynamic film-reality which, to be incisively perceptible, intuitively apprehensible and sensorially absorbing, seeks to channel and focalize the objective components of the cityscape into an enveloping stream of pure forms, tones and rhythms which are most poignantly located within the expressive aesthetic realm, liberated from the anchored objects of photographic mimesis.

By taking ideological perspectives as the prescribed objectives for the film, Kracauer immediately locks interpretation into a rigidly linear formulation of assessment. Whilst Ruttmann's film may pertain to certain aspects of this model, his idiosyncratic production ethos enforces an experiential viewing process which is capable of concurrently assimilating the expressive and abstracted levels of filmic scenario. The viewer's proactive apprehension of their arrangement intricately entangles these elements with the sharp details of specific denotation in the level of their perceptual status. Indeed this multidirectional cross-activation of filmic and perceptual levels, whilst underpinned by inherent principles of structure, generates the vibrant depth and diversity peculiar to *Berlin,* a distinctively nonlinear, yet temporally framed organic rhythm of reflexive experiential "reality," whose ideological implications are not preconfigured destinations.

Kracauer's dogmatic linearity of interpretation might have achieved a greater degree of validity were it to allow for the creative interpenetration of various levels of filmic scenario and perceptual status. However, within the strict parameters imposed by the application of a fixed ideology, the viewer's personal responsive capabilities are inevitably constrained and stultified. Such constrictions to certain levels of perception and implication presupposes an uncreative methodology of imitative

replication in terms of presentation and film style: a constriction to utility rather than creativity. In this way, speculative indoctrination, ideological propositions, and normative value judgements become the inevitably formulaic result.

This fixed perspective lamentably overlooks the specific nature and background of Walther Ruttmann — not originally a documentarist, socio-economic analyst, or political pressure figure — but a pioneering and progressive visual artist. Imposing politically motivated constraints upon the particular nuances of Ruttmann's creative heritage and expressive vision, merely undermines and obscures the integrity of his considerable artistic achievements. The true transcendent strength of Ruttmann's filmic vision resides in the fact that none of his rhythmic forms and objects are configured without an extensive panorama of metaphor and resonance. Indeed it is through such lucidly panoramic resonance — in tone, tempo, dimensional shape, and expressive form — that *Berlin* actuates the sensorial "reality" of experiential fact which corroborates human perception.

Unlike Kracauer, Standish D. Lawder gives an impressively detailed account of the creative background and aesthetic influences which contributed to the development of Walther Ruttmann's career as an artist. In *The Cubist Cinema*, Lawder traces the crucial roots of Ruttmann's idiosyncratic visionary aspirations:

> Walther Ruttmann (1887–1941) studied as an architect, was self-taught as a painter, and was an accomplished violinist. All three of these arts were important sources for the series of short abstract films he produced in Germany during the years 1920 to 1925.
>
> According to his friend Albrecht Hasselbach, who served with Ruttmann during World War I, Ruttmann executed many small watercolors at the front, and at this time began to grow dissatisfied with the limitations inherent in the static medium of painting. A large abstract was his last major work in this medium, and after its execution in 1918, he is reported to have said "It makes no sense to paint anymore. This painting must be set in motion."
>
> Whether apocryphal or not, the remark points to the representation of movement as a prime concern in Ruttmann's art.[3]

Lawder goes on to consider the implications of Ruttmann's early creative development for *Berlin. The Symphony of a Great City:*

> Just as the lyrical aesthetic evident in his painting had determined the stylistic content of Ruttmann's abstract films, so too, in *Berlin*, his feeling for the liquid rhythms of gently undulating forms and his predilection for the visual play of curve against line inspired his choice

of suitably expressive settings and objects in modern Berlin. His un-published note on *Berlin* draws attention to the significance of his ab-stract films in its genesis: "During the long years of my development through abstractionism, I never lost the desire to build from living materials and to create a film symphony out of the myriad moving en-ergies of a great city." *Berlin* is full of images of modern machinery in motion. They are viewed, however, with Ruttmann's lyrical eye and ex-press a fundamentally impressionistic aesthetic, in contrast to the so-called "machine aesthetic" of the 'twenties characterized by percussive rhythms and sharp-edged forms.[4]

By neglecting the progressive visionary heritage of Ruttmann as an artist, Kracauer has left an unconstructive void between the processes of asso-ciative documentation and immediate aesthetic sensation. He has failed to fully demonstrate the fact that Ruttmann's work exists as an expressive entity which is innately couched within the context of apprehending vitally charged holistic qualities of the representational objects captured and constructed on film. Certainly, associative and socially conscious documentation, to be capable of having substantive entities to docu-ment, necessarily requires a basis in the imagistic realm of the objective environment which is inhabited. The components of associative docu-mentation couched within direct sensation, are reciprocal inhabitants of the same sphere. Similarly, in Ruttmann's *Berlin,* these components are merged into a filmic unification, proceeding through a series of interre-lated concentric phases from the basic presentation of objective docu-mentary data to the most sophisticated of sensorially arranged configurations of conceptual vision. The most vital ongoing characteristic of this perceptually unified process of filmic cognition is that throughout each of its oscillating phases it engages abstracted sensation. It is this crucially characteristic process of perceptual phasing, which lies at the core of Kracauer's misunderstanding and which he, regrettably, refers to as "fictitious transitions which are void of content."[5]

Consequently, it is of the utmost importance that the precise nature and significance of Ruttmann's abstracted filmic sensation must be ana-lyzed with special attention. The key tenet of this assertion is relatively straightforward. However, it is quite unlikely that the progressive core qualities of Ruttmann's *Symphony of a Great City* will be clarified, re-deemed and fully embraced unless several of Kracauer's vague or inaccu-rate interpretations are explored and assessed.

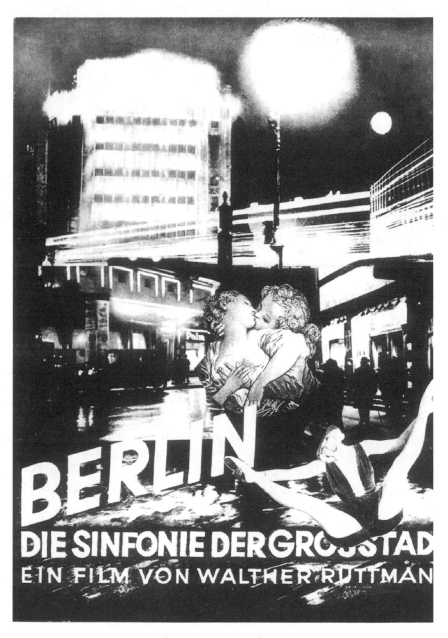

Cover of the program of Ruttmann's
Berlin. The Symphony of a Great City (1927).

In *From Caligari to Hitler,* Kracauer makes it abundantly clear from an early stage that the concepts of expressionistic and, especially, abstract film are symptomatic of regressive tendencies which are innately negative by any definition. In a brief derisory reference to the influential German abstract films of the 1920's, for example, Kracauer claims:

> The first abstract films appeared in 1921. . . . As the titles reveal, the authors themselves considered their products a sort of optical music. It was a music that, whatever else it tried to impart, marked an utter withdrawal from the outer world.[6]

Immediately, therefore, it becomes clear that Kracauer has a firmly stated aversion to the notion of any progressive energies and aspirations emanating from the field of abstract film. The use of the term "withdrawal from the outer world," laden with its insinuations of regressive ostracization, heavily encumbers the purposes of abstract film with a hazy veil of suspicion and unhelpfully dismissive misunderstanding.

This unhelpful confrontational opposition which Kracauer imposes between "abstract films" and "the outer world" is exacerbated in his tendency of mutually excluding the terms "rhythm" and "reality" in his reading of *Berlin* — making the unswerving assumption that a "real" entity can never be "rhythmic," nor a "rhythmic" entity simultaneously "real." For example, in reference to *Berlin,* Kracauer says of Ruttmann: "His penchant for rhythmic 'montage' reveals that he actually tends to avoid any critical comment on the reality with which he is faced."[7]

This sentence succinctly encapsulates Kracauer's central confusion over the precise filmic nature of Ruttmann's rhythmic sensibilities. For Kracauer "rhythmic montage" represents a form of intangibility, yet by propagating this misguided notion of the intangible, "reality" is clumsily detached from (and misappropriated for) "perceptibility." Thus Ruttmann's rhythmic montage becomes, somehow, utterly excluded from its clearly perceptual realms of sensation.

Kracauer similarly obfuscates by defining "reality" as that which is simply objective and "rhythmic" as that which is intangible. For example, in criticizing Ruttmann's manner of editing *Berlin,* Kracauer states:

> This method is tantamount to a "surface approach," inasmuch as it relies on the formal qualities of the objects rather than on their meanings. Ruttmann emphasizes pure patterns of movement. Machine parts in motion are shot and cut in such a manner that they turn into dynamic displays of an almost abstract character. These may symbolize what has been called the "tempo" of Berlin: but they are no longer related to machines and their functions. The editing also resorts to

striking analogies between movements or forms. Human legs walking on the pavement are followed by the legs of cows; a sleeping man on a bench is associated with a sleeping elephant. In those cases in which Ruttmann furthers the pictorial development through specific content, he inclines to feature social contrasts. One picture unit connects a cavalcade in the Tiergarten with a group of women beating carpets; another juxtaposes hungry children in the street and opulent dishes in some restaurant. Yet these contrasts are not so much social protests as formal expedients. Like visual analogies, they serve to build up the cross section, and their structural function overshadows whatever significance they may convey.[8]

Here Kracauer asserts the objective nature of machine parts, yet denounces Ruttmann's presentation of these objectives as intangibly nonobjective. The machine parts are objectively "real" but their rhythmic representation reduces this apparent degree of "reality." Such a seemingly straightforward contradiction is entangled within Kracauer's constitutional confusion over the fact that the *machine parts* are, concurrently or respectively, endowed with the status of *physical* objectivity as well as *psychological* objectivity — whether recollected, interpreted, considered, or imagined. Were Kracauer's contradictory terms of definition used instructively, as means of exploring the curious interrelationships of physical objects within the representative realms of the filmic medium and their psychological status within the mental perceptions of the viewer, his assertions may have carried more incisive validity. However, Kracauer insists upon his presumption of a reductive delineation between physical significatory values, influenced by objective, social, environmental factors *outside* the purely sensory sphere such as "machines and their functions," and psychological significations influenced by perceptual factors *within* the viewer's sensory sphere such as "pure patterns of movement." At this point it is essential to emphasize that both the apparently physical and the psychological within the medium of Ruttmann's film are each as "real" as the other: the viewer's processes of witnessing "formal qualities," "dynamic displays," "striking analogies between movements or forms" exist as much in "reality" as do the various component objects of their construction. Each of these idiosyncratic sensory processes of viewing *Berlin. The Symphony of a Great City*, however acutely documented or obliquely aestheticized, exist as unflinching filmic "reality."

Indeed, all of Ruttmann's visual components in *Berlin* can be described as very specifically significatory entities, however much Kracauer may denounce them as "formal" or "abstract," and regardless of the

extent of their conceptual or visionary intensity. Had Kracauer recognized this fairly simple, yet highly important, point he would certainly have been far better equipped to appreciate and constructively analyze *Berlin,* as well as Ruttmann's overall contribution to German avant-garde film. It is in the collision and interaction of multiple layers of visual signification — whether pure abstraction, expressive stylization, or objective mimesis that Ruttmann makes possible a perceptual process of considerable magnitude within the context of early twentieth-century film art and theory: a specific objective representation on film when apprehended individually may appear mimetic, yet can concurrently achieve a transcendent level of signification through expressive manipulation to activate a multitude of related effects.

The pioneering creative triumph of *Berlin* resides not within objectification, documentation or, as Kracauer puts it, "a fact among facts," but within the film's sensory resonance in direct exchange with objects and their *means* of representation and signification. In this way, Ruttmann's "abstracted dynamic displays of machine parts in motion" are as real, authentic and idiosyncratic a perceptual phenomena as the film viewer's personal psychological visualization of machine parts or, indeed, the photographically utilitarian documentary reproduction of machine parts. The "striking analogies between movements or forms" are themselves as real as the human and animal legs they represent. The inclination "to feature social contrasts" is as real as the hungry children and opulent dishes captured upon the film. With these realities of construction in mind, Kracauer's assertion that "structural function overshadows whatever significance they may convey," could be more precisely reconfigured as: structural function perceptually illuminates the significations they convey. Thus, Kracauer's dichotomous oppositionalism of "rhythm" and "reality" must remain a flawed methodology for the dissection of *Berlin* and its uniquely experiential visual impulses. The "rhythmic" and the "real" exist as reciprocal inhabitants of the same filmic sphere of Ruttmann's formation. Each element pervades the full scope of the work — a unison of object and essence, mind and matter.

Assessing complex questions of reality and its status in terms of reproductive malleability, Jacques Aumont raises the risks of imprecisely applying notions of filmic rhythm:

> Here we touch on the Gordian knot of photography and the photographic art. There have been endless discussions on defining it: is a photograph an imprint, a recording? Or is it a formulation (*mise-en-forme*): is it crafted? . . . The question becomes even more complex when we consider the moving image, be it cinema or video. Composi-

tion (in the plastic sense) takes on another meaning, a resonance of its meaning in music. The temporal organization of a film can be calculated in terms of regularity and rhythm. This has indeed been the case in some films, particularly in what has been mislabeled "experimental film." This form, of all cinematic institutions, is the one which is consciously most akin to the "plastic arts" (to the point that today experimental films are exhibited in museums of modern art). Walther Ruttmann's *Opus I*, Viking Eggeling's *Diagonal Symphony*, the films of Hans Richter . . . and of course much of so-called "Structural" film, all rest on calculations of duration, sometimes to the precise number of individual frames, something which could truly be compared to musical composition.

In any case we should remember that while the eye . . . can discern plastic composition in space, it is by nature much less able to perceive the flow of time. This has been noted by many film theorists from Eisenstein (who derides "metrical montage" as early as 1929) to Jean Mitry, who devotes a chapter to the question in *Esthétique et psychologie du cinéma* (1963–65). Thus the concept of rhythm, even more than composition, is troublesome when applied to film, where, at best it is metaphorical, at worst completely misplaced.[9]

The troublesome misplacement of the concept of rhythm in film is an ailment which has afflicted the Kracauer perspective. The importance of addressing this ailment gains greater urgency as Kracauer continues to insist upon an intrinsic disjunction between the rhythmic and the real, the aesthetic and the actual, the formal and the apparently factual. Again, the Kracauer perspective evades even the possibility of a simultaneously active fusion of these elements in Ruttmann's vision. Subsequently, Kracauer further derides Ruttmann's achievement by asserting that

> his film may be based upon the idea of Berlin as the city of tempo and work; but this is a formal idea which does not imply content either . . . This symphony fails to point out anything, because it does not uncover a single significant context.[10]

Here, Kracauer's assertion misleadingly entangles objective representations in *Berlin* with subjective significations implied via a posited form of visual narrativity within the film, and thus claims that the film must by necessity lack substance in pure form through a perceived lack of explicitly specified "content" or "context."

Every frame of *Berlin. The Symphony of a Great City*, and every object within these frames, exist as cinematic material which, when apprehended by the viewer's mind, may obtain the status of pure, filmically expressive data when sensorially absorbed as phenomena of intensive visionary

fusion — a unified visual impaction of multiple layers of meaning. In Ruttmann's film, this process is delivered via the idiosyncrasy of editorial construction and compositional direction, as well as the deployment of a series of actions, objects and events within which, and throughout which, the core expressive qualities combine to generate a transcendent level of purely cinematic sensation. For Kracauer, this concept of transcendent visionary fusion as a crucial component of the screen sense has been missed. To him there exists here only simplistic symbolization, such as for example — perhaps mirroring his own confusion in the matter — his suggestion of stylistically symbolized chaos:

> Symbols of chaos that first emerged in the postwar films are here resumed and supplemented by other pertinent symbols. Conspicuous in this respect is a unit of successive shots combining a roller coaster, a rotating spiral in a shop window and a revolving door.[11]

In attempting to impose ideological terms upon every aspect of Ruttmann's *Berlin*, Kracauer is allowing his fixation upon representation and symbolization to obscure any awareness of the purely cinematic phenomena which are the most vital creative tools at the malleable disposal of Walther Ruttmann as a filmmaker. The quality of chaos which Kracauer is so determined to force into the communicative equation of *Berlin* and its imagery, seems more of Kracauer's own manufacture than Ruttmann's intention. Neither predominantly symbolic or significatory of chaos, the shot sequence in question is a prime example of Ruttmann's generation of an expressive tension unique to the properties of the film medium.

In this sequence the contrasts of moving camera shots, moving objects, and combinations of the two, create a vibrantly dynamic and undulating screen aesthetic which is most profoundly concerned with the renewed spatio-temporal perceptual status and capabilities of the imagery as pure filmic phenomena, rather than simplistic symbolic connections assumed from pre-existing conventions of representation. The key error of judgment Kracauer makes here is to use a concept of symbolic functionality of representation, drawn predominantly from traditions of literature and sociology, yet which has no effectively penetrative value in the analysis of avant-garde filmic vision and its intrinsic aesthetic levels of transcendent expression. Put simply, Kracauer has brought the wrong tools for the job. Presented with fascinating new means of seeing, of seeing through the objects of vision to the screen sensation of vision, Kracauer merely continues to peer impenetratively at the surface. In this way, Kracauer has become somewhat separated from the idea of the screen sense, and it is the idea of representation which incarcerates his

analysis. This notion of the restrictiveness of representation is elucidated by Jacques Aumont: "The representational tradition can only exist because of ideological (in the last resort mathematical) rules which separate us from real life, from spontaneous encounters with the world."[12]

Key terms deployed by Kracauer in his application of a representational traditionalism in relation to *Berlin* are, as we have seen, "content" and "context." In this manner a schism is imposed between structure and signification, between presentation and revelation. Kracauer then identifies Ruttmann's work as the catalyzing influence in a series of films emphasizing formalism over representationalism: "*Berlin* inaugurated the vogue of the cross-section, or 'montage' films. They could be produced at low cost; and they offered a gratifying opportunity of showing much and revealing nothing."[13] Equipped with the methodology of representational traditionalism, further modified by specific ideological factors, Kracauer believes that the typical trait of the so-called *montage film* is to evade factual information and signification, finding specificity overcumbersome for its aesthetic priorities. As a result, and for reasons of production economy, montage films endeavored to condense or circumscribe the route to signification by impacting objects and scenarios into intensive noncommunicative masses of editorial collision.

This representational traditionalism then, when applied in this particular analysis, instructs that all montage films are somehow rooted in approximation or imprecision. In *From Caligari to Hitler*, Kracauer is so entrenched in this conviction that initial readings of his book may often fail to locate the true lack of penetration he makes into the montage ethos, or Walther Ruttmann's genuine filmic processes of significance. Of course, the methodologies of representation and ideology have their valid roles to certain extents, and these roles must be acknowledged where necessary. However, in the case of *Berlin. The Symphony of a Great City*, more suitably specialized methods of analysis seem to be required. The content/context disjuncture which Kracauer emphasizes, of "showing much and revealing nothing," is an example not only of the implications of applying an ideological imperative to the film's analysis, but is also part of a misguided notion of aesthetic values in film. Kracauer states that "Ruttmann, instead of penetrating his immense subject-matter with a true understanding of its social, economic and political structure . . ., records thousands of details without connecting them."[14] Connection, then, is a crucial quality, in Kracauer's view, whether of connecting content explicitly to context, or image to ideology. This element of the Kracauerian view suggests that the greater the number of visual connections the montage film makes, the fewer connections can then be made

at an ideological level, thereby deteriorating into merely intangible decorative editorial arrangement and rearrangement. However, the substantiated key causes of this type of significatory deterioration remain undisclosed. Full explanation of the reasons why aesthetically influenced editorial collisions of specific individual visual objects, events and structures lose communicative substance or value when placed in a unified filmic configuration is conspicuous in its absence. This is a key flaw in Kracauer's critique of the montage film phenomena. How exactly does the film, and the viewer of the film, enter into a realm of imprecise approximation when the actual components of the film itself comprise a wealth of specifics — or as Kracauer himself says: "a fact among facts," or "thousands of details."[15]

Kracauer's central objection to Ruttmann's recording of these "thousands of details" is that he does so "without connecting them." However, on closer analysis, there are in fact virtually no single details in Ruttmann's film which are *not* somehow connected. Indeed, the vast amount of the film's structured details are very intimately connected. Consider, for example, the manner in which *Berlin* initiates the clustered collective relatedness of a series of visual data. At the representational, symbolic level at which Kracauer operates, these collective relations take the form of, for example, in Kracauer's words: "a night express arrives, and streets still void of human life seem the very counterpart of that limbo which the mind traverses between sleep and consciousness."[16] By selecting certain visual data and characteristics, Kracauer indulges in the understandable desire to attribute to them a concomitant, yet symbolic, concept. Certainly, the connections being made at this level may appear obvious, even literal, however they also carry a subjectivity of correlation which by definition is itself imprecise: it veers away from the raw visual material of the film itself, implying the substance or "truth" of the film's content must be somehow nonfilmic and beyond the screen structure.

To approach and interpret the entire film in this manner alone would result in an indefinite mire of vaguely correlative subjectivity: a vast cloud of imprecision — so apparently abhorrent to Kracauer, according to his stated opinions. Thus, the methodology of subjective symbolism would, taken to its logical conclusion, result in the night express and streets void of human life obtaining the bewildering multisymbolism of objective artifacts, synthetic structures, malignant mechanized entities, benign environmental utilities, essential progressive vectors of communication, divisive disruptions across fractured societies, and on and on through a myriad of presumptive definitions toward an ever receding horizon of interpretation. In the fixed terms of traditional representionalism, and

the symbolism implied therein, each and every one of these infinite correlations must actually always be simultaneously extant when the specific concept is identified; however the expressive precision — the filmic relevance of meaning — arises specifically in *Berlin* through the selected structures of combination and arrangement. It is precisely the very filmic configuration of screen objects and frames which generates the sharply focused cine-communicative power of *Berlin. The Symphony of a Great City.* It is within this quality that the oriented sensory *actuality* of the film resides. Therefore, the elements of *cinematic* connection (not *symbolic* connection) which constitute the structural armature of *Berlin* are in fact its very vehicle of coherently concentrated and informative sensibility.

The hazy multiplicity of Kracauer's implied symbolism, derived from conventional representation, would ultimately subsume the viewer in an incomprehensible ocean of correlative data. In this case, an effective means of reductive interpretation would be required. If, as Kracauer suggests, the "montage" film is nothing more than a simplistic method of condensing the multiple details of meaning into a single superficial suggestion of it, then the perceptual process of viewing such a film would involve the communicative transition from broad indications of superficial meaning toward the gradually narrower details of meaning implied therein. However, there appears to be little evidence that this is what actually occurs. Consider, for example, the details of construction in *Berlin's* early sequence which Kracauer has only briefly assessed: the night train arrives, the fluid transitory planes of editorial arrangement interact with the gliding motion of linear structures across the screen frame. Then, the desolate urban streets are introduced through a complementary transition in which the temporal duration of the relevant frames is a key factor. At this stage the place of the filmmaker as a manipulator of both the temporal and structural configuration of the work is clear. For the viewer, time, shape, linearity of form, tone and tempo become prioritized elements of this film experience: these are particularized factors in the processes of screen expression which, in this case, are mediating and vital parts of the delivery of signification. Numerous though the represented details may be, reduction of their specific meanings is not implicitly an effect of formal arrangement.

This crucial element of particularized meaning as an innate inhabitant of a montage film's formal construction has been eloquently and meticulously elaborated by Sergei Eisenstein. In *The Film Sense,* he states:

From the same formula that unites the *meaning* of the whole piece (whether whole film or sequence) and the *meticulous, cunning selection* of the pieces, *emerges the image* of the theme, *true to its content.* Through this fusion, and through that fusion of the logic of the film's subject with the *highest form* in which to cast this subject, comes the full *revelation* of the film's meaning. Such a premise naturally serves as a source and departure for the whole series of varying approaches to synchronization. For each "different" kind of synchronization is embraced by the organic whole, and embodies the basic image through its own specifically defined limits.[17]

Nowhere in his chapter on "Montage" does Kracauer either develop or acknowledge this concept of the emergence of meaning purely through the active filmic fusion of content and form. Even where Kracauer chooses to negatively contrast Ruttmann's work with that of Dziga Vertov, he fails to fully comprehend the true communicative impact of formal *meanings* contained within montage construction. Kracauer claims that "Vertov implies content."[18] However, as most informed readings of Vertov's work attest, the pioneering Russian filmmaker hardly *"implies"* content, he *builds* with content — it is his raw material. His construction of content actually *constitutes* meaning rather than merely implying it. Nevertheless, Kracauer deployed the contrast of Vertov with Ruttmann, despite the somewhat myopic and ultimately contradictory nature of his statements:

> Only here can the difference between Ruttmann and Vertov be fully grasped: it is a difference of attitude. Vertov's continued survey of everyday life rests upon his unqualified acceptance of Soviet actuality.[19]

To attribute great works to being the result of the unqualified acceptance of actuality seems bizarre to say the least. At best, it appears to demote Vertov's great achievements to those of a restrained receptacle, dutifully reciting hollow messages of rigid reproduction and repetition. Furthermore, the contradiction of Kracauer's claim emerges where he states that: "*Berlin* refrains from idealizing the street" and "*Berlin* is the product of the paralysis itself."[20] No praise for dutiful reproduction in this case it seems, descriptively accurate or otherwise.

The recurring motivation for Kracauer's critical approach to *Berlin*, as we have seen, is the ideological prescription. However, these applications of an ideological imperative, despite representing Kracauer's criteria for filmic validity, do not fulfil his own demands for a form of precision of content which must dominate any notions of aesthetic construction.

Consider, for example, some of Kracauer's insistences for ideological and moral positing:

> The many prostitutes among the passers-by also indicate that society has lost its balance. But no one any longer reacts vigorously against its chaotic condition. Another old motif called upon betrays the same lack of concern: the policeman who stops the traffic to guide a child safely across the street. Like the shots denoting chaos, this motif, which in earlier films served to emphasize authority as a redemption, is how simply part of the record . . . That everybody is indifferent to his fellow men can be inferred from the formalization of social contrasts as well as from the repeated insertion of window-dressings with their monotonous rows of dolls and dummies. . . . People in Berlin assume the character of material not even polished. Used-up material is thrown away. To impress this sort of doom upon the audience, gutters and garbage cans appear in close-up, and . . . waste paper is seen littering the pavement. The life of society is a harsh, mechanical process.[21]

Kracauer's prim disdain for the presentation of prostitution and street litter seems somewhat amusingly alien in the context of a piece of film criticism. Yet the key suggestions he makes as to the requirement for an ideological imperative, located within an apparent embracing of so-called actuality, delivered via an increased precision of content is more problematic. Surely, the forms of precision Kracauer is demanding cannot so much be the intrinsic components of actuality as preordained subjective suggestions — vague *presuppositions* of what *ought* to represent actuality. Among the key words Kracauer uses in the above quotation are those which he deploys as part of his symbolic and rather loosely allocated prescriptiveness. Words such as "indicate," "denoting," "emphasize," "inferred," "assume," and "impress," are all rooted in the familiar Kracauerian conventionalized symbolism of message-based ideology. Where criticism is made of an apparent lack of factual message on Ruttmann's behalf, there is always the concomitant lack of factuality in Kracauer's bases of the delivery of moral/ideological reality. In order for Kracauer's prescriptions to be made, he repeatedly has to deploy a vague and subjective symbolic *denotation*. The moral recommendations he posits are all simply *distillates* of the apparent actuality he wishes to embellish. Without his preconfigured correlative subjectivity there could be no ideologically based prescription within his ideal of the film. What this proves is that contrary to Kracauer's accusations of approximation and imprecision in Ruttmann's use of content, his own prescriptive ideologies are themselves little more than the result of generalized, approximated recommendations for personal dogma.

In this regard, therefore, Kracauer seems to have been hoist with his own petard. He has become trapped by the intrinsic contradictions of his prescriptive position. For example, as we have noted, where Kracauer asserts the omnipresent importance of ideologically based factual detail, he correlatively stresses the weaknesses of Ruttmann's "montage" stylization of form: "a formal idea which does not imply content."[22] Yet, although Kracauer criticizes the diminution of content through heightened formality, as he feels it negates the detailed frameworks of ideological analysis, he fails to establish a framework for the critical analysis of reality that is not somehow tainted by generalities of preordained ideological leanings.

Indeed, these generalities themselves lack a purity of detailed analysis in that their urgency of prescriptive necessity is already clouded by a message-based form which must, surely, obstruct any full access to the perceived possibility of authentically documented actuality. Thus, Kracauer accuses Ruttmann of excluding content through preconditioning stylistic formality, yet is himself guilty of preconditioned ideological formality: whether stylistic or ideological, preconditions of form still apply.

This impenetrable wall that Kracauer attempts to construct through the center of *Berlin* — a wall separating form and content, rhythm and "reality" — has its foundations in uneven ground which has recurrently confused film criticism and theory. What the form/content dichotomies in film criticism frequently obscure are the idiosyncratically filmic processes of revealing core visual *concepts* through the formal framing, selection, editorial configuration, and combined temporal manipulation of *specific* imagistic events and information. We might refer to this process as a filmic *axiom*. It is this, quite particular, axiom which activates the screen viewer's perceptual apprehension of signification from the surge of multiple frames of successive images, their individual and stylistically interrelational implications. It seems abundantly clear to most film viewers that an intrinsic axiom of the screen experience is the omnipresent awareness that presented data is always molded by the very presence of the medium of representation. This axiom represents a reciprocal relationship of object and vehicle, a relationship within which both form and content are so intimately entwined as to generate their own specific objective status: the presentative object.

In his classic essay "The Ontology of the Photographic Image" André Bazin raises the idea of this entwinement or totalizing absorption of sign with referent, medium as object:

The photographic image is the object itself, the object freed from the conditions of time and space that govern it. No matter how fuzzy, distorted, or discolored, no matter how lacking in documentary value the image may be, it shares, by virtue of the very process of its becoming, the being of the model of which it is the reproduction; it *is* the model.[23]

By contrast with Bazin's revelatory awareness of medium as model, Kracauer's unerring commands for content gather increasing crudity. Indeed, as a prescriptive presentation of critical findings, Kracauer's chapter on "Montage" merely serves to incriminate the self-evident fictitiousness of gathering up and representing "factuality" without displaying obscuring stains of ideological preordination. His perspective underestimates both the intrinsic nature of the medium of film *and* the perceptual capacities of the viewer. The implications of which are that the viewer is regarded merely as a hollow recipient of data emerging from the screen with no conception of the nature of medium, creator, or construction. It is an outmoded perspective, couched in the murky realms of veiled messages delivered via invisible media.

Walther Ruttmann's rhythmic stylization, then, does not by necessity negate comment nor content. Neither is it an ambiguous cluster of superfluous sample images. To define Ruttmann's *Berlin,* in Kracauer's words, as: "symptomatic of a withdrawal from basic decisions into ambiguous neutrality,"[24] is a vague oversimplification, as this suggests that the film merely involves the detachment of the elements of construction from their specific origins. In order for Kracauer to have obtained a fully penetrative angle of analysis, it seems certain that he would have had to acknowledge the proactive interrelationships of Ruttmann's filmically organic construction of *Berlin. The Symphony of a Great City.* Kracauer claimed that *Berlin* was among films which "are like dreams called forth by the paralyzed authoritarian dispositions for which no direct outlet is left." "*Berlin,*" he adds "is the product of the paralysis itself."[25] The significant word Kracauer deploys here is *"product."* In concentrating on a concept of "product of paralysis," Kracauer has neglected to pay detailed attention to the diagnosis of the evolving related symptoms which may be active in Ruttmann's work. The way, for example, that such screen symptoms as the following might, in unison, manifest themselves: *Berlin's* congested and impacted architectural configurations; the linear incisions and entanglements of roads, rails, telegraph wires; the surges of social and physical motion; the frenetics of mechanization, production, commercialism. In this symptomatic profile of *Berlin,* each component may, certainly, be laden with socio-economic symbolism of substantial

Ein Werk wurde geschaffen, das mit allem bricht, was der Film bisher gezeigt. Es spielen keine Schauspieler und doch handeln Hunderttausende. Es gibt keine Spielhandlung und es erschließen sich doch ungezählte Dramen des Lebens. Es gibt keine Kulissen und keine Ausstattung und man schaut doch in der wilden Flucht des hundertpferdigen Panoramas die unzähligen Gesichte der Millionenstadt. Paläste, Häuserschluchten, rasende Eisenbahnen, donnernde Maschinen, das Flammenmeer der Großstadtnächte —. Schulkinder, Arbeitermassen, brausender Verkehr, Naturseligkeiten, Großstadtsumpf, das Luxushotel und die Branntweindestille . . .

Der mächtige Rhythmus der Arbeit, der rauschende Hymnus des Vergnügens, der Verzweiflungsschrei des Elends und das Donnern der steinernen Straßen — alles wurde vereinigt zur Sinfonie der Großstadt.

From the program of Walther Ruttmann's
Berlin. The Symphony of a Great City (1927).

gravity, yet as such they exist merely as an aggregate of sweeping ideological data, operative only at a single level of signification. The vital, and utterly dynamic, trait of the film exists in its multireferential construction which is realized through its transcendent embracing of meaning *intrinsic* to medium.

It is in this regard, of transcendental levels of filmic signification, that *Berlin* engages not *paralyzed product* but *active process*. The verdict of this symptomatic revaluation, therefore, is that the rhythms of *Berlin. The Symphony of a Great City* reveal their own deeper realities. A famous statement from Bertolt Brecht seems to intersect here with particular congruity. He stated: "Less than at any time does a simple reproduction of reality tell us anything about reality."[26]

Neither simple nor reproductive, Walther Ruttmann's striking film of Germany's Capital tells a distinctive visual tale of intense and enduring cinematic depth. Albeit, a depth somewhat beyond Siegfried Kracauer's considerable critical faculties. Of course, Kracauer's view of the ideological predicament facing the society of the time is, itself, a part of that reality. Equally, Ruttmann's rhythmic montage is, itself, a part of the reality of the time. If, as Kracauer suggests, the concept of reality is to be treated as a critical imperative of content here, then Ruttmann's film certainly carries considerable gravity as a significant part of the reality of its time, existing within the phenomena of its era as an extant artifact: aesthetic object as cultural fact. Yet the most profound revelation emerging from each of these elements of reality is their existence as parts of *process* — the processes active throughout the broad ranging life of, and lives within, Berlin. Ultimately, therefore, it is the rhythms of process which convey the crucial essence of *Berlin: The Symphony of a Great City*.

Notes

[1] Siegfried Kracauer, *From Caligari to Hitler. A Psychological History of the German Film* (Princeton, NJ: Princeton UP, 1974), 187.

[2] Ibid., 186.

[3] Standish D. Lawder, *The Cubist Cinema* (New York: New York UP, 1975), 57.

[4] Ibid., 62–64.

[5] S. Kracauer, *From Caligari to Hitler,* 187.

[6] Ibid., 68.

[7] Ibid., 187.

[8] Ibid., 184–85.

[9] Jacques Aumont, *The Image* (London: British Film Institute, 1997), 206–8.

[10] S. Kracauer, *From Caligari to Hitler,* 187–88.

[11] Ibid., 186.

[12] J. Aumont, *The Image,* 209.

[13] S. Kracauer, *From Caligari to Hitler,* 188.

[14] Ibid., 187.

[15] Ibid., 186f.

[16] Ibid., 183–84.

[17] Sergei Eisenstein, *The Film Sense,* ed. Jay Leyda (London: Faber and Faber, 1986), 73.

[18] S. Kracauer, *From Caligari to Hitler,* 187.

[19] Ibid., 186.

[20] Ibid., 187.

[21] Ibid., 186.

[22] Ibid., 187.

[23] André Bazin, "The Ontology of the Photographic Image," in *What is Cinema?* trans. Hugh Gray (Berkley: U of California P, 1967), 14.

[24] S. Kracauer, *From Caligari to Hitler,* 187.

[25] Ibid., 187.

[26] Bertolt Brecht, quoted in Walter Benjamin, "A Short History of Photography," *Screen,* vol. 13, no. 1 (Spring 1972): 24.

Filmography

1919

Veritas vincit Dir. Joe May, *Scr.* Ruth Goetz, Richard Hutter, *Cam.* Max Lutze, *Set Des.* Paul Leni, *Mus.* Ferdinand Hummer, *Cast* part 1: Mia May, Johannes Riemann, Magnus Stifter, Emil Albes, Hermann Picha, Maria Forescu; part 2: Mia May, Johannes Riemann, Leopold Bauer, Lina Paulsen, Friedrich Kühne; part 3: Mia May, Johannes Riemann, Bernhardt Goetzke, Adolf Klein, Hermann Picha, Emmy Wyda, *Prod.* Joe May, May-Film GmbH, Berlin, *Prem.* 4 April 1919.

Die Austernprinzessin (The Oyster Princess) *Dir.* Ernst Lubitsch, *Scr.* Hans Kräly, Ernst Lubitsch, *Cam.* Theodor Sparkuhl, *Set Des.* Kurt Richter, *Cast* Ossi Oswalda, Harry Liedtke, Victor Janson, Julius Falkenstein, Curt Bois, *Prod.* Projektions AG Union, *Prem.* 20 June 1919.

Rausch Dir. Ernst Lubitsch, *Scr.* Hans Kräly, *Cam.* Karl Freund, *Set Des.* Rochus Gliese, *Cast* Asta Nielsen, Alfred Abel, Carl Meinhard, Grete Diercks, *Prem.* August 1919

Madame Dubarry (Passion) *Dir.* Ernst Lubitsch, *Scr.* Norbert Falk (as Fred Orbing), Hanns Kräly, *Cam.* Theodor Sparkuhl, Kurt Waschneck, *Set Des.* Kurt Richter, Karl Machus, *Cast* Pola Negri, Emil Jannings, Reinhold Schünzel, Harry Liedtke, Paul Wegener, Eduard von Winterstein, *Prod.* Paul Davidson, Projektions-AG "Union," *Prem.* 18 September 1919.

Die Pest in Florenz (Plague in Florence) *Dir.* Otto Rippert, *Cam.* Willy Hameister, *Cast* Theodor Becker, Marga Kierska, Erich Bartels, Juliette Brandt, Erner Hübsche, Otto Mannstaedt, *Prod.* Decla, *Prem.* 1919.

Die Spinnen (Spiders) Part 1: *Der Goldene See* (The Golden Sea) *Dir.* Fritz Lang, *Scr.* Fritz Lang, *Cam.* Emil Schünemann, *Set Des.* Hermann Warm, Otto Hunte, Carl Ludwig Kirmse, Heinrich Umlauff, *Cast* Carl De Vogt, Ressel Orla, Lil Dagover, *Prod.* Erich Pommer, Decla-Bioscop, *Prem.* 3 October 1919. — Part 2: *Das Brillantenschiff* (The Diamond Ship) *Dir.* Fritz Lang, *Scr.* Fritz Lang, *Cam.* Emil Schünemann, *Set Des.* Hermann Warm, Otto Hunte, Carl Ludwig Kirmse, Heinrich Umlauff, *Cast* Carl de Vogt, Ressel Orla, Lil Dagover, *Prod.* Erich Pommer, Decla-Bioscop, *Prem.* 6 February 1920.

Die Herrin der Welt (Mistress of the World) Part 1: *Die Freundin des gelben Mannes Dir.* Joe May, *Scr.* Joe May, Richard Hutter, Ruth Goetz, Wilhelm Roellinghaus, based on the novel by Karl Figdor, *Cam.* Werner Brandes, *Set Des.* Otto Hunte, Erich Kettelhut, Karl Vollbrecht, Martin Jacoby-Boy, *Mus.* Ferdinand Hummel, *Cast* Mia May, Michael Bohnen, Henry Sze, *Prod.* Joe May, May-Film GmbH, Berlin *Prem.* 5 December 1919. — Part 2: *Die Geschichte der Maud Gregaards Dir.* Joe May, *Scr.* Joe May, Richard Hutter, Wilhelm Roellinghaus, based on the novel by Karl Figdor, *Cam.* Werner Brandes, *Set Des.* Otto Hunte, Erich Kettelhut, Karl Vollbrecht, Martin Jacoby-Boy, *Mus.* Ferdinand Hummel, *Cast* Mia May, Michael Bohnen, Henry Sze, Hans Mierendorff, *Prod.* Joe May, May-Film GmbH, Berlin, *Prem.* 12 December 1919. — Part 3: *Der Rabbi von Kuan-Fu Dir.:* Joe May, *Scr.* Joe May, Richard Hutter, Wilhelm Roellinghaus, based on the novel by Karl Figdor, *Cam.* Werner Brandes, *Set Des.* Otto Hunte, Erich Kettelhut, Karl Vollbrecht, Martin Jacoby-Boy, *Mus.* Ferdinand Hummel, *Cast* Mia May, Michael Bohnen, Henry Sze, *Prod.* Joe May, May-Film GmbH, Berlin, *Prem.* 19 December 1919. — Part 4: *König Makombe Dir.* Uwe Jens Krafft, Joe May, *Scr.* Joe May, Richard Hutter, based on the novel by Karl Figdor, *Cam.* Werner Brandes, *Set Des.* Otto Hunte, Erich Kettelhut, Karl Vollbrecht, Martin Jacoby-Boy, *Mus.* Ferdinand Hummel, *Cast* Mia May, Michael Bohnen, Henry Sze, Bamboula, *Prod.* Joe May, May-Film GmbH, Berlin, *Prem.* 26 December 1919. — Part 5: *Ophir, die Stadt der Vergangenheit Dir.* Uwe Jens Krafft, Joe May, *Scr.* Joe May, Richard Hutter, Ruth Goetz, Wilhelm Roellinghoff, based on the novel by Karl Figdor, *Cam.* Werner Brandes, *Set Des.* Otto Hunte, Erich Kettelhut, Karl Vollbrecht, Martin Jacoby-Boy, *Mus.* Ferdinand Hummel, *Cast* Mia May, Michael Bohnen, Paul Hansen, Lewis Brody, *Prod.* Joe May, May-Film GmbH, Berlin, *Prem.* 9 January 1920. — Part 6: *Die Frau mit den Milliarden Dir.* Uwe Jens Krafft, Joe May, *Scr.* Joe May, Richard Hutter, based on the novel by Karl Figdor, *Cam.* Werner Brandes, *Set Des.* Otto Hunte, Erich Kettelhut, Karl Vollbrecht, Martin Jacoby-Boy, *Mus.* Ferdinand Hummel, *Cast* Mia May, Paul Hansen, Paul Morgen, Wilhelm Diegelmann, Hermann Picha, Victor Janson, Lewis Brody, *Prod.* Joe May, May-Film GmbH, Berlin, *Prem.* 16 January 1920. — Part 7: *Die Wohltäterin der Menschheit Dir.* Karl Gerhardt, Joe May, *Scr.* Joe May, (Richard Hutter), Ruth Goetz, Wilhelm Roellinghoff, based on the novel by Karl Figdor, *Cam.* Werner Brandes, *Set Des.* Otto Hunte, Erich Kettelhut, Karl Vollbrecht, Martin Jacoby-Boy, *Mus.* Ferdinand Hummel, *Cast* Mia May, Paul Hansen, Ernst Hofmann, Hans Mierendorff, *Prod.* Joe May, May-Film GmbH, Berlin, *Prem.* 23 January 1920. — Part 8: *Die Rache der Maud Fergusson Dir.* Joe May, *Scr.* Joe May, Fritz Lang, Wilhelm Roellinghoff, based on the novel by Karl Figdor, *Cam.* Werner Brandes, Friedrich Weinmann, *Set Des.* Otto Hunte, Erich Kettelhut, Karl Vollbrecht, Martin Jacoby-Boy, *Mus.* Ferdinand Hummel, *Cast* Mia May, Hans Mierendorff, Ernst Hofmann, Rudolf Lettinger, Henry Bender, *Prod.* Joe May, May-Film GmbH, Berlin, *Prem.* 30 January 1920.

1920

Das Cabinet des Dr. Caligari (The Cabinet of Dr. Caligari) *Dir.* Robert Wiene, *Scr.* Hans Janowitz, Carl Mayer, *Cam.* Willy Hameister, *Set Des.* Hermann Warm, Walter Reimann, Walter Röhrig, *Cast* Werner Krauß, Conrad Veidt, Friedrich Feher, Lil Dagover, Hans Heinrich von Twardowski, *Prod.* Erich Pommer, Decla-Bioscop, *Prem.* 26 February 1920.

Der Reigen Dir. Richard Oswald, *Scr.* Richard Oswald, *Cam.* Carl Hoffmann, Axel Graatkjaer, *Set Des.* Hans Dreier, *Cast* Asta Nielsen, Conrad Veidt, Eduard von Winterstein, *Prod.* Richard Oswald, Richard Oswald-Film der Deutschen Bioscop AG, Berlin, *Prem.* 27 February 1920.

Kohlhiesels Töchter Dir. Ernst Lubitsch, *Scr.* Hanns Kräly, Ernst Lubitsch, *Cam.* Theodor Sparkuhl, *Set Des.* Jack Winter, *Cast* Henny Porten, Emil Jannings, Gustav von Wangenheim, Jakob Tiedtke, *Prod.* Nero-Film/ Henny Porten Filmproduktion, *Prem.* 9 March 1920.

Das Mädchen aus der Ackerstrasse (The Girl from Acker Street) *Dir.* Reinhold Schünzel, *Scr.* Bobby E. Lüthge, Arzen von Cserépy, based on the novel by Ernst Friedrich, *Cam.* Curt Courant, *Set Des.* Fritz Seyffert, *Cast* Otto Gebühr, Wladimir Agajeff, Lilly Flohr, Reinhold Schünzel, *Prem.* 30 April 1920.

Sumurun Dir. Ernst Lubitsch, *Scr.* Hanns Kräly, Ernst Lubitsch, based on the play by Friedrich Feska, *Cam.* Theodor Sparkuhl, Kurt Waschneck, *Set Des.* Kurt Richter, Ernö Metzner, *Cast* Pola Negri, Paul Wegener, Harry Liedtke, Ernst Lubitsch, *Prod.* Projektions-AG "Union," *Prem.* 1 September 1920.

Genuine Dir. Robert Wiene, *Scr.* Carl Mayer, *Cam.* Willy Hameister, *Set Des.* César Klein, *Cast* Fern Andra, Ernst Gronau, Harald Paulsen, *Prod.* Erich Pommer, Decla-Bioscop, *Prem.* 2 September 1920.

Der Golem, wie er in die Welt kam (The Golem, How He Came into the World) *Dir.* Carl Boese, Paul Wegener, *Scr.* Paul Wegener, Henrik Galeen, adapted from Gustav Meyrink, *Cam.* Karl Freund, *Mus.* Hans Landsberger, *Cast* Paul Wegener, Albert Steinrück, Lydia Salmonova, Ernst Deutsch, *Prod.* Universum Film A. G. (Ufa), *Prem.* 29 October 1920.

Anna Boleyn (Deception) *Dir.* Ernst Lubitsch, *Scr.* Norbert Falk (as Fred Orbing), Hanns Kräly, *Cam.* Theodor Sparkuhl, *Set Des.* Kurt Richter *Cast* Henny Porten, Emil Jannings, Aud Egede Nissen, *Prod.* Universum Film A. G. (Ufa), *Prem.* 14 December 1920.

Von morgens bis mitternachts (From Morn to Midnight) *Dir.* Karl Heinz Martin, *Scr.* Herbert Juttke, Karl Heinz Martin, based on the play by Georg Kaiser, *Cam.* Carl Hoffmann, *Set Des.* Robert Neppach, *Cast* Ernst Deutsch, Erna Morena, Roma Bahn, Hans Heinrich von Twardowski, *Prod.* Herbert Juttke, Ilag-Film, Berlin, *Prem.* December 1922, Tokio (Hong-Za-Kino).

1921

Hamlet Dir. Svend Gade, Heinz Schall, *Scr.* Erwin Gepard, *Cam.* Curt Courant, Axel Graatkjaer, *Set Des.* Svend Gade, Siegfried Wroblewsky, *Cast* Asta Nielsen, Paul Conradt, Mathilde Brandt, Lily Jacobsson, *Prem.* 9 February 1921.

Schloß Vogelöd (Haunted Castle) *Dir.* F. W. Murnau, *Scr.* Carl Mayer, based on the novel by Rudolf Stratz, *Cam.* Lászlù Schäffer, Fritz Arno Wagner, *Set Des.* Hermann Warm, *Cast* Arnold Korff, Lulu Kyser-Korff, Lothar Mehnert, Paul Hartmann, Paul Bildt, Olga Tschechowa, *Prod.* Erich Pommer, Uco-Film GmbH, Berlin, *Prem.* 7 April 1921.

Lichtspiel Opus 1 Dir. Walther Ruttmann, *Mus.* Max Butting, *Prem.* 27 April 1921.

Danton Dir. Dimitri Buchowetzki, *Scr.* Dimitri Buchowetzki, based on motifs of Georg Büchner's drama *Dantons Tod, Cam.* Árpád Virágh, *Set Des.* Hans Dreier, *Cast* Emil Jannings, Werner Krauß, Eduard von Winterstein, Charlotte Ander, Maly Delschaft, *Prem.* 5 May 1921.

Scherben (Shattered) *Dir.* Lupu Pick, *Scr.* Lupu Pick, Carl Mayer, *Cam.* Friedrich Weinmann, *Cast* Werner Krauß, Hermine Straßmann-Witt, Edith Posca, Paul Otto, *Prod.* Lupu Pick, *Prem.* 27 May 1921.

Die Geier-Wally Dir. E. A. Dupont, *Scr.* E. A. Dupont, based on the novel by Wilhelmine von Hillern, *Cam.* Árpád Virágh, Karl Hasselmann, *Set Des.* Paul Leni, *Mus.* Bruno Schulz, *Cast* Albert Steinrück, Henny Porten, Wilhelm Dieterle, Eugen Klöpfer, *Prod.* Henny Porten, Hanns Lippmann, Henny Porten-Film GmbH, Berlin, for Gloria-Film GmbH, *Prem.* 12 September 1921.

Der müde Tod (Between Two Worlds [U.S.]; Destiny [U.K.]) *Dir.* Fritz Lang, *Scr.* Fritz Lang, Thea von Harbou, *Cam.* Erich Nitzschmann, Herrmann Saalfrank, Fritz Arno Wagner, *Set Des.* Walter Röhrig, Hermann Warm, Robert Herlth, *Mus.* Giuseppe Becce, *Cast* Lil Dagover, Bernhard Goetzke, Walter Janssen, *Prod.* Erich Pommer, Decla-Bioscop, *Prem.* 7 October 1921.

Das indische Grabmal (The Indian Tomb) Part 1: *Die Sendung des Yoghi.* Part 2: *Der Tiger von Eschnapur Dir.* Joe May, *Scr.* Thea von Harbou, Fritz Lang, *Cam.* Werner Brandes, *Set Des.* Martin Jacoby-Boy, Otto Hunte, Erich Kettelhut, Karl Vollbrecht, *Mus.* Wilhelm Löwitt, *Cast* Olaf Fönss, Mia May, Conrad Veidt, Erna Morena, Lya de Putti, *Prod.* Joe May, May-Film GmbH, Berlin, for E. F. A., Berlin, *Prem.* 22 October 1921 and 17 November 1921.

Hintertreppe (Backstairs) *Dir.* Paul Leni, Leopold Jeßner, *Scr.* Carl Mayer, *Cam.* Karl Hasselmann, Willy Hameister, *Set Des.* Paul Leni, Karl Görge, *Mus.* Hans Landsberger, *Cast* Henny Porten, Wilhelm Dieterle, Fritz Kortner, *Prod.* Hanns Lippmann, Henny Porten, Henny Porten-Film GmbH, for Gloria-Film GmbH, Berlin, *Prem.* 11 December 1921.

Rhythmus 21 Dir. Hans Richter.

Der verlorene Schatten (The Lost Shadow) *Dir.* Rochus Gliese, *Scr.* Paul Wegener, *Cam.* Karl Freund, *Set Des.* Rochus Gliese, *Cast* Paul Wegener, Lyda Salmonova, Werner Schott, Grete Schoedter, Wilhelm Bendow, *Prod.* Projektions-AG "Union" mm, *Prem.* 1921.

1922

Fridericus Rex (I/II) Part 1: ***Sturm und Drang.*** Part 2: ***Vater und Sohn*** *Dir.* Arzen von Csérepy, *Scr.* Hans Behrendt, Arzen von Csérepy, *Cam.* Guido Seeber, Ernst Lüttgens, *Cast* Otto Gebühr, *Prem.* 31 January 1922.

Das Weib des Pharao (The Loves of Pharaoh) *Dir.* Ernst Lubitsch, *Scr.* Norbert Falk, Hanns Kräly, *Cam.* Theodor Sparkuhl, Alfred Hansen, *Set Des.* Ernst Stern, Kurt Richter, *Cast* Emil Jannings, Albert Bassermann, Harry Liedtke, Paul Wegener, Dagny Servaes, Lyda Salmonova, *Prod.* Ernst Lubitsch Film GmbH/ Europäische Allianz Film, *Prem.* 21 February 1922.

Nosferatu. Eine Symphonie des Grauens (Nosferatu. A Symphony of Horrors) *Dir.* F. W. Murnau, *Scr.* Henrik Galeen, based on Bram Stoker's novel, *Dracula, Cam.* Fritz Arno Wagner, Günther Krampf, *Set Des.* Albin Grau, *Mus.* Hans Erdmann, *Cast* Max Schreck, Gustav von Wangenheim, Greta Schröder, Alexander Granach, *Prod.* Albin Grau, Enrico Dieckmann, Prana-Film GmbH, Berlin, *Prem.* 4 March 1922.

Der brennende Acker (Burning Soil) *Dir.* F. W. Murnau, *Scr.* Thea von Harbou, Willy Haas, Arthur Rosen, *Cam.* Fritz Arno Wagner, Karl Freund, *Set Des.* Rochus Gliese, *Mus.* Alexander Schirmann, *Cast* Werner Krauß, Eugen Klöpfer, Wladimir Gaidarow, Lya de Putti, *Prod.* Sascha Goron, Goron-Films, Berlin, for Deulig-Film GmbH, Berlin, *Prem.* 8 March 1922.

Dr. Mabuse, der Spieler (Dr. Mabuse, the Gambler) Part 1: ***Der Grosse Spieler. Ein Bild unserer Zeit*** (A Picture of the Time). Part 2: ***Inferno, Ein Spiel von Menschen Unserer Zeit*** (Inferno — Men of the Time) *Dir.* Fritz Lang, *Scr.* Thea von Harbou, based on the novel by Norbert Jacques, *Cam.* Carl Hoffmann, *Set Des.* Otto Hunte, Carl Stahl-Urach, Erich Kettelhut, Karl Vollbrecht, *Cast* Rudolf Klein-Rogge, Bernhard Goetzke, Alfred Abel, Gertrude Welcker, Aud Egede Nissen, Paul Richter, *Prod.* Erich Pommer, Uco-Film, *Prem.* 27 March 1922.

Lucrezia Borgia Dir. Richard Oswald, *Scr.* Richard Oswald, *Cam.* Karl Freund, *Set Des.* Robert Neppach, *Cast* Liane Haid, Conrad Veidt, Albert Bassermann, Paul Wegener, Heinrich George, Wilhelm Dieterle, Anita Berber, *Prem.* 6 October 1922.

Vanina Dir. Arthur von Gerlach, *Scr.* Carl Mayer, based on a novel by Stendhal, *Cam.* Frederik Fuglsang, *Set Des.* Walter Reimann, *Cast* Paul Wegener, Asta Nielsen, Paul Hartmann, *Prem.* 6 October 1922.

Phantom *Dir.* F. W. Murnau, *Scr.* Thea von Harbou, based on the novel *Phantom* (1923) by Gerhart Hauptmann, *Cam.* Axel Graatkjaer, Theophan Ouchakoff, *Set Des.* Hermann Warm, Erich Czerwonski, *Mus.* Leo Spieß, *Cast* Alfred Abel, Frida Richard, Aud Egede Nissen, Lya de Putti, *Prod.* Erich Pommer, Uco-Film GmbH, Berlin, *Prem.* 13 November 1922.

1923

Erdgeist (Earth Spirit) *Dir.* Leopold Jeßner, *Scr.* Carl Mayer, based on Wedekind's play, *Cam.* Axel Graatkjaer, *Set Des.* Robert Neppach, *Cast* Asta Nielsen, Albert Bassermann, Rudolf Forster, Alexander Granach, Heinrich George, *Prem.* 22 February 1923.

Der Schatz (The Treasure) *Dir.* G. W. Pabst, *Scr.* G. W. Pabst, Willy Hennings, based on a short story by Rudolf Hans Bartsch, *Cam.* Otto Tober, *Set Des.* Robert Herlth, Walter Röhrig, *Mus.* Max Deutsch, *Cast* Albert Steinrück, Lucie Mannheim, Ilka Grüning, Werner Krauß, Hans Brausewetter, *Prod.* Carl Froelich, Froelich-Film GmbH, Berlin, *Prem.* 26 February 1923.

Schatten (Warning Shadows) *Dir.* Arthur Robison, *Scr.* Rudolf Schneider, Robison, *Cam.* Fritz Arno Wagner, *Set Des.* Albin Grau, *Cast* Fritz Kortner, Ruth Weyher, Gustav von Wangenheim, Alexander Granach, *Prem.* 16 October 1923.

Das Alte Gesetz (The ancient law) *Dir.* Ewald André Dupont, *Scr.* Paul Reno, based on Heinrich Laube's memoirs, *Cam.* Theodor Sparkuhl, *Set Des.* Alfred Junge, Kurt Kahle, *Cast* Henny Porten, Ernst Deutsch, Werner Krauß, Avrom Morewski, *Prod.* Comedia-Film GmbH, Berlin, *Prem.* 29 October 1923.

Raskolnikow *Dir.* Robert Wiene, *Scr.* Wiene, based on the Fjodor Dostojewski's novel *Crime and Punishment, Cam.* Willy Goldberger, *Set Des.* Andrej Andrejew, *Cast* Grigori Chmara, Michael Tarschanow, Maria Germanowa, Pawel Pawloff, *Prem.* 29 October 1923.

I.N.R.I. *Dir.* Robert Wiene, *Scr.* Wiene, *Cam.* Axel Graatkjaer, Ludwig Lippert, Reimar Kuntze, *Set Des.* Ernö Metzner, *Cast* Grigori Chmara, Henny Porten, Asta Nielsen, Werner Krauß, *Prem.* 5 November 1923.

Die Strasse (The Street) *Dir.* Karl Grune, *Scr.* Karl Grune, Julius Urgiß, *Cam.* Karl Hasselmann, *Set Des.* Karl Görge-Prochaska, Ludwig Meidner, *Cast* Eugen Klöpfer, Lucie Höflich, Aud Egede Nissen, *Prod.* Karl Grune, *Prem.* 29 November 1923.

Rhythmus 23 *Dir.* Hans Richter, *Cam.* Charles Métain.

1924

Sylvester (New Year's Eve) *Dir.* Lupu Pick, *Scr.* Carl Mayer, *Cam.* Karl Hasselmann, Guido Seeber, *Set Des.* Klaus Richter, Robert A. Dietrich, *Prod.* Lupu Pick, *Prem.* 3 January 1924.

Die Nibelungen Part 1: *Siegfried.* Part 2: *Kriemhilds Rache* (Kriemhild's Revenge) *Dir.* Fritz Lang, *Scr.* Fritz Lang, Thea von Harbou, *Cam.* Carl Hoffmann, Günther Rittau, Walther Ruttmann, *Set Des.* Otto Hunte, Erich Kettelhut, *Mus.* Gottfried Huppertz, *Cast* Paul Richter, Margarethe Schön, Hanna Ralph, Hans Adalbert Schlettow, *Prod.* Erich Pommer, Decla-Bioscop, *Prem.* 14 February 1924 and 26 April 1924.

Diagonale Sinfonie (Diagonal Symphony) *Dir.* Viking Eggeling, *Prem.* 3 May 1925.

Das Wachsfigurenkabinett (Waxworks) *Dir.* Paul Leni, *Scr.* Henrik Galeen, *Cam.* Helmar Lerski, *Set Des.* Paul Leni, *Cast* Emil Jannings, Conrad Veidt, Werner Krauß, Wilhelm Dieterle, *Prod.* Alexander Kwartiroff, Arthur Kiekebusch, Neptun-Film AG, Berlin, for Ufa, Berlin, *Prem.* 13 November 1924.

Der letzte Mann (translated as *The Last Laugh*) *Dir.* Friedrich Wilhelm Murnau, *Scr.* Carl Mayer, *Cam.* Karl Freund, *Set Des.* Robert Herlth, Walter Röhrig, *Mus.* Giuseppe Becce, *Cast* Emil Jannings, Maly Delschaf, *Prod.* Erich Pommer, Union-Film der Universum-Film AG (Ufa), Berlin, *Prem.* 23 December 1924.

Orlacs Hände (The Hands of Orlac) *Dir.* Robert Wiene, *Scr.* Ludwig Nerz, based on the novel by Maurice Renard, *Cam.* Günther Krampf, Hans Andreschim, *Cast* Conrad Veidt, Alexandra Sorina, Carmen Cartelleri, Fritz Kortner, *Prod.* Pan-Film, *Prem.* 1924.

1925

Die Chronik von Grieshuus (The Chronicle of Grieshus) *Dir.* Arthur von Gerlach, *Scr.* Thea von Harbou, based on the novel by Theodor Storm, *Cam.* Fritz Arno Wagner, *Set Des.* Robert Herlth, Walter Röhrig, Hans Poelzig, *Cast* Paul Hartmann, Rudolf Forster, Lil Dagover, *Prod.* Ufa, *Prem.* 11 February 1925

Die freudlose Gasse (The Joyless Street) *Dir.* Georg Wilhelm Pabst, *Scr.* Willy Haas, based on Hugo Bettauer's novel, *Cam.* Guido Seeber, Curt Oertel, Walter Robert Lach, *Set Des.* Hans Sohnle, Otto Erdmann, *Cast* Werner Krauß, Greta Garbo, Asta Nielsen, Valeska Gert, *Prod.* Michael Salkin, Romain Pinès, Georg Wilhelm Pabst, Mark Sorkin, Sofar-Film-Produktion GmbH, Berlin, *Prem.* 18 May 1925.

Varieté (Variety) *Dir.* Ewald André Dupont, *Scr.* Ewald André Dupont, based on motifs of Felix Holländer's novel *Der Eid des Stephan Huller, Cam.* Karl Freund, Carl Hoffmann, *Set Des.* O. F. Werndorff, *Mus.* Ernö Rapée, *Cast* Emil Jannings, Lya de Putti, Warwick Ward, *Prod.* Universum-Film AG (Ufa), Berlin, *Prem.* 16 November 1925.

1926

Tartüff (Tartuffe) *Dir.* Friedrich Wilhelm Murnau, *Scr.* Carl Mayer, based on Molière's comedy *Le Tartuff ou L'imposteur, Cam.* Karl Freund, *Set Des.* Robert Herlth, Walter Röhrig, *Mus.* Giuseppe Becce, *Cast* Emil Jannings, Werner Krauß, Lil Dagover, Lucie Höflich, *Prod.* Erich Pommer, Universum-Film AG (Ufa), Berlin, *Prem.* 25 January 1926.

Geheimnisse einer Seele (Secrets of a Soul) *Dir.* Georg Wilhelm Pabst, *Scr.* Colin Roß, Hans Neumann, *Cam.* Guido Seeber, Curt Oertel, Walter Robert Lach, *Set Des.* Ernö Metzner, *Cast* Werner Krauß, Ruth Weyher, Jack Trevor, Ilka Grüning, *Prod.* Hans Neumann, Neumann-Film-Produktion GmbH, Berlin, for Ufa-Kulturabteilung, Berlin, *Prem.* 24 March 1926.

Faust Dir. Friedrich Wilhelm Murnau, *Scr.* Hans Kyser, based on motifs of Christopher Marlowe and Johann Wolfgang von Goethe's versions of the Faust legend as well as on Ludwig Berger's manuscript *Das verlorene Paradies, Cam.* Carl Hoffmann, *Set Des.* Robert Herlth, Walter Röhrig, *Mus.* Werner Richard Heymann, based on motifs from Richard Wagner and Richard Strauß, *Cast* Gösta Ekman, Emil Jannings, Camilla Horn, Wilhelm Dieterle, *Prod.* Erich Pommer, Universum-Film Af (Ufa), Berlin, *Prem.* 14 October 1926.

Der Student von Prag (The Student of Prague) *Dir.* Henrik Galeen, *Scr.* Henrik Galeen, Hanns Heinz Ewers, based on Hanns Heinz Ewers' idea, *Cam.* Günther Krampf, Erich Nitzschmann, *Set Des.* Hermann Warm, *Mus.* Willy Schmidt-Gentner, *Cast* Conrad Veidt, Elizza La Porta, Fritz Alberti, Agnes Esterhazy, Ferdinand von Alten, Werner Krauß, Erich Kober, Max Maximilian, Sylvia Torf, Marian Alma, *Prod.* H. R. Sokal, H. R. Sokal-Film GmbH, Berlin, *Prem.* 25 October 1926.

Die Abenteuer eines Zehnmarkscheins (Uneasy Money) *Dir.* Berthold Viertel, *Scr.* Béla Balázs, *Cam.* Helmar Lerski, Robert Baberske, *Cast* Agnes Müller, Oskar Homolka, Walter Franck, Werner Fuetterer, *Prem.* 28 October 1926.

1927

Berlin. Die Sinfonie der Großstadt (Berlin. The Symphony of a Great City) *Dir.* Walther Ruttmann, *Scr.* (based on an idea by Carl Mayer) Karl Freund and Walther Ruttmann, *Mus.* Edmund Meisel, *Prod.* Fox Europa, *Prem* 23 September 1927.

Bibliography

Adkinson, R. V., ed. *The Cabinet of Dr. Caligari*. A Film by Robert Wiene, Carl Mayer, and Hans Janowitz. London: Lorrimer; New York: Simon & Schuster, 1972.

Arnheim, Rudolf. *Kritiken und Aufsätze zum Film*. Ed. Helmut H. Diederichs. Frankfurt am Main: Fischer, 1979.

Arnold, Loy, Michael Farin and Hans Schmid, eds. *Nosferatu. Eine Symphonie des Grauens*. Munich: Belleville, 2000.

Arns, Alfons, and Hans Peter Reichman, eds. *Otto Hunte. Architekt für den Film*. Frankfurt am Main: Deutsches Filmmuseum, 1996.

Atwell, Lee. *G. W. Pabst*. Boston: Twayne, 1977.

Aurich, Rolf, and Wolfgang Jacobsen, eds. *Werkstatt Film. Selbstverständnis und Visionen von Filmleuten der zwanziger Jahre*. Munich: edition text + kritik, 1998.

Aurich, Rolf, Wolfgang Jacobsen, and Cornelius Schnauber, eds. *Fritz Lang. His Life and Work. Photographs and Documents*. Berlin: Filmmuseum Berlin, 2001.

——. *Fritz Lang. Leben und Werk in Bildern und Dokumenten*. Berlin: Jovis, 2001.

Balázs, Béla. *Schriften zum Film*. 2 vols. Ed. Helmut H. Diederichs, Wolfgang Gersch, and Magda Nagy. Munich: Hanser, 1982–84.

Barlow, John D. *German Expressionist Film*. Boston: Twayne, 1982.

Behr, Shulamith, David Fanning, and Douglas Jarman, eds. *Expressionism Reassessed*. Manchester: Manchester UP, 1993.

Belach, Helga, and Wolfgang Jacobsen, eds. *Richard Oswald: Regisseur und Produzent*. Munich: edition text + kritik, 1990.

Benson, Timothy. *Expressionist Utopias. Paradise — Metropolis — Architectural Fantasy*. Los Angeles: Los Angeles County Museum, 1993.

Berg-Ganschow, Uta, and Wolfgang Jacobsen, eds. *Film . . . Stadt . . . Kino . . . Berlin*. Berlin: Argon, 1987.

Berg-Ganschow, Uta, et al. *Friedrich Wilhelm Murnau, 1888–1988*. Bielefeld: Bielefelder Verlagsanstalt, 1989.

Berriatúa, Luciano. *Los Proverbios chinos de F. W. Murnau. Filmoteca Española*. 2 vols. Madrid: Instituto de la Cinematografia y de las Artes Audiovisuales, 1990.

Bitomsky, H. *Die Röte des Rots von Technicolor.* Neuwied: Luchterhand, 1972.

Bock, Hans-Michael, ed. *Paul Leni. Grafik, Theater, Film.* Frankfurt am Main: Deutsches Filmmuseum, 1986.

Bock, Hans-Michael, and Claudia Lenssen, eds. *Joe May. Regisseur und Produzent.* Munich: edition text + kritik, 1991.

Bock, Hans-Michael, and Michael Töteberg, eds. *Das Ufa-Buch.* Frankfurt am Main: Zweitausendeins, 1992.

Brennicke, Ilona, and Joe Hembus. *Klassiker des deutschen Stummfilms. 1910– 1930.* Munich: Goldmann, 1983.

Bretschneider, Jürgen, ed. *Ewald André Dupont. Autor und Regisseur.* Munich: edition text + kritik, 1992.

Brill, Olaf, and Thomas Schultke, eds. *The Internet Source Book for Early German Film.* Version 4.2. http://www.filmgeschichte.de/.

Bronner, Stephen Eric, and Douglas Kellner, eds. *Passion and Rebellion: The Expressionist Heritage.* South Hadley, Mass.: J. F. Bergin, 1983.

Budd, Mike, ed. *The Cabinet of Dr. Caligari. Texts, Contexts, Histories.* New Brunswick, NJ: Rutgers UP, 1990.

Cardullo, B. "Expressionism and the real Cabinet of Dr. Caligari," *Film Criticism,* vol. 4, no. 2 (1982): 28–34.

Carroll, Noël. *Interpreting the Moving Image.* Cambridge: Cambridge UP, 1998.

Coates, Paul. *The Gorgon's Gaze: German Cinema, Expressionism, and the Image of Horror.* Cambridge: Cambridge UP, 1991.

Cook, David. *A History of Narrative Film.* New York: Norton, 1981.

Courtade, Francis. *Cinéma expressionniste.* Paris: Beyrier, 1984.

———. *Fritz Lang.* Paris: Le Terrain Vague, 1963.

Dahlke, Günther, and Günter Karl, eds. *Deutsche Spielfilme von den Anfängen bis 1933.* Berlin: Henschel, 1988.

Degenhardt, Inge. "Kleinbürgerschicksale im deutschen Spielfilm: Die Strasse (1923)," in *Fischer Filmgeschichte,* vol. 1, ed. Werner Faulstich and Helmut Korte, 394–411.

Dupont, E. A. "Abwege der Filmregie," *Film-Kurier,* 29 July 1919.

Eisenschitz, Bernard, and Jean Narboni, eds. *Ernst Lubitsch.* Paris: Cahiers du Cinéma / Cinémathèque Française, 1985.

Eisner, Lotte H. "Der Einfluß des expressionistischen Stils auf die Ausstattung der deutschen Filme der zwanziger Jahre," in *Paris — Berlin: 1900–1933.* Munich: Prestel, 1979, 266–73.

———. *Fritz Lang.* New York: Oxford UP, 1977.

————. *L'Écran Démonique*. Paris: André Bonne, 1952; rev. edition: Paris: Le Terrain Vague, 1965; German trans.: *Dämonische Leinwand. Die Blütezeit des deutschen Films*. Wiesbaden-Biebrich: Der neue Film, 1955; rev. edition: *Die dämonische Leinwand*. Frankfurt am Main: Kommunales Kino, 1975; Frankfurt am Main: Fischer, 1980; Engl. trans.: *The Haunted Screen. Expressionism in the German Cinema and the Influence of Max Reinhardt*. Berkeley: U of California P, 1973.

————. *Murnau. Der Klassiker des deutschen Films*. Hannover: Friedrich Verlag, 1967; Engl. trans., *Murnau*. London: Secker & Warburg, 1973.

————. "Stile und Gattungen des Films." In *Das Fischer Lexikon. Film. Rundfunk. Fernsehen*, ed. Lotte H. Eisner and Heinz Friedrich. Frankfurt am Main: Fischer, 1958. 263–65.

Elsaesser, Thomas. "Film History and Visual Pleasure: Weimar Cinema." In *Cinema Histories, Cinema Practices*. Ed. Patricia Mellencamp and Philip Rosen. Metuchen, NJ: U Publications of America, 1984. 47–84.

————. *Metropolis. Der Filmklassiker von Fritz Lang*. Hamburg: Europa Verlag, 2001.

————. "Social Mobility and the Fantastic: German Silent Cinema," *Wide Angle*, vol. 5, no. 2 (1982): 14–25.

————. *Weimar Cinema and After. Germany's Historical Imaginary*. London, New York: Routledge, 2000.

————. "Zwischen Filmtheorie und Cultural Studies. Mit Kracauer noch einmal im Kino." In *Idole des deutschen Films*, ed. Thomas Koebner. 22–40.

Elsaesser, Thomas, and Michael Wedel. *A Second Life: German Cinema's First Decades*. Amsterdam: Amsterdam UP, 1996.

Esser, Michael, ed. *Gleißende Schatten. Kamerapioniere der zwanziger Jahre*. Berlin: Henschel Verlag, 1994.

Farin, Michael, and Günter Scholdt, eds. *Dr. Mabuse, Medium des Bösen III. Das Testament des Dr. Mabuse*. Reinbek: Rowohlt, 1997.

Faulstich, Werner, and Helmut Korte, eds. *Fischer Filmgeschichte*. Vol. 1: *Von den Anfängen bis zum etablierten Medium, 1895–1924*. Frankfurt am Main: Fischer, 1994. Vol. 2: *Der Film als gesellschaftliche Kraft, 1925–1944*. Frankfurt am Main: Fischer, 1991.

Film und Kritik, Heft 1: *Revisited. Der Fall Dr. Fanck. Die Entdeckung der Natur im deutschen Bergfilm*. Frankfurt am Main: Stroemfeld/Roter Stern, 1992.

Fischer, Robert. *Das Cabinet des Dr. Caligari*. Stuttgart: Focus, 1985.

Franju, Georges. "Le style de Fritz Lang," *Cinematopgraph* (March 1939); rev. version: *Cahier du Cinema*, no. 101 (November 1959); Engl. trans. in L. Braudy and M. Dickstein, *Great Film Directors*. New York: Oxford UP, 1978. 583–89.

Frankfurter, Bernhard, ed. *Carl Mayer: Im Spiegelkabinett des Dr. Caligari. Der Kampf zwischen Licht und Dunkel.* Vienna: Promedia, 1997.

Frieden, Sandra, et al. *Gender and German Cinema: Feminist Interventions.* 2 vols. London: Berg, 1992.

Fritz, Horst. "Ästhetik des Films im Kontext von Expressionismus und Neuer Sach-lichkeit." In *Drama und Theater der europäischen Avantgarde,* ed. Franz Norbert Mennemeier and Erika Fischer-Lichte. Tübingen: Francke, 1994. 387–410.

Galeen, Henrik. *Das Wachsfigurenkabinett.* Munich: edition text + kritik, 1994.

Gehler, Fred, and Ullrich Kasten. *Friedrich Wilhelm Murnau.* Berlin: Henschel, 1990.

The Germanic Review. Special Issue: *German Film,* ed. Richard J. Murphy, vol. 66, no. 1, 1991.

Ginsberg, Terri, and Kirsten Moana Thompson, eds. *Perspectives on German Cinema.* New York: G. K. Hall; London: Prentice Hall International, 1996.

Goergen, Jeanpaul. *Walther Ruttmann. Eine Dokumentation.* Berlin: Freunde der Deutschen Kinemathek, 1990.

Grafe, Frieda. "Für Fritz Lang. Einen Platz, kein Denkmal." In Grafe et al., *Fritz Lang.* Munich: Hanser, 1987. 7–82.

Grafe, Frieda, and Enno Patalas. "Doktor Caligari gegen Doktor Kracauer oder Die Errettung der ästhetischen Realität." In *Im Off. Filmartikel.* Munich: Carl Hanser, 1974. 159–62.

———. "Ernst Lubitsch. Inflationskino." In *Im Off. Filmartikel.* Munich: Carl Hanser, 1974. 268–72.

———. "*Trouble in Paradise (Ärger im Paradies)* von Ernst Lubitsch." In *Im Off. Filmartikel.* Munich: Carl Hanser, 1974. 69–71.

Greve, Ludwig, et al., eds. *Hätte ich das Kino! Die Schriftsteller und der Stummfilm.* Stuttgart: Klett, 1976.

Gunning, Tom. "The Cinema of Attractions: Early Film, Its Spectator and the Avant-Garde." In *Early Cinema. Space, Frame, Narrative,* ed. Thomas Elsaesser. London: British Film Institute, 1990. 56–62.

———. *The Films of Fritz Lang. Allegories of Vision and Modernity.* London: British Film Institute, 2000.

Güttinger, Fritz. *Der Stummfilm im Zitat der Zeit.* Frankfurt am Main: Deutsches Filmmuseum, 1984.

Güttinger, Fritz, ed. *Kein Tag ohne Kino. Schriftsteller über den Stummfilm.* Frankfurt am Main: Deutsches Filmmuseum, 1984.

Hake, Sabine. *The Cinema's Third Machine. Writing on Film in Germany 1907–1933.* Lincoln: U of Nebraska P, 1993.

———. "Lubitsch's Period Films as Palimpsest: On *Passion* and *Deception*." In *Framing the Past,* ed. Bruce A. Murray and Christopher J. Wickham. 68–98.

———. *Passions and Deceptions. The Early Films of Ernst Lubitsch.* Princeton, NJ: Princeton UP, 1992.

Hansen, Miriam. "Early Silent Cinema: Whose Public Sphere?" In *New German Critique,* vol. 29 (1983): 147–84.

Heller, Heinz B. *Literarische Intelligenz und Film: Zu Veränderungen der ästhetischen Theorie und Praxis unter dem Eindruck des Films 1910–1930 in Deutschland.* Tübingen: Max Niemeyer, 1985.

Hempel, Rolf. *Carl Mayer. Ein Autor schreibt mit der Kamera.* Berlin: Henschelverlag Kunst und Gesellschaft, 1968.

Hess, Klaus Peter. *Das Cabinet des Dr. Caligari. Materialien zu einem Film von Robert Wiene.* Duisburg: atlas film + av, 1988.

Hofmannsthal, Hugo von. "Der Ersatz für die Träume." In *Kino-Debatte. Texte zum Verhältnis von Literatur und Film 1909–1929,* ed. Anton Kaes. Tübingen: Niemeyer, 1978. 149–52.

Jacobsen, Wolfgang. *Berlin im Film: Die Stadt — die Menschen.* Berlin: Argon, 1998.

Jacobsen, Wolfgang, ed. *G. W. Pabst.* Berlin: Argon, 1997.

Jacobsen, Wolfgang, Hans Helmut Prinzler, and Werner Sudendorf, eds. *Filmmuseum Berlin.* Berlin: nicolai, 2000.

Jacques, Norbert, and Fritz Lang. *Dr. Mabuse, der Spieler. Roman / Film / Dokumente,* ed. Günter Scholdt. Ingbert: Werner J. Röhrig Verlag, 1987.

Jansen, Peter W., and Wolfram Schütte, eds. *Friedrich Wilhelm Murnau.* Munich: Hanser, 1990.

———. *Fritz Lang.* Munich: Hanser, 1976.

Jenkins, Stephen, ed. *Fritz Lang. The Image and the Look.* London: British Film Institute, 1981.

Jensen, Paul M. *The Cinema of Fritz Lang.* New York: A. S. Barnes, 1969.

Jung, Uli, *Dracula. Filmanalytische Studien zur Funktionalisierung eines Motivs der viktorianischen Populär-Literatur.* Trier: Wissenschaftlicher Verlag, 1997.

Jung, Uli, and Walter Schatzberg. *Beyond Caligari: The Films of Robert Wiene.* Oxford: Berghahn Books, 1999.

———. *Robert Wiene: der Caligari-Regisseur.* Berlin: Henschel, 1995.

Jung, Uli, and Walter Schatzberg, eds. *Filmkultur zur Zeit der Weimarer Republik. Beiträge zu einer internationalen Konferenz vom 15. bis 18. Juni 1989 in Luxemburg.* Munich: K. G. Saur, 1992.

Kaes, Anton. "Film in der Weimarer Republik: Motor der Moderne." In *Geschichte des deutschen Films,* ed. Wolfgang Jacobsen, Anton Kaes, and Hans Helmut Prinzler. Stuttgart / Weimar: J. B. Metzler, 1993, 39–100.

———. "Filmgeschichte als Kulturgeschichte: Reflexionen zum Kino der Weimarer Republik." In *Filmkultur zur Zeit der Weimarer Republik*, ed. Uli Jung and Walter Schatzberg. 54–64.

Kaes, Anton, ed. *Kino-Debatte. Texte zum Verhältnis von Literatur und Film. 1909–1929.* Tübingen: Niemeyer; Munich: dtv; 1978.

Kaplan, E. Ann. "Fritz Lang and German Expressionism: A Reading of *Dr. Mabuse, der Spieler.*" In *Passion and Rebellion: The Expressionist Heritage*, ed. Stephen Eric Bronner and Douglas Kellner. 398–408.

Kasten, Jürgen. *Der expressionistische Film. Abgefilmtes Theater oder avantgardistisches Erzählkino? Eine stil-, produktions- und rezeptionsgeschichtliche Untersuchung.* Münster: Maks Publikationen, 1990.

Kaul, Walter, ed. *Caligari und Caligarismus.* Berlin: Deutsche Kinemathek, 1970.

Kiefer, Bernd. "Eroberer des Nutzlosen. Abenteuer und Abenteurer bei Arnold Fanck und Werner Herzog." In *Idole des deutschen Films*, ed. Thomas Koebner. 104–15.

Koebner, Thomas. "Von der Schwäche der starken Männer. Über Emil Jannings, Werner Krauss, Heinrich George und ihre Rollen." In *Idole des deutschen Films*, ed. Koebner. 83–103.

Koebner, Thomas, ed. *Idole des deutschen Films. Eine Galerie von Schlüsselfiguren.* Munich: edition text + kritik, 1997.

Korte, Helmut. "Die Welt als Querschnitt: *Berlin — Die Sinfonie der Großstadt.*" In *Fischer Filmgeschichte*, vol. 2, ed. Werner Faulstich and Helmut Korte. 75–91.

———. "Geschichte und Realität: Madame Dubarry 1919." In *Fischer Filmgeschichte*, vol. 1, ed. Werner Faulstich and Helmut Korte. 326–43.

Kracauer, Siegfried. *From Caligari to Hitler. A Psychological History of the German Film.* Princeton, NJ: Princeton UP, 1947; German trans.: *Von Caligari zu Hitler. Eine psychologische Geschichte des deutschen Films.* Frankfurt am Main: Suhrkamp, 1979.

———. "The Little Shopgirls Go to the Movies." In Kracauer, *The Mass Ornament. Weimar Essays.* Cambridge, MA: Harvard UP, 1995. 291–304.

Kreimeier, Klaus. *Die Ufa-Story. Geschichte eines Filmkonzerns.* Munich: Hanser, 1992.

Kreimeier, Klaus, ed. *Die Metaphysik des Dekors. Raum, Architektur und Licht im klassischen deutschen Stummfilm.* Marburg: Schüren, 1994.

———. *Fanck — Trenker — Riefenstahl. Der deutsche Bergfilm und seine Folgen.* West Berlin: Stiftung Deutsche Kinemathek, 1972.

Kuenzli, Rudolf E., ed. *Dada and Surrealist Film.* New York: Willis Locker & Owens, 1987.

Kurtz, Rudolf. *Expressionismus und Film.* Berlin: Verlag der Lichtbildbühne, 1926.

Lawder, Standish D. *The Cubist Cinema.* New York: New York UP, 1975.

Ledig, Elfriede. *Paul Wegeners Golem-Filme im Kontext fantastischer Literatur.* Munich: Schaudig / Bauer / Ledig, 1989.

Ledig, Elfriede, ed. *Der Stummfilm. Konstruktion und Rekonstruktion.* Munich: Schaudig / Bauer / Ledig, 1988.

Leni, Paul. "Baukunst im Film." In *Der Kinematograph,* no. 911 (1924).

Lenssen, Claudia. "Die 'Klassiker'. Die Rezeption von Lotte H. Eisner und Siegfried Kracauer." In *Recherche. Film. Quellen und Methoden der Filmforschung,* ed. Hans-Michael Bock and Wolfgang Jacobsen. Munich: edition text + kritik, 1997. 67–82.

———. "Rachedurst und Reisefieber. Die Herrin der Welt — Ein Genrefilm." In *Joe May,* ed. Hans-Michael Bock and Lenssen. 31–44.

Maibohm, Ludwig. *Fritz Lang.* Munich: Heyne, 1981.

Mayer, Carl, and Hans Janowitz. *Das Cabinet des Dr. Caligari.* Munich: edition text + kritik, 1995.

Mayne, Judith. "Dracula in the Twilight: Murnau's *Nosferatu* (1922)." In *German Film and Literature,* ed. Eric Rentschler. 25–39.

McCormick, Richard W. "From Caligari to Dietrich. Sexual, Social and Cinematic Discourses in Weimar Film." In *Signs: Journal of Women in Culture and Society,* vol. 18, no. 3 (1993): 640–68.

Möbius, Hanno, and Guntram Vogt. *Drehort Stadt. Das Thema "Großstadt" im deutschen Film.* Marburg: Hitzeroth, 1990.

Müller, Corinna, and Harro Segeberg, eds. *Die Modellierung des Kinofilms.* Munich: Fink, 1998.

Murphy, Richard J. "Carnival Desire and the Sideshow of Fantasy: Dream, Duplicity and Representational Instability in *The Cabinet of Dr. Caligari.*" In *The Germanic Review* (Special Issue: *German Film*): 48–56.

Murray, Bruce. *Film and the German Left in the Weimar Republic. From Caligari to Kuhle Wampe.* Austin: U of Texas P, 1990.

Murray, Bruce A., and Christopher J. Wickham eds. *Framing the Past. The Historiography of German Cinema and Television.* Carbondale and Edwardsville: Southern Illinois UP, 1992.

New German Critique. Special Issue: *Cinema Theory in the Twenties,* ed. David Bathrick, Thomas Elsaesser and Miriam Hansen, no. 40 (1987).

Patalas, Enno. *Metropolis in / aus Trümmern. Eine Filmgeschichte.* Berlin: Bertz, 2001.

Pehla, Karen. "Joe May und seine Detektive. Der Serienfilm als Kinoerlebnis." In *Joe May,* ed. Hans-Michael Bock and Claudia Lenssen. 61–72.

Petro, Patrice. *Joyless Streets. Women and Melodramatic Representation in Weimar Germany.* Princeton, NJ: Princeton UP, 1989.

Plummer, Thomas G., et al., eds. *Film and Politics in the Weimar Republic.* Minneapolis: U of Minnesota P, 1982.

Prawer, Siegbert S. *Caligari's Children. The Film as Tale of Terror.* Oxford: Oxford UP, 1980.

———. "Vom 'Filmroman' zum Kinofilm." In *Das Cabinet des Dr. Caligari. Drehbuch von Carl Mayer und Hans Janowitz zu Robert Wienes Film von 1919/20,* ed. Helga Belach and Hans-Michael Bock. 11–45.

Prinzler, Hans Helmut. *Chronik des Deutschen Films 1895–1994.* Stuttgart / Weimar: Verlag J. B. Metzler, 1995.

Prinzler, Hans Helmut, and Enno Patalas, eds. *Lubitsch.* Munich: Bucher, 1984.

Rall, Veronika. "Geschichten vom Kleinbürgerinstinkte des Publikums. Zum Diskurs der Schaulust in *Varieté.*" In *Ewald André Dupont,* ed. Jürgen Bretschneider. 61–70.

Reichmann, Hans-Peter. *Walter Reimann. Maler und Filmarchitekt.* Frankfurt am Main: Deutsches Filmmuseum, 1997.

Rentschler, Eric, ed. *The Films of G. W. Pabst. An Extraterritorial Cinema.* New Brunswick, NJ: Rutgers UP, 1990.

———. *German Film and Literature: Adaptations and Transformations.* New York/London: Methuen, 1986.

Richter, Hans. "Der avantgardistische Film in Deutschland." *Cinéast. Sonderheft Deutsche Filmtage Göttingen 1953.* 13–23.

———. *Filmgegner von heute — Filmfreunde von morgen.* Berlin: Hermann Reckendorf, 1929.

———. *Malerei und Film.* Frankfurt am Main: Deutsches Filmmuseum, 1989.

Robinson, David. *Das Cabinet des Dr. Caligari.* London: British Film Institute, 1997.

Rotha, Paul. *The Film Till Now.* London: Jonathan Cape, 1930.

Rubenstein, Lenny. "*Caligari* and the Rise of the Expressionist Film." In *Passion and Rebellion,* ed. Stephen Eric Bronner and Douglas Kellner. 363–73.

Salt, Barry. "From Caligari to who?" *Sight and Sound,* vol. 48 (1979): 119–23.

———. "Die innere Welt von Ernst Lubitsch." In *Filmkultur zur Zeit der Weimarer Republik,* ed. Uli Jung and Walter Schatzberg. 65–70.

Saunders, Thomas J. "History in the Making: Weimar Cinema and National Identity." In *Framing the Past,* ed. Bruce A. Murray and Christopher J. Wickham. 42–67.

———. *Hollywood in Berlin: American Cinema and Weimar Germany.* Berkeley: U of California P, 1994.

Schall, Hans Dieter. "Spaces of the Psyche in German Expressionist Film," *Architectural Design*, vol. 70, no. 1 (2000): 12–15.

Schaudig, Michael. *Positionen deutscher Filmgeschichte. Hundert Jahre Kinematographie: Strukturen, Diskurse, Kontexte*. Munich: diskurs film, 1996.

Scheunemann, Dietrich. "*Intolerance — Caligari — Potemkin:* Zur ästhetischen Funktion der Zwischentitel im frühen Film." In *Text und Ton im Film*, ed. Paul Goetsch and Scheunemann. Tübingen: Gunter Narr, 1997. 11–45.

———. "Wiedergelesen: Siegfried Kracauer, *Von Caligari zu Hitler.*" In *Medienwissenschaft*, no. 1 (1999): 118–21.

Schlemmer, Gottfried, Bernhard Riff, and Georg Haberl, eds. *G. W. Pabst*. Münster: Maks Publikationen, 1990.

Schlüpmann, Heide. *Ein Detektiv des Kinos. Studien zu Siegried Kracauers Filmtheorie*. Basel: Stroemfeld Verlag, 1998.

———. "Phenomenology of Film: On Siegfried Kracauer's Writings of the 1920s." In *New German Critique*, 40 (1987): 97–114.

Schobert, Walter. *Der deutsche Avant-Garde Film der zwanziger Jahre / The German Avant-Garde Film of the 1920s*. Munich: Goethe-Institute, 1989.

Schöning, Jörg, ed. *Fantaisies russes. Russische Filmmacher in Berlin und Paris 1920–1930*. Munich: edition text + kritik, 1995.

Seeber, Guido. "Doppelgängerbilder im Film." In *Die Kinotechnik* (1919, no. 1). 12–17.

Segeberg, Harro. *Die Perfektionierung des Scheins. Das Kino der Weimarer Republik im Kontext der Künste*. Munich: Wilhelm Fink Verlag, 2000.

Silberman, Marc. *German Cinema. Texts in Context*. Detroit: Wayne State UP, 1995.

———. "Imagining History: Weimar Images of the French Revolution." In *Framing the Past*, ed. Bruce A. Murray and Christopher J. Wickham. 99–120.

———. "Industry, Text, Ideology in Expressionist Film." In *Passion and Rebellion*, ed. Stephen Eric Bronner and Douglas Kellner. 374–83.

———. "The Modernist Camera and Cinema Illusion: Friedrich Wilhelm Murnau's *The Last Laugh.*" In *German Cinema*, ed. Silberman. 19–33.

———. "Specular Presence and Historical Revolution: Ernst Lubitsch's *Passion.*" In *German Cinema. Texts in Context*, ed. Silberman. 3–18.

Simsolo, Noël. "Le Kammerspiel." *Revue du Cinéma*, no. 413 (1986): 75–81.

Sitney, P. Adams. *The Avant-Garde Film. A Reader of Theory and Criticism*. New York: New York UP, 1978.

Sopocy, M. "The circles of Siegfried Kracauer: From Caligari to Hitler re-examined." *Griffithiana*, vol. 14, nos. 40–42 (1991): 61–73.

Spaich, Herbert. *Ernst Lubitsch und seine Filme*. Munich: Heyne, 1992.

Sturm, Georges. *Die Circe, der Pfau und das Halbblut. Die Filme von Fritz Lang, 1916–1921*. Trier: Wissenschaftlicher Verlag, 2001.

Sudendorf, Werner. "Das Bildjournal E. A. Duponts." In *Filmkultur zur Zeit der Weimarer Republik*, ed. Uli Jung and Walter Schatzberg. 120–27.

———. "Expressionism and Film: the Testament of Dr. Caligari." In *Expressionism Reassessed*, ed. Shulamith Behr, David Fanning and Douglas Jarman. 91–100.

———. "Das Weimarer Kino,." In *Recherche: Film. Quellen und Methoden der Filmforschung*, ed. Hans-Michael Bock and Wolfgang Jacobsen. Munich: edition text + kritik, 1997. 177–85.

Sutcliffe, Anthony. *Metropolis 1890–1940*. London: Mansell, 1984.

Thiele, Jens. "Die dunklen Seiten der Seele: Das Cabinet des Dr. Caligari (1920)." In *Fischer Filmgeschichte*, vol. 1, ed. Werner Faulstich and Helmut Korte. 344–60.

Tomasulo, Frank P. "Cabinet of Dr. Caligari: History/Psychoanalysis/Cinema." *On Film*, no. 11 (1983): 1–7.

Töteberg, Michael. "Die Rückkehr des Dr. Mabuse. Das Ende eines genialen Verbrechers. Serienheld im westdeutschen Unterhaltungskino." In *Idole des deutschen Films*, ed. Thomas Koebner. 362–71.

———. *Fritz Lang*. Reinbek: Rowohlt, 1985.

Tudor, Andrew. "Elective Affinities. The Myth of German Expressionism." *Screen*, vol. 12 (1971): 143–50.

———. "The Famous Case of German Expressionism." In *Image and Influence: Studies in the Sociology of Film*. London: George Allen and Unwin, 1974. 155–79.

———. *Theories of Film*. New York: Viking P, 1973; German trans., *Film-Theorien*. Frankfurt: Kommunales Kino, 1977.

Wegener, Paul. "Neue Kinoziele." In *Kein Tag ohne Kino. Schriftsteller über den Stummfilm*, ed. Fritz Grüttinger. 341–50.

Weinberg, Herman G.. *The Lubitsch Touch*. New York: Dover, 1977.

Wiene, Robert. "Expressionismus im Film." In *Das Cabinet des Dr. Caligari: Drehbuch von Carl Mayer und Hans Janowitz zu Robert Wienes Film von 1919/20*, ed. Helga Belach and Hans-Michael Bock. 149–52.

Willett, John. *The New Sobriety: Art and Politics in the Weimar Period, 1917–1933*. London: Thames and Hudson, 1978.

Wolitz, Seth L. "*The Golem* (1920): An Expressionist Treatment." In *Passion and Rebellion*, ed. Stephen Eric Bronner and Douglas Kellner. 384–97.

Contributors

THOMAS BRANDLMEIER is director of exhibitions at the Deutsches Museum, Munich, and teaches film studies at the University of Siegen. He has published widely on subjects such as grotesque and melodramatic forms in film, and film techniques and aesthetics. His books include: *Filmkomiker. Die Errettung des Grotesken* (1983), and *Die amerikanischen Filme der schwarzen Serie* (1985).

ANTHONY COULSON teaches Intercultural Studies and German Studies at Dublin City University. He edited *Exiles and Migrants. Crossing Thresholds in European Culture and Society* (1997), and has published articles on German cinema from the 1920s to the 1990s with a particular interest in silent film and cross media relationships between cinema and literature. He is currently working on aspects of exoticism in German literature and film of the early twentieth century.

THOMAS ELSAESSER is Professor of Film and Television Studies at the University of Amsterdam. He has published extensively on German cinema. His books include *New German Cinema: A History* (1989), *Fassbinder's Germany. History, Identity, Subject* (1996), *Weimar Cinema and After: Germany's Historical Imaginary* (2000), and a monograph on *Metropolis* (2000).

NORBERT GROB is is Professor of Film and Media Studies at the Johannes Gutenberg-University of Mainz. He has published extensively on American and European film. His books include *Wenders* (1991), *Erich von Stroheim* (1994), *Das Jahr 1945 und das Kino* (1995), *William Wyler* (1996), *Otto Preminger* (1999), and *Zwischen Licht und Schatten* (2002). He is currently preparing a monograph on German Crime Films.

JÜRGEN KASTEN teaches film studies at the Humboldt-Universität, Berlin, the University of Hamburg, and the Hochschule für Film und Fernsehen, Potsdam-Babelsberg. He publications focus on silent film and the theory and history of screenwriting. His books include *Der expressionistische Film. Abgefilmtes Theater oder avantgardistisches Erzählkino?* (1990); *Carl Mayer: Filmpoet* (1994), and *Theorie und Geschichte des*

Drehbuchs in Deutschland (1998). He is managing director of the German Scriptwriters' Guild and editor of the yearbook *Drehbuchautoren Guide* (1990–2002).

THOMAS KOEBNER is Professor of Film Studies at the University of Mainz. He has published widely on German literature, music and cinema. Among his books are *Lehrjahre im Kino* (2nd ed., 2000), *Halbnah* (1999), and *Wie in einem Spiegel* (2003). He has edited the volumes *Idole des deutschen Films* (1997), *Filmklassiker* (4th ed., 2002), *Filmregisseure* (2nd ed., 2002), and *Sachlexikon des Films* (2002).

DAVID MACRAE teaches European film studies at the University of Edinburgh, Center for Continuing Education, and is currently researching the optical aesthetics of early avant-garde film. His most recent publication is "Painterly Concepts and Filmic Objects: The Interaction of Expression and Reproduction in Early European Avant-Garde Film," in *European Avant-Garde: New Perspectives* (2000).

HELMUT SCHANZE is Professor of German Literature at the University of Siegen. He has published on a wide range of topics in German literature and media studies, including Romanticism, drama and theatre, the history of German literature from the Renaissance to the twentieth century, rhetoric, and computing in the humanities. He recently edited the *Handbuch der Mediengeschichte* (2002) and the *Metzler Lexikon Medientheorie — Medienwissenschaft* (2003).

DIETRICH SCHEUNEMANN is Walter H. Bruford Professor of German at the University of Edinburgh. He has written extensively on European literature, art, and film in the modern period. Most recent books published include *Orality, Literacy, and Modern Media* (1996), *Text und Ton im Film* (with P. Goetsch, 1997), *Europäische Kinokunst im Zeitalter des Fernsehens* (with V. Roloff and H. Schanze, 1998), and *European Avant-Garde: New Perspectives* (2000). He is currently organizing an international research project on literature, art and film of the Avant-Garde.

WALTER SCHOBERT is director of the German Film Museum in Frankfurt am Main and Professor at the University of Heidelberg. He has edited a great number of books on film and film history, including the first complete German edition of Lotte Eisner's *Die dämonische Leinwand*, the *Fischer Film Almanach* (1982–2000), and *Kinematograph*, the book series of the German Film Museum. Among his book publications is *Der klassische deutsche Avantgardefilm der Zwanziger Jahre* (1989).

MARC SILBERMAN is Professor of German at the University of Wisconsin in Madison. He has published extensively on German literature, drama, culture, and cinema of the twentieth century, including *German Cinema: Texts in Context* (1995). He also edited and translated the volume *Bertolt Brecht on Film and Radio* (2000). He is currently working on East German cinema of the 1950s.

Index

References to illustrations have page numbers in *italic*.